$99.00

Understanding Digital Color

Understanding Digital Color

Second Edition

by
Phil Green

GATFPress
PITTSBURGH

GATF*Press*
Graphic Arts Technical Foundation
200 Deer Run Road
Sewickley, PA 15143-2600
Phone: 412/741-6860
Fax: 412/741-2311
Email: info@gatf.org
Internet: http://www.gatf.org

Orders to:
GATF Orders
P.O. Box 1020
Sewickley, PA 15143-1020
Phone (U.S. and Canada only): 800/662-3916
Phone (all other countries): 412/741-5733
Fax: 412/741-0609
Email: gatforders@abdintl.com

GATF*Press* books are widely used by companies, associations, and schools
for training, marketing, and resale. Quantity discounts are available
by contacting Peter Oresick at 800/910-GATF.

Contents

Foreword vii

Preface ix

Introduction 1

1 Fundamentals of Color 5

2 Color Measurement and Specification 37

3 Digitizing Color 65

4 The Color Original 85

5 Scanning and Digital Photography 111

6 Color Conversion and Separation 139

7 Color Management 165

8 PostScript and PDF 193

9 Output Systems 215

10 Workflow 247

11 File Preparation 277

12 Proofing 299

13 Digital Printing 319

14 Conventional Printing 337

Appendix: *Understandig Digital Color* Website 361

Index 363

About the Author 369

About GATF 371

GATFPress: Selected Titles 373

Foreword

Roosevelt Paper Company is pleased to donate 70# Roosevelt Offset Enamel for the second edition of *Understanding Digital Color*.

GATF provides invaluable information and education to the printing industry, and Roosevelt Paper is proud to support GATF in this vital work.

Ted Kosloff
President
Roosevelt Paper Company

To Rosalie and Anna

Preface

The first edition of *Understanding Digital Color* arose from the need for a guide for those who had embarked on the route to digital color reproduction and who wanted the best that the graphic arts industry had to offer—for whom "good enough" doesn't even come close.

Four and a half years later, digital color reproduction is no longer in its infancy and many of the concepts introduced in the first edition are now much more widely understood. Moreover, the increased affordability of color imaging systems from digital cameras through scanner, RIPs, and printers have greatly enlarged the user community. Of particular note is the greater acceptance of color management to ensure that color is communicated consistently between imaging devices, and associated with this the greater use of color measurement.

To differentiate their work from the built-in capabilities of the imaging devices now on the market, I believe that graphic arts professionals need a much more advanced knowledge of color imaging. This new edition of *Understanding Digital Color* has been comprehensively rewritten to meet this need. In addition to expanded sections on colorimetry and color management, I have restructured the material to add new chapters on workflow, output systems, and file preparation. I have also taken the opportunity to add many new figures and revise a number of the existing ones.

I would like to thank the many organizations and individuals that have contributed to this project by supplying information and illustrations. I would particularly like to thank Professor Anthony Johnson of the London College of Printing, who reviewed the entire text and made many invaluable comments, and Tony Hodgson of Kall Kwik UK, who made useful suggestions of material to include in the

new edition. All errors and omissions are, of course, entirely my responsibility.

Tom Destree and Erika Kendra edited the text and prepared the illustrations and diagrams, and their great care and meticulous attention to detail is greatly appreciated. Finally, I would again like to thank my partner Ruth, who suffers my preoccupations with great fortitude.

Phil Green
London, England
May 1999

Introduction

The graphic arts industry continues to undergo fundamental transformations in every aspect of color reproduction. These changes are strongly interwoven, and a synergy between many of them can be identified.

Digital production systems using standard-platform computers have now become the dominant method of production throughout the industry. Manufacturers of traditional prepress systems have been forced to reinvent themselves as participants in this open-systems world, focusing on ways of marketing their core expertise in color reproduction and downscaling their development and production of specialized, high-end hardware. It is now possible to implement an all-digital workflow, from initial capture of an original scene by digital photography through to reproduction by digital printing or display.

There is a continued convergence of different media. This makes it essential to move away from traditional practices and embrace production methods that enable repurposing of content.

The value chain continues to shorten, with the automation of both production and management tasks, and the elimination of much traditional prepress work. The proliferation of businesses servicing the different stages in production is telescoping down, so that in many cases there are only the creator and producer in the chain.

Production is becoming globalized. Buyers of imaging services are increasingly able to source production in any part of the world, particularly as all intermediates up to hard-copy reproductions can now be in digital form. The increasing harmonization of production methods through the work of international standards committees has contributed to this process.

Perhaps the largest single driver for change is the growing importance of the Internet, and its ability to both support the imaging chain (through enhanced communication between suppliers and their customers, in addition to file transfer capabilities) and to substitute for many of its products (through the use of the Web as an alternative means of communication).

Management information systems have been common in printing plants for some time, largely handling functions such as costing and estimating. Increasingly the management of production workflows is being undertaken by powerful production management systems, handling functions such as job tracking, scheduling, loading, production control, and management reporting. These systems are increasingly communicating online with suppliers and customers at all stages of production, from initial order inquiries through to receipt of job files and tracking of work in progress.

One of the determinants of success in the graphic arts business is the ability to manage production workflows. Many plants have opted where possible for all-digital workflows, not simply because of the increased productivity of individual processes, but because of the benefits of integrating all processes and the ability to move data through the value chain without the need to convert to physical intermediates at any stage. Speed, quality, and cost efficiency are all improved, and customers have more control of the quality and content of their products. Digital workflows are essential in order to support on-demand and distributed models of printing.

At many stages in the imaging chain there are operations that have eluded the digital workflow. In some cases technological and economic developments point to the integration of these processes into the digital workflow, while in others at least some sectors will continue to use other methods.

Color originals. These continue to be supplied to the printer or repro house as transparencies. Digital photography is growing in importance as an input medium, but a majority of original images continue to be created on photographic media. Artists' illustrations also contribute a small but significant number of color originals, despite the use of computer graphics applications for a large proportion of illustration work.

Work supplied on film. Some elements continue to be supplied as film, requiring either manual stripping or rescanning. Many of these items, such as advertisements, are now increasingly supplied in digital form, following the development of appropriate working conventions and file formats.

Proofs. The adoption of digital proofing has been slow, although it is now becoming widely accepted. Improved calibration systems and the falling costs of proofing systems have allowed digital proofs to become part of the mainstream proofing market. The growing reliance on the designer's page proof, and the wider adoption of soft proofing techniques for content, make it likely that analog proofing technologies will in the future be reserved for specialized functions.

Plates. Computer-to-plate(CTP) systems make it possible to entirely eliminate film and are an important bridge between digital prepress and print production. However, the cost of CTP systems (especially in comparison with traditional plate-making equipment) will restrict their adoption to a relatively small proportion of plants.

Printing. Digital printing systems are absorbing higher market shares as their functions become more comparable with traditional printing processes and they compete effectively on a wide range of different types of work. However, it is unlikely that digital printing will replace conventional printing in many sectors, especially where volumes are high.

Competition in color reproduction is intensifying. Thanks to digital communications, publishers are able to buy print anywhere in the world, and the increased competition is driving down prices. Designers and publishers are now able to carry out many production tasks themselves, and it is no longer possible to charge commercial prices for anything other than high-quality work.

Consistent high-quality color reproduction is the heart of the graphic arts. Color is used to convey meaning, identify brands, and enhance content, and the quality of the reproduction is of the utmost importance. Poor color reproduction causes real, tangible losses, both to the producer and the purchaser.

The technologies used for color reproduction increasingly embody in software the traditional skills of the graphic arts

specialist, and users with no background in color reproduction are now capable of achieving adequate results without using commercial services. As a result, color reproduction professionals need to be able to apply a more advanced understanding of their trade to develop greater levels of quality and consistency, implement faster and more efficient workflows, and meet their customers' needs through specialized services.

1 Fundamentals of Color

Color reproduction is concerned with the rendering of colors onto a medium, whether a permanent physical medium such as a print on paper, or a display screen. The physical properties of color are determined by colorants, substrates, and illuminants, but judgment of the finished reproduction depends on the way that the reproduction is perceived, and so it is necessary to understand something of the intricate mechanism of human color perception. These issues are the focus of this chapter.

Light

Light is produced when electrons move from a higher energy level to a lower one, and, in the process, energy is emitted. If some of this radiated energy has a wavelength that falls within the visible part of the **electromagnetic spectrum,** then it will be detected by the human eye as visible light.

The light that we see is a small part of the electromagnetic spectrum, which also includes microwave, ultraviolet (UV) and infrared (IR) radiation, and radar and radio waves. The wavelengths of the visible spectrum lie between approximately 400 and 700 nanometers (one nanometer equals one millionth of a millimeter) with blue light at one end and red light at the other. Microwaves, x-rays, and ultraviolet light (with shorter wavelengths) and infrared and radio waves (with longer wavelengths) lie beyond the visible spectrum. The term "visible spectrum" is slightly arbitrary since, for many mammals, the visible portion extends into the UV or IR regions.

Light can be understood both as a wave and as an energy-carrying particle called a **photon.** Its wavelength property governs the perception of hue, while its particle behavior can be used to describe the way it causes light-sensitive media, such as photographic emulsions, to undergo chemical or physical changes.

Figure 1-1.
The electromagnetic
spectrum.

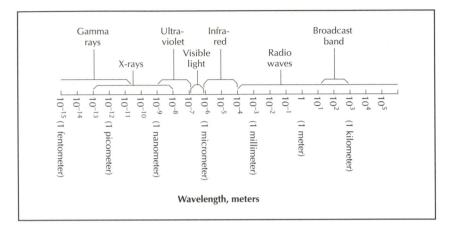

The color spectrum that we see in a rainbow or in a light
beam split by a prism does not have clear boundaries
between the different colors. The main bands of pure color
that we see in the spectrum—blue, green, yellow, and red—
blend into each other, producing intermediate colors such as
turquoise and orange. It is often useful to divide the visible

Figure 1-2.
Light can be split by a
prism into its component
wavelengths.

© *David Parker,* Science
*Source: Photo
Researchers*

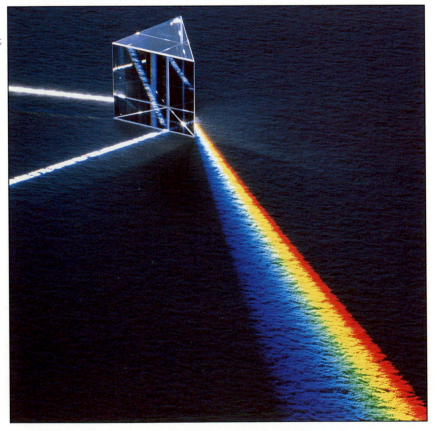

Figure 1-3.
The visible spectrum.

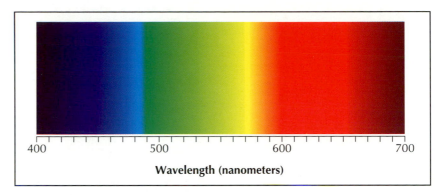

spectrum into three regions, corresponding to red, green, and blue colors. The wavelengths are not themselves colored, however, but stimulate the visual mechanism to produce the sensation of color.

Light is usually more or less colorless, or "white," but when some of the wavelengths are removed, the color we see is made up of the remaining wavelengths. For example, if a red filter is placed over a light source, the green and blue components are masked and only red light is transmitted.

White light comprises all wavelengths in approximately equal proportions. So if equal amounts of red, green, and blue lights are combined, the result is white light. If they are combined in unequal proportions, the result is a color. For example, by combining red and green light with little or no blue, we see a yellow. Similarly, green and blue lights together make cyan, and blue and red combine to produce magenta.

Computer monitors and television screens follow this principle by emitting light from individual red, green, and blue phosphors in different proportions to additively synthesize millions of different colors.

Spectral Power Distribution

For any color, the relative amount of light at each wavelength can be plotted as a **spectral power distribution** (SPD) that is a unique "fingerprint" for that color. When different spectral power distributions are added, they create a new color. This makes additive color mixing the inverse of mixing inks or paints, which produce their secondary colors by absorbing light at selected wavelengths.

Thus, on a computer monitor, yellow is displayed by firing electrons at red and green phosphors, causing them to emit light that the eye perceives as yellow. On paper, yellow is made by printing an ink film containing a pigment that subtracts from the spectral power distribution of the light source

Figure 1-4.
Spectral reflectance
of a green ink.

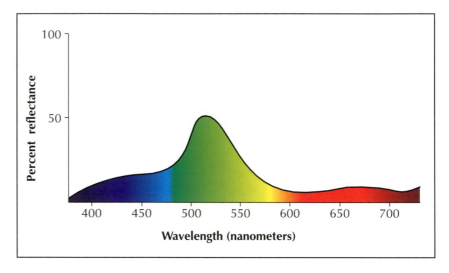

in the blue region, reflecting light only in green and red wavelengths.

A plot of a spectral power distribution for a transparency is often referred to as a **spectral transmittance** curve, while a plot of the amount of light reflected at each wavelength from a colored surface is a **spectral reflectance curve.**

Some colors are missing from the spectrum: the cool reds, magenta, the purples, violets, and mauves. If we turn the spectrum into a circle, these colors lie between red and blue. The "color circle" formed in this way is extremely useful in choosing colors and in looking at the relationships between

Figure 1-5.
The color wheel.

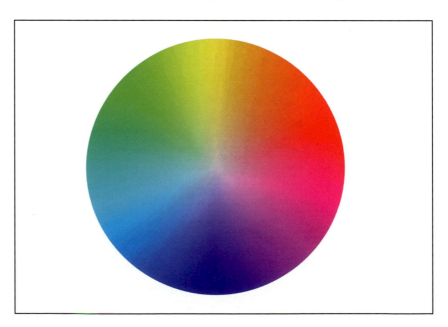

them. All possible hues lie around the circle, and opposite colors (lying on either side of the center on a line that passes through the center) form complementary pairs. The theme of the color circle will be taken up again later in this chapter.

Color Temperature

When describing the color properties of a light source the concept of **color temperature** can also be used. This is based on the observation that a body emits light as it is heated, glowing first red, then yellow, and continuing through a neutral white to a blue.

Color temperature is measured on the Kelvin scale (0 K is equal to –273° Celsius). A light source with similar power at

Figure 1-6.
Correlated color temperature of typical light sources.

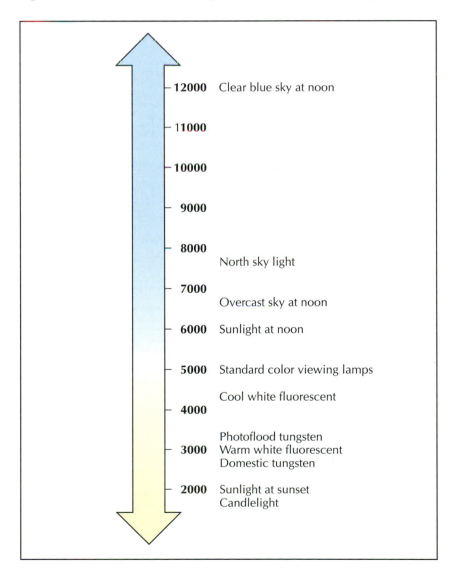

12000	Clear blue sky at noon
11000	
10000	
9000	
8000	
	North sky light
7000	
	Overcast sky at noon
6000	Sunlight at noon
5000	Standard color viewing lamps
	Cool white fluorescent
4000	
	Photoflood tungsten
3000	Warm white fluorescent
	Domestic tungsten
2000	Sunlight at sunset
	Candlelight

each wavelength is considered to have a color temperature of approximately 5,600 Kelvin. Lower color temperatures are more yellow, and higher color temperatures are more blue.

A series of spectral power distributions have been defined by the **CIE** (**Commission Internationale de l'Eclairage**) as standard illuminants. An illuminant with a color temperature of 5,000 K and a spectral power distribution similar to natural daylight is known as a **D50 illuminant;** this is widely used in the graphic arts as a basis for standard light sources for viewing color originals, proofs, and prints.

Colored Surfaces A surface does not itself have a precise color but rather an ability to absorb certain wavelengths of visible light. A leaf appears green, for example, because it contains a pigment that absorbs red and blue wavelengths from the incident light, reflecting only green to the observer.

The reflection of light from a colored surface has two components. First, some light is reflected unchanged from the first layer of the surface. The remainder enters the substrate and undergoes scattering and multiple reflections inside the material. Eventually, unless the light energy decays within the material, it emerges from the surface as a diffuse reflection. Where the light meets a pigment particle within the surface, some wavelengths will be absorbed while others will be reflected and allowed to continue on their path through the material. Any light that emerges will be perceived by an observer as having a color corresponding to the unabsorbed wavelengths.

The light that is reflected from the first layer of the surface (the "first-surface reflection") makes the surface appear

Figure 1-7.
Light reflectance.

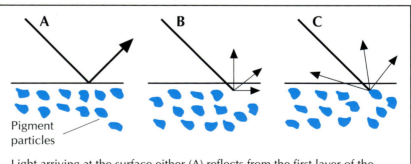

Light arriving at the surface either (A) reflects from the first layer of the surface or (B) enters the material and is scattered internally, some being absorbed but some re-emerging as diffusely reflected light. Where the light strikes pigment particles, (C) some wavelengths will be absorbed.

lighter, since light has been reflected without any part of it being absorbed. This effect is known as **flare.** In the case of a computer monitor, incident light that strikes the surface and is reflected to the user causes the screen display to lose contrast, since the dark areas appear lighter.

Subtractive color systems, such as the inks used in commercial printing processes and the dyes in photographic prints and transparencies, produce their range of colors by absorption, subtracting wavelengths of light rather than combining them. The subtractive primaries (cyan, magenta, and yellow) are the opposites, or complementaries, of the additive primaries of light. Each of the subtractive primaries absorbs one of the additive primaries (thus cyan absorbs red, magenta absorbs green, and yellow absorbs blue), giving the widest gamut possible with just three colors. Just as combining different proportions of the additive primaries (red, green, and blue) allows millions of different colors to be produced, overprinting different amounts of cyan, magenta, and yellow also creates a large gamut of different colors.

In an ideal system, the process colors would have the following properties:

- A spectral absorbency that exactly mirrored the red, green, and blue bands of the spectrum, with no reflection in wavelengths beyond.
- Perfect additivity, so that the density of the three layers of ink is the same as the sum of three separate densities (and similarly for individual colors: the red density, for example, of the three layers should be the same as the sum of the red densities of the separate layers).

In practice, real inks cannot be formulated to have ideal spectral absorbencies. For inks in commercial use a compromise has to be made between the spectral reflectances and the cost of the formulation.

Additivity depends partly on the transparency of the inks (so that overprinting colors do not mask the underlying colors), and on their ability to adhere equally to unprinted and printed surfaces. Special colors, such as PANTONE colors, are usually more opaque because they are not intended to overprint with other colors. Again, it is impossible to formulate inks with completely ideal properties.

If the spectral absorbency of the three process colors were ideal, printing cyan, magenta, and yellow on top of each other would absorb all of the additive primaries (red, green,

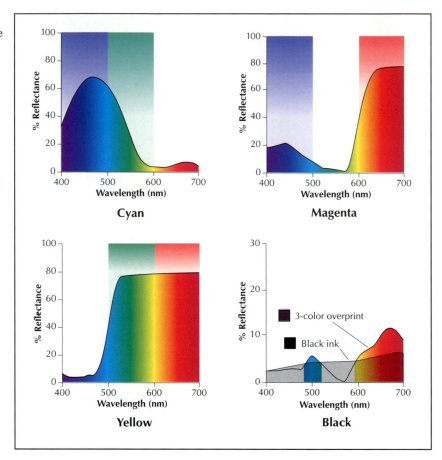

Figure 1-8.
The spectral reflectance curves of the three process color inks and black.

and blue) to produce black. In practice, overprinting these three colors creates a dark brown; to enable a wider range of densities to be printed a black ink must also be used. Black can also accentuate the edges of an image, and it reduces the quantity of more expensive colored inks that need to be used. The four colors—cyan, magenta, yellow, and black—are often abbreviated as CMYK. Many people in the graphic arts industry refer to cyan and magenta as "process blue" and "process red" (or, confusingly, as just blue and red).

Although three subtractive primaries is the minimum required to reproduce the full range of hues, it is possible to use an ink set with more than three primaries. This is done with systems such as Hexachrome, and it has the effect of expanding the gamut of colors that can be reproduced.

As well as any pigment that may be present, substrates have other properties that affect color appearance. The precise way in which a surface reflects the light that falls on it will be crucial to the appearance of color; properties such as

gloss, texture, absorbency, and fluorescence must be considered when choosing or comparing colors. These properties cannot easily be simulated on a computer monitor or proofing medium.

The gloss of a surface is determined by the way in which light is reflected from it. The greater the proportion of incident light that is reflected at the same angle as it strikes the surface, the glossier the surface appears. A surface that scatters light randomly has a diffuse appearance. Paper gloss depends mainly on smoothness and the type of surface coating applied. It can also be altered by finishes, such as calendering, varnishing, and laminating.

Figure 1-9.
Reflection from
(A) a matte surface and
(B) a glossy surface.

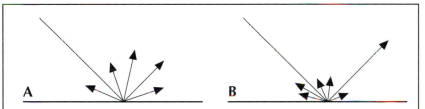

On a matte surface (A), light is reflected randomly in all directions. On a glossy surface (B), a larger proportion is reflected in the "specular" angle, and when viewed from this angle the surface appears to glare.

Because gloss affects the first-surface reflection rather than reflection from inside the substrate, its effect on a printed surface is to reduce the amount of colorless light reflected and intensify the appearance of the color, except when viewed in the specular angle.

Textured surfaces and pearlescent and metallic inks affect appearance by changing the way in which light is scattered and reflected. Absorbent papers make colors look duller and darker and can also make hues seem slightly redder.

Fluorescence occurs when ultraviolet radiation from just outside the visible spectrum is absorbed and re-emitted as visible light, thus increasing the total amount of light reflected from a surface. Fluorescent brightening agents are commonly added to paper and boards to make them brighter and whiter and to increase the possible density range that can be achieved when printing on them.

Human Color Perception

The way in which we perceive color is still not fully understood, but what we do know reveals an extraordinary apparatus with some surprising features. It has evolved over millions of

years from very simple light-sensitive cells in primitive animals, and it is astoundingly good at tasks like distinguishing between different colors and recognizing people and objects on the basis of subtle variations in tone and color. Although we do not all see color in exactly the same way, for the majority of the population the amount of natural variation between individuals is small.

The elements of the human visual apparatus are shown in Figure 1-10. Light enters the eye through the lens and is focused onto the retina, where an array of tiny cells, known as **photoreceptors,** respond to the light by stimulating specialized nerve cells, which pass on signals to the brain. The light receptors in the retina of the eye are called **rods** and **cones.** Rods, which are not sensitive to color and work best at low levels of illumination, capture only lightness information. In other words, they can only tell how much light they receive, not what color it is. Because they are distributed throughout the retina, rods can respond to images throughout the visual field.

Figure 1-10.
The human eye.

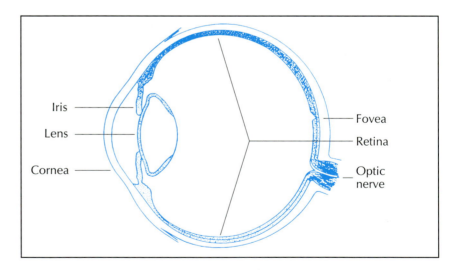

The cone photoreceptors are responsible for the sensation of color. Cones, which need higher levels of illumination than rods, are concentrated in the central region of the retina, corresponding to a central region of focus within the visual field. They contain a pigment called **rhodopsin,** which absorbs light energy and stimulates an electrochemical response. In human cone cells there are three versions of the rhodopsin molecule. One allows only the shorter wavelengths to pass through, another allows only the longer wavelengths,

and a third the middle region of the visible spectrum. These three bands of sensitivity correspond to peaks in the blue, green, and yellow-green regions of the spectrum. The long, medium, and short wavelength cones are often referred to as L, M, and S, rather than as R, G, and B. The L cone is unique among mammals to humans and a small number of other primates. The peak sensitivities of the M and S cones appear to be optimal for detecting food sources against the background of mature leaves in forests.

Figure 1-11.
Scanning electron microphotograph of rod and cone cells in the eye. As in all mammals, these cells are inverted, facing away from the light.

© *Omikon,* Science
Source: Photo Researchers

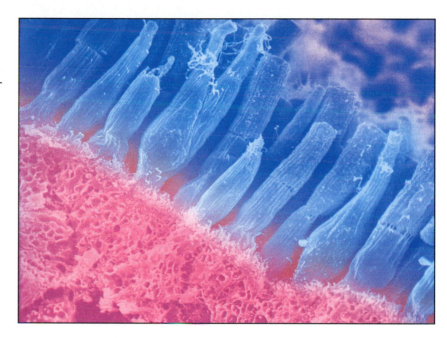

The greater the amount of light that falls on the retina, the greater the response produced by the rod and cone cells. The responses produced by rod and cone cells when light falls on them are not uniform, since at higher levels of intensity, the response begins to fall. The effect of light intensity on the response of the photoreceptor cells can be modeled as a logarithmic or cube root relationship rather than a linear one, as illustrated in Figure 1-12. This relationship is typical of physiological stimulus-response mechanisms, and it is also seen in other perceptual channels, such as the auditory system's response to sound.

As can be seen in Figure 1-13, there is considerable overlap among the three cone responses. In addition, the cones are not equally distributed among the L, M, and S receptors, but are present in a ratio of 40:20:1. The M (green) cones are

Figure 1-12.
The response to increasing light intensity can be represented by a log or cube root function.

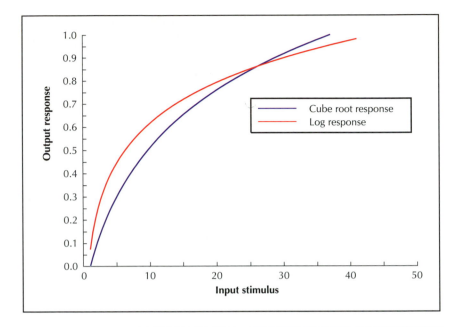

Figure 1-13.
Relative spectral absorbencies of the three types of receptor in the retina, measured by Bowmaker and Dartnall in 1980.

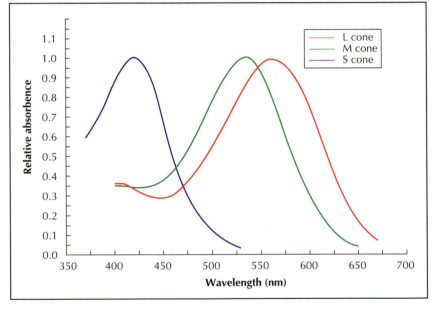

most sensitive and S (blue) the least, and as a result we are more able to discriminate between colors in the red-yellow-green-cyan regions of the spectrum than in the blue region. Because only short-wavelength receptors distinguish between the response to yellow and white (and between blue and black), yellow type on a white background (and blue on black) are poorly discriminated.

There is a delay of around 0.4 seconds between the time the image falls on the retina and the brain becomes conscious of it, although intense flashes of light are processed more quickly. Once perceived, the sensation may take up to two minutes to fade, sometimes leading to after-image effects. This "persistence of vision" phenomenon is exploited by film, television, video, and computer monitors, which display a rapid succession of still images, or illuminate successive pixels, and refresh them before the perceptual image has decayed.

The six million or so cones are stimulated when light passes through the lens and strikes the retina. The impulse is first processed in the ganglion cells immediately adjacent to the retina, then it passes through the optic nerve to the region of the brain known as the **visual cortex,** where further processing takes place.

For every photoreceptor cell in the retina, there are around 100 neurons in the visual cortex grouped together in information-processing regions that specialize in different attributes of the perceptual image. These regions extract information about edges, movement, color, faces, and so on, and synthesize it into the image we recognize. The perception of edges in particular is given a great deal of weight, and this makes sharpness (or definition) a vital criterion for judging image reproduction.

It is tempting to draw an analogy between the human visual system and an optical image sampling system such as the charge-coupled devices (CCDs) used in video recorders and scanners. They both respond to light of different wavelengths and intensities by sending out signals; they both require an optical system to focus the image onto an image-capture plane; and they both use filters to analyze the red, blue, and green components of the image.

However, the analogy cannot be taken any further since the perceptual image in the human visual system is not a photographic record of the real world, but an active image made up of elements from the different regions of the brain that have processed signals from the eye. Unlike a color scanner, the human visual system does not sample the visual field as a static array of point intensities, but as a dynamic, moving image. The brain may discard much of the available information from the visual field in its search for patterns and objects that it can relate to images recalled from memory.

Deviations in Color Perception

The majority of the population shares the same color perception mechanism, and differences in color perception amongst this majority are largely related to aging of the optical apparatus and experience of making color judgments. For this majority it is possible to define a statistically "normal" observer. A small percentage of the population diverges from this normal perception, usually through having inherited a variant of the genes that control the cone pigments.

Some cases of visual divergence are not retinal but cognitive (i.e., they take place in the brain after the initial response has been received from the retina), being caused by damage to one of the brain's "image-processing" centers, often due to an accident or a stroke. There have, for example, been cases of people who have normal visual systems but a complete inability to recognize faces. Other instances of unusual color perception include the phenomenon of **synaesthesia,** the ability to perceive a sensation like color from a different sense, such as sound, smell, or taste. (Vasily Kandinsky was, like a number of artists, a synaesthetic, and many of the images he produced were influenced by music that he heard or composed.)

Approximately one in ten men and one in a hundred women experience some form of defective color vision, the most common being confusion between red and green. In extreme cases, the individual is likely to be conscious of the problem, but, in more borderline cases, he or she may not be. Such divergences in color perception may be inconvenient for the individual, but give us powerful insights into the ways in which the brain is organized and the mechanism of color perception operates.

Color vision that diverges from the statistically normal can lead to errors in color matching. It is recommended that people involved in making critical judgments in color selection or color reproduction take color vision tests, if only to become more aware of any limitations they may have.

Discriminating Between Colors

We are highly sensitive to changes in lightness, owing to the larger numbers of cells in the eye and the brain that are dedicated to analysis of the spatial information in the incoming signal (such as specialized edge detection cells). The implications of this are:

- The lightness information in an image should ideally be given greater precision in sampling and encoding than the color information.

- If both lightness and color are sampled with equal precision, some color data can be discarded without affecting the appearance of the image.

Figure 1-14 shows how the lightness channel is the most important for the recognition of the subject.

Mechanisms of Adaptation

The color sensation of which the observer is conscious is affected by both retinal and cognitive processes, the most important of which are discussed here.

Daylight varies in intensity from one lux at dawn to 100,000 and more in bright sunshine, and in color from the pink of dawn through the blue of noon to the red-orange of sunset. Artificial lighting tends to be lacking in blue wavelengths, and many fluorescent illuminants have highly irregular spectral power distributions with strong spikes of energy at certain wavelengths. Yet we have no difficulty in adapting to these changes and continuing to recognize objects under enormous variations in lighting conditions.

The evolution of the visual mechanism from sightless creatures to birds and mammals with high visual acuity is linked to the success of each organism in terms of its survival and reproduction, through its ability to recognize objects and features under different lighting conditions. The factors that influence perception can be understood as a combination of the light capture mechanism of the eye and image-processing carried out by the neural cells in the eye and the brain. The mechanism by which this is achieved is by adaptation to the intensity and color of the illumination.

Brightness Adaptation

Adaptation to different intensities of illumination is highly effective. Consider as an example a white screen illuminated by a constant diffuse room light. When an image is shone onto it from a projector, parts of the screen receive additional light to form the image. The brightest regions of the projected image will now be seen as white, and the background (previously seen as white) is now seen as black, despite receiving no less light than before.

Many people are familiar with these effects on a computer screen. The appearance of the color display varies considerably according to whether the room is lit by daylight or artificial light, and the brightness of the screen appears to increase as the day draws to a close and the eye adjusts to lower light intensities.

Figure 1-14.
Most of the spatial and tonal information in an image is found in the lightness channel. Here the individual L* (lightness), a* (relative redness-greenness), and b* (blueness-yellowness) channels of an image in the CIELAB color space are shown.

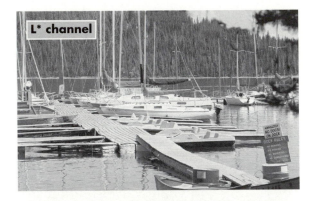

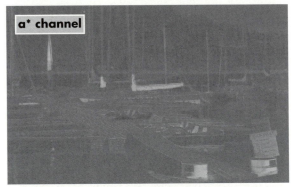

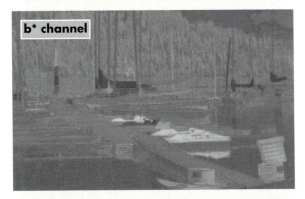

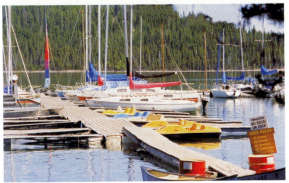

The stimulus generated by the amount of light received at the eye is modulated at several points. First, the iris adjusts its opening over a range of 0.06–0.31 in. (1.5–8 mm), rather like a camera aperture. Next, the response of the photoreceptor cells is nonlinear, as indicated in Figure 1-12, effectively compressing the response at higher light intensities. Finally, individual cone cells undergo a temporary "bleaching" effect whereby their response is further reduced following exposure to bright light. There is also some evidence that further adaptation takes place in the cells beyond the retina.

Brightness adaptation takes place mainly as a result of physiological changes in the eye, which are not immediate but take place over time. When going from light to dark conditions, this adaptation can take several minutes to complete.

Chromatic Adaptation

The eye adapts to the color as well as the intensity of the illuminant, tending to perceive it as neutral and colorless. The mechanism for chromatic adaptation is located mainly in post-retinal cells, and unlike brightness adaptation has a cognitive component that is instantaneous.

Chromatic adaptation effects can be quite extreme, although one is rarely conscious of them unless there are ambiguities in the field of view, such as multiple illuminants with different colors. One moves from a tungsten-lit room to daylight without normally being aware of the large shift in illuminant color (although if the scenes are photographed the resulting images will show the differences clearly).

Similarly, if the tungsten-lit room is viewed from outside, and the sun is low so that the intensities of the two illuminants are similar, the observer is adapted to daylight and the room light is seen as strongly yellowish.

The chromatic adaptation effect can also takes place within an image. The visual system adjusts the perceived colors of the image to compensate for the apparent illuminant color, as shown in Figure 1-15. The mechanisms that generate the chromatic adaptation effect cause a general shift in perceived color away from the hue of the surrounding color.

The effects of both brightness adaptation and chromatic adaptation mechanisms can be seen in Figure 1-16.

Basic Perceptual Attributes

Although the cones are sensitive to short, medium, and long wavelengths of light, as a result of the processing that takes place in the post-retinal cells we do not perceive colors

Figure 1-15.
Chromatic adaptation.
The girl's shirt is
printed only in black,
its apparent hue being
caused by adaptation to
the surrounding
black/cyan duotone.

Figure 1-16.
Simultaneous contrast.
Each row of color targets
contains circles of the
same color. The sur-
rounding colors affect
the perceived lightness
and hue.

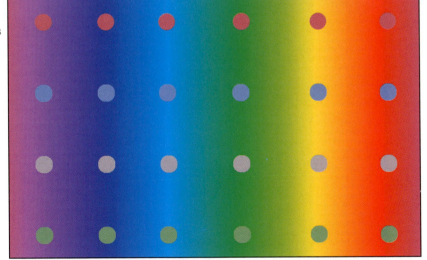

directly in terms of their spectral distribution. When we look
at a color, the basic properties that we observe are:
- Its **brightness.** (How much light is it reflecting?)
- Its **hue.** (What are the proportions of red, green, blue, and
 yellow? In other words, what wavelengths are present?)
- Its **colorfulness.** (How vivid is the color? How well does
 the hue stand out against a neutral background?)

Figure 1-17.
Most color spaces have three dimensions. One is invariably hue, another brightness or lightness, and the third, colorfulness. The hue and colorfulness co-ordinates of a three-dimensional color space are defined by their angle and radial distance from the achromatic center.

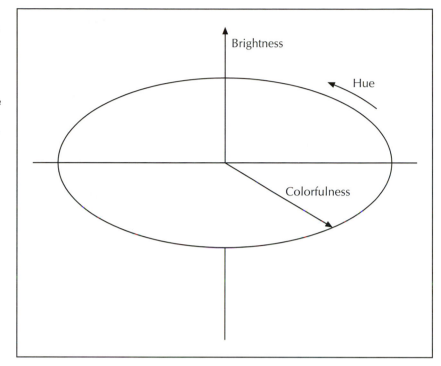

These general perceptual attributes of hue, brightness, and colorfulness can also be used as the basis of related, quantifiable terms that are particularly useful when considering color reproductions.

Because of the adaptation effect described earlier, the perception of brightness is governed by the amount of illumination present. In a graphic arts context, we are likely to judge the brightness of a color not by the absolute amount of light reflecting from it, but relative to the lightest area visible (such as the white point of a monitor or an unprinted area of paper). Relative brightness is called **lightness.** Lightness is an achromatic attribute in that it gives no information at all about the color of an object, only about how light or dark it is.

It is also preferable to have a relative measure of colorfulness, as the perception of it also varies according to brightness. Two terms are used to indicate relative colorfulness. Chroma is colorfulness relative to the brightness of a white area which has the same level of illumination; while saturation is colorfulness relative to the brightness of the color itself.

Although chroma and saturation are similar concepts, they have different applications. If an observer examines a

Figure 1-18.
Hue axis (top), and spectral reflectance curve (bottom). The hue axis in the HSL model is circular, hues being defined by the angle they make (red is usually 0°).

Hues are also differentiated by their peak wavelengths on a spectral reflectance curve. Two greens are shown here, one of which is slightly more blue in appearance.

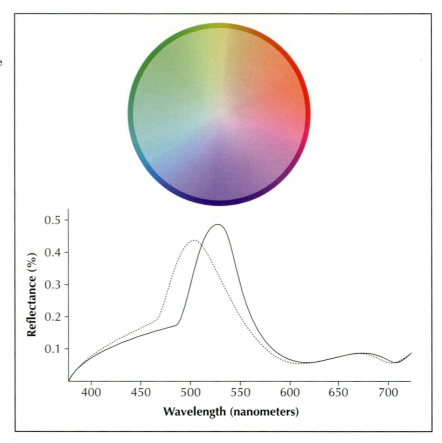

Figure 1-19.
The HSL color model.

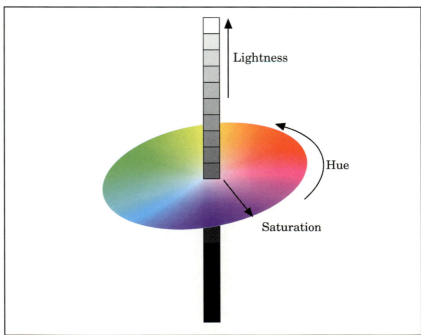

color print, the colorfulness will fall as the level of illumination falls. The adaptation mechanism allows the observer to compensate for the perceived fall in colorfulness and recognize the object as the same. As the whole surface of the print receives the same illumination, the colorfulness can be judged relative to the brightness of the white, and chroma is the most appropriate measure.

In a natural scene the amount of light falling on a surface will vary according to factors such as its nearness to and angle to the illuminant. There is no reference white which is similarly illuminated by which to judge the chroma, and the observer will assume that darker, less illuminated areas have a similar colorfulness to brighter areas. In this case colorfulness relative to the brightness of the color, or saturation, is being judged.

Saturation and chroma indicate the intensity or purity of a color: highly saturated colors are said to be vivid, while desaturated colors are referred to as dull or dirty. On a color wheel, they are represented by the distance from the center of the wheel; the nearer to the periphery, the higher the saturation and the chroma.

Figure 1-20. Saturation axis. The saturation axis in the HSL color model extends from neutral gray at the center to the saturated colors at the periphery. Colors can have a saturation value from 0 at the center to 100 at the periphery.

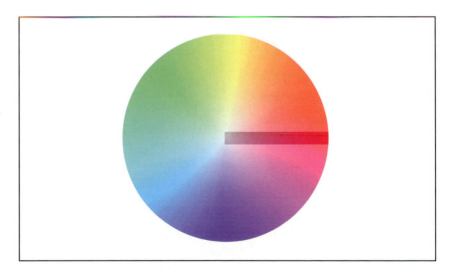

Because red, green, blue, and yellow have the unique property of being seen as spectrally pure, hue can be considered as the relative amount of these four colors. The hue of a color can be communicated by its position around the circumference of a color wheel, or by its spectral power distribution relative to a given light source. In a spectral power distribution the peak wavelength is the most important indicator of

Figure 1-21.
Lightness axis. The lightness axis in the HSL color model is at right angles to the chromatic plane. Colors have a lightness value from 0 (black) to 100 (white).

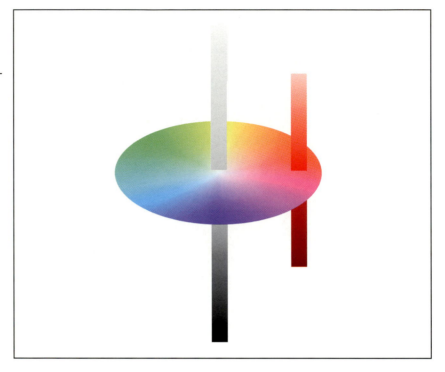

hue. Thus a green with a "hue angle" of 120° would have a peak wavelength of around 520 nm (depending on the way that hue angle is calculated).

Color Systems

There are a number of ways of arranging colors by attributes based on hue, colorfulness, and brightness. Color systems of this kind are known as **color order systems** and **color spaces.** A color order system is a systematic way of arranging individual colors, while a color space extends this concept to provide continuous dimensions for the chosen attributes, making it possible to precisely quantify any color. For designers and printers, both color order systems and color spaces are valuable tools for visualizing, specifying, quantifying, and controlling colors.

The three basic attributes of human color perception—brightness, hue, and colorfulness—form the basis of many color order systems and color spaces. Examples include hue, saturation, and lightness (HSL); hue, saturation, and brightness (HSB); hue, saturation, and value (HSV); and lightness, chroma, and hue (LCH).

All such systems are three-dimensional, reflecting the minimum of three components needed to define color. Perceptual color spaces are organized around axes based on brightness

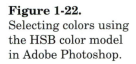

Figure 1-22.
Selecting colors using
the HSB color model
in Adobe Photoshop.

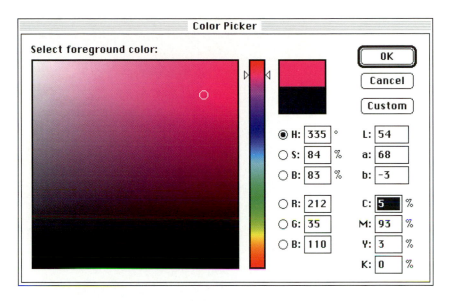

(usually shown vertically), hue, and colorfulness. The last two axes can be thought as forming a two-dimensional chromatic plane where the color information is defined independently of luminance.

The axes of a color space define a coordinate system which enables colors to be precisely located relative to each other. If the color space is perceptually uniform, differences between colors can be quantified in a meaningful way.

Color Order Systems

Color order systems define a number of discrete colors in a way that differences between them are seen as perceptually equal. The two best-known are the Munsell system and the Natural Color System (NCS). Color order systems are often realized as a set of real color surfaces, which are widely used in colorant industries where it is important to have a systematic way of defining a large range of colors.

The Munsell system. The Munsell system contains color patches arranged on the axes of hue, chroma, and value (value being the Munsell term for lightness). Considerable trouble has been taken in arranging all the patches in the Munsell system so that the distance between patches along each of the axes are perceptually uniform throughout the system. This means, for example, that two patches adjacent on the chroma axis in the red region have perceptually the same difference in chroma as two adjacent patches in the blue region.

Figure 1-23.
A three-dimensional representation of the Munsell system.

Reproduced by permission of Munsell Color©.

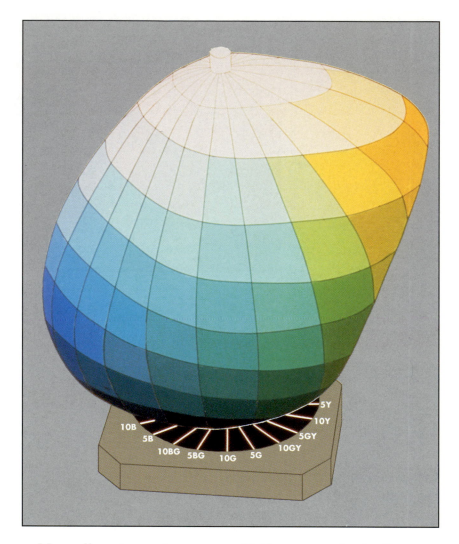

Munsell system colors are available as samples in the Munsell Book of Color.

The Natural Color System. In the Natural Color System, or NCS, hues are defined in terms of the proportions of red, green, blue, and yellow. On the lightness axis, colors are specified in terms of their whiteness/blackness; and colorfulness is defined as chromatic intensity.

Device Color Spaces

Color devices are based on RGB, CMY, and CMYK. The appearance of a color specified as amounts of RGB and CMYK depends on the characteristics of the system used to reproduce it. On a monitor, the precise nature of the phosphors and the shadow masks and the exact potentials used by the

electron gun determine the actual color displayed from a given RGB specification. The steps of RGB space are thus based on the characteristics of the display device, rather than any visual appearance criteria. These steps do not produce uniform changes in perceived intensity, and the three color signals cannot be combined in ways that are analogous to the human visual mechanism.

In printed output, the color is specified in terms of the dot percentages of cyan, magenta, yellow, and black, but other factors, such as the characteristics of inks and presses and the type of paper used will also contribute to the final appearance. The CMYK space is even less consistently related to color appearance than RGB.

Thus both RGB and CMYK are device-dependent color spaces that inevitably have restrictions in communicating and converting information about colors among different color devices. They also have different color gamuts, or ranges of reproducible colors. For example, monitors can display many colors that cannot be printed, especially in the saturated red, green, and blue regions, but are unable to display some colors (especially cyan) to the same degree of saturation as a print.

HSB. In the HSB display space, the hue, saturation, and brightness components are similar to those described above, but with an important difference. Display HSB is directly based on the RGB intensities of the computer color display monitor. What this means in practice is:
- The hue of a color is adjusted by altering the balance of RGB intensities, keeping the total intensity the same.
- The saturation of a color is adjusted by increasing or decreasing the intensities of the complementary RGB color, keeping the dominant color the same.
- The brightness of a color is adjusted by scaling the RGB intensities up or down equally, keeping the balance of intensities the same.

Many computer applications support the specification of colors in HSB, for example through controls with separate "sliders" for hue, saturation, and brightness. The Color Picker on the Macintosh, which interfaces with the Quick-Draw graphics controller, allows colors to be selected in both RGB and HSB.

Device-Independent Color Spaces

Device-independent color spaces are based on the response of the visual system to color, rather than the colorant system of a given device. They are all transformations of the tristimulus values defined by the CIE, which are described in more detail in the next chapter. Two examples are CIELAB and YCC.

CIELAB. The CIELAB system is based on the Munsell system and closely follows the spacing of the Munsell system. Instead of a series of color samples, though, it represents a continual three-dimensional space within which a color can be located and given a numeric value.

Figure 1-24.
The CIELAB color space is a Cartesian system whose dimensions L*, a*, and b* are all at right angles to each other. Coordinates for hue angle (H$_{ab}$) and chroma (C*) can be calculated from the values for a* and b*.

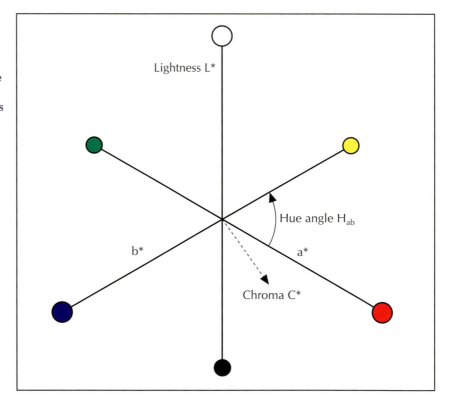

The lightness axis, L*, correlates more or less perfectly with Munsell Value. This lightness axis is at right angles to the chromatic plane, whose axes are called a* and b*. In CIELAB, a* represents relative yellowness-blueness, and b* represents relative redness-greenness. This system works well for most purposes in color measurement and specification, although recent improvements to its perceptual uniformity have been made.

YCC. The YCC color space is the basis of the Kodak Photo CD system. It was developed by Eastman Kodak from a method of encoding color images for display on TV screens or computer monitors. Like the perceptual color models, it encodes lightness information separately from chromatic information.

Images are encoded in YCC by converting the red, green, and blue components recorded by the scanner to one luminance component (Y) and two chromatic components (C1 and C2). The three channels are then quantized to eight bits per component.

A feature of the YCC model is that it is designed to be able to encode the full range of luminance values in the original scene captured by the photographer, values which are often greater than the display capabilities of a color monitor. When Photo CD images are translated back to RGB, the YCC data must be scaled to the levels available or highlight information may be lost.

When the YCC data is written as a Photo CD file, the chromatic data is subsampled, so that only one bit of color information is stored for every four luminance bits (making use of the characteristic of human visual perception that gives greater prominence to lightness than to color). When the file is converted back to RGB, the color data is restored by interpolation.

Viewing Conditions

The dependence of color appearance on the light source makes it extremely important to have some standardization of viewing conditions in the graphic arts. The international standard ISO 3664:1974, *Viewing Conditions—Prints, transparencies and substrates for graphic arts technology and photography*, based on the American National Standards Institute (ANSI) standard ANSI PH2.30-1989, specifies viewing conditions for the graphic arts.

ISO 3664 specifies characteristics of the light source to be used, as summarized in Table I. In addition, the chromaticity coordinates of the light source and the tolerances allowed are defined.

The standard is mainly directed at manufacturers of color viewing equipment. Points that users need to be aware of are listed here.

In general:
- Lamps should warm up for 15–45 minutes before use to reach a stable temperature.

Table 1-1.
ISO viewing conditions.

ISO viewing condition	Illuminant	Chromaticity tolerance	Luminance level	Color rendering index	Surround
Critical comparison of prints (P1)	D50	0.005	2,000 lux ±250 lux	>90	Neutral matte surface; <60% reflectance
Critical comparison of transparencies (T1)	D50	0.005	1,270 cd/m² ±160 cd/m²	>90	Neutral, extending at least 50 mm on all sides; 5–10% of luminance levels
Practical appraisal of prints (P2)	D50	0.005	500 lux ±125 lux	>90	Neutral matte surface; <60% reflectance
Color monitors	D65 white point	0.25	>100 cd/m²	N/A	Neutral; dark gray or black; ambient illumination <64 lux

Note: For direct comparison with prints, a D50 monitor white point is preferred. This is encompassed by the chromaticity tolerance specified.

- You should allow time for your eyes to adjust to the D50 illuminant.
- Any ambient lighting that is not standardized should be reduced or eliminated—room lights should be dimmed or turned off and blinds or drapes closed.

Figure 1-25.
Color viewing booth with standard 5000 K lamps. At the far left in the viewing booth is a transparency viewer.

- Bright colors on furniture or clothing should be avoided as they will cause a color cast.
- All surfaces surrounding the viewing area should be a neutral gray in color with a reflectance of 60% (Munsell N8/).
- Manufacturers recommend that lamps should be changed after 2,500–5,000 hours of use because the color temperature changes as the lamps age.

For transparencies:
- Inspect on a transparency viewer equipped with D50 lamps.
- Have a 2-in. (51-mm) white border around the transparency, with a gray surround beyond it.
- Place the transparency viewer in a viewing cabinet with D50 overhead lamps, or under D50 room lamps.

For prints:
- Use a viewing cabinet equipped with D50 lamps and an interior painted neutral gray.

For monitors:
• Ensure that ambient lighting is minimized unless it conforms to the standard.
• Keep the intensity of ambient lighting consistent throughout the day.
• Remove any light sources that shine directly on the color monitor.

ISO 3664 (revised) includes specifications for viewing on color monitors. It recommends setting the monitor white point to D65 or D50.

There is inevitably some variation even within standardized lighting conditions, due to factors including lamp characteristics, ambient temperatures, and the amount of electrical power available. Once color viewing equipment has been installed, it is difficult to test how well it conforms with the standard, unless expensive equipment, such as a spectroradiometer, is used. The GATF/RHEM Light Indicator is a useful visual guide to identify nonstandard light sources. It is a small printed target that is attached to color proofs and prints. When examined under D50 illuminant, it appears to be printed in a single ink color, while stripes of two different colors are apparent when it is examined under many other illuminants.

Standard viewing conditions are not required in all design and production areas, only where color matching or appraisal

Figure 1-26.
GATF/RHEM Light Indicator. Under 5000 K lighting the indicator appears as a solid magenta patch, while under other sources the stripes of the two metameric colorants are apparent.

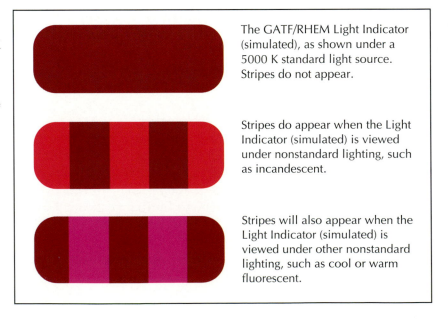

The GATF/RHEM Light Indicator (simulated), as shown under a 5000 K standard light source. Stripes do not appear.

Stripes do appear when the Light Indicator (simulated) is viewed under nonstandard lighting, such as incandescent.

Stripes will also appear when the Light Indicator (simulated) is viewed under other nonstandard lighting, such as cool or warm fluorescent.

Figure 1-27.
Spectral reflectance curves produced by two paper samples. One has a peak reflectance at 440 nm caused by the presence of fluorescing pigments. It has absorbed radiation in the ultraviolet region and re-emitted it as visible light.

From Color and Its Reproduction *by Gary Field.*

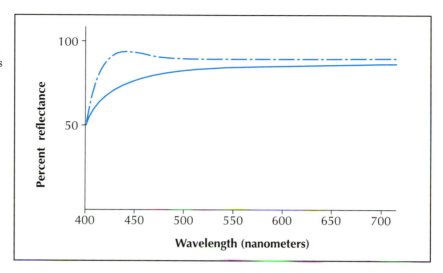

takes place. It is perfectly acceptable for colors to be selected in the lighting conditions in which they will be viewed by the end user, such as store or office lighting, but standard viewing conditions should be used when comparisons between originals, proofs, and prints are made to ensure accuracy.

Implementation of standard viewing conditions can be costly, but it is the only way you can have assurance of accurate color appraisal. The minimum installation is a D50 viewer for color transparencies and a D50 cabinet for color proofs and prints; it is possible to install D50 lamps into a homemade cabinet if attention is paid to the detailed points of the standard on the viewing geometry.

Bibliography

Boynton, R. M. (1996). *Human color vision.* 2nd ed. New York: Holt, Rinehart and Winston.

Cage, J. (1993). *Colour and culture: practice and meaning from antiquity to abstraction.* London: Thames and Hudson.

Field, G. (1999). *Color and Its Reproduction.* 2nd ed. Pittsburgh, PA: GATF*Press.*

ISO 3664:1974, *Viewing conditions — Prints, transparencies and substrates for graphic arts technology and photography.*

ISO 3664:199x (revised), *Viewing conditions — Prints, transparencies and substrates for graphic arts technology and photography.*

Itten, J. (1970). *The elements of color.* New York, Van Nostrand Reinhold

Johnson, A. and M. Scott-Taggart. *Pira guidelines on viewing conditions.* Leatherhead: Pira International.

Jackson, R. et al. (1994). *Computer generated colour.* Chichester: Wiley.

Jameson, D. and L. Hurvich (1964). "Theory of brightness and color contrast in human vision." *Vision Research* 4 135–154.

Lamb, T. and J. Bourriau (eds.) (1995). *Colour: art and science.* Cambridge: Cambridge University Press.

Wright, W. D. (1967). *The rays are not coloured.* Adam Hilger.

2 Color Measurement and Specification

Color reproduction systems can reproduce an immense range of different colors. This chapter will help you to specify the colors you want more effectively and to judge whether or not they have been accurately reproduced.

When we want to communicate information about a color to someone else, we have the same problem that we have in describing other sensations such as taste or smell; we have relatively few words in our language with which to describe the millions of possible colors that we can see. For this reason, colors are specified by reference to color measurement and color sample systems.

Colorimetry

In the last chapter we saw how the spectral reflectance or **transmittance** (the relative amount of light reflected or transmitted at each wavelength across the visible spectrum) provides a complete description of any color. It does not, how-ever, provide a complete definition of the color sensation it gives rise to. In particular, a given spectral power distribu-tion does not define a unique color, as it is possible for different SPDs to induce the same color sensation (this phe-nomenon is called **metamerism**). To define a color properly from the point of view of what we see, we need to include both the light that enters the eye from the sample and the response of the visual system to it. This is the basis of CIE colorimetry.

The CIE System

A truly independent and objective method of defining colors must be ultimately based on human visual perception and also be independent of both input and output device. The CIE system, developed by the Commission Internationale de l'Eclairage (CIE) in 1931, is universally accepted as the stan-dard basis of color specification and measurement.

Figure 2-1.
CIE color-matching functions for 2° observer.

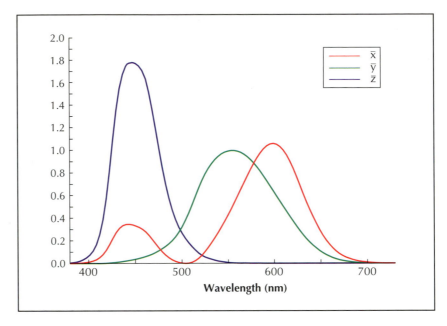

The 1931 CIE system is based on the appearance of color to an average person, defined as a theoretical **standard observer.** The CIE definition followed experiments with a total of seventeen human observers, and although the sample size was small the results have since been confirmed in many other experiments.

The CIE definition of the standard observer is based on the color mixing properties and the sensitivity of the visual system to three arbitrarily selected monochromatic (i.e., single-wavelength) lights at 436 (blue), 546 (green), and 700 (red) nanometers. This sensitivity is used to define a set of matching functions that cover the visible spectrum. A unique set of three values that characterize the visual response can then be defined for any color. The RGB amounts themselves would be inconvenient to use because they would be negative for some colors, so they are transformed to a set of all-positive values. These **tristimulus values,** as they are known, can be computed from measurements made at a series of wavelengths across the visible spectrum. This is done by multiplying together the matching function by the spectral power of the illuminant and the spectral reflectance or transmittance of the sample being measured at a series of wavelength intervals.

The *XYZ* tristimulus values for a sample correspond very approximately to the relative amounts of red, green, and blue present. The coefficients used to obtain the *Y* tristimulus value are chosen so that *Y* is directly proportional to lumi-

nance. The Y tristimulus value thus correlates with the perception of luminance. The X and Z tristimulus values do not correspond directly to any perceptual attribute.

By a further simple mathematical transformation, the tristimulus values can be translated into a projection on a two-dimensional plane. The x,y coordinates of this plane are called **chromaticity coordinates.** The resulting x and y values for all perceptual colors can be plotted on a two-dimensional chromaticity diagram to form the horseshoe-shaped space shown in Figure 2-2. Wavelengths from the blue end of the spectrum through to the red are labeled around the curved rim of the horseshoe, and the closer to the rim a color is, the more saturated it is.

Figure 2-2.
The CIE chromaticity diagram showing the wavelengths of light and the x,y coordinates. Values for Y (lightness) are at right angles to the x,y plane.

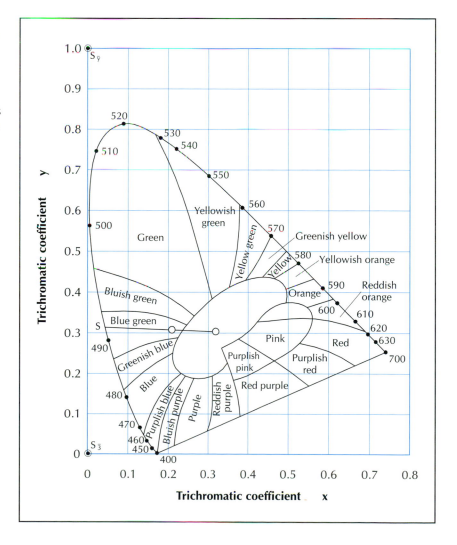

Figure 2-3.
Tristimulus values for a given color are calculated by multiplying its reflectance (A) with the value of the matching functions (B) and the illuminant's spectral power distribution (C) at a series of wavelength intervals, and then summing the results.

In the example shown here, at 600 nm, $0.9769 \times 0.631 \times 0.45 = 0.277$. This is added together with the result at all the other wavelengths to give the Y tristimulus value for the color in C.

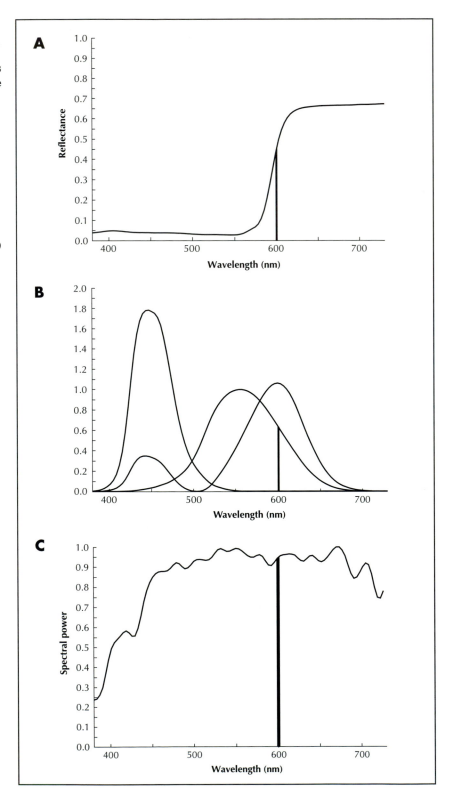

The chromaticity of a color can be specified in terms of its x,y coordinates, or the luminance information can be included by giving both the x,y chromaticity coordinates and the Y luminance value.

The 1931 CIE system underlies all color measuring and encoding systems and provides the basis for all objective color definition. Yet using it as a conceptual model does have some drawbacks:

- Both XYZ and x,y values can be difficult to interpret as they do not relate directly to any of the perceptual attributes of color.
- The chromaticity diagram is not perceptually uniform (equal distances in it do not represent equal shifts in color appearance).
- Tristimulus values take no account of the adaptive nature of color vision and the cognitive mechanisms responsible.
- Since a color stimulus is dependent on illumination as well as a selectively reflecting or transmitting surface, tristimulus values cannot specify the appearance of a surface which is viewed under different light sources.

CIELAB and Other Modifications to Tristimulus Values

There have been a number of modifications to the 1931 CIE system that have made the color appearance of the model more uniform by transforming the XYZ or x,y values. Adaptations of the 1931 CIE system are widely used in the specification and measurement of color. The 1976 CIELAB system is used for reflective color samples, including paints and textiles as well as prints on paper, and the CIELUV system is commonly used for self-luminous color displays (TV, video, and computer monitors). Both CIELAB and CIELUV have a vertical lightness dimension and two-dimensional chromatic coordinates (like the HSL model).

In the CIELAB system, the lightness $(L*)$ value of a color ranges from 0 (black) to 100 (white), while the chromatic axes are called $a*$ (red-green) and $b*$ (blue-yellow). A neutral gray has a zero value for both $a*$ and $b*$ components.

In CIELUV, the $L*$ lightness is the same as in CIELAB, while u and v are transforms of the x and y chromaticity coordinates. Both CIELAB and CIELUV are much more perceptually uniform than XYZ or x,y.

All CIE-based color spaces are based on XYZ tristimulus values, and, as a result, conversion from one CIE space to any other CIE space is a relatively simple mathematical task that can easily be done in a spreadsheet.

Color Difference

Quantifying the difference between two colors is useful in determining whether a color has been reproduced acceptably, and in defining tolerance limits for color reproduction. The CIELAB color space is used as the basis of most color difference systems. Because the axes of CIELAB are orthogonal, color difference can be defined as the distance in three-dimensional space between the coordinates for two colors.

For L^*, a^*, and b^*, the differences are defined as the arithmetic difference between the values of the two colors being compared (usually called the **reference** and the **sample**). The difference in L^* is written ΔL^*; similarly, differences in a^* and b^* are written Δa^* and Δb^*. The difference between two colors is usually reported in terms of an overall difference measure ΔE that is defined as:

$$\Delta E^*_{ab} = (\Delta L^{*2} + \Delta a^{*2} + \Delta b^{*2})^{0.5}$$

In principle the CIELAB color space is such that a just-noticeable difference corresponds to a ΔE of 1, although in reality there remains considerable perceptual nonuniformity in both CIELAB and CIELUV, especially in the yellow region.

Alternative color difference spaces have been proposed to reduce perceptual nonuniformity still further, such as the CMC$(l{:}c)$ metric, and this has been adopted as the basis of the CIE94 color difference standard. In this standard, weightings for lightness and chroma can be adjusted according to the application. The weightings are set to a ratio of 1:1 relative to hue for the prediction of perceptibility; while for acceptability prediction the weightings may be set higher than 1.

Tolerance limits for printing special colors are typically set at around 4–8 ΔE^* units.

Color Measurement

There are three instruments used for the measurement of color samples in the graphic arts: densitometers, colorimeters, and spectrophotometers.

Densitometers

A densitometer is based on a simple photometer (light-measuring instrument). Densitometers record the total amount of light reflected from a surface, as a proportion of the light falling on it from the instrument's lamp. This reflectance reading is converted to a log scale to give an optical density value, using the formula $D = -logR$, where D is the density and R is the reflectance.

This density scale provides a practical way of evaluating the depth of tone in different parts of the image, and it accords reasonably well with the human visual response. It also provides a useful scale by which to evaluate the thickness of a layer of ink, since it correlates well with the thickness of image-forming films such as photographic emulsions and printing inks.

A density measurement provides no information about chromaticity, so it cannot tell you, for example, if your PANTONE color is the wrong hue because it was incorrectly mixed. Density measurements should also be used with caution when comparing prints or proofs made with different colorant systems (such as inkjet prints). The densitometer is normally zeroed on a clear area of the film or paper being measured. First-surface reflections (gloss and flare), which can vary as wet print dries, can be largely eliminated by fitting a polarizing filter.

Density is effectively a measurement of the darkness or **opacity** of a surface—the amount of light it absorbs. It has no direct relationship to the hue of the surface (although most hues become slightly warmer as ink weights increase), but it does affect the perceived colorfulness of a color. It can be evaluated by visual comparison with printed density scales, or it can be measured with a densitometer.

When a density reading is made, a filter complementary to the color being measured is selected so that the color appears to the densitometer to be a gray. A beam of light is emitted from the densitometer's light source, strikes the surface being measured, and is reflected back to a photocell that calculates the amount of light that has been reflected. There are several different filter sets in use. The spectral absorbence of Status T filters is shown in Figure 2-4.

Typically, graphic arts materials have the maximum densities shown in Table 2-1.

Table 2-1.
Maximum densities of materials and processes.

Process or material	Maximum density
Single-color lithography	1.8
Four-color lithography	2.4
Black-and-white photographic print	2.0–2.2
Color transparency	3.5–4.0
Lith film	4.5

Figure 2-4.
Relative spectral product of densitometers with Status T filters. This is a product of the spectral sensitivity of the device and the spectral power distribution of its light source.

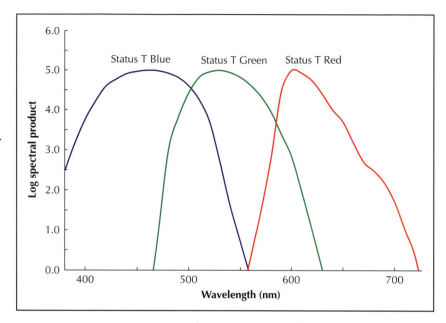

Densitometers are also useful in measuring tint percentages on films and on prints, and thus can be used to monitor dot area and dot gain. When used for process control in color printing, it is assumed that the chromaticities of the inks are standardized so that the only variable is the ink film thickness.

Production tolerance levels are normally set at a density of 0.1, which approximates a just-noticeable difference for many colors.

The instruments are relatively inexpensive and easy to use, and most printers and trade shops make extensive use of them, as do some designers and print purchasers.

Most densitometers have a serial port for downloading measurements to a computer. But in practice this is rarely done, as the number of measurements made is generally small, unless the instrument is configured for online press control. Computation of attributes like dot gain is usually carried out by electronics on the circuit board, although the very simple calculations could also be done in a calculator or spreadsheet.

On many press control systems, densitometers provide an online measurement of the inking levels and enable the press operator (or automated control system) to correct the inking.

Relevant ISO standards currently in preparation are:
• ISO 13656:199x, *Graphic Technology—Application of measurements made by reflection densitometry and colorimetry to process control in the graphic arts.*

- ISO 14981:199x, *Graphic Technology — Process control: optical, geometrical and metrological requirements for densitometers for graphic arts use.*

Colorimeters

A colorimeter reports the *XYZ* tristimulus values for a sample, which can also be transformed to *x,y* chromaticity values, CIELAB, or other metrics. Most colorimeters take measurement through red, green, and blue filters which have spectral sensitivities similar to the CIE matching functions. Tristimulus colorimeters are less widely used than spectrophotometers. Their usefulness is limited by an inability to record spectral data; they cannot predict effects of metamerism.

Scanners and video recorders can in principle also be colorimetric devices, if the sensitivities of their filters are closely related to the CIE matching functions. However, in most cases their sensitivities do not correspond to the matching functions; they are better described as densitometric devices.

Figure 2-5.
A Techkon colorimeter. Reflectance measurements are made with red, green, and blue filters and displayed as CIE values.

Courtesy Techkon

Spectro-photometers

The spectrophotometer is a more versatile instrument. It samples the reflectance (or transmittance, if used for displays) at a series of wavelengths across the spectrum. The wavelength intervals are typically 10 nanometers. This spectral data can be used to output a spectral reflectance curve or to compute a measurement in any CIE system such as *x,y* or CIELAB.

Figure 2-6.
GretagMacbeth Spectro-
lino. A hand-held
spectrophotometer.

*Courtesy Gretag
Macbeth Inc.*

In the past some spectrophotometers incorporated a set of filters for each wavelength band, but in the majority of current instruments a diffraction grating is used to split the incoming light into its spectral components and illuminate a photocell. The diffraction grating may either slide to illuminate a single photocell or be fixed to illuminate an array of cells.

To avoid complications from first-surface reflections, spectrophotometers use one of a number of measuring geometries that define the path of the light from the source to the receptor. In the graphic arts this is normally 0/45°.

Packaging and pharmaceutical printers and ink manufacturers were initially the main graphic arts users of spectrophotometers, but they are increasingly being used to characterize and calibrate digital color systems. The increasing use of spectrophotometers has enabled manufacturers to reduce unit costs and develop innovative instrument designs, so that they are much more affordable than they were a few years ago.

Spectrophotometers can be linked to match prediction software that will analyze a color sample and calculate the proportions of base colors that should be mixed to give an ink that produces an accurate match. Some multicolor printing presses are equipped with online spectrophotometers for monitoring of colors during printing.

Standards for color measurement are defined by ISO 13655:1996 *Graphic Technology—Spectral measurement and colorimetric computation for graphic arts images.*

Two other types of color-measuring devices have more specialized uses. A **spectrocolorimeter** is a device which measures light at wavelength intervals, like a spectrophotometer, but reports the data as tristimulus values. A **telespectroradiometer** measures color at a distance from the sample. Thus it records ambient lighting incident on the sample (unlike the other instruments described here, which use their own light source).

Making Color Measurements

When you make a color measurement, the following should be done as part of the setup procedure:
- Set the observer (usually 2°).
- Set the illuminant (usually D50).
- Decide where you want measured values to go. Many instruments allow you to input readings directly into another application, i.e., a spreadsheet or word processor.
- Make the reference white measurement, either to the "perfect diffuser" or to a white area of the substrate (an unprinted area of a print, or a white area on a screen). In most cases the substrate should be chosen.
- After setting up the instrument the measurements can be made. The reference white measurement should be repeated periodically to counter instrument drift.

ISO 13655 specifies 2° observer and D50 illuminant. It also specifies that measurements should be made relative to the media white (not the perfect diffuser), that no polarization filters should be used, and that an opaque black surface should be placed behind the samples being measured.

Interpreting Color Measurements

The measurements made by a color-measuring instrument will allow samples to be evaluated and compared; provide a basis for quantifying the difference between two samples; and be useful for calculating the corrections required to a color to make it more like a reference sample.

However, a color measurement will only predict the actual appearance of the color in a narrow context. First, the light source used to view the sample must be identical to that used in measuring. Second, there must be no surrounding colors that will influence the perception. Finally, the reflection properties of the substrate must be the same as the one used for normalizing the measurement.

In practice it is rarely possible to fully realize these conditions, and as a result color measurements do not define the

appearance of color in situations such as the reproduction of an image on different media to the original. (Color appearance models are discussed in more detail in chapter 7.) A more comprehensive prediction of color appearance can be achieved by taking into account the effect of visual phenomena, such as chromatic adaptation, and of the following variables.

- Fluorescence. The measured color of a sample can be difficult to interpret if there is a fluorescent component.
- Observer variation. The CIE Standard Observer represents an average response to color stimulus, and for individual observers there can be some variation. In such cases, the tristimulus values will not exactly predict the appearance of a color, even when the viewing conditions are identical.
- Measurement instruments have a tendency to drift during use and need to be periodically recalibrated. There is always a small amount of variation between measurements, which is quantified as the repeatability of the instrument. There might typically be an average variation of 0.05 ΔE when measuring the same sample at the same location.

Color Specification

There are two basic methods of reproducing color in printing, using process colors and special colors.

Process colors are specified as combinations of cyan, magenta, and yellow, plus black (CMYK). They can be printed solid, or in tints of specified percentages. The advantage of specifying process colors for graphic elements is that a large palette of colors is made available to the designer without the need for additional printing plates.

Special colors (also referred to as accent, spot, highlight, and PANTONE colors) require an additional plate for each color that is used. They have the advantages of producing a larger color gamut than process colors and easier matching to identity colors.

Often both process and special colors are specified for one printed piece.

When specifying colors in digital prepress, it is important to distinguish between these two color systems. Where a special color is selected in an image-editing, page-makeup, or illustration program, it will be converted into a process color unless it is defined as a separation and output as a separate film. Special colors that have been converted to process colors in this way seldom match the color originally chosen.

Figure 2-7.
Printed tint selectors, such as the PANTONE Process Color Tint Selector, are available commercially. Many printers also produce their own versions to show the effect of specifying CMYK colors on their own presses.

Courtesy PANTONE Inc.

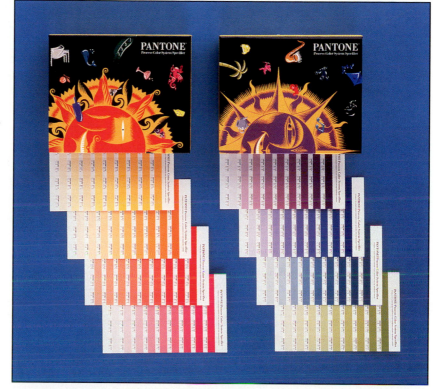

Figure 2-8.
Color swatches for the Focoltone specification system.

Courtesy Focoltone Ltd.

Although color specification systems are initially based on physical color samples, the increasingly divergent types of output media used for color reproduction, with different colorants and substrates (together with variation in the physical samples themselves caused by batch differences or fading), have led some vendors to adopt CIE-based color measurements as the basic reference for their color specifications. Different color systems can then be calibrated to give the closest match possible with the colorants available.

It is preferable to select colors from printed samples rather than a computer display, particularly where the goal is consistent color reproduction, as the screen representation is unlikely to be able to accurately simulate the printed color.

Specifying CMYK

Most color jobs are printed on multicolor presses that have at least four printing units to carry the black, cyan, magenta, and yellow inks. Specifying tints of these process primaries allows the designer to incorporate a large range of colors in the graphic elements of a job at no additional cost for extra plates or passes through the press. However, the designer should still take the constraints of the printing process into consideration.

For the printer, precise control of tints is especially difficult when printing them alongside pictures and solids. It is therefore preferable to avoid tint combinations using three or more colors whenever a color match is important. You can match any three-color tint by using two colors and a black, and this combination is easier to control on press. (See gray component replacement in chapter 6.)

The hues produced by most printing presses are fairly similar, but the amount of dot gain can vary tremendously. In tints, any variations in the amount of dot gain can affect the color that is reproduced. The paper used will also affect the appearance of the printed color. Prints on coated papers exhibit low dot gain and appear cleaner and brighter, while on uncoated papers dot gain is higher and colors appear duller.

In the traditional photomechanical method of creating a tint for a color job, a piece of film with the appropriate dot size was used. These mechanical tints were available only in 5% or 10% steps and in a limited range of screen rulings. Digital tint generation methods now allow tint selection in any increment and full control over dot sizes and shapes as well as screen angles and rulings. This permits the use of such effects as graduated (or gradient) tints and blends and

pastel colors, together with more accurate matches of special colors. Due to the cost of original tints, trade shops sometimes used second-generation duplicate copies that distorted the tonal values and could be slightly uneven when printed. The use of digital tints ensures that clean, first-generation tints appear on the final films for platemaking.

Process color tints can be selected from printed samples, known as tint charts, tint books, or color atlases. Tint selectors should ideally be printed on the same paper that will be used for a given job, and with the same densities and dot gain values as the printing press where the final reproduction will be created. If the job is being printed on a printing press or digital printer that conforms to one of the industry standards for density and dot gain (such as SWOP), it is possible to use tint selectors printed to the same standards. Alternatively, you can use a tint selector produced by your printer to reflect the actual characteristics of the printing press and inks available. Several tint selectors are described here, which are available as electronic sample libraries in graphics applications such as Photoshop, Illustrator, QuarkXPress, and PageMaker.

PANTONE. The PANTONE Process Color Tint Selector shows all the possible combinations of the process colors in 10% steps, in both SWOP and Eurostandard versions.

Figure 2-9.
PANTONE Matching System swatch.

Courtesy PANTONE Inc.

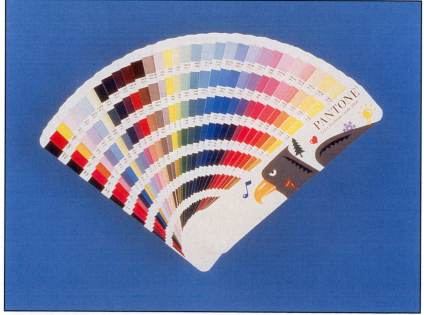

Focoltone. Focoltone's library of CMYK colors is arranged as a series of color palettes that group contrasting colors together. This method is preferred by many designers over the traditional tint chart system, which displays colors according to constant increments of their CMYK values. The Focoltone color samples, selected to minimize moiré, are available in the form of color charts, swatches, and tear-off chips. To ensure consistent reproduction across different printing processes and papers, the dot percentages are adjusted accordingly. Swatches are available in coated, uncoated, and newsprint versions.

Figure 2-10.
Selecting Focoltone colors in Adobe Photoshop.

TRUMATCH. TRUMATCH offers another method of ordering colors, this time according to their perceptual attributes. The TRUMATCH system contains a series of colors ordered by hue, with saturation and lightness steps for each. On each page of the printed swatch book, the ratio of cyan, magenta, and yellow (and thus the color balance) for each hue remains constant, and the steps for saturation and lightness are created by altering the overall amount of color and the amount of black. TRUMATCH is available in editions for coated and uncoated papers.

Figure 2-11.
Selecting TRUMATCH colors in Adobe Photoshop.

Special Colors

Special colors (often referred to as **spot colors)** are mixed from a set of intense, saturated base colors. By combining different amounts of the base colors and adding black and transparent white, a large palette of different colors can be created. These colors are used extensively in advertising and product packaging where brand identification and logo recognition are of utmost importance. Many printers (especially those who print packaging) have multicolor presses with five or more printing units. These additional units can be used to add special colors to a four-color print. Each special color used requires a separate printing plate, and although it is possible to print a tint of a special ink color, it is not a good idea to overprint combinations of them because the inks used for special colors are normally quite opaque and the resulting colors are difficult to predict.

Special colors are typically used:

- *On jobs that are not printed in CMYK.* Some jobs that do not contain color pictures are printed in only two or three colors.

- *In cases where accurate color matching is essential.* Using a special color to print a corporate logo or a product package eliminates the risk that the hue will change as the ink

weights or dot values of process colors fluctuate during printing.

- *For improved matching of design elements.* When backgrounds, rules, or borders appear on several pages, there is a risk that their appearance will not be consistent, especially if the tint is two or more colors. Special colors improve the consistency of design elements from page to page.
- *For nongamut colors.* If the design calls for a color that is outside the range that can be reproduced in CMYK, such as highly saturated colors and pastels, special colors can be used to extend the printable gamut.
- *For printing inks with special optical characteristics.* Metallic, fluorescent, and pearlescent finishes cannot be rendered with normal printing inks. Greeting cards and gift wrap, for example, require these specially formulated inks.
- *To print large areas of solid color.* Overprints of large solids can lead to problems, such as setoff, tracking, ghost patterns, or an excess of ink in other images on the printed sheet. Using special inks can assist in avoiding these difficulties.
- *To avoid a visible screen pattern.* Special colors produce smooth flat colors with no visible dot pattern.
- *To replace one of the process colors.* It is common in some types of work, such as packaging, to substitute a special color for a CMYK color where the special color allows better color matching of the subject of the reproduction. For example, printing a dark brown in place of a black on a pack of chocolates can give a better and more consistent match to the chocolate colors. Color substitution avoids the cost of additional colors, but the color separations must be adjusted to allow for the hue of the new color. Process color substitution can also reduce the number of inks needed where a special ink is required by the design.
- *To extend the colors available in CMYK.* One or more additional colors can be incorporated into a CMYK separation to extend the range of colors that can be printed throughout an image, add a bump color to intensify color in selected parts of an image or in certain tonal values, or incorporate a metallic color into the separation.

The terms **extra-trinary, multi-ink,** and **HiFi** are used to describe the extension of the set of primary colors beyond the basic four-color CMYK system. The use of these additional colors is discussed further in chapter 6.

If the cost can be justified, the intensity of special colors can be extended by printing the same image twice, or double-hitting the color, to give a much denser and more saturated result. This technique is particularly effective with fluorescent colors. On CMYK jobs, a fifth color may also be used to heighten the color intensity in selected parts of an image or in certain tonal values.

The color specification sent to the printer should, where possible, incorporate a physical sample of the color to be matched as well as its reference number, if it is part of a sample system. Providing an actual sample of the color allows the ink manufacturer and printer to check that the original specification, the ink mix, and the pressrun are all in agreement, thus eliminating the problem of color shifts caused by differences between samples when the designer relies on reference numbers alone.

PANTONE

The most widely used specification system for special colors is the PANTONE Matching System. It was the first standardized system for color communication among designers, clients, and printers, and it has since been adopted in most countries throughout the world. Before the PANTONE Matching System was developed, ink manufacturers produced their own ink sets using their own unique pigment blends.

The PANTONE system has nine base colors, plus black, transparent white, and a selection of fluorescent and metallic colors. A second series of four colors, which are used to substitute for some of the base colors on jobs where lightfastness is essential, provide an additional selection of saturated colors. The Color Formula Guide shows the 1,012 colors in the system and the mixing formula for each one. PANTONE also produces books of tear-off color tabs that designers can attach to jobs to ensure that their printers can match the visual samples that they have shown to their clients.

PANTONE reference samples are available on coated and uncoated stock, with the suffixes U or C used to distinguish between the two. However, it is not necessary to actually write U or C on the specification as this refers to the paper chosen and not the ink. Further, it is not possible to print a C color on uncoated paper or vice versa with conventional inks (although the toners used in laser printing achieve a closer match to the C colors than the U colors when printed on uncoated papers).

Since special color systems have larger color gamuts, many special colors cannot be matched accurately in CMYK. If the chosen color is eventually to be printed in CMYK, there is little advantage in using a special color selector; it is better to make the initial selection from a printed CMYK tint book rather than to choose an unprintable color on the basis of its appearance on screen or in a swatch book.

Alternative Specification Systems for Special Colors

Alternative color specification systems produced by ink manufacturers continue to be marketed and used because they often offer a range of highly saturated pigments and an improved color gamut in comparison with other systems. Yet unless the specification systems are adopted by both specifiers and printers, incompatibilities can result. It is therefore important that the choice of color specification system is agreed to by the printer.

Toyo. The Toyo Color Finder, produced by the Toyo Ink Company of Japan, is based on the HSL color model. It arranges colors in hue order and provides for degrees of saturation and lightness for each hue. The Toyo system is widely used in Japan and southeast Asia. It is supported in many imaging applications such as Adobe Photoshop.

Figure 2-12.
Selecting Toyo 88 colors in Adobe Photoshop.

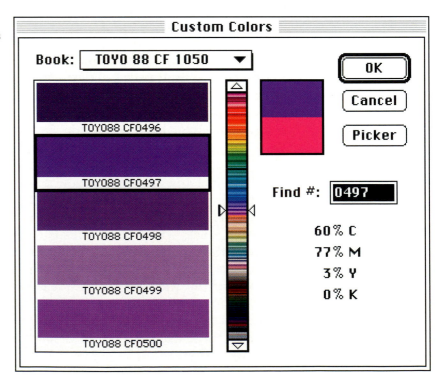

Specifying Colors in Electronic Applications

In image-editing and page-makeup applications, CMYK tints can be specified either by entering the values directly or by using one of the sample libraries described below.

To enter the dot percentage values directly, the file must be in the CMYK rather than the RGB mode, and the desired CMYK values entered as the current foreground color in the Color Picker.

If the CMYK tints you specify are to reproduce consistently and match the original sample in a printed tint book, it is essential that no global color edits (such as RGB/CMYK conversion, color correction, etc.) are carried out on the file after the tints have been specified. Similarly, CMYK colors selected from color libraries, such as the PANTONE Process Color Tint Selector or the Focoltone system, already incorporate the effect of dot gain during printing, and further compensation should not be applied through transfer curves.

Special color specification systems are available as custom color selectors in page-makeup and image-editing applications. Special colors selected with these systems have to be either:

- Defined as a separation and output directly to film,
- Defined as a separation and saved as part of a suitable file format (see chapter 5) for import into another application or for output, or
- Converted to CMYK as a process color simulation.

Custom libraries of special colors usually incorporate pre-calculated conversion values for CMYK and RGB, so that when a color is selected it is immediately applied to the image or document in the current color mode. If the file is not in the CMYK mode (or if the mode is subsequently changed), the values will be changed during separation to CMYK before output. In addition, different applications will handle the color separation process differently, and the actual dot values generated by different applications (and thus the output color) can vary slightly.

Electronic Sample Libraries

Graphic arts applications such as Adobe Photoshop, Adobe PageMaker, and QuarkXPress incorporate licensed sample libraries that allow the user to specify colors for use in an image or document.

CMYK selectors include the PANTONE Process Color Tint Selector, TRUMATCH, and NAA (formerly ANPA).

TRUMATCH also markets a printer utility that outputs a tint chart to any PostScript color printer, giving the designer an instant means of comparing screen and output colors.

The NAA selector simulates on screen a selection of CMYK colors as they print on newsprint.

Sample libraries of special colors include:

PANTONE. These include the PANTONE Matching System, together with other PANTONE specifiers, such as the Pastel and Metallic swatches, a Hexachrome specifier, and a number of PANTONE ProSim selectors for different printing conditions for which PANTONE provides the CMYK values from its PANTONE Color Imaging Guide.

The letters CV (for computer video) are prefixed to the PANTONE number to remind the designer that the color selected on screen will not exactly match the printed output. The color should always be checked against a printed color sample where a match is required.

Web colors. These are the 224 colors that are common to both Mac and PC operating systems when displays are set to 8-bit color depth. They are considered preferable for Web pages to avoid colors being remapped by the user's operating system.

Figure 2-13.
Using the PANTONE Process Simulator (ProSim) to choose approximate CMYK equivalents of special colors in the PANTONE Matching System.

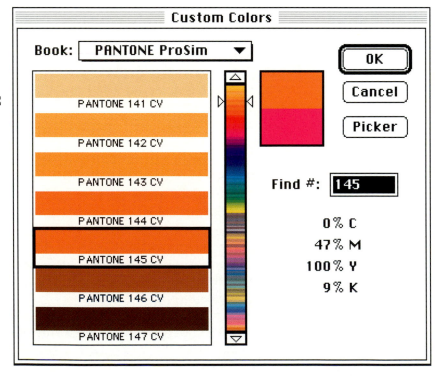

Munsell. The Munsell system, licensed by the Macbeth Corporation, is based on the three-dimensional hue, value, and chroma color model described in chapter 1. A high-chroma version is also available. The Munsell system is used by designers in many industries, although it is less well known in the graphic arts industry, and printers may have difficulties in matching colors specified in the Munsell notation.

Other special color specification systems that support CMYK simulations include Munsell, Toyo, and the DIC (Dainippon Ink and Chemicals) Color Guide.

Figure 2-14.
Selecting Munsell colors in Adobe PageMaker.

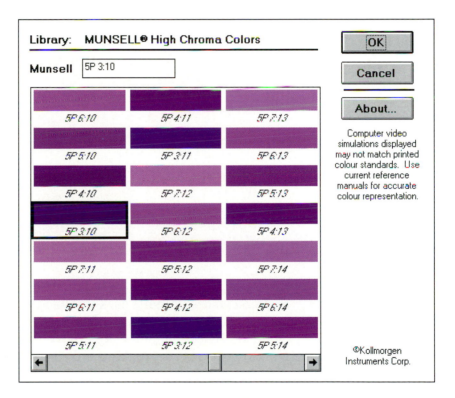

User-Oriented Specification Systems

Color specification systems are arranged in different ways. Printed versions of CMYK tint selectors are usually arranged by increasing dot values. Electronic color selectors usually have a slider to select hue, then present variations within a given hue by lightness and chroma.

With both these methods, similar colors appear together and the effects of contrasting colors that might be used in a graphic design are not readily seen. This problem is addressed by alternative arrangements such as the one provided in the Focoltone system, where colors that share the same CMYK values appear together. The advantage of using

Figure 2-15.
Output from PANTONE
Color Chart software,
showing how
PANTONE Matching
System colors are simu-
lated on a Xerox 5775
digital color printer
using CMYK process
colors.

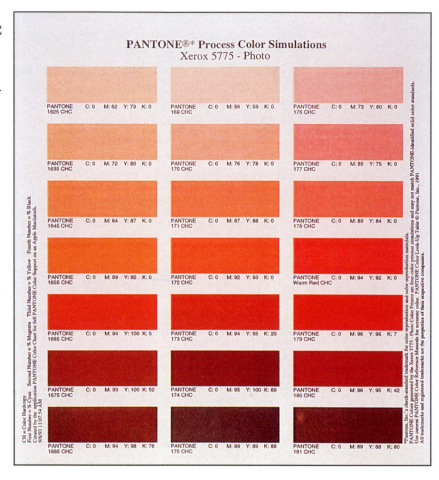

common colors is that knock-outs do not require careful trap-
ping of adjacent colors (see chapter 11), simply the removal
of one of the component colors. Several other applications
and plug-ins are designed to aid the designer in creating and
managing color palettes.

Color Matching and Ink Formulation

When a color is required that does not appear in one of the
standard sample systems, the best way of specifying it is to
select the PANTONE or CMYK color closest to it. It is possible
to supply a physical sample of an item to be matched, such as
a piece of fabric, although differences in texture and pigment
will inevitably lead to differences in color appearance.

If a precise color match is required, ink can be mixed spe-
cially. The mix can be created by the printer or by the ink
manufacturer, who can prepare quite small quantities quickly
and economically. They will often make use of a computer-
based matching system, which predicts the proportions of

base colors that will match the sample. A test mix is prepared and remeasured, and any deviation from the original sample is noted. Correction routines are then used to recalculate the proportions of ink needed to achieve a more accurate match, and the process is repeated if necessary.

Evaluating Color

When a color has been output, the printed color can be compared with the color of the original, or the specified color, to determine how well it has been reproduced. Differences between two colors may need to be communicated: for example, it may be necessary to mark up originals and proofs to show desired color changes, or to evaluate the difference between two colors that should match. Depending on the degree of precision required, color can be evaluated by eye or with the aid of color measuring instruments.

The human eye is a very good judge of color, as long as it is not deceived by variations in lighting conditions or surrounding colors. Always make a comparison between two colors on identical backgrounds (one method is to punch a hole in a piece of gray card) and under standard lighting conditions. Very small differences, at the limits of perception, should be discounted since it is not possible to match colors with absolute precision.

The differences between colors can be described by referring to the HSL model described earlier. Differences in hue are often described as simply warmer or colder. However, the perception of warmness and coldness is a little subjective, and it is often preferable to base hue changes on the colors universally perceived as spectrally pure—red, green, blue, and yellow. Hue changes are thus described as more green, more red, and so on.

The twelve terms for saturation and lightness in the ISCC-NBS Color Name Chart are an effective way of describing differences in these color attributes. Alternatively, changing saturation can be described as making a color cleaner or dirtier, and changing lightness as making it lighter or darker. Changes to the strength or density of an ink affect both saturation and lightness, and it is difficult to adjust saturation or lightness independently by manipulating the amount or strength of colorant.

The terms "more red/green/blue/yellow," "lighter/darker," and "cleaner/dirtier" can be used to achieve a reasonable degree of precision and reduce ambiguity in evaluating color samples and in marking up proofs for correction. Gary Field

Figure 2-16.
The ISCC-NBS terms for brightness and saturation. These terms are useful for identifying the color changes required on an original or proof.

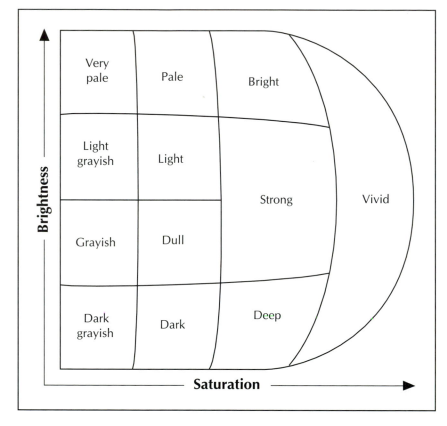

in *Color and Its Reproduction* recommends using the modifiers "slight," "moderate," and "significant" to specify the amount of change required.

Changing the hues of special colors can only be done by remixing the base inks, while changing the hues of CMYK tints or color images requires altering the color balance in the color separations or adjusting the ink weights on press. It is not possible to alter ink weights without unanticipated and possibly unwanted effects on other elements in the page, so it is usually necessary to correct the color separations.

The difference between two colors can only be quantified precisely by reference to measured color values.

Bibliography

CIE Publication 15.2 (1986). *Colorimetry.* 2nd ed.

Billmeyer, F. W., and M. Saltzman (1981). *Principles of colour technology.* 2nd ed. John Wiley & Sons.

ISO 13655:1996, *Graphic technology — Spectral measurement and colorimetric computation for graphic arts images.*

Grum, F., and R. Becherer (1981). *Optical radiation measurement: 1. Radiometry.* Academic Press.

Grum, F., and C. J. Bartleson (1980). *Optical radiation measurement: 2. Colour measurement.* Academic Press.

ISO 13656:199x, *Graphic technology — Application of measurements made by reflection densitometry and colorimetry to process control in the graphic arts* (in preparation).

ISO 14981:199x, *Graphic technology — Process control — optical, geometrical and metrological requirements for densitometers for graphic arts use* (in preparation).

Hunt, R. W. G. (1995). *The reproduction of colour.* 5th ed. Tolworth: Fountain Press.

Hunt, R. W. G. (1996). "Why is black and white so important in colour?" *Proceedings of IS&T/SID Colour Imaging Conference 4.* 54–57.

Hunt, R. W. G. (1998). *Measuring colour.* 3rd ed. Tolworth: Fountain Press.

Judd, D. B., and G. Wyszecki (1979). *Colour in business, science and industry* : John Wiley & Sons.

Stokes, M.; M. D. Fairchild; and R. S. Berns (1992). "Colorimetrically quantified visual tolerances for pictorial images." *TAGA Proceedings.* 757–778.

McDonald, R. (1997). *Colour physics for industry.* Society of Dyers and Colourists.

Wright, W. D. (1964). *The measurement of colour.* 3rd ed. Adam Hilger.

Wyszecki, G., and W. S. Stiles (1982). *Colour science.* 2nd ed. New York: Wiley.

3 Digitizing Color

The real world is unquestionably analog. Look closely at a photograph, for example, and you will see shades that vary in a smooth and continuous way between the lightest and darkest tones in the picture. These tones convey all of the image information in the picture, including light, shade, color, and detail, and allow us to recognize the different objects that are present.

Analog reproduction systems suffer from degradation during the transfer from one medium to another, often due to noise (random fluctuations in the signal that convey no information), and sophisticated methods have to be employed to prevent or reverse this degradation.

Digital methods of recording and reproduction are increasingly dominant in many fields, such as audio, video, photography, and graphic reproduction. The benefits include freedom from the distortions that accompany analog reproductions, the ability to manipulate the digital signal in more powerful ways, and a potentially more accurate reproduction of the original.

The basis of a digital system is the handling of discrete, rather than continuous, data. This requires that a continuously varying quantity (such as light intensity) is **quantized** or allocated to one of a series of discrete steps. The resulting digital values are then encoded as binary digits (or bits) before subsequent processing. A bit can have a value of 0 or 1. Although a binary system will need a larger number of digits to encode a given sample value than the more familiar "base ten" number system, it is faster and more robust for a number of reasons.

First, by encoding the data in binary form the highest possible signal-to-noise ratio is achieved. This makes the data virtually immune to deformation by the inevitable signal

Figure 3-1.
Analog and digital
transmission.

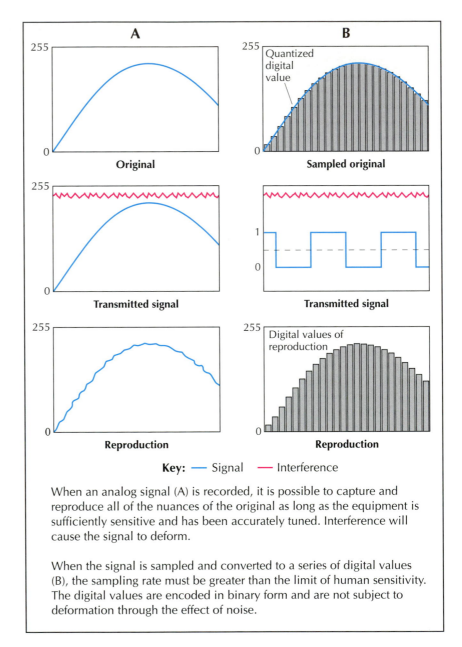

When an analog signal (A) is recorded, it is possible to capture and
reproduce all of the nuances of the original as long as the equipment is
sufficiently sensitive and has been accurately tuned. Interference will
cause the signal to deform.

When the signal is sampled and converted to a series of digital values
(B), the sampling rate must be greater than the limit of human sensitivity.
The digital values are encoded in binary form and are not subject to
deformation through the effect of noise.

fluctuations that occur within electronic systems during
transmission and read and write operations. The addition of
error correction methods ensures complete data integrity
even in conditions where noise levels are high.

Second, binary data can be stored at much higher densi-
ties on physical media, and transferred between devices at
higher speeds, through the need to switch between only two

states instead of many. Binary data can also be readily compressed to remove redundancies in the data.

Third, by employing Boolean logic (in which logic gates evaluate one or two binary inputs and yield a binary output value) implemented through transistors etched in silicon, extremely high processing speeds can be achieved. These elementary processing operations can be aggregated to produce computations of whatever complexity is required.

The reductive nature of binary systems and Boolean logic by no means restricts the complexity of the operations that can be achieved or the data structures that can be encoded. In the natural world, for example, the entire gamut of life itself is defined by combinations of just four basic elements in DNA. The smaller the number of primitives, the greater the potential signal-to-noise ratio and the more robust the information that has been encoded will be.

It may appear that a digital system can never match the fine modulations of an analog signal. However, if the analog signal is sampled at a high enough frequency, the reproduction will be perceived as identical to the original. The problem is to achieve a high enough sampling rate and to ensure that the resulting data has some meaningful relationship to human perception.

Digital Color Systems

Computers and computer peripherals handle images and graphics in two fundamental ways:
- As a two-dimensional (raster) grid of individual picture elements, or **pixels.**
- As a list of drawing instructions, or **vectors.**

A digital image or graphic is created with the intention that it will be rendered on an output device, whether as a display image on a monitor or projector, or as a hard copy on a physical medium such as film or paper. Output devices used in the graphic arts are invariably raster devices, in that they form the image as an array of individual pixels. A vector graphic must therefore be redefined as a raster image before it can be output. Vector graphics are discussed in more detail in chapter 4.

The Digital Image

A digital image is a two-dimensional array of intensities. The individual array elements are known as picture elements or pixels, and each pixel can have one or more intensity values associated with it, depending on how many color channels are defined for the image.

A digital image is usually the result of a process in which a continuous-tone original (such as a photograph) is sampled by a scanner or digital camera. A numerical representation of the sampled intensities is encoded, from which a visible image can be reconstructed either as a screen display or as a hard copy print.

These three stages—sampling, encoding, and subsequent reconstruction—are the basis of digital imaging, and are the focus of this chapter.

Sampling

Sampling an image involves two basic steps:
1. The original is spatially subdivided into discrete (individually separate and distinct) regions that will form the individual samples of the image.
2. The intensity value of each sample is measured and quantized.

When an intensity value is quantized, it is converted to a scale with a fixed number of steps. No partial steps are allowed, so the original intensity value must be rounded to the nearest quantization step. The process is often carried out in hardware by an analog-to-digital converter (ADC).

In these two steps, there are clearly a number of choices that can be made. In the first step, the size of the samples must be decided, and this will define the resolution of the final image. In the second step, the number of quantization steps chosen will define the number of bits required to store the intensity values.

Spatial Resolution

The sampling resolution of a graphic arts scanner ranges from 300 pixels per inch (ppi) on a low-end system to around 5,000 ppi on a high-end system. High resolution is necessary to preserve the definition and sharpness in an original image. Photographic systems have very high resolving capabilities, and the eye can register much of this information without magnification. In good lighting, the eye may even succeed in resolving detail in the 1–5 micron (0.001–0.005 mm) range, such as the tracks on a CD and small dust spots.

The optimum sampling resolution will depend on the resolution of the output system. For conventional halftone screens, a scanning resolution of twice the halftone screen frequency is usually recommended. This issue is taken up in more detail in chapter 5. The color values are defined for each individual sample, but the physical size of the samples

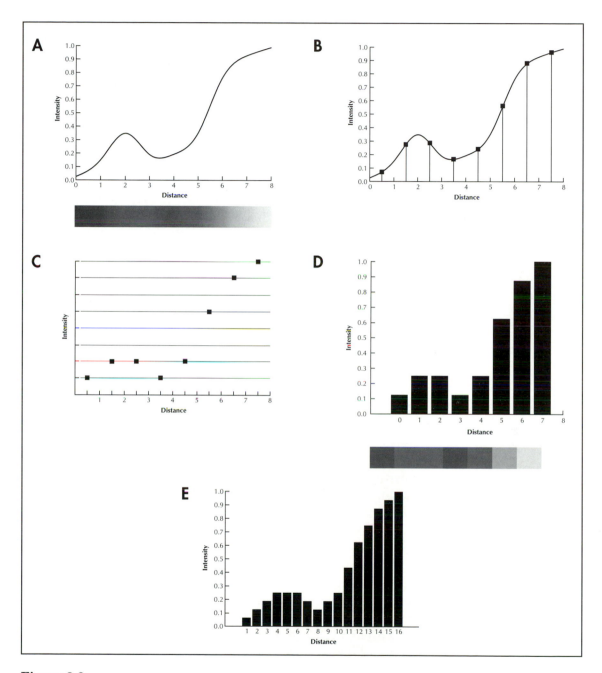

Figure 3-2.
A. Intensity or lightness varies across a continuous-tone original as an analog function.
B. The intensity of the original is sampled at a series of spatially discrete points.
C. The resulting analog intensity values are moved to the nearest quantization level.
D. The image is stored as a digital value for each sampling point. It can then be reconstructed by rendering these digital values in the same spatial relationship on an output medium.
E. The reconstruction of the original will be improved if there are more sampling points or more quantization levels.

The Meaning of "Resolution"

There is often confusion over the meaning of resolution arising from the different ways in which the term is used, and in particular the different devices to which it is applied.

The number of pixels in an image file is determined by the resolution with which the original was sampled, together with any subsequent resampling.

The output device on which an image is rendered will have its own resolution capability. In addition, the output may need to be dithered if the gray levels of the image are greater than the number of gray levels of which the device is capable.

Thus we have three stages for which resolution can be defined: the image samples, the output device, and the halftoning screen or dither pattern. For example, an image might be scanned at 300 ppi and output on an imageset-ter with a resolution of 2400 dpi, for a printed screen ruling of 150 lpi.

As there is no universal agreement on which terms to use to describe resolution, it is best to emphasize sampling resolution (usually in ppi), the output device resolution (usually in dpi) and the halftone screen frequency (usually in lpi).

is defined for the whole file and can easily be changed by editing the image size. Thus the important property is the number of pixels, not their size.

Resolution can be changed after the original sampling stage by applying a resolution conversion to the image data. This process is often referred to as **resampling.** Reducing resolution (interpolating down) can be achieved either by discarding pixels (subsampling or decimating) or by averaging pixels together (downsampling). For a higher resolution, intermediate pixels can be calculated by interpolating up from the values of the surrounding sampled pixels. Resampling cannot create detail that was not present in the original scan, and it is preferable to make sure that the original is scanned at an appropriate resolution, as described in chapter 5.

At the output stage, individual pixels of the output device are imaged. The output device resolution will rarely coincide with that of the image data, so some further resolution conversion will be necessary. The output device resolution is determined largely by the number of scan lines in the y direction combined with the stepping or switching increments in the x direction. These combine to form the address grid of the device, and their frequency is referred to as the **addressable resolution** of the device. The physical image spot produced by the device may not coincide exactly with a pixel on this address grid; the pixel will be square or rectan-

Figure 3-3.
Line pair target used to evaluate the resolving power of an imaging device.

1 pt. 0.5 pt. 0.25 pt. 0.1 pt. 0.05 pt. 0.025 pt. 0.01 pt.

gular, while the spot will often be circular or elliptical. Imaged spots may overlap considerably with each other. Some manufacturers have developed lasers and LEDs in which the spot tends towards being square (which improves the addressing precision of high-resolution devices), while others have exploited spot roundness to smooth out the staircasing effect (which is a benefit on low-resolution devices).

Bit Depth

On a photographic print or transparency, there is a smooth transition from the lightest to the darkest regions of the image. The darkness of any one area will depend on the number of atoms of metallic silver present and the consequent thickness of color dyes. The imperceptibly minute tonal gradations that are possible make this type of original continuous tone. Many other originals, such as artists' illustrations, are also continuous tone, with the darkness of any area depending on the thickness and concentration of the coloring medium.

Digital processes require the conversion of this analog intensity scale into a digital one, turning a smooth transition into a series of separate steps between the lightest and darkest points on the scale. These separate quantization levels are often called **gray levels.** The number of gray levels that can be defined is important to graduated tints and blends as well as sampled images. If insufficient gray levels are available, the separate steps will be visible—a phenomenon called **contouring** or **banding.**

Uniform sampling of the light reflected or transmitted by a continuous-tone original is not ideal since, as we have seen, perceptual mechanisms generally respond to stimulus in a nonlinear manner. The inevitable result is either undersampling in regions of greater perceptual sensitivity, leading to perceptual discontinuities or contouring in the reproduction; or oversampling in regions of lower perceptual sensitivity, resulting in more samples than are necessary to achieve a satisfactory reproduction, and greater demands on storage and processing as a result. In a well-designed system, the method used to encode the sampled data ensures a good fit with perception.

Figure 3-4.
Digital grayscales.
A. A binary grayscale
 has only two possible
 values, black or
 white. One bit of
 data is needed.
B. 4-level grayscale:
 2 bits.
C. 16-level grayscale:
 4 bits.
D. 256-level grayscale:
 8 bits.

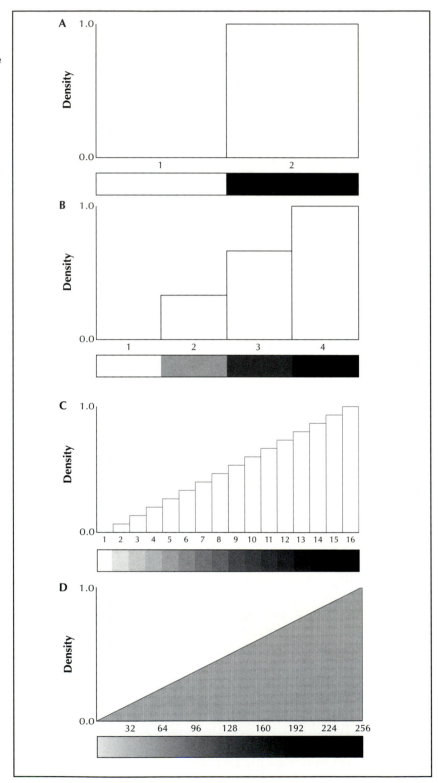

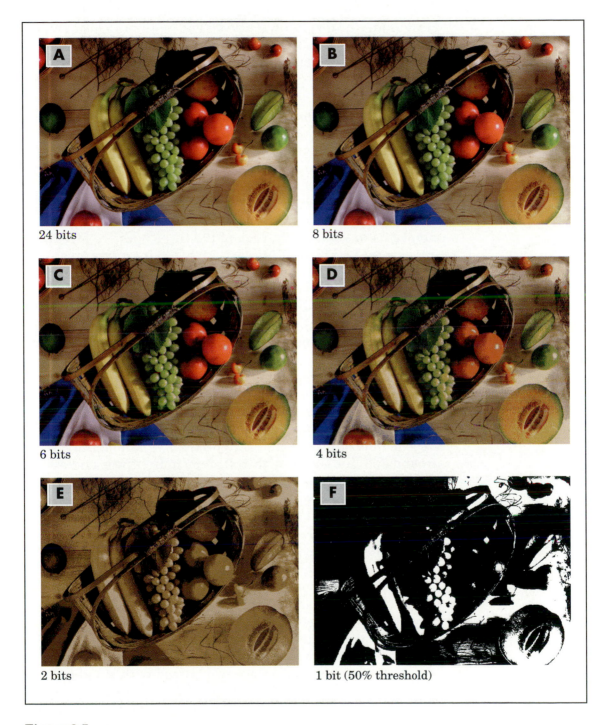

Figure 3-5.
Image A is a normal 24-bit image (8 bits per color). Images B–F use various levels of indexed colors, from a maximum of 8 bits (B) to a minimum of 1 bit (F).

How many colors do we need? The more gray levels that are available, the closer the reproduction will simulate the continuous gradation of the original; but the more steps there are, the more processing and storage will then become necessary. The eye can distinguish 100 or more steps along many perceptual dimensions, such as lightness. It is convenient to define 256 quantization levels, mainly because it allows the sample value of each pixel to be encoded as a single byte. It also makes some allowance for the nonlinearity of the perceptual response, the extra data being useful in regions where sensitivity is greatest.

How many colors should a digital color system be able to support? Conventionally, each of the three additive primaries (red, green, and blue) is encoded with 256 intensity levels. The possible permutations of the three primaries can then be represented by $(2^8)^3$ or 2^{24}, which naturally requires 24 bits of storage. Hence 24-bit color has become the standard for systems that attempt to replicate the range of colors available to human perception. However, this does not mean that 24-bit color is the same as human perception. Our responses to different parts of the color gamut are not uniform. Identical changes in color stimulus do not produce identical responses.

The number of colors we can actually distinguish can be roughly approximated by considering the number of separate steps of hue, lightness, and chroma that we can identify. With around 200 hues, each with 100 steps in lightness and an average of 135 steps in chroma, one would have a maximum of 2.7 million colors.

This may suggest that the gamut of colors available to human perception can be represented adequately within a 24-bit system, but because perception is nonuniform this is not so. What we can say is that the 24-bit system approximates the range of perceptible colors that fall within the gamut of output systems, although, in most cases, either too much or too little information is obtained.

Because the eye is not equally sensitive to gray levels in all parts of the gray scale, there is some loss of information when a continuous-tone image is digitized with equal quantization levels. These quantization errors can be reduced or eliminated by increasing the sampling precision, or by adjusting the spacing of the input signal before encoding.

Increasing the sampling precision (from 8 to 10 or 12 bits per pixel, for example) would increase the amount of data captured and the consequent file size. Sampling with 12 bits

per component would give 4,096 levels per color, and a resulting RGB file with three color channels would have a total of 36 bits per pixel instead of 24 bits.

Adjusting the spacing of the data to make it more perceptually uniform is more promising, and is done by applying a **transfer function** to each channel before encoding. A transfer function simply maps a set of values to a new set of values, as illustrated in Figure 3-6.

Figure 3-6.
A transfer function maps a set of input values to new output values. In some cases the function can be defined symbolically (e.g., $y = x^{0.8}$). Otherwise it is stored in the form of a lookup table in which each input value is associated with the corresponding output value.

In most systems, a combination of these two methods is used. The sampling precision is 10 or more bits per pixel, and the resulting data is then respaced by a transfer function in hardware or software. The resulting data is then requantized to 8 bits before encoding.

Eight bits per color is an acceptable bit depth for most purposes, and imaging workflows are usually designed around it. It is possible to use higher bit depths where the image quality requirements demand it. The PostScript language supports the use of up to 12 bits per component, while Photo-

shop supports 8 and 16 bits per channel for RGB, CMYK, LAB, and grayscale images.

Although in practice 16-bit images are rarely used, it is a good idea to convert an 8-bit image to 16 bits where the image editing task involves a series of processing stages, if necessary to convert back to 8 bits afterwards. This helps to minimize quantization errors that can arise when processing images with less data.

If contouring is visible within an image, it may be possible to eliminate it by introducing a very small amount of noise. This eliminates tonal artifacts without making much perceptible difference to image quality. Contouring can sometimes be seen within individual color channels that make up an image, but it is frequently obscured when the channels are composited together and rendered on an output device.

The Relationship Between Gray Levels and Resolution

Although spatial resolution and bit depth are defined separately, in terms of the visual appearance of an image there is in fact a relationship between them. At high spatial frequencies, the eye is not able to resolve color information, and there is a trade-off between the spatial frequency of a pixel and the number of bits needed to describe its color. In other words, the smaller an image area, the harder it becomes to see its color. Thus a 100-micron spot needs 24 bits to describe it, since the eye can identify its color, while just two bits are needed for a 10-micron spot, as the eye will, at best, just recognize its presence, without being able to distinguish its color. This has implications for the choices made while scanning and printing, including sampling resolution, bit depth, and halftone screens, as well as for the design of imaging systems.

Encoding

At its most basic, encoding an image involves simply recording the quantized intensity levels in a way that they can subsequently be reconstructed as required. However, as we have seen, there will usually be some processing of the raw data before encoding. Examples include applying a transfer function to respace the date more uniformly, data compression to minimize the storage and file transfer requirements, and requantization of the data. There may also be further processing such as transformation of color space.

Before reconstructing the image it will be necessary to decode some of the processing carried out as part of the encoding process. This leads to a five-stage process as shown in Figure 3-7.

Figure 3-7.
A color image under-
goes a series of stages
between sampling and
reconstruction.

File Size

Sampled color images yield large files, since every pixel requires one byte per color component to define its color value. Thus a 2,000×3,000-pixel image creates an 18-MB RGB file (2,000×3,000×3) or a 24-MB CMYK file.

Note that the file size is reported differently according to which convention is followed: some systems describe 1 MB as 1,000,000 bytes, others as 1,048,576 (2^{20}) bytes. To complicate matters further, data are written in blocks of a fixed size, which are a multiple of 512-byte sectors, and file sizes are often reported in terms of whole blocks used.

File formats for encoding digital images are discussed in chapter 4.

Reconstruction

The reconstruction of a digital image from its encoding involves mapping suitable intensity values onto an output device. The output device may render the image as a display or as a hard copy on a physical medium.

When an image is rendered on a monitor, the color of each pixel is controlled by the voltage of the electron beam that strikes the phosphors on its face. The digital value for the red, green, and blue signals for each pixel are stored in the video frame buffer, which will normally support eight bits per pixel per color. The minimum intensity has a value of 0 and is rendered as zero intensity (i.e., no light from the pixel). In an eight-bit grayscale, the maximum intensity has a value of 255. A white pixel on the screen thus has RGB values of 255, 255, 255, and a black pixel has values of 0, 0, 0. However, the actual intensities displayed are also determined by the brightness and contrast settings (under user control), and the gamma value. **Gamma** is a value that describes the relationship between the digital values and the gun intensities as an exponent: e.g., $R' = R^{1/1.8}$ where R' is the red gun intensity, R is the red digital value, and 1.8 is the gamma.

When an image is output as hard copy, the digital value defines the amount of colorant that is to be imaged. The scale goes from 0 (no color) to 100 (maximum colorant density). For most digital printers the number of levels available will be less than 100, and the device must create the missing

levels by **dithering** (i.e., by creating a pattern of printed and unprinted areas that integrate to the required density). The halftone process is an example of a dither pattern.

The relationship between digital values and printed result is more complex than for displays, and is discussed further in chapter 7. Halftoning methods are considered in chapter 9.

Whether the image is to be reproduced on a display or a hard copy, there is a need to discuss the objectives of this stage, as they affect the choices made throughout the imaging chain.

Reproduction Objectives

The objective in reproducing a color original may appear on the face of it to be straightforward—to achieve a match to the colors of the original at each point through the reproduction. In practice the problem is more complex. First, there is the problem that a simple colorimetric match will not suffice if the reproduction is to be viewed under different conditions from the original, or rendered on a different medium. Second, human observers tend to have preferences for color reproductions that differ from the original. Finally, there is the problem that different media have different properties, including different surface textures, different color gamuts, and different white points. The more different the media, the more difficult it will be to achieve a convincing reproduction.

This suggests that the aim of color reproduction should be equivalent color appearance, with remapping for different media and adjustments where necessary to accommodate reproduction preferences.

Reproduction preferences are dependent on the characteristics of the observer, including such factors as their experience in judging color reproduction and their cultural background. Some common preferences are:

- *Saturation*. When comparing a series of color reproductions, observers often report a preference for those with greater saturation or chroma, even when higher than in the original.
- *Brightness*. Images whose colors are lighter and cleaner are usually preferred.
- *Sharpness*. Observers usually express preferences for sharp reproductions, even when the reproduction is sharper than the original.
- *Contrast*. Observers prefer most images to be reproduced with the maximum contrast possible for the medium, which implies that the original white and black point of the original should be reproduced as the white and black point of the reproduction, and not to some intermediate value.

- *Neutrality.* Discrimination of neutrals is greater than for chromatic colors, and as a result it is important to reproduce them consistently. This is particularly important for highlights, and where similar images are reproduced together.

Tolerances

The tolerances that are defined for the reproduction system need to accommodate both the acceptability criteria of the customer and the limitations of the process. Although the human visual system is typically able to discriminate between colors that differ by approximately 1 CIELAB ΔE^* unit when simple color patches are viewed side by side, for complex images the threshold of perceptibility is much greater. Commercial reproduction tolerances for special colors are typically 4–8 ΔE, but for color images, with a much larger number of colors, average color differences can be greater.

The White Point

Different media have widely differing luminances and chromaticities at their D_{min}, or **white point,** and it is usually preferable to reproduce the white point of the original as the white point of the reproduction medium. Color casts in originals are very common, and where they occur the nature of the white point in the original needs to be considered, with different reproduction strategies according to whether it is a specular highlight or a diffuse highlight. The chromaticity of the white point may need to be changed to the chromaticity of the reproduction medium, or it may need to be preserved.

Tonal Reproduction

Whether the reproduction is intended to look as much like the original photograph as possible, without any effects caused by the mechanics of the printing process, or whether the original is to be enhanced to create a more acceptable or more striking image, precise control over the reproduction of the lightness of each pixel in an image is essential.

The process used should ideally be capable of achieving:

- *High contrast.* It should be possible to match the highlight and shadow densities of the original image.
- *Good tonal rendering.* It should be possible to reproduce all the tones in the original accurately.
- *Good tonal gradation.* It should be possible to emphasize the areas of interest and maintain good separation between the tones of the original.
- *High resolution.* It should be possible to retain or enhance the sharpness and definition of the original.

It is also important to optimize contrast, resolution, and tonal gradation for the particular image and for the printing process.

It is usually preferable to map the lightness range of the original media linearly to that of the reproduction (as shown in Figure 3-8), as this optimizes the reproduction of detail throughout the tonal range. The maximum density of the original and reproduction media are often quite different, so this implies a compression into the lightness range of the reproduction.

Figure 3-8.
Typical reproduction of the lightness range of a transparency original on a proof, with an approximately linear mapping of lightness between original and artwork.

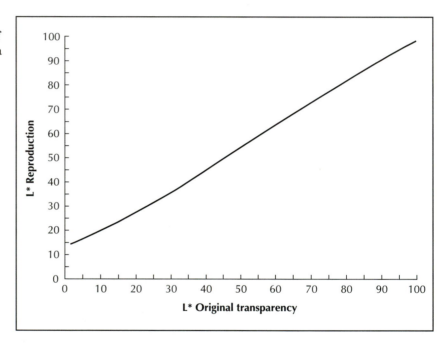

The reproduction is usually improved by mapping linearly between the lightness of the white and black points of the individual image rather than those of the original media.

For the purpose of process control, lightness is often defined in terms of the density of colorants or the dot area of halftone screens.

Contrast

The **contrast** of an original is the difference in lightness between the lightest and darkest areas. In a photograph, the lightest tone is the unprinted white of the paper, while the darkest occurs where the photographic emulsion or printing ink has the greatest density. The amount of contrast will depend both on the brightness of the unprinted paper surface and on the maximum density of the ink or emulsion.

Contrast is also used to describe the distribution of tones within an image. An image with little midtone detail, heavy shadows, and bright highlights is said to be **high-contrast,** and, conversely, a picture with lots of midtone detail and little in the highlights and shadows is **low-contrast.**

In screen (RGB) and print (CMYK) color, contrast depends on the range of intensities available. To increase screen contrast the black of the unilluminated screen must be made darker and the intensities produced by the electron guns greater. Similarly, the contrast of a print on paper is increased by using a brighter paper and by increasing the range of ink densities.

It is also possible to talk about color contrast in an image. An image made up mostly of grays and neutrals has little color contrast, while images with high color contrast are vivid and colorful.

Lightness contrast and color contrast are in practice interdependent; they can only be changed independently of each other if adjustments for lightness independently of saturation or chroma are available.

Tonal Gradation

The range of lightnesses that can be reproduced depends on the imaging process and the media. At the highlight end, the very smallest image areas may not be reproduced; they may be lost during transfer to the substrate, or in some cases they can be worn away during printing. At the shadow end, the

Figure 3-9.
Tonal gradation can be adjusted to control the way that the tonal range of the original is reproduced, in order to emphasize areas of interest in the original.

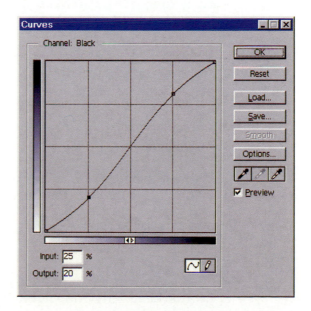

image areas may merge together, so that they appear solid. In sheetfed offset litho on coated paper, the reproducible tonal range can be as much as 2–98%, while in flexo on newsprint it may be as little as 25–50%. Digital printers typically have minimum dot sizes between 4% and 10%, depending on the design of the marking head and the controller.

The highlight dot placement is the most important setting, both in scanning the original and in adjusting the gradation before output. To make sure that highlight detail is not lost, the lightest point of the original should be mapped to the smallest value that the reproduction process can hold. Reproducing the lightest areas of the original (the **diffuse highlights**) with the lowest imageable density still allows for specular highlights, or **catchlights** (those points in the image that transmit or reflect light directly to the observer, such as street lights or light bouncing off metallic surfaces) to be reproduced as clear substrate.

Similarly, the darkest point on the original in which detail occurs should be mapped to the highest imageable density that can be distinguished from a solid area. For a conventional printing process, this is the largest dot size that can be printed without filling in on press.

The intermediate tones can be distributed to control the placement of the midtones or to emphasize the interest areas of the original. The gradation can be adjusted using the gradation curves in image-editing software applications. These allow complete flexibility over the tonal gradation, so that the user can adjust each region of tone independently.

Bibliography

Ammeraal, L. (1992). *Programming principles in computer graphics*. Chichester: Wiley.

Agfa Compugraphic (1993). *An introduction to digital color pre-press*. 5th ed. Mt. Prospect, IL: Agfa Prepress Education Resources.

Foley, J. and others (1990). *Computer graphics, principles and practice*. 2nd ed. Reading, MA: Addison-Wesley.

Kang, H. R. (1996). *Color technology for electronic imaging devices*. Bellingham, WA: SPIE Press.

Mortimer, A. (1998). *Colour reproduction in a digital age*. Leatherhead: Pira International.

Ray, S. (1994). *Applied photographic optics, lenses and optical systems for photography, film, video and electronic imaging.* 2nd ed. Oxford: Focal Press.

Stokes, M.; M. D. Fairchild; and R. S. Berns (1992). "Precision requirements for digital color reproduction." *ACM Transactions on Graphics.* 11 406–422.

Yule, J. A. C. (1967). *Principles of color reproduction.* New York: Wiley.

4 The Color Original

Digital color systems allow the designer to incorporate original images from a wide range of different sources. They can be edited and manipulated in ways that are increasingly powerful, flexible, and intuitive. Selecting the right originals results in better quality printing and saves time and cost in retouching.

The original images that might be used for reproduction come in many different formats, sizes, and media. Conventional images include photographic originals and artists' illustrations, while electronic images include both digitally captured images and images created in graphics programs.

Photographic Images

The ease of capturing an image on film makes photography likely to continue as the dominant recording method in many sectors, although digital photography is increasingly attractive for a wide range of products.

Color photographs can be in the form of transparencies, prints, or negatives.

Both color prints and transparencies are made with dyes in the subtractive primaries: cyan, magenta, and yellow. The different photographic emulsions in use have slight variations in spectral absorbency, as a result of which they are recorded differently when scanned. For many pictures, this difference may not be sufficient enough to require allowances to be made for it (in setting up the scanner or selecting the color management profile), but for high-quality reproductions, this factor has to be considered. The scan parameters can be adjusted for the emulsion type, which is imprinted on the rebate at the film's edge.

The main variables in film emulsions are speed and color balance. As a general rule, slower film speeds (lower ISO numbers) produce finer grain and higher color saturation.

Transparency films are balanced for daylight (5,000 K) conditions, but for situations where tungsten lighting is the main light source, tungsten-balanced (3,400 K) emulsions are available and arguably give better results than the alternative of using filters in conjunction with daylight films. The 35-mm slide films have a slight blue cast to compensate for the tungsten illuminant in a slide projector.

Fluorescent lighting does not emit light energy evenly across the visible spectrum but has pronounced "spikes" in certain regions. It often gives a greenish color cast, which can be partially compensated for with the use of a magenta filter.

The variations in color balance and saturation between different brands of film, together with the spectral absorbency characteristics of different dye sets, make it preferable to specify the use of a single emulsion type when commissioning photography where the subject matter is similar.

Transparencies normally give better results than prints because they are sharper and have a better tonal range and color saturation. When the bit depth of the scanner is limited, better results can often be obtained from negatives and prints, which have a more restricted dynamic range than transparencies. Duplicate transparencies inevitably lose sharpness and distort color and tonal values, and they tend to increase color contrast somewhat.

Although the dynamic range of the negative emulsion is less than that of transparencies, color negatives can record a higher dynamic range within the original scene. However, color negatives are infrequently used in conventional scanning, as the color values are difficult to judge and many scanners do not have the appropriate software to handle them. They do have the advantages of finer grain and a tonal range that can be captured by a CCD scanner. For conventional scanning, a print should be made from the negative, so that the client and the scanner operator can evaluate it; in many cases, it is this print that is scanned. Alternatively, photo labs can create positive transparencies from negatives, or the negatives can be scanned directly (using a conventional scanner if the scanner software supports negatives, or by using Photo CD).

Artists' Illustrations

Artists' illustrations are created in many different media, from traditional oils and watercolor, through gouache, tempera, chalk, crayon, and poster paint, to more recent innovations

like color photocopies. Artwork can be scanned directly, as long as it fits on the scanner. It must not be larger than the maximum size the scanner can accept, and, with drum scanners, it must be sufficiently flexible to wrap around the scanner drum without cracking or otherwise becoming damaged.

Where large-format originals that are too big for the scanner are to be captured, they can be shot on a digital camera.

Color reproduction of artists' originals can sometimes be disappointing, because the pigments and dyes in the illustrations are recorded by the scanner in a manner that does not replicate the way in which they are seen by the eye. The alternatives to scanning directly from the artwork are to use a digital camera or to have a transparency made, ensuring that a color guide is included in the shot if possible. Neither will guarantee fidelity to the original, but both will give a hard copy preview and allow the designer to specify any corrections that are needed. A transparency will also restrict the recorded gamut to one closer to the print gamut.

Other problems that can occur when artists' originals are digitized include:

- The color gamut of the pigments used may be different from the gamut of photographic media and printing inks.
- Fluorescence occurs with some pigments.
- The surface texture of the illustration can influence the appearance of the reproduction.

Marking Up Originals

Before you decide how original illustrations are to be scanned, evaluate the subject matter and the relative importance of its different elements. The color of the key areas of interest usually has much more importance than the rest of the image. In some pictures, strongly colored elements are an important part of the design, while in others neutral backgrounds may be important. If the most critical elements of the picture can be identified, they can be given priority when the picture is scanned and color-separated.

Paper clips or ballpoint pen marks on the protective sleeve or overlay can damage the surface of the original and may show on the scanned image. Any instructions should be written with a felt tip. Depending on the workflow, these may include:

- The publication and the page number where the image will appear.
- Scaling and cropping details.

- Identification of any priority areas of the original to guide the scanner operator in setting up the tonal gradation.
- Any alterations you want to make to the color balance, including removal of color casts.
- Identification of any specific areas of color in the original that must reproduce accurately, possibly with CMYK values from a tint selector.
- Any other desired reproduction objectives, such as overall sharpness or color contrast.

Originals may need to be cleaned before scanning to prevent sticky marks or excessive dust ending up on the final image.

When sending color originals out for scanning by a third party, it is necessary to mark them up to indicate the reproduction priorities and to prevent damage. Transparencies should be protected by a plastic sleeve, and color prints should be given a protective overlay. Glass and cardboard mounts should be avoided where possible, as they can cause damage to the emulsion during transport or when the mount is opened to remove the film.

Occasionally, it is necessary to use as an original an image that has already been printed. Apart from the obvious degradation of the detail and color values that this will involve, there is the risk of moiré on the reproduction. Some scanner and separation software programs have the ability to apply descreening algorithms to eliminate moiré, although some further loss of detail or sharpness may result.

Copydot scanners are designed to scan elements that have already been imaged onto film or paper, which may be necessary, for example, where an ad has been supplied on film for insertion into a job that is being output to a computer-to-plate system.

Digital Images

In chapter 3 it was shown how computers and computer peripherals handle graphics in two fundamental ways: by creating a list of drawing instructions or vectors, or by defining a two-dimensional grid of individual picture elements, or pixels. Vectors are mainly used to define graphics that are constructed in illustration programs using well-defined graphical operators, while sampled images are typically used to define pictures and complex graphics in which detail is comparatively unstructured.

Sampled Images

An image is sampled as a raster array of separate pixels, in which each pixel is assigned a color value defining the intensities of its primary color components. Scanned images are often referred to as **sampled images,** and their resolution corresponds to the sampling frequency (the distance between individual samples).

Other terms used to describe sampled images include **bitmap** and **raster images.** The term bitmap implies the use of a single bit to describe each pixel, and so is more suitable for defining binary images (i.e., images with only two possible values—usually black or white). The term raster image is a synonym for sampled image, but is also commonly used to refer to pages prepared for output by conversion into a bitmap of device pixels.

Image processing, which involves calculating new values for each pixel, can be performed at high speed regardless of the apparent complexity of the image. However, since it is necessary to compute new values for every single pixel, spatial operations, such as scaling and rotating, are slow when compared to the alternative vector-based methods.

Figure 4-1.
A vector graphic consists of instructions to draw shapes: the object on the left is defined as a line between two coordinates. In a sampled image (right) the color of every pixel is defined. On enlargement, the vector graphic retains its smooth outline; while in the raster image the pixels become more apparent.

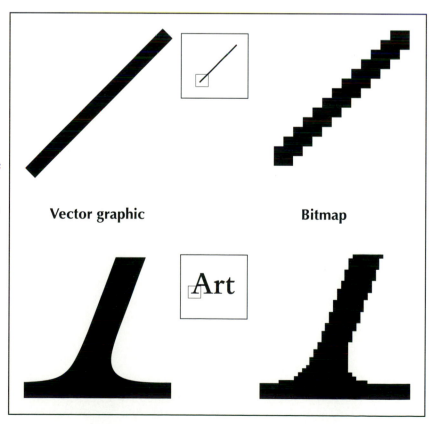

Vector graphic **Bitmap**

Vector Graphics Graphics created by computer systems are usually defined as a list of drawing instructions, which are encoded as individual vectors. Vector-based graphics are much more compact than sampled images and are also largely resolution-independent.

Figure 4-2.
Vector graphics are based on a small number of "primitives" from which all objects can be built: the straight line (A), the arc (B) and the curve (C).

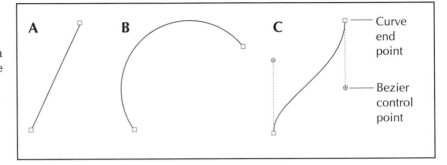

Each vector defines the coordinates of the beginning and the end of the element being drawn as well as a mathematical description of the path between these two points. The elements defined in the mathematical description can be based on straight lines, arcs, or curves. There are a number of mathematical functions that will allow a complex curve to be defined, but graphic programs almost invariably use a cubic curve known as a **Bezier curve.** In a Bezier curve, two control points are defined in addition to the two end points of the curve, the coordinates of the control points providing the parameters of the cubic function.

Figure 4-3.
The end points and control points of a Bezier curve.

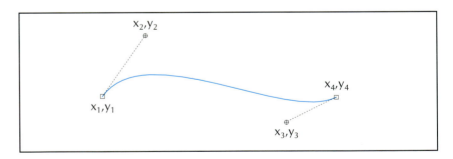

The end points and control points shown in Figure 4-3 define the coordinates x_{0-3} and y_{0-3}. A set of cubic equations are solved to find values for a_x, a_y, b_x, b_y, c_x, and c_y.

$$x_1 = x_0 + c_x/3 \qquad\qquad y_1 = y_0 + c_y/3$$

$$x_2 = x_1 + (c_x + b_x)/3 \qquad\qquad y_2 = y_1 + (c_y + b_y)/3$$

$$x_3 = x_0 + c_x + b_x + a_x \qquad\qquad y_3 = y_0 + c_y + b_y + a_y$$

The path between the curve end points is then given by:

$$x\,(t) = a_x t^3 + b_x t^2 + c_x t + x_0$$
$$y\,(t) = a_y t^3 + b_y t^2 + c_y t + y_0$$

as t varies from 0 to 1.

Since vector graphics are nearly always output by raster devices, they must be converted to a raster format before output. Because of the processing involved in computing the function and mapping the graphic object to the raster grid of the output device, output time is usually longer than that for sampled images. The processing time required is directly related to the complexity of the graphic.

Vector graphics are also known as **object-based graphics** (since they are built up from individual objects). A vector object has a set of attributes (such as font, size, and style for a type object), remains a separate entity, and can be edited at any point until it is rasterized for output.

Because the object description is defined mathematically, and not by reference to individual pixels, it is resolution-independent. Objects such as type can be scaled to the exact size required with all lines and curves remaining completely smooth, until it is rasterized for output on a specific device. Bitmapped type, on the other hand, cannot be scaled without the risk of **aliasing effects** (or pixelation), in which individual pixels in a character are enlarged to the point where they become objectionable.

The drawing instructions contained in a vector graphics file are couched in the graphical operators of the operating system, application, or programming language. PICT files, for example, contain QuickDraw operators; others include PostScript files (PostScript operators) and Windows Meta-files (Windows GDI operators). It can be difficult to exchange object-based graphics between applications or platforms.

In a vector graphic, new objects are always drawn on top of preceding objects. The display sequence is changed when a graphic is edited to bring an object "in front" or place it "behind."

Spatial operations, such as scaling and rotating, that affect individual objects or the whole graphic, can be performed very easily on vector graphics. On the other hand, changes that affect individual pixels or groups of pixels may not be possible without converting the graphic to a raster image.

Converting Between Vector and Raster

It is sometimes necessary to convert between raster and vector formats for the purpose of editing or output.

Vector-to-raster conversion is always required in order to transform an image into the device pixels of the output device. It may also be done for other reasons during the production workflow, for example to reduce the processing needed on a complex graphics when it is output. Converting a vector-based graphic to a raster image is a simple task, but once the conversion has taken place the elements of the graphic no longer exist as individual objects, and vector information such as Bezier control points is lost.

Raster-to-vector conversion is necessary in order to import a raster image into an object-based illustration. This is accomplished by an autotrace routine that finds the edges of all the possible objects by looking for adjacent pixels that have different color or luminance values and separating them into different objects.

File Formats

Numerous file formats have evolved to describe digital images and graphics. Raster formats are differentiated mainly by the color spaces supported, and the information that can be included in the file headers or tags. Vector formats normally allow the inclusion of raster image data, as well as vector graphics. In addition to their raster attributes, they are differentiated by their ability to incorporate other features, such as layers, multiple color channels, and separations. Raster formats can be single-file composites or multiple-file separations; they can be pixel-interleaved or separated.

A **composite file** is one which includes the data for all the color components in a single file. Occasionally separated files are required, in which the different color components are encoded in separate files.

Raster files usually encode pixels in **interleaved form** (i.e., for each pixel the values for each color component are defined in turn). Some formats enable the color values to be encoded separately with the file, so that, for example, all the pixels for the red channel of an RGB file are defined, followed by those for the green and blue channels.

EPS and TIFF are the main file formats used for color images in the graphic arts. As well as file formats for storing color images and exchanging them between applications, there are formats used by the applications themselves and by the operating system. These are often known as "native"

file formats and may require translation to be available to another application or operating system. Native formats such as PICT2 and QuickDraw on the Mac, and WMF and PCX on the PC platform, have limited use in the graphic arts and are often limited to RGB. Properties of different file formats are summarized in Table 4-1.

Encapsulated PostScript (EPS)

The PostScript page description language allows objects to be incorporated into pages as encapsulated PostScript (EPS) files. EPS is primarily a vector format that includes a description of one or more raster or vector objects with no page setup information or fonts. Unlike PostScript files, EPS files are limited to a single page. They can also include a low-resolution preview of a bitmap image for display on screen, together with high-resolution image data. EPS files can also incorporate the halftoning parameters for when the image is output, including screen ruling, screen angle, and dot shape, and any transfer functions that have been applied.

Vector formats such as EPS can include multiple layers, and this helps to preserve the editability of different elements of the file.

EPS files are structured in a way that is specific to the creator application. They may be unreadable by another program unless it has a filter that allows it to import files from the creator application.

Figure 4-4.
Saving a DCS (Desktop Color Separation) file in Adobe Photoshop.

The **Desktop Color Separation** (**DCS**) format is an EPS file format that places each color component of an image in a separate file and also includes a low-resolution preview image that can be used for page placement. DCS files are used to output CMYK images as separate films (or plates) for each color on high-resolution imagesetters that cannot process composite files. Since the separate color components do not have to be extracted from a single composite file, output processing can be faster.

Format	Color Spaces	Alpha Channels	Compression	Web Browser Support (may depend on browser version and plug-in)	Progressive Download	Clipping Paths	Vector or Raster***	Max Bit Depth per Channel
EPS	RGB, CMYK, LAB	No	JPEG	No	No	Yes	Vector	8
DCS	CMYK	Yes	JPEG	No	No	Yes	Vector	8
TIFF	RGB, CMYK, grayscale, LAB, index**	Yes	LZW, JPEG, Packbits, Huffman CCITT*	Yes	No	No	Raster	8–16*
Flashpix	RGB, grayscale	No	JPEG	Yes	Yes	No	Raster	8
JPEG	RGB, CMYK, grayscale	No	JPEG	Yes	Yes	No	Raster	8
PDF	RGB, CMYK, grayscale, LAB	No	JPEG, LZW, ZIP, CCITT	Yes	Yes	No	Vector	8
PNG	RGB, grayscale	One	Various	Yes	Yes	Transparent background	Raster	8
GIF	Index	No	LZW	Yes	Yes	Transparent background	Raster	256 colors maximum
PCD	YCC	No	Various	No	No	No	Raster	8

*Depends on application.
**Others possible through TIFF extension tags.
***Vector formats can incorporate raster image data.

Table 4-1. File formats.

DCS files can be created by image-editing and page-makeup applications. The DCS-2 format has been established to support color graphics and images with more than four component colors, allowing them to be exchanged between applications and output as separate films. The additional colors can be used to define spot colors and HiFi color separations.

Scitex PSImage is a composite EPS file format that contains a low-resolution CMYK preview. It is intended for use with Automatic Picture Replacement (APR), a system in which high-resolution Scitex scan files are substituted for the low-resolution versions on output.

EPS files are essential for incorporating objects and images within pages for output. However, because they are, to some extent, application-specific, they are less suitable for the interchange of high-resolution image data between the scanner, the desktop, and the output device. This function is better carried out by TIFF files.

Tagged Image File Format (TIFF)

The Tagged Image File Format (TIFF) is a rich and versatile file format that is capable of being extended as new requirements appear. Most bitmap file formats contain a small number of headers that describe the properties of an image, but TIFF images can include up to 60 tags (from an almost unlimited number of possible tags), each defining different properties. Tags are divided into **baseline tags** and **extensions.** Baseline tags include basic image data, such as image size and resolution. Extension tags define many other features, such as alternative color spaces and compression methods. Extension tags have been defined for many different image metadata purposes, including device profile data. They can also be used for proprietary information (for example, one proprietary tag stores a lookup table for interpreting 14-bit data from a digital camera) which is inaccessible to other applications.

Virtually all graphics applications are capable of reading baseline TIFF images, but the features of the TIFF extensions are supported by a more limited number of applications. Applications such as Adobe Photoshop are capable of reading all the extensions defined in TIFF 6.0 that are relevant to graphic arts applications and can convert images from one format to another.

TIFF variants defined in the TIFF 6.0 standard for use in the graphic arts include the RGB, CMYK, YCC, CIELAB, and JPEG formats.

The TIFF/IT format is designed to incorporate the information that a high-end graphics system would use in addition to the basic CMYK information, including linework and both high- and low-resolution raster data. It has been proposed as an ISO standard for interchange between high-end systems (ISO 12639: *Graphic Technology — prepress digital data exchange — tag image file format for image technology (TIFF/IT)*. The TIFF/IT format has a number of subtypes:

- TIFF/IT-CT for contone color data
- TIFF/IT-LW for line art image data
- TIFF/IT-HC for high-resolution contone data
- TIFF/IT-MP for monochrome contone data
- TIFF/IT-BP for binary image data
- TIFF/IT-BL for binary line art data

In addition, the TIFF/IT-P1 format is defined in the standard for the encoding of TIFF/IT files with restrictions on encoding options, in order to simplify the structure and make it a more reliable and robust interchange format. The TIFF/IT-P1 format can be read by Adobe Photoshop. It specifies CMYK color space, pixel interleaved, and a single orientation and dot range.

JPEG

JPEG compressed files are a TIFF file subtype, with a JPG or JPEG extension in place of TIFF or TIF. JPEG compression is discussed in more detail in chapter 10.

Scitex CT

Scitex CT is a high-resolution composite CMYK format designed for output to high-end Scitex output devices. The format is supported by many image-editing and page-makeup applications.

Photo CD

Kodak Photo CD was originally developed for the consumer market, but the low cost of scanning Photo CD images has led to its widespread adoption by publishers.

Photo CD images are encoded in the 24-bit Photo YCC model described in chapter 3 and can be easily converted into other digital file formats. Both negatives and transparencies are scanned with Kodak's Photo CD film scanner, converted to YCC, compressed, and written to disc as a PCD file.

The main technical limitation of the PCD scanner is that the maximum density that it can read is only 2.8. As a result, detail can be lost in deep shadow areas in transparencies (although not on negatives, which have a maximum

Figure 4-5.
A. Image scanned conventionally on a Crosfield Magnascan.

B. Kodak Photo CD image scanned from the same transparency:
 1. Opened in RGB and converted to CMYK without correction.

 2. Opened in CMYK using a Photo CD Universal E6 ICC source profile and a SWOP/Coated ICC destination profile.

density of around 2.0). Color correction and sharpening are often needed.

The Photo CD image is stored in an **image pac,** which contains the information necessary for five image resolutions. The highest resolution in the standard Photo CD scans 35-mm as 2,048×3,072 pixels, yielding an 18-MB file after decompression; while in Pro Photo CD a 5×4-in. (635×102-mm) original is scanned as 4,096×6,144 pixels, giving a 72-MB file.

Decoding of the compressed YCC image data and translation to RGB is critical to final image quality. Some decoding utilities that allow users to access Photo CD images do not retain the image information fully.

Because the process of converting from YCC to RGB or CIELAB, and then to CMYK, results in some information loss, it is preferable to transfer directly from YCC to the destination color space. This can be done with the use of Kodak device profiles.

The larger files produced by Pro Photo CD require special access utilities or plug-ins, as they cannot be read by the versions available for standard Photo CD.

Print Photo CD is a variation on the Photo CD system designed for use by trade shops. This format allows trade shops to write images to disk both as standard CMYK TIFF files and as YCC files. It is not restricted to Photo CD files and can handle images from a range of different sources, including high-end scanners and edited Photo CD files. The Print Photo CD discs can be read by users in the same way as standard Photo CD and can also include other page layout elements such as text and graphics.

Flashpix

The Flashpix format is designed to enable users to work on high-resolution files without having to continually refresh the screen image. It stores an image file as an array of 64×64 pixel tiles, and loads only those tiles that are currently within the field of view. Flashpix is a highly extensible format; it can readily incorporate image metadata, such as color profiles, and additional media objects, such as audio streams. In conjunction with the Internet Imaging Protocol, Flashpix files can be efficiently downloaded within Web pages.

Sources of Digitized Images

There is increasing interest in acquiring images in an already digitized form, through media such as digital photography, digitized picture libraries, or Photo CD. There are considerable advantages for publishers, including savings

on scanning costs, reductions in production time, increased flexibility and control, and the benefits of an all-digital work-flow. It is possible to import pictures into page layouts and prepare visualization proofs before making a final selection, as well as produce color separations directly from the digital file without an intermediate film stage. Photographers and picture libraries are able to add value to their images by sup-plying them ready for use—already scanned and retouched. Image creators and copyright owners, as well as designers and publishers of images, are now able to take responsibility for bringing an image into digital form.

Some issues that need to be considered here are:
- *Search methods*. Searching a picture library's stock for physical images currently involves a combination of searching a text database and handling prints or trans-parencies. Digital images enable fast online searching through low-resolution viewfiles and the distribution of low-resolution catalogs.
- *Compression*. The large file sizes of high-resolution digital images make some form of compression necessary for stor-age and transfer.
- *Transmission*. High-bandwidth communications links are needed in production situations where speed or volume requirements are high.
- *Color management*. Ensuring that digital images appear on different platforms in a consistent way that reflects the photographer's original intentions requires the use of color management systems and calibration tools.
- *Copyright protection*. Fear of unrestricted copying of high-quality digital images can act as a deterrent to distributing images in this way. A copyright owner can be identified by embedding an invisible watermark into an image.

Digital Photography

An alternative to photographing images onto film is to record them in digital form, using a digital camera. This saves on film and processing costs and removes the need for image digitization later in the process. The cost savings for high-volume users can bring a quick return on investment. For the photographer, there is the additional advantage of being able to electronically retouch and composite images, allowing more salable images to be produced with less work. Pictures can be immediately displayed, eliminating the need for Polaroid previews, and can be imported directly into image-editing applications.

Digital photography has particular application in sectors where its immediacy and workflow benefits have value. This includes news photography, small ads, Internet images, and product shots for catalogs.

Picture Libraries

Many picture libraries are making their collections available in digital form, giving users fast, 24-hour access to high-quality professional images. For the library, supplying digitized pictures eliminates the costs associated with sending out high-value original transparencies, such as transport and insurance, and removes the need to make duplicates. Since the cost and availability of picture library images have become increasingly attractive, there has been a corresponding reduction in commissioned photography.

Online searching provides access to picture libraries all over the world through the Internet, allowing picture researchers to search for images in the same way that online database users search for text. Thumbnails can be viewed and downloaded, and after an image has been selected, the photographer or picture library can be contacted in order to obtain a transparency or high-resolution file of the image.

Figure 4-6.
An image from the PhotoDisc library of copyright-free images.

Copyright-Free Images

Clip art is a widely available source of images in both vector and bitmap formats, offering access to an enormous selection of images, often at little or no cost. Although many scanned clip art libraries consist of relatively low-resolution images that can look good at the display resolution but are not adequate for printing, some collections of professional images are now being distributed on CD. These collections are often organized around a particular theme. The user pays a single fee to acquire the disk and limited reproduction rights; he or she can reuse images without incurring additional costs. The cost of acquiring digitized images in this way is usually much less than using pictures from conventional picture libraries, although their use for promotional purposes is limited by the fact that users cannot secure exclusive rights. The main drawback in using images of this kind is that they tend to be of a rather general nature, although by compositing multiple images together the designer is often able to achieve the desired effect.

Graphics

Most illustrations and graphics are originated in graphics programs. They can be created as either vector-based graphics in draw programs or as pixel-based images created in paint programs.

Draw programs are used to generate the type of illustrations that a graphic artist would create, using pens or rulers, or applying color with dry transfer materials or an airbrush. The resultant file describes the image as a series of objects.

Paint programs, on the other hand, are used to produce images that an artist or illustrator might create with oils, watercolors, crayons, gouaches, and so on. A file created by a paint program defines the color and intensity of every pixel in the image.

Once an object has been "painted" on to the image canvas, it no longer exists as a separate object. It is now a series of color values for the individual pixels.

Some programs allow the designer to create both object and raster layers within the same image, so that the most appropriate method of creating the different elements of the image can be used. They may also allow the designer to use an autotrace routine to import a sampled image into a draw program and convert it into a series of objects in order to manipulate it.

Evaluating Color Originals

Assessing Photographic Originals

It is important to make sure that the pictures chosen or commissioned are suitable for reproduction. The most important attributes are sharpness, color balance, and contrast.

When assessing a photographic original it is important to use standard lighting conditions, especially when viewing transparencies (see chapter 1). When ordinary room light is used to evaluate a transparency, color values will be difficult to judge and any color casts may not be apparent.

Two points should be borne in mind when considering viewing conditions for originals. First, the enlargement and reduction of an original can affect color and tone in ways that are difficult to predict. Color contrast appears to decrease when the picture is enlarged and increase when the picture is reduced. In addition, midtones appear to be lighter on enlarged images and darker on reduced ones.

Second, even where the intensity of illumination meets the requirements of the standard, there can be transparency detail in deep shadows that is not visible. Using a magnifier helps to identify shadow detail, but there remains the possibility that some detail can only be seen with the assistance of a dark surround, or a more powerful light source.

Sharpness. The sharpness or definition of a picture is especially important, unless it is an intentionally grainy or soft-focus image. Readers of a publication may not be in a position to judge color values or tonal gradation without being able to refer to the original image, but lack of sharpness will be noticeable to anyone. For this reason, picture editors nearly always insist on pin-sharp transparencies.

Images are normally sharpened during scanning by the process of **unsharp masking,** which is described in chapter 5. Unsharp masking and sharpening filters can also be applied in image-editing applications.

Most transparencies are enlarged during reproduction, and some of the image definition is lost in the process. To avoid this, transparencies should ideally be as close to the size of the reproduction as possible. Enlargements above 250% will certainly appear less sharp than the original. You can get an idea how your image will appear after enlargement by inspecting it with a low-power magnifier such as a linen tester.

Figure 4-7.
A sharp image (top)
looks much better than
a softer, unsharp image
(bottom).

Color balance. A common problem with color originals is poor color balance, usually in the form of an excess of one of the photographic dye colors throughout the whole image. This effect is called a **color cast,** and it is especially noticeable in highlights and neutral colors, which show a shift towards the cast color, and in complementary colors, which are desaturated. Overall color casts are caused by poor processing or lighting, or by the use of film that is out of date or has the wrong color balance for the lighting conditions.

Because the eye tends to adapt to any near-neutral color, the cast may not be apparent until it is seen alongside an image with a different color balance. For this reason it is a good procedure to collect together all the illustrations that will print in the same publication and view them side by side in order to identify any differences in color balance.

Slight color casts may not be objectionable, or they may even be a desirable feature of the image. The effect of removing a color cast should be considered carefully, as it will affect the color balance of the whole picture, possibly making it warmer or colder.

Removing a magenta color cast, for example, will make the reds in a picture warmer, the blues and neutrals cooler, and the complementary color—green—will become more saturated. Color casts are easy to remove during scanning or in an image-editing application.

Sometimes a color cast can be seen over a small area of the original. This is known as a **local color cast** and is usually caused by poor lighting of the subject. It will take much longer to correct than an overall cast.

Contrast. A common problem with transparencies is that shadow detail is lost when printed. If an original has a maximum density greater than the scanner is capable of recording, then detail in the shadows and deep saturated colors will be lost. A good reproduction will compress the tonal range of the original into the tonal range that can be achieved by the printing process, keeping most of the detail but losing a little of the separation between tones.

To get the best from a transparency, a scanner with an adequate density range (or dynamic range) should be used, but in cases where there is important shadow detail at the end of the tonal range, shadow expansion can be applied by adjusting the tone curve. This will change the way the tonal range is compressed, allocating more gray levels to the shadow end and less to the midtones and highlights. Highlights and midtones can also be expanded, but expanding any one region of tone causes compression and the loss of gray levels elsewhere in the picture.

Good color contrast is essential for colorful and appealing pictures. Color contrast depends on the saturation of individual colors and also on the balance of saturation in all the saturated colors throughout the image. Colorful pictures have clean saturated reds, greens, blues, and yellows, and it helps

Figure 4-8.
A. Normal contrast.

B. High contrast.
High contrast can
make the colors in
a picture look too
strong.

C. Low contrast.
Low contrast can
make the colors in a
picture look dull.

if the original has good saturation in these colors. Color contrast can be enhanced in image-editing applications, but if the color is very desaturated the scanner or image-editing program may be unable to restore it. The detail in a saturated color is usually carried by the complementary color, and since enhancing color contrast involves reducing the complementary colors, loss of detail can result.

Grain. Visible grain in a reproduction is usually objectionable, although for some images it forms part of the mood of the picture. Fast films (ISO 400 and above) exhibit more grain than slow ones. When a transparency is enlarged the grain becomes more apparent, and a transparency that seemed acceptable when viewed without enlargement may show objectionable grain when printed.

When enlargement is necessary, the grain of the transparency should be checked carefully with a magnifier. Grain suppression is available in some electronic image manipulation systems. The despeckle filter in Adobe Photoshop has the same effect.

Blemishes. Any dust, finger marks, scratches, or other blemishes on an original may well appear on the reproduction, often becoming more pronounced. Care should be taken in handling all originals, preferably keeping them in mounts or sleeves except when they are being scanned. A quick wipe over the surface of an original before scanning can save a great deal of time pixel cloning later in an image-editing program. On some scanners, transparencies are mounted in oil to improve the contact with the scanner drum and reduce the likelihood of scratches and Newton's rings appearing on the scanned image. If scratches or other marks appear on an image they can be removed in an image-editing application.

Other requirements of good originals include good tonal gradation and good tonal separation between areas of detail (bearing in mind that this tonal separation will be compressed when the image is scanned).

Assessing Digital Images

Two essential requirements for judging color images on screen are:
- Ensure that the ambient lighting and display setup conform with the standard viewing conditions (see chapter 1).
- Ensure that the monitor is accurately profiled (see chapter 9).

Figure 4-9.
Color values for the
current pixel shown in
Photoshop's Info dia-
log. This is sometimes
called a "software den-
sitometer."

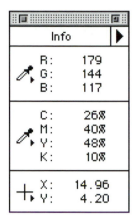

Digital images require different methods of evaluation, since the characteristics of the display can influence the way the image is perceived and some aspects of the image may not be readily visible. If it is not possible to determine the quality of an image from the display, it is possible to make a visualization proof at the size of the final print, preferably using a dye sublimation printer and a color management system.

Checking digital images on screen makes use of the software densitometer that is available in many image-editing applications. The cursor is positioned over a pixel and its values appear in an information panel or the application's status line at the bottom of the display.

The recommendations below are not intended to be applied to every image, but they can be used as a guide for typical images without special requirements.

Sharpness. Check that the file is large enough to contain all of the information for the output size you want, then check that unsharp masking has been applied to the image. Next, choose the part of the image where the lack of sharpness will be most noticeable, zoom in so that the individual pixels are visible, and check to see that edges do not feather across more than one or two pixels. A fair representation of image sharpness can be obtained by viewing the image at a 2:1 zoom.

Color balance. Check the white point in the image and any neutral colors. In the RGB mode you should see equal values for red, green, and blue, while in CMYK mode you should see cyan, magenta, and yellow in ratios corresponding to a neutral gray (5:4:4).

Contrast. Check the overall lightness contrast of an image by reading its lightest and darkest points. For high contrast, they should be close to 5% in highlights and to 95% in shadows. Specular highlights (small areas of the image that correspond to light sources or bright reflections) can have values close to 0%.

Color contrast can be checked in a number of different ways. You can read a value for saturation directly by setting the Colors palette to HSL and using the eyedropper to select the most saturated colors in the image: the closer to 100, the more saturated the color. Alternatively, check the amount of the complementary color present in each of the saturated colors. For example, check the amount of cyan in a saturated red, or the amount of blue in a yellow color. Also check that the saturation of reds, greens, blues, and yellows is roughly equal for a balanced appearance.

Tonal gradation. Make a grayscale copy of the image, zoom in on the areas of interest and check that there is good separation between areas of detail (a difference of at least 5–10%). In areas of smooth transition between tones, check

Figure 4-10. Zooming in on a picture allows you to determine whether it has adequate sharpness. In the top image, the boundary of the detail area does not extend over more than one or two pixels. While in the bottom image, the boundary extends much further and the resulting reproduction will not appear as sharp. Detail from both images has been enlarged 8×.

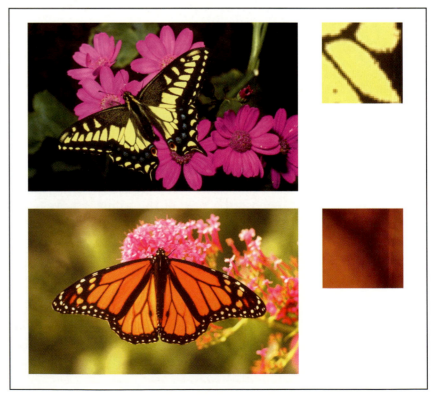

that the difference between adjacent areas is less than 2%. Any wanted detail in shadow areas should have values of 90% or less.

Image Editing

Retouching photographic images is now performed with electronic tools, rather than by traditional manual methods using brushes, dyes, and chemicals. The advantages of electronic retouching are:

- It is easier to see the effects of what you do.
- Retouching can be carried out on a copy, leaving the original intact.
- Image-editing applications are faster, more controllable, and offer many more editing techniques and filters than manual methods.

Image-editing applications combine the functions of the photographer, the artist, the retoucher, and the electronic prepress system, in a powerful digital darkroom. All the image attributes described above can be altered in an image-editing application, but it is important to recognize that the total amount of information from the original scene cannot be increased after the image has been captured. It can only be redistributed in different ways. It is preferable to start with a good image than to spend time correcting a defective image in an application. Image-editing applications are used most productively for creative design work and for preparing images for output, rather than for the routine corrections of defects, such as poor lighting or spots.

Bibliography

Adobe Systems (1992). TIFF Revision v. 6.0.

Davies, A. (1998). *Digital imaging for photographers*. Oxford: Focal Press 1998.

Evening, M. (1998). *Adobe Photoshop for photographers*. Oxford: Focal Press.

ISO 12639:199x. *Graphic technology — Prepress digital data exchange — Tag image file format for image technology (TIFF/IT)*.

Rimmer, S. (1995). *Bitmapped graphics*. 3rd ed. Blue Ridge Summit, PA: Windcrest/McGraw Hill.

5 Scanning and Digital Photography

In this chapter we consider the digitization of images through scanning and digital photography.

The aim of this digitization stage is to capture all the information from an original that will be needed in the reproduction. The human visual system actively seeks cues that will give it information about the objects within the visual field, and, for this reason, a reproduction of an image that contains a large amount of detail is almost always preferred to one in which some of the detail has been lost. The more information that the reproduction contains about the original scene—the objects in it, their colors, textures, and so on—the closer and more real the original scene appears.

Information that is not captured when the image is scanned cannot be replaced. Any further image processing will discard data but will not be able to retrieve it from the original. For example, if the resolution of an image is downsampled, detail will have been lost, and it cannot be retrieved other than by returning to the unedited image.

Image processing can sometimes improve the information content of a picture. When an image has become degraded, it is possible to employ algorithms that reverse the degradation, if enough is known about the way the image became degraded. Removing moiré and adding sharpness fall into this category. Mathematical solutions of this kind can restore or enhance an image, and make it much more acceptable, but the new information added was not necessarily present in the original image.

A good scan will capture information by sampling it at the right points. For example, a transparency with middletone areas of interest should be scanned in a way that maintains the separation between tones in these areas, so that all the wanted detail will appear in the reproduction. Expanding the

midtones later, by adjusting the gradation in an image-editing application, will redistribute the tones that have been captured, but without adding any further tonal steps to contribute to perceived detail. Adding intermediate tones by interpolation will only average the existing tones, making the transition between them smoother, but not actually adding any more detail.

There is, however, a limit to how much information can be used in the reproduction, and acquiring more than this simply makes files larger than necessary. Every subsequent file operation will take longer, resulting in a serious loss of productivity. When scanning an original, then, the objective is to capture all the information that it will be possible to reproduce, while at the same time making sure that file sizes are as small as possible.

Development of Electronic Scanning

Scanning began to eclipse photographic color separation techniques during the 1970s, bringing automation to what had been a manual operation. The electronic scanner offered control, repeatability, and productivity to those with the necessary skills and capital to purchase and operate the equipment. The economics of using the new equipment led to the development of specialized trade shops that supplied color separations to printers and agencies. Prices of color separations tumbled in real terms, contributing to the increasing affordability of color printing.

The initial advantage of using a scanner instead of a process camera was that color correction was programmed into the circuitry of the scanner and the laborious retouching of films by masking and etching could be almost eliminated.

The first color scanners were analog rather than digital, and the image was exposed onto film by the recording unit at the same time as it was being read by the analyze unit. The development of digital scanners, first introduced by Crosfield in 1975, created the possibility of digital storage and processing of the image before output to film. Since then, scanner quality and productivity have increased enormously. Preview stations have been added, modular and multistation scanners have been developed to maximize throughput, and workstations for color image assembly and planning have been incorporated.

At the same time that graphic arts scanners evolved into highly efficient and consistent workhorses for quality prepress, businesses began to identify a need for small, simple

scanning devices that could be used in the office environment. These flatbed scanners use simple solid-state electronics to record the image instead of the sensitive photomultiplier tubes found in high-end scanners. With their resolution and sensitivity rapidly improving, flatbed scanners soon became of interest to the emerging desktop publishing (DTP) market. Since then, the quality and price performance of flatbed scanners has reached the point where they are able to challenge specialized commercial drum scanners in the graphic arts market.

Types of Scanners

The majority of scanners produced today are compact desktop machines. They include flatbed scanners intended mainly for reflection copy, transparency scanners for 35-mm and medium-format transparencies (occasionally taking transparencies up to 5×4 in.), and desktop drum scanners similar to the larger commercial systems that accept both reflection copy and transparencies. High-end scanners, designed for trade shops and commercial printers, are normally built as large drum scanners with internal programs for performing CMYK conversions. Some have direct connections to film recorders. High-end scanners are relatively costly, but they generate high-quality output and tend to have higher productivity.

Parts of a scanner have functionality similar to the eye:
- An optical system to focus light onto the image plane.
- Light-sensitive receptors.
- Filters that adjust the spectral sensitivity of the receptors and allow three color channels of the image to be recorded separately.

Because a sampled image is a static two-dimensional array of point intensities, unlike a perceptual image which is dynamic and highly complex, the analogy cannot be taken very much further. Nevertheless, a scanner also has other components—hardware and software—that have parallels to elements of the visual system:
- A transport system to move the original in relation to the scanner so that it can be sampled pixel-by-pixel at the required frequency.
- Controlling software.
- Processing software to carry out initial image processing before recording.

Light intensity is detected in a scanner or digital camera by an electronic photosensor. This is normally a **photomultiplier tube (PMT)** or **charge-coupled device (CCD),** although **CMOS (complementary metal-oxide silicon)** devices are beginning to appear in some systems.

When photons strike the sensor, they give up energy. This causes electrons to be emitted, turning the energy of the photons into electrical energy. The number of electrons that are emitted can be measured to determine how many photons struck the capture element, and from this the scanner can generate a value for the intensity of light arriving from the point on the original being analyzed.

Drum Scanners

Drum scanners are equipped with one photomultiplier tube for each of the red, green, and blue filter signals (with an additional tube for the unsharp masking signal on some systems). The original transparency is mounted on the drum. A beam of light is transmitted from inside the drum, through the transparency, and onto the scanner optics. (In the case of reflection copy, it is reflected from the surface of the copy.)

By rotating the drum at high speed and moving the analyze head slowly along the drum's axis, the entire surface of the transparency is read in a helical scan.

After being split into red, green, and blue beams by filters, the light strikes the end of the photomultiplier tube. The photomultiplier tube consists of a photocell inside a vacuum tube, with a light-sensitive cathode at one end and an anode

Figure 5-1.
Screen SG-7060P drum scanner.
Courtesy Screen USA.

Figure 5-2.
Photomultiplier tube (PMT).
From Color Scanning and Imaging Systems by Gary Field.

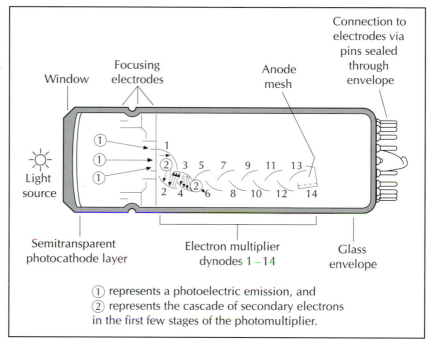

Window — Focusing electrodes — Anode mesh — Connection to electrodes via pins sealed through envelope

Light source

Semitransparent photocathode layer — Electron multiplier dynodes 1–14 — Glass envelope

① represents a photoelectric emission, and
② represents the cascade of secondary electrons in the first few stages of the photomultiplier.

at the other. The photocathode emits electrons as it is struck by photons in the light beam. A series of electrodes amplifies the electron stream until it reaches the tube's anode, and the amplification effect allows the PMT to read small changes in lightness with great accuracy over a large density range. The smallest number of photons that can be detected (indicating the darkest areas of the original) is limited by the amount of noise present in the system. The maximum density that a PMT can detect is between 3.5 and 4.0, depending on the amount of stray light present.

On older high-end scanners, the input (or **analyze**) unit was connected via the color computer directly to the output (also known as a **plotter** or **recorder**) unit. This color computer calculated the correct CMYK dot values for each pixel.

The maximum resolution of a scanner is dependent largely on mechanical factors, such as the smallest spot size that can be focused and the stepping increments of the analyze head travel. The scanner is normally controlled from a host computer, either in a standalone scanner driver or in a plug-in to an image-editing application (such as Adobe Photoshop).

Flatbed Scanners Solid-state sensors (CCD or CMOS) are found in many different kinds of electronic equipment, including camcorders, fax machines, and digital cameras. A CCD consists of an array of

Figure 5-3.
Scitex Smart 340
flatbed scanner.
*Courtesy Scitex
Europe SA.*

tiny electrodes packed closely together on a layer of silicon.
When a photon strikes an electrode it causes an electron to
be emitted from the silicon layer. Like an airline baggage
conveyor, electrons are **tagged** with their position and trans-
mitted along pathways to an analog-to-digital converter
(ADC), where the voltage for each pixel is measured and
given a digital value. The tagging of the electrons to the loca-
tion of individual pixels is called **charge-coupling.**

The CCD can detect the presence of a single photon, but
the interference caused by stray light, system noise, and
crosstalk (interference between the signals produced by
adjacent electrodes) is higher than that of the photomulti-
plier, and thus the ability of CCDs to resolve detail in deep
shadow areas tends to be more limited. The density range is
typically up to 3.0, although a D_{max} of up to 3.5 or even 4.0 is
possible. The difference between 3.0 and 3.5 may not seem

Figure 5-4.
A charge-coupled
device (CCD) is a type
of metal oxide semi-
conductor (MOS).

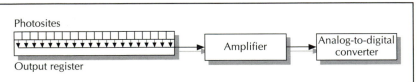

Photons falling on an electrode (or "photosite") lead to an electrical
charge being stored in a "potential well." The charge from one site is
passed to the next electrode and sequentially on to the final output, where
it is amplified and then quantized to a discrete digital value by an analog-
to-digital converter (ADC).

like very much, but because density is a log scale it implies a three-fold increase in sensitivity to detail in dark areas of the original.

The simplest way of increasing the sensitivity of the CCD and reducing the effect of noise so that it has a higher density range is to make each electrode larger. Unfortunately image resolution is dependent on the size of electrodes that can be packed onto the silicon wafer, and hence there is a trade-off between density range and resolution. High-quality CCDs with elements of 10 microns or less and a D_{max} as high as 4.0 have been developed, but they are expensive. So as the imaging capability of CCD scanners rises to the level of PMTs, the price advantage of CCDs starts to disappear. Early scanners were only able to resolve 6 bits of data for each color. Since then, graphic arts scanners have become capable of resolving from 8 to 12 or more bits per color.

Image noise can be greatly reduced by a simple image-processing technique that averages a number of scans of the same original. Some scanners now incorporate this facility, and this extends the effective dynamic range to as much as 4.3.

Figure 5-5.
Two-dimensional
array CCDs.

The analog-to-digital converter (ADC) turns the continuously varying electron levels into digital values, and the number of bits output by the ADC defines the number of gray levels captured. An 8-bit ADC can output 256 gray levels for each color, but since tonal compression will occur after digitization, the ADC should ideally be able to handle more than 8 bits per color. Some systems employ CCDs that can detect up to 12 bits and then effectively resample down to 8 bits, while others retain all 12 bits for later manipulation.

Because a PMT captures data serially, one pixel after another, the scanner design must arrange for every pixel to pass under the optics in turn, and this is achieved by a helical scan around a drum. In a CCD scanner, the data is captured in parallel, and the travel of the scanner head depends on the way the CCD elements are arranged. If the elements are in a row (or **linear array**) the scanner head makes a single pass over the original for each filter color.

Many scanner CCDs are arranged in a row for each color (a **trilinear array**), which requires a single pass to scan the image. A two-dimensional array captures the whole image in a single snapshot without the need to move either the sensors or the original. Low-resolution, two-dimensional arrays are used in devices like camcorders, but they are costly to fabricate in the higher resolutions required in the graphic arts. High-resolution, two-dimensional CCD arrays are found mainly in digital cameras.

When a solid-state sensor is arranged as a two-dimensional array, there is a design choice between a **single-shot** or **three-shot** system. In the former, the available elements are divided between the three colors: red, green, and blue. In a three-shot system, the full number of elements on the chip are available for each shot, and the resolution will be higher.

A two-dimensional array can generate considerable amounts of heat during operation, and this can cause noise in the resulting images. In some systems the sensor chip is cooled to minimize this problem.

The fabrication process does not always produce a defect-free chip, and as a result there may be bad pixels present, especially in a two-dimensional array. It is usual to identify the addresses of any bad pixels during manufacture so that the software can disregard them.

Likely developments in solid-state sensors include the use of further image-processing techniques to filter noise and

Figure 5-6.
Solid-state sensors.

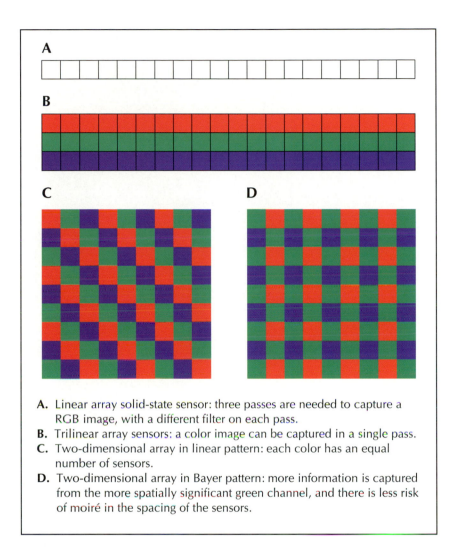

A. Linear array solid-state sensor: three passes are needed to capture a RGB image, with a different filter on each pass.
B. Trilinear array sensors: a color image can be captured in a single pass.
C. Two-dimensional array in linear pattern: each color has an equal number of sensors.
D. Two-dimensional array in Bayer pattern: more information is captured from the more spatially significant green channel, and there is less risk of moiré in the spacing of the sensors.

amplify the response in shadows, as well as continuing improvements in resolution and sensitivity.

Camera

Like conventional cameras, digital cameras come in **compact, single-lens reflex (SLR),** and **large-format** varieties. Low-resolution compacts are useful for producing classified advertisements and tend to have relatively simple optics, image-sensing electronics, and controlling software.

Digital SLR cameras, such as the Kodak and the Nikon cameras, are often based on existing SLR camera designs with the addition of CCD backs and storage subsystems. The capture resolution of these cameras is ideal for news photography and other applications with similar quality requirements.

Figure 5-7.
High-resolution digital camera back fitted to conventional large-format camera. *Courtesy Phase One.*

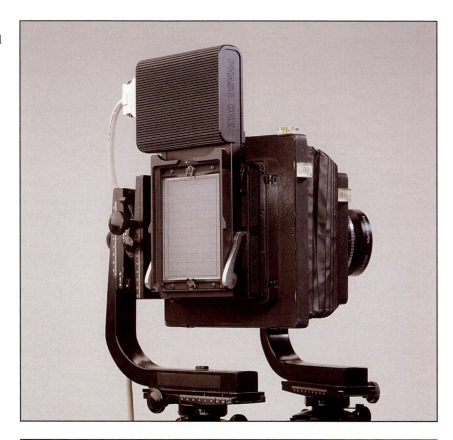

Figure 5-8.
Hand-held single-shot digital camera. *Courtesy Eastman Kodak.*

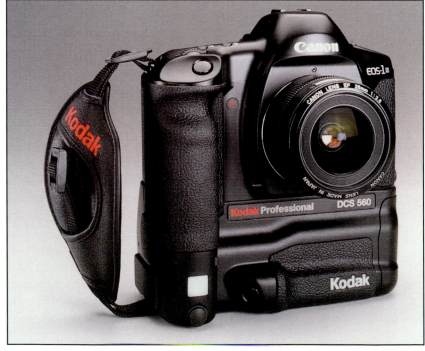

Large-format systems can take the form of digital backs that can be used in conjunction with existing large-format cameras, providing an interchangeable alternative to a film back. Or they can be designed from the start as digital cameras. These large-format systems have adequate resolution for most graphic arts purposes, and in most cases do not require their own storage subsystems since the image is downloaded directly to a host computer. They are most suitable for studio work and are widely used in catalog production, where the volume of product shots means that large savings can be made on film and processing.

When using a digital camera, the level and color temperatures of the lighting will inevitably change from shot to shot. A camera will have a fixed ASA/ISO speed equivalent, and if the brightness of the scene is higher than the camera is designed for, **blooming** can result where the charge induced in one element spills into adjacent elements.

Resolution

The maximum resolution of the scanner determines its ability to capture detail from the original, especially where the original is enlarged. Sampling resolution depends on a number of factors, including:

- The size of the sensor element or scanner spot.
- The size of the stepping increments of the scanning head as it travels over the original.
- The focusing accuracy and depth of field of the optical system.
- The mechanical precision of the scanner's moving parts.

The width of the solid-state sensor array is normally much less than the width of the scanner bed, and the image is projected through a lens system onto the sensor array. The scanning resolution in some systems is adjusted by moving the lens or using an alternate lens.

Lower-quality scanners do not have the mechanical precision to achieve high resolutions. Those that require three passes to capture all the color information need to have particularly good mechanical precision or they may fail to register the colors together accurately.

In a flatbed scanner, the resolution is controlled by software, and unwanted information is simply thrown away. So, for example, if a scanner has an addressable resolution of 1,200 ppi and the user selects 600 ppi for an image, the data from every other pixel is discarded or averaged.

In a drum scanner, the analyze head moves along the drum while the drum is rotating. Each revolution of the drum captures a line of data from the image. The resolution is determined by the speed of the analyze head in one direction, and by the drum diameter and the way the data is digitized in the other.

A scanner's maximum resolution, as determined by the scanner design, is often referred to as its optical resolution. If the scan resolution is not adequate (for example, if the image is being greatly enlarged or the scanner only supports low sampling resolutions) it is possible to avoid **pixelation** (individual samples becoming visible) by creating new pixels through interpolation. Interpolation can be accomplished by the scanner software during scanning or by resampling in an image-editing program. Interpolation does not add any new information to an image and, depending on the algorithm used, may tend to make fine detail appear blurred.

XY Scanner

Instead of making a single pass up the center of the scanning bed, an XY scanner can move the scanning head in two dimensions and scan an original in a series of strips. The image is stitched together by software at the end of the scan. When this is done the maximum resolution of the scanner can be used on any image regardless of the size of the original. XY scanners may incorporate a zoom lens to accommodate alternative resolutions for cases where such high resolution is not required.

Copydot Scanning

Where previously screened originals (usually halftone films, but also bromides and prints) are scanned, for example for insertion into all-digital workflows, a copydot scanner is used. This is a high-resolution scanner that employs two or more linear arrays to achieve resolutions of up to 5,000 dpi or more. Older models were designed for single-color line work only, but current systems may also be capable of high-resolution color scanning.

Scanner Choice

The decision to use a particular scanner will depend on a number of factors:

Design or production environments. For production environments, the emphasis will be on productivity, quality capability, and functionality, in order to be able to meet customers' requirements. There will be a need to transfer files

between the scanner and the desktop with standard file formats, but it will not automatically be necessary for the scanner to work internally in these formats. For design environments, the emphasis will be on ease of use, low capital costs, support for creative design work, and the ability to work in open formats that can be transferred to the desktop without time penalties or the need for additional processing.

Technical capabilities. The aspects of the scanner's technical specification to consider include:
- The scan area and the maximum enlargement.
- The bit depth available.
- The scanner D_{max}.
- The sampling resolution in general, and, more specifically, whether this is optical resolution or the resolution achieved through interpolation.
- The scan controls, including unsharp masking, color cast removal, and gradation control.
- Productivity issues, including preview and scan times, storage and buffering, interfaces with other platforms, and the degree of automation.

The volume of work. If scanning volumes are low, the productivity advantages of high-end scanners will be less relevant and can be traded against the convenience of being able to scan directly into the desktop environment without involving external suppliers.

The level of quality needed. It is important to match the output quality that can be expected from different scanners carefully to the quality requirements of the work being produced. Low-cost scanners are increasingly producing acceptable quality, especially when color management is used.

An RGB or a CMYK workflow? This decision will need to be taken in the context of the management of design and production generally and is discussed further in the following chapter.

Drum or Flatbed? Broadly, high-end scanners are appropriate to trade shops, service bureaus, and printers. Designers and publishers, as well as some printers and service bureaus, will employ mid-range desktop systems, while low-end scanners will be mainly

used for visualization purposes and for work where reproduction quality is not important.

The following are advantages of drum scanners:
- High sensitivity and high D_{max}
- High resolution
- Low noise
- High productivity for volume scanning
- Accept large-format originals

The following are advantages of flatbed scanners:
- Ease of use
- Faster scanning of single images
- Compact construction
- Good price/performance
- Accept rigid originals

The productivity advantage of a drum scanner lies in its ability to scan multiple originals simultaneously and to output color-corrected images directly to disk or film without the need for further processing. An increasing number of flatbed scanners now share these productivity features. Moreover, for many users, productivity is not a major issue, and the number of scans they produce does not justify the capital investment. The time involved in dealing with outside suppliers, and in transporting files and originals, can outweigh any savings made during production. The control over image reproduction that in-house scanning can bring may be a far more important consideration.

Internal Color Models

Scanners handle data internally in ways that are most efficient for the scanner hardware and software to process. The output from both CCDs and PMTs is initially an analog voltage that is digitized and then converted into a common format. (On high-end systems, these formats are sometimes proprietary and cannot be accessed directly by other applications. If this is the case, some form of translation will have to take place to convert the data into an open file format.) The internal color models of scanners are based on RGB, CMYK, or a CIE color space.

All scanners initially capture the color information that is output from the CCDs or photomultipliers as RGB values. The RGB values are **device-dependent**—they relate to the way in which the individual scanner transforms light intensity into output voltages and codes them as RGB values—

and if they are to be printed they must, at some point, be transformed into the device space of the printing system. Most desktop scanners do not carry out this transformation; they simply record the RGB values in a file.

High-end drum scanners usually carry out color separation as the image is scanned, translating the output voltages of the photomultipliers directly into CMYK dot values. The CMYK dot values are stored in the device space of the printing system, giving more efficient image handling, but requiring that the target printing system is known at the time of scanning and the image is intended for output to one printing system at a single size and resolution.

If an image has been scanned as CMYK and any of these output parameters change, the image will have to be edited or possibly rescanned, with the potential loss of image data and of productivity.

Scanner Adjustments

Scanning resolution needs to be chosen carefully to make sure that all wanted detail is captured without making files larger than necessary. Guidelines for optimum scanning resolution are often related directly to the halftone screen ruling of the reproduction, and they assume that there should be two scan lines for every line of the halftone screen in the printed reproduction:

Sampling frequency (in ppi) =
Halftone screen frequency (in lpi) \times scaling factor $\times Q$

where Q is a quality factor set initially to 2.0.

For example, a picture that is to be enlarged by a factor of 1.5, and printed at 150 lpi, should be scanned at $2 \times 150 \times 1.5$, or 450, ppi. Note that the sampling resolution for same-size reproduction must always be multiplied by the scaling factor by which an original is enlarged or reduced.

This value of Q has been found to give good results, but should not be interpreted as a rigid rule. Reducing the sampling resolution causes a gradual loss of detail and sharpness, and even at 1.2× the screen frequency, the loss of quality is still quite marginal, as shown in Figure 5-9. Increasing Q above this figure does increase the amount of detail that can be reproduced, even if the difference is small. The choice of sampling resolution is to a large extent influenced by the type of original. Where there is high-frequency detail present, originals can benefit noticeably from an increase in the Q parameter.

Figure 5-9.
A. Image sampled at 300 ppi (2 times the halftone screen frequency). File size is 6.3 MB.

B. Image sampled at 450 ppi (3 times the halftone screen frequency). File size is 14.2 MB.

Additional detail is present, although almost imperceptible.

C. Image sampled at 180 ppi (1.2 times the halftone screen frequency). File size is 2.3 MB.

The reduced sampling frequency has caused the image to begin to lose detail, despite the higher level of unsharp masking.

This method of defining scanning resolution in terms of the printed halftone screen does not account for imaging methods on systems that have more limited spatial resolution or variable colorant density, as is the case with most digital printers (for examples, see Figure 9-1).

In an ideal reproduction there would be no visible spatial artifacts arising from the imaging process. At normal viewing distances, this would correspond to a sampling resolution for same-size reproduction of about 300 ppi for continuous-tone originals with no sharp edge detail. This figure rises as edge contrast increases and the eye becomes more sensitive to spatial discontinuities. This occurs when there is high-frequency edge detail in the original or when the number of gray levels in the original falls, reaching a maximum of about 2400 ppi for line art originals. Most continuous-tone originals do include some edge detail, so to ensure that the capabilities of the output device or printing system are fully utilized there should be at least one pixel sampled for each discrete dot that is imaged (as described above for conventional halftones). The frequency of such dots is not the same as the addressable resolution, since several spots or droplets are typically clustered together to form a screen dot.

As before, the sampling resolution should be multiplied by the chosen Q value and the scaling factor.

In situations where line art is scanned, there is no halftoning and the discrete dots of the printing system are in effect the device pixels of the imagesetter or platesetter. Where it is necessary to scan previously screened originals, this has to be done at high resolution to capture the precise size of the original halftone dots. In practice, copydot scanning of linework originals is often done at 12 times the screen frequency of the original halftone, although if a small amount of blurring is acceptable it is also possible to scan as continuous tone at a lower resolution.

The halftoning methods used by the output device influence the perceived spatial appearance of the reproduction. In particular, the periodicity of the halftone screen appears to affect the ability of a printing system to reproduce detail. (Conventional halftone screens are highly periodic, while FM screens are much less so). In general, the sampling resolution can be multiplied by a factor for the periodicity of the halftoning method. This factor can be given a value between 0.5 for a completely aperiodic (random) screen and 1.0 for a completely periodic screen such as a conventional halftone.

Where commercial frequency-modulated screens are used, experience suggests the periodicity factor should be about 0.7, leading to a halving of file sizes in comparison with a conventional periodic screen.

Some high-end output systems employ complex methods of building a halftone dot which allow them to modify the dot shape to accommodate local edge detail. Where this occurs, higher sampling resolutions will result in better rendition of detail even though the halftone frequency is unchanged.

If the reproduction is intended for viewing at a distance (a poster, for example), the sampling frequency should be reduced.

Where the size of the reproduction is not known when the original is scanned, or when the image is destined for archiving for multiple future uses, the original can be scanned at the highest resolution that is likely to be required and then interpolated down to the appropriate size as necessary. This archival scan then becomes a **digital negative.** Assuming a maximum of $10\times$ enlargement and a screen frequency of 200 lpi, the maximum scan resolution likely to be needed for the majority of work is 4,000 ppi.

As an image is scanned, you can crop any unwanted areas from the image in order to reduce the file size. If the exact crop is not known when the image is scanned, cropping can be completed later in image-editing or page-layout applications.

Sharpness

The sensitivity of the visual mechanism to edge definition makes sharpness a priority for all images, except those that are intentionally soft or defocused. Visual perception in all animals naturally exaggerates the effect of edges. The result is a heightened perception of the boundaries of objects, a trait that is useful in identifying food and predators. A typical example is shown in Figure 5-10 in the response of the horseshoe crab to a transition between light and dark.

Electronic scanners achieve the same effect on an image by adding an unsharp image created by applying a blur filter, producing the effect shown in Figure 5-11. This is known as **unsharp masking (USM),** and the result is increased contrast at the boundaries between different parts of the image. Virtually all sampled images gain from sharpening in this way and it can bring out the detail in an image better than increasing the resolution. Unsharp masking can be carried out on the fly during scanning, or can be applied later in an image-editing application.

Figure 5-10.
The visual mechanism enhances the perception of edges within the visual field by altering the response to light and dark at a boundary. *From* Visual Perception *by Vicki Bruce and Patrick Green.*

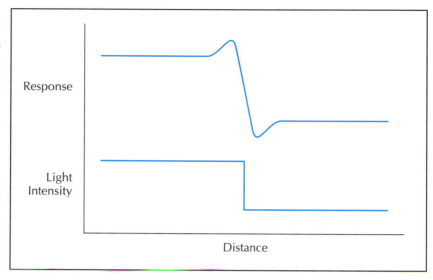

Figure 5-11.
Adding an unsharp signal that is a "negative" of the normal scan causes the definition of the edges to be enhanced in a way that is similar to the response of the eye.

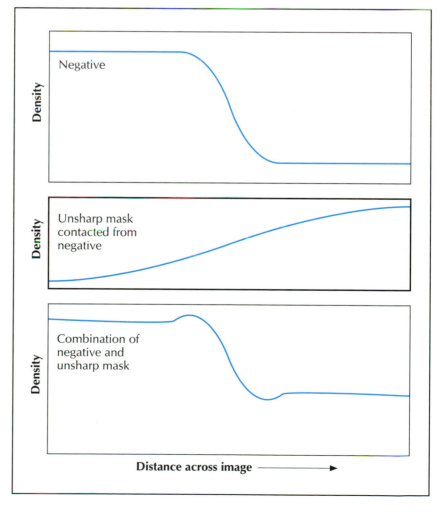

Figure 5-12.
Typical unsharp masking settings for high-resolution images.

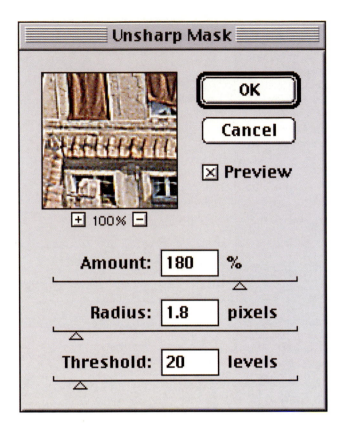

Unsharp masking comes into play when there is a significant difference between two adjacent tones, but it can usually be set up to ignore minor differences that are caused by small variations of tone within an object. Where all tonal values need to be given increased separation, a sharpening filter should be applied instead.

Excessive use of USM can exaggerate unwanted effects, such as random noise and blemishes in flesh tones. USM settings for different originals include:

- The amount of USM to apply (the degree of contrast enhancement to apply to adjacent areas).
- The USM **radius** (the number of pixels on each side of the boundary to which it should be applied).
- The USM **threshold** (the amount of contrast difference between adjacent areas that must exist before they are recognized as an edge and USM is applied).

Tone Adjustment

The tone controls of a scanner have two basic functions. First, they are used to set the location of the endpoints (the extremes of highlight and shadow) of the original and to con-

Figure 5-13.
Unsharp masking
makes scanned images
look sharper and
crisper:
A. Before sharpening

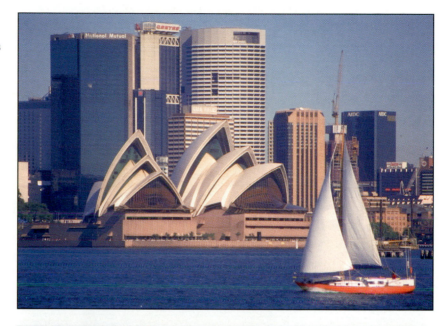

B. After sharpening

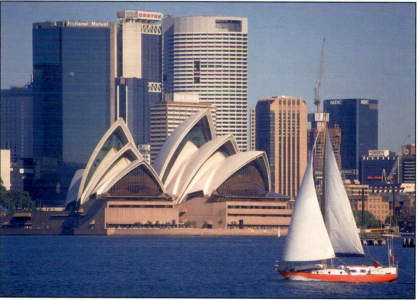

trol the tonal compression. Second, they allow the user to adjust the distribution of the intermediate tones in the original through the tonal gradation.

Both endpoints and gradation can be altered later in an image-editing package, but correct adjustment during scanning will capture more wanted detail from the original. If the conversion into CMYK is not well controlled, it can be difficult to set the end points with adequate precision when the image

Figure 5-14.
The top image, with end points set correctly, exhibits the proper tonal gradation with good rendering of midtones.

Poor adjustments of end points in the middle image has produced inadequate contrast, with veiled highlights and flat shadows.

In the bottom image, poor end point adjustment has resulted in excessive contrast with bleached highlights and filled in shadows.

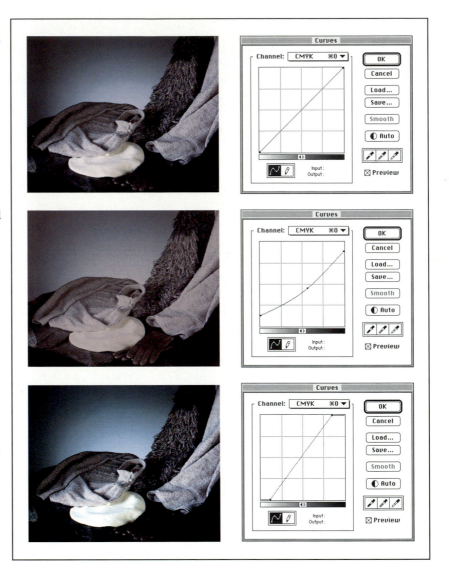

is in another color space. In this case the end points should be adjusted after the image has been converted into CMYK.

Accurate setting of the end points is the most important scanning adjustment, and it ensures that there is good contrast in the reproduction, with highlight detail, specular whites where necessary, and good tonal rendering in highlights and midtones.

White Point Adjustment

If the image is being captured in RGB or independent color space, the white point is set to the lightest tone in the original. If there is no white in the original, the white point can be set from a white patch on a photographic gray scale.

If the image is being scanned into CMYK, the objective is to make the diffuse white point on the original correspond exactly to the smallest dot that can be printed:

- If the original has a tone that can be used as the diffuse white point, set the smallest printing dot at this point (e.g., 5% cyan, 4% magenta, 4% yellow).
- If there is no white point, use complementary colors. Set the smallest dot for cyan in a red part of the image, for magenta in a green, and for yellow in a blue.
- Alternatively, choose the lightest tone in the image and set the CMYK values by reference to the closest color in a printed tint chart.

The end points can be checked by inspecting a histogram of the image data, as shown in Figure 5-15.

Setting the white point to a tone on the original with a density that is too high will cause the reproduction to look light and washed out, with a loss of highlight detail. Setting it too low, in a white that should print as a specular, will cause the reproduction to be dark and lacking contrast.

Figure 5-15.
The Levels dialog in Photoshop allows the image white and black points to be set. The histogram illustrates the distribution of intermediate tones within the image.

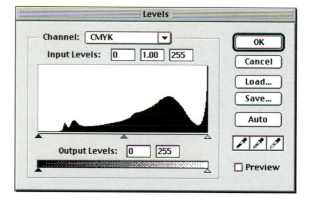

Black Point Adjustment

Adjusting the black point affects the way that the density range of the original is compressed into the density range that will be printed. This tonal compression is usually non-linear, with the shadows compressed more than the high-lights and midtones, in order to achieve a more or less linear compression of lightness.

Correct black point adjustment ensures that the scanner is capturing only wanted detail and not wasting available gray levels by using them to record tones that will not be printed.

Saturated colors are also affected by the black point set-ting. If it is set too high, saturation is reduced and colors look

washed out. Conversely, if the black point is set too low, the color contrast of the reproduction may seem excessive.

If the image is being scanned in RGB or independent color space, set the black point to the darkest tone in the original. If there is no black in the original, set the black point from a photographic gray scale.

If the image is being scanned in CMYK, set the darkest tone in the original to the largest printable dot (e.g., 95%).

If there is no black tone in the original, use a tint chart to set CMYK values for the darkest point available. It may also be possible to use the black border of a transparency (or the black patch on a photographic grayscale), if care is taken to check the dot values of highly saturated colors, and to ensure that shadows are not compressed more than is necessary.

If the contrast of the original is too low, it can be enhanced by moving the endpoints or by adjusting a tone curve. The latter option will tend to hold detail better.

Gradation

After the endpoints have been set, the gradation of the scan can be adjusted if necessary. The gradation adjustment can be used to control the setting of the midtones and the distribution of tones on the reproduction. It can expand the number of gray levels in a specific region of the tonal range to emphasize the interest areas of the original or to compensate for originals with unsatisfactory contrast or exposure. Typical gradation curves are shown in Figure 5-16.

The number of gray levels (and thus the amount of detail that is captured) can be increased in a part of the tonal range by making the gradation curve steeper in that area. That part of the density range of the original is then distributed over a wider range of gray levels in the resulting file.

Figure 5-16.
Tonal gradation can be adjusted through gradation curves, either during scanning or as a post-scan correction. The curve on the left will increase contrast, while the curve on the right will make an image look less yellow (more blue).

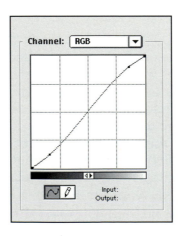 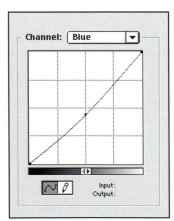

An efficient way of working with gradation curves is to store a set of basic curves (such as those shown in Figure 5-16) and call them up as needed. Adjustments can be made to a basic curve to suit the particular requirements of the original if necessary.

Color Adjustments

The majority of professional-quality transparencies can be scanned without the need for color editing. On a high-end scanner, correction can take place during scanning, but on desktop scanners color correction is normally applied after the image has been captured. However, if the original has an overall color cast, it can be handled during scanning. If a color cast has been identified on an original, the alternatives are to ignore it, reduce it, or remove it altogether.

If the intentions of the designer are not known when the image is scanned, the cast should probably be removed or reduced by 50%, particularly if it gives an objectionable appearance to the image or has the effect of reducing the color contrast. Otherwise, it may be safer to leave it for adjustment in an image-editing application.

Color cast is removed by manipulating the red, blue, and green output of the scanner, either by controls on the scanner itself or in the controlling software. Preview scans are useful in identifying color casts, and a software densitometer can evaluate color components much more accurately than simple visual assessment, since the eye will tend to view any near-white as a neutral white.

If the cast is localized, it will not be possible to remove it during scanning without affecting the rest of the picture, unless the scanner has selective cast removal. It will have to be dealt with in an image-editing application, but bear in mind that adjusting local color balance can be time-consuming.

Automating Scanner Adjustments

Image capture has made a transition from a highly-skilled operation, requiring considerable familiarity with the printing processes and experience in evaluating color originals, to one for which skill requirements can be minimal. Image capture can take place within a design and publishing environment, now, rather than at a specialized prepress supplier.

To achieve this, the knowledge of the skilled operator has to a large extent been encoded into software, so that functions like tone adjustment and color balance can be decided by built-in artificial intelligence. Nevertheless, experienced

scanner operators continue to achieve more consistently high-quality results, especially where customer requirements need to be interpreted.

Preparing Originals for Scanning

Before scanning, originals should be assessed and any special requirements noted. They should be cleaned if necessary, as removing dust or marks at this stage will be more productive than pixel-editing in an image-editing application.

Transparencies should be held firmly on the drum or transparency holder so that there is no danger of the distance to the scanner optics varying. The depth of field of a scanner lens is quite small, and focus can be lost if the original is not held flat.

In most scanners, the original is held against a smooth, plastic surface. This helps the original remain flat, but can lead to the appearance of Newton's rings, an optical phenomenon that can occur when two very smooth surfaces are held tightly together. Coating the transparency or negative with mounting oil avoids the formation of Newton's rings.

Depending on the scanner, it may be preferable to scan a transparency with the emulsion up or down. If the orientation needs to be altered, this can easily be done in an image-editing application.

Scanner Workflow

A color scanner is one of the more expensive pieces of pre-press equipment, and most users will want to maximize their investment in it. In many instances, the economic case for scanning in-house instead of using external suppliers is not convincing, since scanning is a very competitive market and prices are low. Here are some key points on managing the workflow most efficiently:

- Ensure that decisions about how to handle originals are made in advance of scanning to save unnecessary rescans.
- Categorize originals into groups of similar kinds and sizes and use batch scanning where possible.
- Ensure that post-scanning operations, such as file transfer, are not workflow bottlenecks.
- Use intelligent software for adjusting tones and removing color casts in routine images.
- Ensure that scanner operators have appropriate training.

Bibliography

Agfa Compugraphic (1994). *Introduction to digital scanning*. Mt. Prospect, IL: Agfa Prepress Education Resources.

Blatner, D., and others (1998). *Real world scanning and halftones*. Peachpit Press.

Busch, D. (1995). *Digital photography*. New York: MIS Press.

Butkowski, J., and A. Van Kempen (1998). *Using digital cameras: a comprehensive guide to digital image capture*. Amphoto.

Dyson, P., and R. Rossello (1995). *Digital cameras for studio photography — the 1995 Seybold shootout,* Seybold Publications.

Field, G. (1990). *Color scanning and imaging systems*. Graphic Arts Technical Foundation.

Hamber, A., and P. J. Green (1999). *Digital photography*. Leatherhead: Pira International.

Ray, S. (1999). *Scientific photography and applied imaging*. Oxford: Focal Press.

Zaucha, R. (1991). *The scanner book: how to make sellable color separations on any scanner*. Blue Monday.

6 Color Conversion and Separation

When a color image is reproduced, it is invariably necessary to change its color space. In most cases a single conversion is required to transform the image between the source device and destination device, such as when an image is scanned in RGB and converted to CMYK. It is also possible for a series of conversions to be performed, as when an image is displayed, corrected, and output to a proofing device before final reproduction.

Conversions between CIE-based color spaces use relatively simple algorithms, and there is little or no loss of color information other than that caused by a lack of precision in the data and subsequent rounding errors. However, in conversions involving device spaces (RGB, CMYK), the digital values of RGB or CMYK do not necessarily have any consistent and objective meaning in terms of the appearance of color.

The ultimate aim of color conversion is to reproduce the desired appearance of a color. To achieve this it is necessary to be able to define the relationship between digital device values and the resulting color appearance on different media. Since the source and destination media are usually different, this will also involve making adjustments for the different color gamuts and white points of the two media.

The process of conversion from any color space into CMYK is generally referred to in the graphic arts as **color separation.** It is more complex than other color space conversions, and there is a real risk that color values will be significantly degraded by the conversion process.

The objectives of color reproduction were described in Chapter 4. Poor separations typically have:

- Poor color balance, with hue shifts in some or all colors including neutrals.

Figure 6-1.
Good separations have bright, clean colors *(top).* Separation may introduce color casts *(A),* reduce brightness *(B)* or chroma *(C),* or increase chroma *(D).* Most of these changes degrade the image quality, but reproductions with higher chroma than the original can often be more pleasing.

- Poor tonal rendering, with inaccurate mapping of lightness between original and reproduction, and inadequate contrast and loss of detail.
- Unsatisfactory rendering of chroma, with dull or washed-out colors, possibly excessive chroma in some colors.

Color space conversions originally required the performance of specialized systems. The increasing speed of desktop

computers means there is no longer any need to use dedicated hardware, although some performance issues still remain. While it is not essential to fully understand the process of conversion from one color mode to another in order to produce color separations, an appreciation of the methods used, and the limitations of different approaches, can be helpful in analyzing the reasons for unsatisfactory color reproduction and in developing solutions to these problems. Selecting the conversion method, and defining the transformations to be used, require a greater understanding of the process, for which this chapter is intended.

For a color separation system to work reliably, the different components of the system must be accurately calibrated to ensure consistent and repeatable results.

Color Separation Principles

We will begin by examining a simple conversion from RGB to CMY, based on an "ideal" spectral absorbency of printing inks. We will leave consideration of the black component until later in the chapter.

Since the printing primaries cyan, yellow, and magenta, are complementary to the additive primaries red, green, and blue, it should in principle be possible to find the relative amounts of CMY required to reproduce a color by simply inverting the RGB values, as illustrated in Figure 6-2.

Figure 6-2.
Elementary conversion of RGB to CMY. The values for cyan, magenta, and yellow are simply the negatives of the values for red, green, and blue.

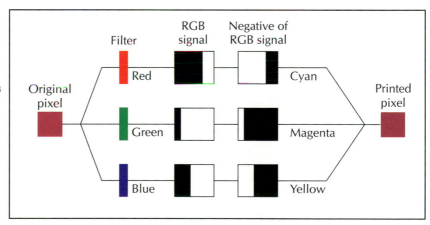

Indeed this has been done in some algorithms such as those in PostScript Level 1. The steps involved in this method are:

1. Scale the RGB values to the range 0–1 by dividing by 255.

2. Compute CMY as follows:
$$C = 1.0 - R$$
$$M = 1.0 - G$$
$$Y = 1.0 - B$$

3. Scale the CMY values to the range 0–100 by multiplying by 100.

For example, converting from the RGB inputs in Figure 6-2:

1. $R' = 180/255 = 0.706$
$G' = 17/255 = 0.150$
$B' = 100/255 = 0.392$

2. $C' = 1.0 - 0.706 = 0.294$
$M' = 1.0 - 0.150 = 0.850$
$Y' = 1.0 - 0.392 = 0.608$

3. $C = 0.294 \times 100 = 29.4$
$M = 0.850 \times 100 = 85.0$
$Y = 0.608 \times 100 = 60.8$

This simple conversion requires that either:
- The filters of the scanner or camera match the spectral absorptions of the ink set *or*
- The spectral absorbencies of the inks are "ideal."

An "ideal" ink perfectly absorbs all the light in one third of the visible spectrum and perfectly reflects all light in the other two thirds.

The "ideal transform" assumes that printing inks behave in a perfectly ideal and linear way. It assumes that:
- The inks are perfectly transparent; thus the sequence in which the colors are printed makes no difference in the color appearance of the final print.
- Uniform increases in dot value produce a uniform increase in density.
- The density of a pixel where two or three colors overprint is the sum of the separate densities.

Unfortunately, the spectral absorptions of available pigments make it impossible to realize any of the conditions described. As a result, a proportion of the hues that should be absorbed are reflected, and some hues that should be reflected are absorbed (ideal spectral absorbency is compared

Figure 6-3.
Color lookup table. At each grid intersection a value is stored in the input color space (a "key"), together with its corresponding value in the output color space. Where the input value to be converted does not fall on an intersection, its output value is found by interpolating from the values at the closest intersections.

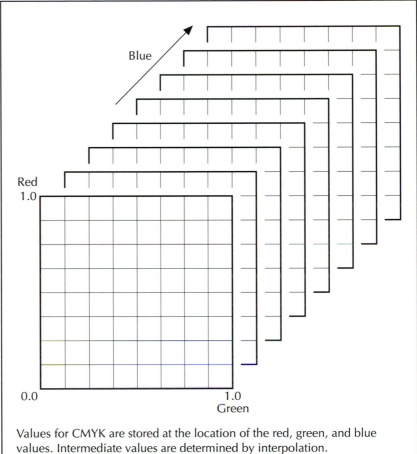

Values for CMYK are stored at the location of the red, green, and blue values. Intermediate values are determined by interpolation.

with the spectral absorbency of actual inks in Figure 1-8 in Chapter 1). In addition, the colorimetric behavior of printing inks is nonlinear — uniform increases in density or dot area do not produce completely uniform color changes in all regions of color space.

There are further problems with the ideal transform, in that we are also unable to identify colors in the original that fall outside the gamut of the reproduction, and thus we cannot apply a suitable compression to avoid contouring.

The ideal transform approach is clearly inadequate, and more suitable methods must be sought. Some high-end scanners use a direct RGB-to-CMYK transformation, but it is now more usual to separate the conversion into two stages through the medium of CIE-based color. In this case the conversion between source color space and tristimulus values is defined separately from the tristimulus-to-destination con-

version. Defining the relationship between device color and tristimulus values is known as **characterization.**

We will examine the conversion between RGB and tristimulus values first, and then consider methods of converting these tristimulus values to CMY.

RGB to XYZ

The relationship between RGB and tristimulus values can sometimes be reasonably linear. If so, it can be defined by using a set of nine coefficients as follows:

$$X = a_{1,1} \times R + a_{1,2} \times G + a_{1,3} \times B$$

$$Y = a_{2,1} \times R + a_{2,2} \times G + a_{2,3} \times B$$

$$Z = a_{3,1} \times R + a_{3,2} \times G + a_{3,3} \times B$$

Using matrix algebra, this can be written as

$$\begin{bmatrix} X \\ Y \\ Z \end{bmatrix} = A \begin{bmatrix} R \\ G \\ B \end{bmatrix}$$

where A is the 3×3 matrix whose rows and columns are the coefficients $a_{1,1}$ to $a_{3,3}$ above, the subscripts referring to the rows and columns of the matrix. The coefficients of the matrix A will vary according to the precise relationship between device RGB and tristimulus values.

A gamma function or other transfer function may also be applied to each channel.

An example of the use of such a matrix is the **sRGB space,** which defines an RGB space with a fixed colorimetric relationship with XYZ tristimulus values. In this case the coefficients of the matrix A have the following values:

3.2410	−1.5374	−0.4986
−0.9692	1.8760	0.0416
0.0556	−0.2040	1.0570

In sRGB, a gamma of 2.2 is specified.

If the matrix coefficients are not known, they can be found for an input device by the following procedure:

1. Sample a set of color patches with known tristimulus values.

2. Compare the resulting RGB values with the corresponding tristimulus values and use statistical methods to find the coefficients that give the best fit to all the patches.

The accuracy of this transform can then be tested by using it to predict the tristimulus values of a further set of patches from their RGB values, and comparing these predictions with the tristimulus values found by measurement. The smaller the errors, the better the accuracy of the transform.

If the errors given by this method remain unacceptably large, a different method of characterizing the relationship between RGB and XYZ must be used. This involves creating a lookup table from a larger set of sample patches, and is in principle similar to the method described below for printers.

XYZ to CMYK

In the early days of color separation, correction was carried out manually by a retoucher who would hand-etch the separation films. Later, a method of color correction was devised that involved making semi-transparent masks from the separation films and using these to modify the separations. This method became popular as it was faster and more consistent than wet dot etching.

The first electronic scanners replicated the effect of the masking technique with a bank of potentiometers for the operator to adjust. With the advent of digital scanners, a computational approach became possible, and mathematical models of the effects of color masking were used to calculate the correct densities of ink needed to reproduce a given color. A similar approach was to use a mathematical model of the interactions between light, ink, and paper to calculate the required dot size. These two models are known as the **masking equations** and the **Neugebauer equations.**

The masking equations are very similar to the matrix of coefficients described above for converting RGB to XYZ. In their simplest version, they take the form:

$$\begin{bmatrix} D_r \\ D_g \\ D_b \end{bmatrix} = A \begin{bmatrix} c \\ m \\ y \end{bmatrix}$$

Here, D_r, D_g, and D_b are colorimetric densities (the log of the tristimulus values X, Y, and Z) and A is a 3×3 matrix.

These **first-order** masking equations do not define CMY colors with very high accuracy, but good results can be obtained

by extending the transform to include further coefficients which are multiplied together with exponents of the ink densities c, m, and y. The coefficients are again determined statistically by finding the terms that best fit the measurement data from a set of color patches. These extended masking equations are called **second-order** and **third-order** equations, depending on whether the exponents square or cube the ink density values.

An alternative approach to modeling the relationship between CMY and XYZ is provided by the Neugebauer equations. These are used with halftone printing processes. They assume that the fractional area of a halftone dot of a printing ink consists of the area of the dot less the areas of the overlap colors and the area of unprinted white paper, and that these fractional amounts can be combined additively to determine the tristimulus value for the area. It is also assumed that within a given area the dots are randomly located and are printed with a uniform density.

Tristimulus values are then found as follows:

$$X = (1-c)(1-m)(1-y)X_w + c(1-m)(1-y)X_c +$$
$$m(1-c)(1-y)X_m + y(1-c)(1-m)X_y + cm(1-y)X_b +$$
$$cy(1-m)X_g + my(1-c)X_r + cmyX_k$$

where X_w, X_c, X_m, X_y, X_g, X_r, X_b, and X_k are the X tristimulus values of the unprinted white paper; cyan, magenta, and yellow solids; red, green and blue secondary overprints; and three-color overprint, respectively. The Y and Z tristimulus values are found in the same way.

The Neugebauer equations can be extended to improve their accuracy by various methods, including compensating for the effect of the paper type, using spectral data instead of tristimulus values, and by using tint patches as well as solid colors. When these extended methods are used, the accuracy is similar to the second- and third-order masking equations.

Using the equations described above to compute the transformation between RGB and CMYK, pixel by pixel, for a high-resolution image could be time-consuming, even on the powerful computers now used in the graphic arts. In most practical applications the calculation is executed just once for a sample of colors, and the results stored in a **lookup table (LUT)** or separation table. When a color is converted, the computer just has to locate the entry in the table to obtain

the required output value. If an exact match exists, the output values are read, but if an exact match is not possible, the nearest values in the table are used to calculate the value by interpolation.

Conceptually, the LUT can be thought of as a three-dimensional grid or lattice, in which the intersections of the lattice define the input value, and the corresponding output value is stored at the same location. The LUT entries for a given lattice point are also known as a **key-value pair,** the input value being the key and the corresponding output the value.

The number of colors in a LUT varies considerably. High-end scanner LUTs typically contain 8,000 entries. Although larger tables can mean smaller errors, in fact LUTs with as few as 512 colors can give good results, provided that the colors chosen are well-spaced. Significant interpolation

Figure 6-4.
A printing system can be characterized by printing and measuring a representative sample of colors. This set is defined as a standard characterization target in ISO 12640:1998 and ISO 12642:1998.

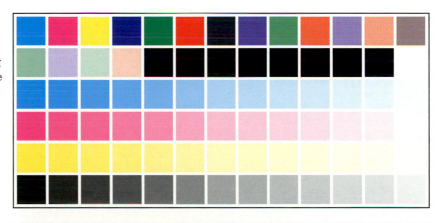

errors can arise from a lack of precision in the values stored in the table, and it is better to use two bytes (sixteen bits) for each output value rather than a single byte.

The number of dimensions used in the LUT corresponds to the number of channels in the input data, which in most cases is three. Although it cannot be represented graphically, a LUT can be extended to further dimensions if there are additional color channels.

Instead of using the mathematical models described above to predict the output values of the LUT, they can be determined by direct measurement. A large number of patches are printed

Figure 6-5.
A lookup table can be created by printing and measuring a large set of color patches that sample the whole printer color space. This set is part of the ISO 12640/12642 standard, which can be purchased on CD from national standards organizations.

and measured, and the resulting tristimulus values and the CMYK values of the patches are used as the input and output entries of the table. The accuracy of this method can be good, but again there is a need to ensure that the lattice points (and therefore the corresponding input values) are well spaced. It is common practice to print and measure a smaller number of patches, and calculate the LUT entries from these.

Because a LUT is only valid for the conditions for which it was computed (printer, ink, paper, etc.) it may need to be recomputed for different conditions. This has workflow implications in a production environment, and there is a need to minimize LUT computation time, and to be able to store and load LUTs as necessary. The time taken to compute a new lookup table varies according to the algorithms used.

Minor adjustments, such as dot gain for different paper types, can often be accommodated by applying a further transform or by correcting the output, rather than recomputing the LUT.

In practice the color conversion that best reproduces the desired appearance for a given image can be dependent on the content of the image. Many professional color separators have a baseline transformation (a single LUT) for a given process that gives a reasonable reproduction of all types of image. Then they make corrections for the particular image. This would include tonal corrections (adjusting for the image white point rather than the media white point, gradation corrections to maximize detail in areas of interest) and color corrections (adjusting color balance, improving the reproduction of memory colors or identity colors). It is also possible to create a set of LUTs for different image types (e.g., high key, low key, high chroma, high contrast, low contrast) that optimize the color reproduction. Image-dependent LUTs can give optimum results in mapping the gamut of the original to that of the reproduction.

Rendering Intents

It is also common to use different LUTs according to whether the colors being reproduced are images, special colors, or graphics. A color image contains a large number of different colors, and some will be outside the gamut of the reproduction. There will be a need to compress the gamut of the original, and the compression will also have an effect on colors inside the reproduction gamut, which will be moved to make room for colors from outside the gamut. This will maintain the relative chroma and lightness of the colors of the original.

Compressing chroma and lightness in this way is suitable for images, but not for special colors or graphics. The strategy for a special color should be to reproduce it as accurately as possible, with an absolute minimum of compression.

Some types of graphic use only primary and secondary colors, with the intention of reproducing them in solid colors. A color conversion using an LUT created for color images will move the colors away from the color solids, and often introduce unwanted tertiary colors. The reproduction strategy for such graphics should be to keep them as saturated as possible.

These three reproduction strategies are referred to as **rendering intents,** and require a different LUT for each. The rendering intents described above are usually called **perceptual** (for images), **colorimetric** (for special colors), and **saturation** (for so-called "business graphics"). For the colorimetric intent, two alternative intents are often defined according to whether the reproduction is intended to be relative to the media white point or to a perfect white diffuser—**relative colorimetric** and **absolute colorimetric.** More details on gamut mapping are given in chapter 7.

Black Generation

The conventional printing processes, and many digital printers, cannot produce a density high enough in deep shadows by overprinting yellow, magenta, and cyan alone, so black is added to extend the density range of the ink set.

The amount of black to print in any pixel is traditionally computed from the values for cyan, magenta, and yellow. Two methods can be used:

- **Conventional.** Start to generate black when the values for CMY all exceed a certain level, such as 50%, and increase the black as the CMY total increases.
- **Gray component replacement.** Generate black from the amount of the complementary color present in each pixel.

Note that there is no unique solution to the RGB-to-CMYK conversion because of the different amounts of black that can be used. When converting from CMYK to other color spaces and back again, the black generation may be done differently, depending on the algorithm used.

Although the black printer was originally introduced to increase the density range, its potential use goes beyond this to the replacement of some of the more expensive colored inks in shadows and tertiary colors.

Figure 6-6.

A. Black is added to cyan, magenta, and yellow in shadows to extend the range of densities that can be printed.

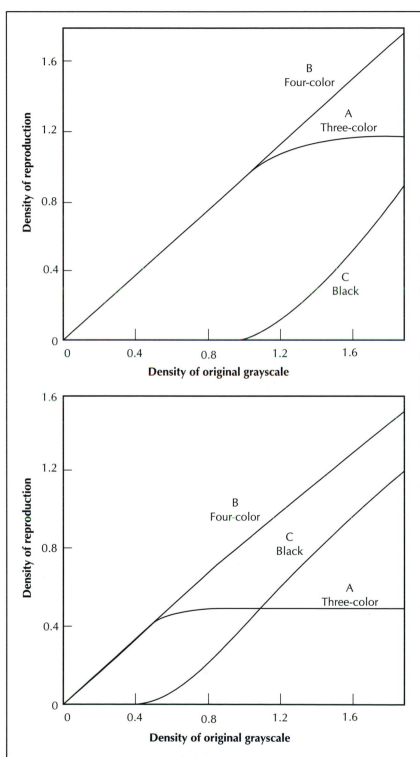

B. Black can also be added in neutrals at lower densities, when it replaces equivalent amounts of gray made up of cyan, magenta, and yellow. This is known as undercolor removal (UCR).

From Principles of Color Reproduction *by J. A. C. Yule (John Wiley and Sons).*

In a color reproduction, most colors include amounts of all three CMY primaries. In any one pixel, one or two of the primaries dominates and determines the pixel's hue. The remaining one or two primaries make the color duller and darker and are complementary to the dominant color. For example, in a red color, magenta and yellow form the dominant component, and cyan is the complementary (or tertiary) component.

Since equal amounts of cyan, magenta, and yellow approximate to gray, it is possible to remove process color up to the amount of the complementary component and replace it with an equivalent amount of black. This is the principle underlying undercolor removal and gray component replacement.

Undercolor removal (UCR) involves removing primary colors in neutrals (particularly in dark colors) and replacing them with black. The reasons for doing this are:

• To save on the amount of colored ink used, and
• To avoid very high ink weights that could cause setoff and marking during printing.

Web offset is especially prone to ink smearing or marking during printing, and so printers specify a maximum ink limit that must not be exceeded. The maximum amount of ink, or **maximum overprint**, is the limit to the sum of CMYK dot values for any pixel. For example, CMYK values of 80, 82, 85, and 100% would produce a total overprint of 347%. Maximum overprints specified for web offset printers are usually around 250%, while for sheetfed printing 300–350% is acceptable. The maximum overprint is also known as the **total ink limit** or the **UCR amount.**

Figure 6-7.
Setting black generation options for Photoshop's built-in conversion engine in the CMYK Setup dialog.

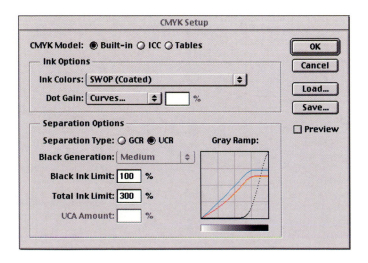

The effect of applying UCR is to cause the gray component in deep neutrals to be replaced by black.

Undercolor replacement aids in the adhesion or trapping of ink layers on top of each other, although it does reduce the possible contrast of a reproduction. UCR also makes color balance in neutrals more stable during printing, since using less of the process colors minimizes the hue shifts that can occur if they fluctuate.

While UCR traditionally is applied mainly in shadow areas where the total amount of color printed is high, **gray component replacement** (**GCR**) replaces the gray component of CMY in other colors. Removing the gray component completely creates separations similar to those shown for maximum GCR in Figure 6-8. The result is a major reduction in the amount of colored ink used and increased control of color balance during printing. However, in practice, taking the gray component out completely can have some unwanted effects (particularly if the algorithms used are poor), such as a slight shift in the hue of some colors and a possible reduction of contrast. Removing 50% of the gray component has been found to give optimum results in most images, and is applied by many professional color separators. (This percentage corresponds to the medium GCR setting in Adobe Photoshop.)

The reduction in contrast can be reversed by the use of **undercolor addition (UCA),** which adds color to the deep shadows to extend the density range.

Heavy amounts of GCR produce color separations that are unfamiliar to many litho printers, who may then find it difficult to judge the color values. Using such separations also requires careful consideration of the printing sequence, and it may be advisable to move the heavy black plate from its usual position on the first unit to a later unit.

The more GCR is applied, the more critical the control of the black printer becomes, and the more likely it is that any small fluctuation in ink density or dot gain will have a significant effect on the lightness of the reproduction. At the same time, the effect of fluctuations in the process colors becomes less significant, and color balance is much more stable.

This principle can be applied to three-color tints, which are notoriously difficult to match in pages made up of a mixture of graphics and images, because of the conflicting inking priorities. Replacing the gray component of the tint completely and reducing the number of colors to two plus black (using the GCR principle) make it much easier to achieve a consistent reproduction.

Figure 6-8.
The three-color, black, and four-color prints for different levels of gray component replacement (GCR).

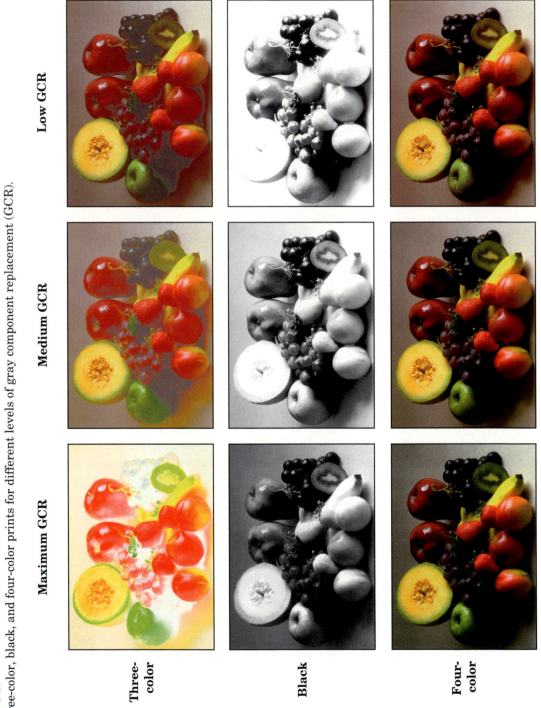

When selecting PANTONE MATCHING SYSTEM colors for a CMYK object, the PANTONE recommended CMYK simulations are mostly two colors plus black and rarely include a third process color. Naturally, the image must be in the CMYK mode for the simulated PANTONE colors to be retained, as they will be changed when the object is converted from RGB to CMYK and the black generation settings specified in the separation setup are applied.

Figure 6-9.
Specifying GCR tints. Most PANTONE Matching System colors are automatically converted to CMYK with no more than two process colors, plus black if necessary. This helps the printer to match the color more accurately. A small number of PANTONE colors are converted to four-color tints, and if possible, these should be avoided or changed to GCR tints. In the example shown here, the cyan component could be eliminated by a full gray component replacement.

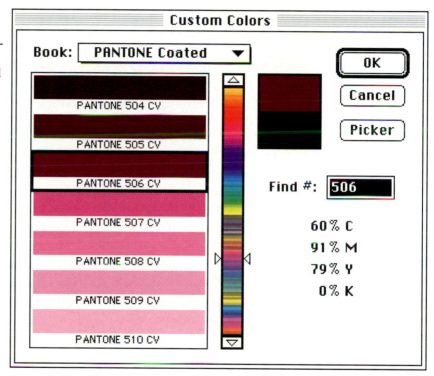

Implementation

When selecting a method of implementing color conversion in a production workflow, it is possible to choose between the transforms provided in Adobe Photoshop, specialized applications, the PostScript language, or ICC-based color management.

Adobe Photoshop. Photoshop offers three methods of converting colors to CMYK.

1. Conversions can be carried out using ICC profiles. These are discussed in more detail in Chapter 7.
2. The built-in conversion engine is similar (but not identical) to using ICC profiles. It allows users to modify the method of black generation (choosing UCR or GCR and

specifying total ink limits, GCR amounts, and UCA settings), dot gain and ink colors. The curve option for dot gain allows users to enter values for the full tonal range, which will give more accurate results. The ink colors dialog enables users to select different ink/media combinations. Ink colors can also be directly measured and entered using the Custom option.

3. Separation tables created in earlier versions of Photoshop can be loaded. CMYK separation configurations can be saved as ICC profiles or as separation setup parameters for future use by the "built-in" engine.

Source colors can be defined by an ICC profile (embedded into the image or selected when the image is opened), or by selecting from a list of device-independent RGB color spaces based on color monitors. If no profile is embedded or selected, the current RGB space selected in the RGB Setup dialog is assumed.

The method of converting colors to CMYK is chosen in the CMYK Setup dialog. When an image is converted by the Image...Mode command, the methods and profiles defined in CMYK Setup and RGB Setup are used to execute the conversion.

Figure 6-10.
When ICC profiles are used to convert to CMYK, the black generation settings are defined in the profile.

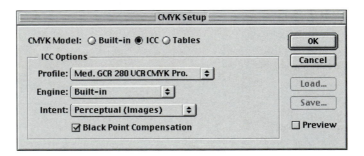

Specialized applications. Specialized applications for color conversions include:

- General-purpose packages, which often include color correction and editing. Among these are Binuscan ColorPro, Scitex Colorshop, and LinoColor Elite. Many of these are developed by high-end prepress vendors, and incorporate highly sophisticated separation algorithms and editing tools.
- Device-specific packages, usually developed for a particular input device. These include the separation packages bundled by several vendors with scanners and digital cameras, and Photo CD-specific applications such as PhotoImpress.

ICC-based color management. ICC color profiles (provided by device vendors or created by the user in a profile-building application) can be used in any ICC-aware application to define the transformation between color spaces. Further details are given in Chapter 7.

RGB workflows. An increasing number of hard-copy output devices accept color data in RGB, from low-cost color inkjet printers to high-end proofing systems and digital photographic printers and transparency recorders. These devices have their own conversion from RGB to CMY(K) drive signals, which may not be accessible to adjustment. In such cases it is possible to define a transformation between source RGB and printer RGB. An increasing number of low-end devices are using the standardized colorimetric definition of the RGB color space, **sRGB.** Where devices are able to generate or

Figure 6-11.
Colorimetric (or "calibrated") RGB spaces are based on the phosphors of ITU BT-709 (e.g., sRGB) or NTSC (e.g., Adobe RGB). Here the gamuts of these color spaces are compared with a Cromalin proof.

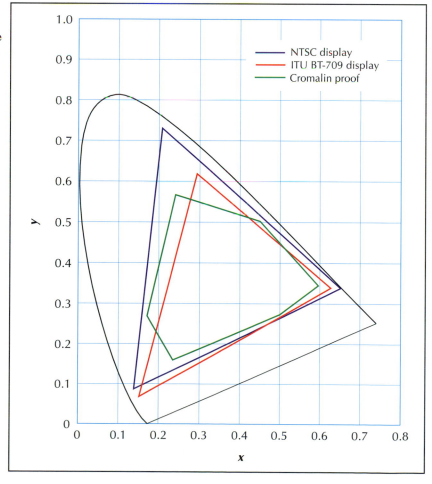

accept sRGB data there is no need to apply a transformation. It is also possible to create transformations between sRGB and ICC profiles in Photoshop.

Color Conversion Workflow

Conversion to CMYK can take place at any time from initial capture through final output, according to the working preferences and technology available. The basic possibilities are:

- Convert to CMYK immediately after scanning and perform any edits on the CMYK file.
- Scan into RGB and edit the RGB file, converting to CMYK immediately prior to output.
- Scan into RGB and include the RGB file in the page sent to the output device, allowing the conversion to take place in the RIP.

All three methods are perfectly feasible, and separation software makes it possible for conversion to take place at any point in the production process without compromising quality. The advantages of immediate conversion to CMYK on a high-end scanner include the availability of powerful separation routines and the possibility of checking the results of the

Figure 6-12.
Color conversions can take place at different points within the workflow, as shown in light blue.

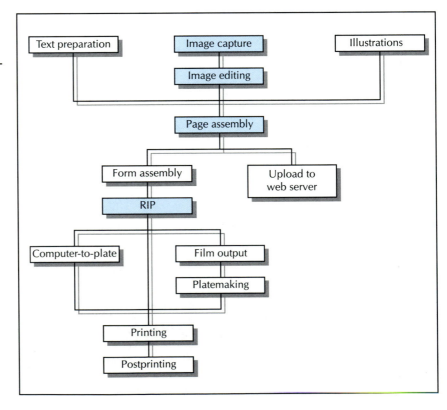

transformation before printing. On the other hand, converting as late as possible keeps image data in a more device-independent color space, and enables decisions about the output device to be taken at a later stage.

Because tints and other graphic elements are usually created in CMYK, it is usually preferable to keep page data in CMYK even when sampled images are in RGB. Conversion to CMYK is a somewhat variable process, and it is important that it is performed only once on any color object. Repeated conversions between device-specific CMYK values and other color spaces can introduce rounding errors and progressively degrade the color values of the separation. Conversion from CMYK will also change any specified CMYK tint values, often altering the tints specified in two process colors to three or even four colors, and changing the GCR levels chosen.

N-Color Separations

In Chapter 3 reference was made to the use of additional colors beyond the basic subtractive primaries: cyan, magenta, and yellow, plus black. The reason for using additional colors is to extend the gamut available with CMY, which is especially deficient in the orange-warm red, green, and blue-violet regions.

There has been considerable interest in extending this concept further, using up to three additional colors in a color separation to make a much larger color gamut available. Using more than three process colors in this way is known as **extra-trinary** or **N-color** separations.

The different possibilities include:
- Bump plates
- Touch plates
- Custom palettes
- A larger set of primary colors

Bump plates add additional cyan, magenta, and yellow plates to the four-color set. This increases the range of densities possible with the standard process set.

Touch plates are created by adding one or more special colors to the CMYK set to emphasize areas of interest or match specific identity colors within the original. Several software plug-ins are available to create touch plates, including TransCal's HiFi ColorSeps.

Custom palettes are in effect an extension of touch plates. Multiple extra colors (including special colors, metallics, and fluorescents) are chosen according to the spe-

cific requirements of the original and added to the process set. Creating a custom palette allows the color reproduction of an original to be optimized, but it is only feasible in printed pieces, such as packages or posters, that do not include a range of different illustrations.

Additional primary colors can be used to extend the process set from four to six or seven colors. Several multi-ink sets have been developed, including Eder-MCS (orange, green, and blue-violet), and PANTONE Hexachrome (orange and green).

Figure 6-13.
Comparing gamuts obtainable with different colorants on gloss coated paper. The values for ISO 12647 are as specified by the standard, while the others are measured from typical prints.

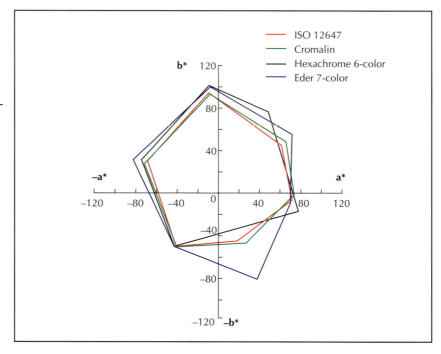

PANTONE's Hexachrome system is a six-color set that modifies the existing cyan, magenta, and yellow colorants as well as adding two new colors. The use of six instead of seven colors makes it possible to take advantage of the many existing six-color presses that print all of the colors in a single pass. The Hexachrome system is designed to make close matches possible with 90% of the PANTONE MATCHING SYSTEM colors, in addition to extending the process gamut. Hexachrome color separations can be created by using a Hexachrome ICC device profile.

To add additional colors to the process set, the separation software has to use a different color lookup table, and the quality of the resulting color separation is very much depen-

dent on the lookup tables used. Color substitution, touch plates, and custom palettes require a new separation table for every set of colors chosen, while systems based on standardized colorant sets utilize reusable separation tables. Color separations with more than four colors are normally saved as DCS-2 files for import into page-makeup programs.

Additional colors can be created during color separation when a file is converted from RGB or CIE-based colors to the colors of the printing process, or by converting the CMYK data.

Screen clashes (moiré patterns) are a potential problem with extra-trinary colors. Only three colors can be accommodated at the ideal screen angle separation of 30°, and moiré becomes more noticeable with the use of additional colors. The complementary color in each area should be removed by the separation algorithm if conventional halftone screens are used. Because frequency-modulated screening removes the possibility of moiré altogether, it is the preferred method of halftoning when more than four colors are printed. Alternatively, it is possible to use high screen frequencies (over 200 lpi) with some variation between the screen frequencies of the individual colors.

Cost is an important factor in evaluating which colors to use on which jobs. Jobs with extra-trinary colors need a plate for each additional color and must be run on a multicolor press with seven units—four for CMYK, plus three for the extra-trinary colors—or they must be printed in two or more passes through the press. Since this can add significantly to the cost of production, careful judgment is needed to establish which jobs will benefit from the additional colors. In many jobs, it is possible to enhance the areas of interest with just one or two extra colors.

The available color gamut can also be considerably enlarged by:
- Increasing the densities printed.
- Using a better paper.
- Using CMY inks with a greater spectral purity.

All these options would increase costs, but in most cases would cost less than printing an extra color.

Not all printing processes support the use of more than four colors. Many printing presses, such as webs for publication printing and digital color presses, are restricted to four printing units. Similarly, proofing for colors outside the nor-

mal process set can be difficult, since many proofing systems are based on the use of CMYK only. Among the alternative possibilities are:

- Digital proofs using a system that has more than four printing units, such as the Indigo E-Print.
- Digital proofs made using a colorant set with a gamut equivalent to that used in the job, such as the Iris inkjet.
- Cromalin prepress proofs that support the use of PANTONE colorants.
- Press proofs using the inks specified for the final job.

Bibliography

Berns, R. S.; R. J. Motta; and M. E. Gorzynski (1993). "CRT colorimetry. Part 1: Theory and practice." *Color Research and Application* 18, 299–314.

Clapper, F. R. (1961). "An empirical determination of half-tone colour reproduction requirements." *TAGA Proceedings* 31–41.

Heuberger, K. J., and Z. M. Jing (1991). "Colour transformations from RGB to CMY." *Advances in Printing Science and Technology,* Proceedings of IARIGAI Conference.

Heuberger, K. J.; Z. M. Jing; and S. Persiev (1992). "Color transformations and look-up tables." *Proceedings of TAGA/ISCC Conference* 2, 863–881.

ISO 12640:1998. *Graphic technology — Statistics of SCID images.*

ISO 12641:1998. *Graphic technology — Prepress digital data exchange — Colour targets for input scanner calibration.*

ISO 12642:1998. *Graphic technology — Prepress digital data exchange — Input data for characterization of 4-colour process printing targets.*

ISO 12647:199x. *Graphic technology — Process control for the manufacture of half-tone color separations, proofs and production prints — Parts 1–7.*

Johnson, A. J., and M. R. Luo (1991). "Optimising colour reproduction." *Advances in Printing Science and Technology,* Proceedings of IARIGAI Conference.

Johnson, A. J. (1996). "Methods for characterizing colour scanners and digital cameras." *Displays* 16, 183–191.

Johnson, A. J. (1996). "Methods for characterizing colour printers." *Displays* 16, 193–202.

Kang, H. R. (1996). *Color technology for electronic imaging devices*. Bellingham, WA: SPIE Press.

Kasson, J.; W. Plouffe; and S. Nin (1993). "A tetrahedral interpolation technique for colour space conversion." *Proceedings of SPIE Conference on device-independent colour imaging* 1909, 127–138.

Laihanen, P. (1987). "Colour reproduction theory based on the principles of colour science." *Advances in Printing Science and Technology,* Proceedings of IARIGAI Conference 19, 1–36.

MacDonald, L. W.; J. M. Deane, and D. N. Rughani (1994). "Extending the colour gamut of printed images." *Journal of Photographic Science* 42, 97–99.

Maier, T. O., and C. E. Rinehart (1990). "Design criteria for an input scanner test object." *Journal of Photographic Science* 38, 169–172.

Rolleston, R., and R. Balasubramanian (1994). "Accuracy of various types of Neugebauer models." *Proceedings of IS&T/SID Colour Imaging Conference* 1, 32–37.

Yule, J. A. C. (1967). *Principles of color reproduction*. New York: Wiley.

7 Color Management

Color management is a collection of utilities and resources whose goal is to automate color conversions between different media and devices, and at the same time to reproduce the desired color appearance of an original in a way that is consistently pleasing and acceptable. Color management is also differentiated from traditional systems by extensive use of color measurement as a reference.

In a traditional **closed loop** color conversion, where originals are scanned with the ultimate destination of process and media in mind, the workflow is relatively straightforward. Images can be scanned directly into CMYK with a "baseline" setup, with occasional variations to accommodate the requirements of different processes, paper types, and any customer preferences. The operator of such a system is likely to have considerable experience and expertise in adjusting the parameters to achieve optimum results with individual images. He or she will often be working with CMYK data at every stage, because no additional conversions between different color spaces take place after the scanner initially separates each image into CMYK.

In today's production environment, it is increasingly likely that there will be many different sources of color images, including digital cameras as well as a wide range of scanners, all with different characteristics. Color images are also reproduced on many different devices, including digital color printers, digital proofing devices, and conventional presses. The printing press is often geographically remote from the point at which the image is captured or edited. Images may also go through one or more transformations between different color spaces, such as scanner RGB, monitor RGB, CIE-based independent color space, and CMYK proofing device, before reaching the destination color space. Images

Figure 7-1.
Color conversions
between different
devices.

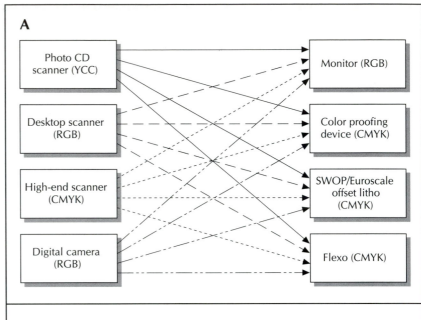

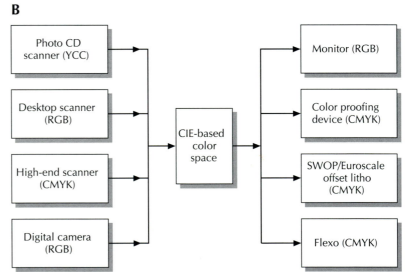

Generating profiles that define how color is to be converted directly
between source and destination is feasible if there are only a small
number of color devices used to capture or output color. Each source
and destination pair requires a separate profile. As the number of
potential devices increases, the number of profiles becomes too large
to handle (as shown in A).

The solution to this problem is to ensure that each device has a
profile that defines the way it captures or outputs color in terms of
a device-independent color space (as shown in B).

are increasingly intended for reproduction on a range of different media, including Web pages as well as hard copy.

Controlling the transformations required between these different device color spaces, and ensuring that color reproductions are consistent, requires the use of a **color management system (CMS).**

The basic architecture of a color management system is shown in Figure 7-2. A **device profile** defines the characterization of each device used for the input and output of color, and a CIE-based color space is used as an intermediate space for color transformations. Devices also need to be calibrated to define optimum performance and maintain it.

Figure 7-2.
Color management architecture.

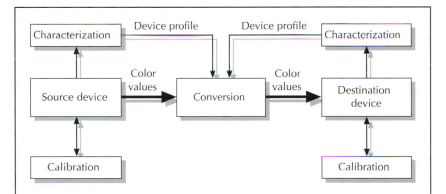

Profiles are generated for both input and output devices to define the way that they capture or reproduce color. These profiles tell the conversion routine how to create a lookup table to convert from the color values of one device to another. Devices are maintained in a stable condition, producing consistent color values through periodic calibration. The conversion "engine" handles the transformation of colors using the information defined in the source and destination profiles.

Color management is now an established methodology; it can give excellent results in achieving the best available color match between originals, monitor displays, and printed output. It is also an evolving methodology, with continuing advances in the techniques used to map colors between these different systems and media. Color management allows the user to focus on creation and reproduction without having to be concerned with the complex mechanics of device behavior and separation setup. But it also gives users a basis for greater control over the reproduction process, by configuring CMS elements to suit their needs.

Figure 7-3.
Color lookup tables.

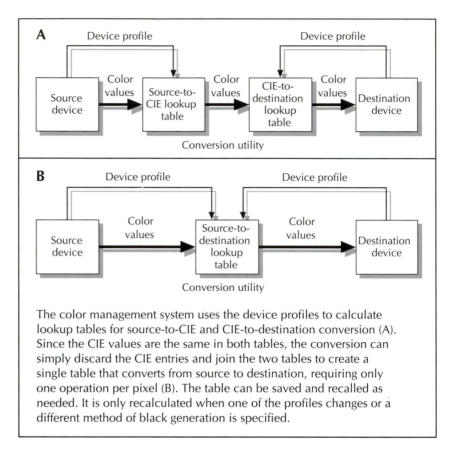

The color management system uses the device profiles to calculate lookup tables for source-to-CIE and CIE-to-destination conversion (A). Since the CIE values are the same in both tables, the conversion can simply discard the CIE entries and join the two tables to create a single table that converts from source to destination, requiring only one operation per pixel (B). The table can be saved and recalled as needed. It is only recalculated when one of the profiles changes or a different method of black generation is specified.

ICC Color Management

Color management systems were first developed by Kodak and EFI, and they included profiles for Kodak devices, as well as other output systems, including monitors and commercial printing standards. Other vendors, such as Agfa and Linotype, followed suit, with CMS and profiles focused mainly on their own imaging devices. However, as the use of color management grew among the graphic arts community, a barrier to further development emerged: profiles from one vendor could not be used in another vendor's CMS. This lack of interoperability clearly compromises the primary objective of a CMS, which is to enable the user to exchange color data between a wide range of devices.

The International Color Consortium (ICC) was established by a group of vendors including Adobe, Agfa, Apple, Kodak, Microsoft, Sun, and Silicon Graphics, under the guidance of FOGRA, with the goal of creating a common profile format and a common transformation framework for exchanging color data between devices and between operating systems.

There has been much debate among participants in the ICC on the best way of handling these questions, and there remain some issues to be resolved. However, the basic framework is in place and is included as a core part of the Mac OS and Microsoft Windows (although at the time of this writing, problems remain in the Windows implementation). The current version of the profile format can be downloaded from *www.color.org*.

A common framework for color management requires agreement on a data structure for the device profile and a definition of the intermediate device-independent color space. Implementation also requires a standard framework which can handle different profiles and manage color transformations.

The ICC color management architecture consists of four elements, whose relationship is shown in Figure 7-4. These elements are:

- **Profiles** communicate device characteristics to the CMM.
- The **color management module (CMM)** connects together profiles to produce transformations for any group of devices, using the **profile connection space (PCS)** as the common reference color space.
- The **application** calls on the CMM to handle color transformations as required by the user.
- The operating system **framework** enables the application to access profiles and CMMs, and provides a default CMM in the event that user has not installed a third-party CMM.

Figure 7-4.
The basic architecture of the ICC system. Applications make calls to the operating system-level framework (ColorSync or ICM), which loads the required profiles and passes data to the color-matching module (CMM).

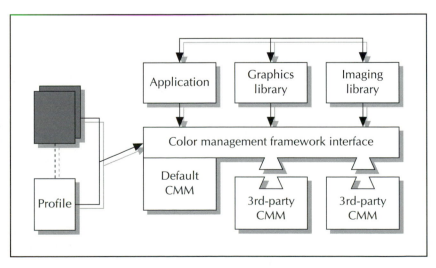

The CMM

The architecture provides for a default CMM within the operating system, and also for third-party vendors to extend the functionality of the CMM with their own solutions. In the Macintosh environment the framework is known as **ColorSync;** in Windows it is called **ICM.** A baseline CMM is being developed by the ICC.

The PCS

The profile connection space defines both a reference medium and the viewing environment, with the intention of conveying actual color appearance, rather than merely tristimulus values. The PCS operates as a virtual space, defining the relationship in color between different device spaces so that a unique transformation can be created for any pair of devices (or indeed series of devices) for which profile information is available. It is not generally intended that color data will actually be converted into that of the PCS, although it is possible to do so.

The ICC defines the PCS as "the CIE colorimetry required to achieve the desired color appearance on a reference media and viewing environment." The initial PCS definition includes a standard viewing environment (ANSI PH-2.30/ISO 3664), and a theoretical reproduction medium (a reflection print using colorants of unlimited gamut on perfectly diffusing white paper). This definition is under review, with the aim of supporting a wider range of media and viewing conditions.

This definition of the PCS implies that the color matching module simply provides a means of connecting two or more profiles together (and where necessary interpolating the LUT data). Modeling device behavior, color appearance, gamut mapping, and so on are done by the profile.

The definition of the role of the PCS, the profiles, and the CMM together provide the default behavior of the system, which can be implemented at the level of the operating system with minimal computational overhead. It is possible for third-party CMM vendors to implement more complex transformations, but the default behavior ensures that profiles will operate on any system, regardless of the operating system or CMM used.

Profiles

There are profiles for all the different types of device in the imaging chain (e.g., scanner, monitor, printer) and also some profile types for other situations, such as defining colors in CIELAB or in special colors. There are a total of fourteen profile types provided for in the ICC profile format specifica-

Figure 7-5.
Color conversions using ICC profiles and different combinations of CMM and PCS color spaces.

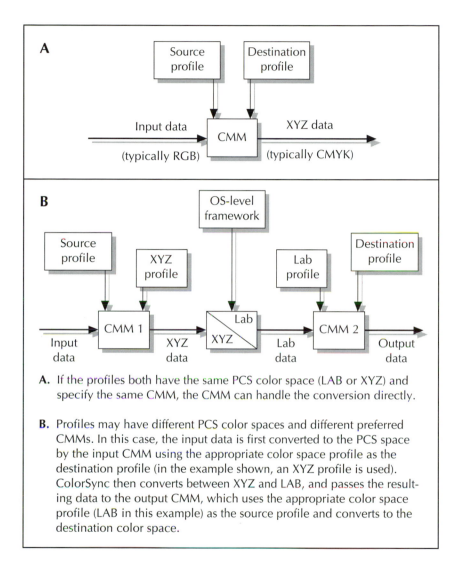

A. If the profiles both have the same PCS color space (LAB or XYZ) and specify the same CMM, the CMM can handle the conversion directly.

B. Profiles may have different PCS color spaces and different preferred CMMs. In this case, the input data is first converted to the PCS space by the input CMM using the appropriate color space profile as the destination profile (in the example shown, an XYZ profile is used). ColorSync then converts between XYZ and LAB, and passes the resulting data to the output CMM, which uses the appropriate color space profile (LAB in this example) as the source profile and converts to the destination color space.

tion, of which the input, display, and output types are the most widely used. Input profiles will normally be for RGB data, but LAB and CMYK can also be treated as input data. Similarly, output profiles can be for RGB and LAB, as well as CMYK and other colorant spaces such as Hexachrome. Optional tags can be included for information only (such as screening or black generation methods), or for processing by the color matching module (such as named colors). Other profile types, such as device link profiles, are designed to enable users to perform a range of different transforms and to include color edits.

The data structure of the profile is not unlike the TIFF file format, in that it is an extensible format based on fields or

tags which define different attributes of the profile. The profile format specifies a number of required tags, which must be present to enable base-level performance of the profile. Developers can also include additional optional tags if they want to convey additional information to the CMM.

Input profiles. An input profile for a scanner or camera contains the color processing information needed to convert the image data from RGB to PCS LAB or XYZ, including media white point (recorded from the white patch on the IT8 target), tone reproduction curves, and either tristimulus values for the filter set or a lookup table. It will also include information about the type of device and the photographic medium as text fields.

Monitor profiles. A monitor profile has the same structure as an input profile, with phosphor tristimulus values defined in place of filters. It defines the color display of a monitor at a given brightness and contrast setting, in a given viewing environment. If any of these vary, the validity of the profile can be questionable.

Manufacturers' profiles will usually give an acceptable definition of the display characteristics at the point of manufacture, although they will not compensate for variations arising from factors such as phosphor decay or batch variation in the manufacturing process. Ambient illumination is the most significant factor in display appearance, and control of viewing conditions must be given careful attention in a color-managed environment where colors are being judged on displays.

Where users make adjustments to brightness and contrast, they usually do so to maintain a consistent appearance as the intensity of daylight changes. This process is to some extent self-regulatory, and the recommendation to tape down display and contrast settings after profiling or calibration is only appropriate if the user environment is illuminated consistently with artificial light, with no daylight to influence the visual appearance of the display.

Output profiles. An output profile includes a set of LUTs that define the conversion from PCS LAB/XYZ to CMY(K) and back again, and media white point. There is a different LUT for each rendering intent supported in the profile.

Color Processing Color transformations defined by ICC profiles are either
matrix-based or lookup-table-based.

A **matrix-based** profile carries out only two computations
to convert data from one color space to another. The first is a
tone reproduction curve, which spaces out the input data
evenly, avoiding bunching in the light or dark regions. The
second is a 3×3 matrix, which is used to multiply the RGB
values to convert them to CIELAB or CIEXYZ.

Figure 7-6.
Color processing
model for matrix-
based conversions.

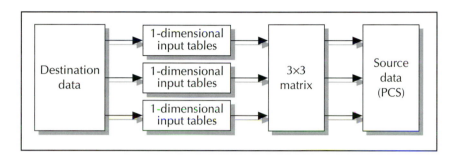

In a **LUT-based** profile, the CMM searches the lookup
table for the current color and if necessary interpolates any
intermediate values. As with matrix-based profiles, a tone
reproduction curve is applied prior to the LUT to ensure opti-
mum spacing of the data, and again afterwards to respace
the data for the output device.

Figure 7-7.
Color processing models
for LUT conversions.

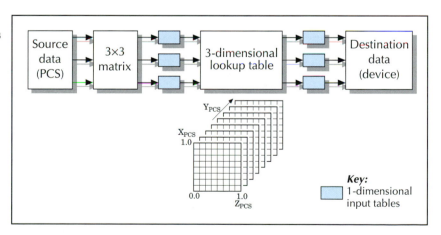

Monitors can readily be characterized by the simpler
matrix-type profile. Cameras and scanners can too, although
in practice they usually give better results with a LUT-type
profile. Printers always require lookup tables, as described in
Chapter 6.

Creating Profiles

Most color devices now ship with an ICC profile, and profiles for commercial printing are readily available. Users can incorporate these profiles in their workflow, or they can make their own with one of the profile creation applications available. It can be quite difficult to improve on the results obtained from a vendor-supplied profile, especially for output devices. In some situations the ability to generate profiles is important: for example, when a device exhibits drift, or when a profile is not available.

To define the color processing information required by the profile, the response to a test image is recorded. Input profiles are usually based on the response of a scanner or camera to a standard test target, known as an **IT8 target.** Display and printer profiles require measurement of the device output, on screen or hard copy.

Factors to consider when choosing a profile building application include:

- Ease of use,
- Options for including color edits such as tonal mapping,
- Facilities for editing profiles, including those created in other applications,
- Ability to handle color negatives,
- Support for digital cameras, and
- Quality of profiles.

The IT8 Test Target

The IT8.7/2 target (based on the Kodak Q60 target) is shown in Figure 7-8. It includes 228 color patches (12 rows by 19 columns) distributed throughout color space, together with a 24-step grayscale and three further vendor-defined columns in which individual manufacturers can add their own elements: Kodak includes a pictorial image with flesh tones, while Agfa incorporates color patches in flesh-tone colors.

The IT8 target has three forms: 35 mm, 4×5-in. transparency (IT8.7/1), and photographic print (IT8.7/2). For transparencies and prints, the film or print material (e.g., Ektachrome, Agfachrome, etc.) used for the target should ideally be the same as that of the transparencies being scanned. Data files containing measurements of all the patches are supplied with the target, normally in both CIELAB and CIEXYZ. The measurements are for a production batch, and there can be a small amount of variation between the batch average and individual targets. It is possible to measure a target for increased accuracy, although for

Figure 7-8.
The IT8.7/2 reflective target for characterizing input devices. A similar image with a wide gamut is available as a transparency (IT8.7/1).

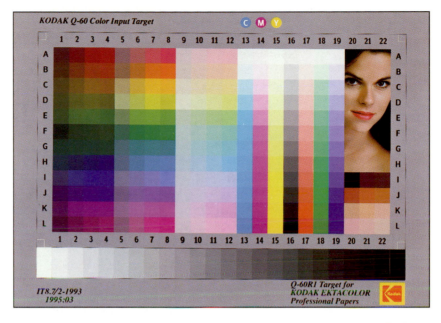

transparencies this requires specialized equipment, and the improvement is unlikely to be significant.

Test targets should not be duplicated as the measurements then become invalid.

A different target is used to create printer profiles. Although there is a standard target for hard copy prints (IT8.7/3), it is really defined for traditional CMYK processes. In practice many vendors of profile creation applications choose to define their own color patches which are optimized for their printers, as well as the algorithms they use. Printer targets usually have a greater number of patches than the IT8 input target; however, the number of patches does not necessarily determine the quality of the resulting profiles, and it is quite possible to produce a good characterization with 512 or fewer patches if the characterization methods are well designed.

Creating an Input Profile

To determine the values for the matrix or LUT, the profile creation application compares the RGB values of the scan to the measured CIE values from the target data file, then works out a best fit between the two. Depending on the algorithms used, there can be some patches that are not calculated very accurately by this process, often in the darker regions or in highly saturated colors.

The first step in creating a profile is to scan the test target. This should be done for same-size reproduction; the resolution is not critical, and a file size of 1–2 MB is

adequate. The scanning should be done at normal settings. Use an image-editing application to rotate the image, if necessary, so that it is not skewed.

In the profile creation application, invoke the application's command to create a new input profile and identify the location of the image file and its associated data file. The test image is then positioned by identifying the position of the four corner registration marks.

Many applications will enable tonal mappings to be defined at this stage. If, for example, a scanner always produces slightly dark images at default settings, it is possible to compensate in the profile by choosing a "Light" gradation.

A default rendering intent should also be specified for the profile. This will always be "Pictorial," "Perceptual," or "Photographic" for images. (Note that pictorial, perceptual, and photographic are all different terms for the same intent.) The rendering intent can be selected during use, but it is usual to have a default behavior specified.

Figure 7-9.
Creating an ICC input profile in ColorSavvy ProfileSuite.

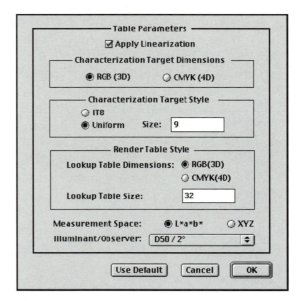

After all the information has been input, the profile can be calculated and saved. (Note that some profiling applications show a Save dialog for the location of the log file; the profile itself is almost always saved to the System\Preferences\ColorSync Profiles folder (Mac) or Windows\System\Color folder (Windows), which is where ICC-aware applications will expect to find it.

Several applications initially create profiles in their own internal format, which then needs to be converted to an ICC profile. There may be the option to save the profile in other forms, such as a CRD for PostScript color processing.

Creating a Digital Camera Profile

A digital camera profile has the same structure and usage as a scanner profile. There is the additional complication, however, that unlike a scanner, which has controlled and consistent lighting, a camera is used over a very wide range of illumination conditions. A profile made for a given lighting setup is only valid for images taken under the same conditions. This would in effect make it necessary to generate a separate profile for each image that is shot, unless the application used allows the user to record information about the lighting conditions at the time of shooting. An alternative is to consider the camera and monitor as a system, and optimize the camera image for display on the monitor. If the display is accurately profiled and the viewing conditions are standardized, the image can be considered a display image instead of a camera image. It is then possible to adopt a device-independent RGB profile or workspace such as Adobe RGB (1998) or sRGB.

Creating a Display Profile

Display profiles are always matrix-based, and they require only a small number of measurements to determine the phosphor chromaticities and the display intensity. Measurements of color patches on screen can be made with a spectrophotometer (if it has the ability to handle emissive light), or with a colorimeter. Monitor profiles can be created in profile-creation applications, as well as specialized display profiling applications (which are often bundled with an appropriate measurement instrument), and utilities provided by high-end display vendors.

It is also possible to create a display profile without measurement, using utilities such as the monitor calibration utility bundled with Adobe Photoshop, although these are likely to be less accurate than a profile based on measurement.

Creating a Printer Profile

Creating a printer profile is similar to making an input profile. A test target is printed and measured; the measurement data is entered into the profiling application. The application will usually have a special "Print Target" dialog, for which the printer needs to be online, although it is also possible to

print a PostScript file to disk and download it to a printer subsequently. Some applications require the measurements to be made online, although it is more convenient to enter the measurements in a data file which can be saved and imported into the profiling application as needed.

After reading in the measurement data, there will be options to set up for rendering intent, the way in which black is to be generated (ranging from full black with gray component replacement to skeleton black), and the properties of the media. Profile calculation and saving then takes place as for input profiles.

Measurement Issues

Accurate and valid measurements are essential to profile creation, as a single error in several hundred measurements can seriously weaken the quality of the resulting conversions. It is best to follow the recommendations in ISO 13655 (as described in chapter 2) unless directed otherwise by the instructions for the profiling application.

Instruments should be recalibrated regularly, and checks on repeatability should always be made by remeasuring a small number of patches several times and checking the resulting values.

Making a large number of measurements to create a printer profile is rather tedious, and as a result errors are possible. Scan tables that hold the spectrophotometer and measure a large array of color patches automatically are available for some instruments.

The ICC Profile in the Workflow

When a page containing color images or graphics for which ICC profiles are available is displayed or printed, the CMM reads the profile data and applies the color processing transforms described earlier. The CMM is also responsible for handling profile mismatches, such as when the user inadvertently selects a CMYK profile for an RGB device.

Input profiles can be embedded into many image file formats, including EPS and TIFF. This does increase the file size, but it ensures that the profile will be available when the image is converted to another color space.

An embedded profile does not alter the image data but passes the information to the CMM. Care should be taken when images with embedded profiles are converted to other RGB spaces, as the embedded profile will then produce unexpected effects. If color management is not active at the output site, the embedded profile will simply be ignored.

Figure 7-10.
Editing an ICC profile in Kodak ColorFlow.

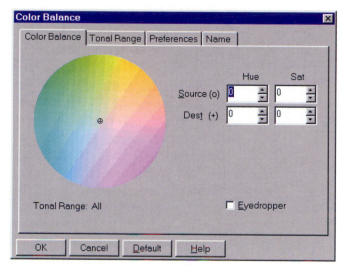

In the previous chapter it was shown that color conversion can take place at different points within the production workflow. With ICC profiles used to define the conversions, some of the possibilities are:

1. The image is converted through a profile-to-profile or mode change into the destination color space in an image editing application such as Adobe Photoshop.

2. The image is converted as above into a device-independent color space for storage.

3. The image is printed from an ICC-aware application such as Adobe PageMaker or Adobe Photoshop. The appropriate source and destination profiles are selected in the print dialog, and the conversion takes place on the host platform.

4. The image is sent to a RIP driving a platesetter, image-setter, or proofing engine. The source profile is embedded in the image file or accompanies the image, while the destination profile is available locally.

The latter option will tend to be the most efficient, as the processor power available is likely to be much greater than on a desktop machine.

Evaluating Profile Quality

Some profile-building applications report a statistical analysis of the accuracy of the fit to the data. An average deviation of around 1 ΔE would be a good characterization, although this is purely an indication of the fit to the data, not the accuracy of the profile when it is used on real images.

There are several methods of evaluating the quality of color conversion defined by a profile.

PostScript Color Processing

The color management incorporated in the PostScript language is very similar to using ICC profiles. Like other elements of a page description, such as resolution and screening, PostScript Level 2 treats conversion into device color values as a process that can take place in device space. This is achieved by keeping color values in RGB, or in a device-independent color space such as LAB or XYZ, until actual output.

The device-specific information is then used by the output device interpreter to perform the required conversions.

Device profiles in PostScript are known as color space arrays and color rendering dictionaries. A **color space array (CSA),** which defines the way that the RGB values are captured by an input device, is used by the interpreter to convert the original RGB values into independent color space. The conversion between RGB and a CIE-based color space involves a straightforward linear conversion. Converting color values into RGB again so that they can be output on a monitor is simply a matter of applying the conversion in reverse.

For conversion to CMYK a lookup table is used. This is known as a **color rendering dictionary (CRD),** and it is similar in structure to an ICC profile. The CRD converts from independent color space into device space. Color output devices supporting Level 2 often have a resident default CRD, but it is also possible for user-defined CRDs to be used instead. These can be created by a number of profile creation applications.

Figure 7-11.
PostScript color processing. For more details of color processing in PostScript, see Figure 8-9.

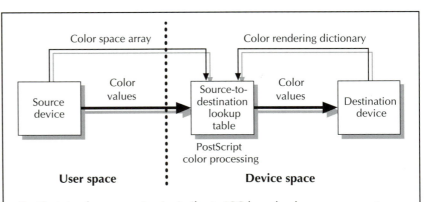

PostScript color processing is similar to ICC-based color management, except that conversion can be carried out in the PostScript interpreter Images can be kept in RGB except when they are actually being output. The advantages are greater device-independence and smaller file sizes.

A CSA can be included with a PostScript file, while a CRD can be downloaded by a PostScript interpreter—just like a font is downloaded. If the CSA and CRD are available, and the setcolorspace operator has been invoked by the Post-Script printer driver to turn on Level 2 color processing, conversions can be carried out entirely in device space, leaving the image in RGB or in device-independent color right up to the actual output. This approach allows the user to keep all image files in device-independent color and avoid converting the image until the output device is known. PostScript allows each object within a page to have a different CSA if required.

Black Generation

None of the different color management systems address black generation in a standard way. There are a number of options for UCR and GCR (described in Chapter 6) that depend on the destination printing device and, to a lesser extent, on the requirements of the image. Color management systems enable different black generation options through separate profile versions, which is somewhat clumsy since the user must have multiple profile versions in order to specify black-generation options. Because black generation is device-dependent, it needs to be handled during the transformation into the output device color space and thus included into the profile, although it would be preferable for users to be able to specify black generation options more flexibly.

Calibration

Calibration is a necessary precursor to profiling to ensure that a device is correctly set up before its colorimetric performance is characterized. Devices should also be recalibrated periodically so that they consistently produce the same color values and continue to perform in the way defined in the device profile. The frequency with which calibration should be performed depends on the type of variables that occur. CCD scanners, for example, usually need little or no adjustment once the initial calibration has taken place. At the other extreme, film output devices, which can be subject to variation in the intensity of laser exposure intensity, emulsion sensitivity, and developer strength, may need to be checked as often as twice daily.

The calibration procedure depends on the device in question, but the general steps are:

1. Establish the variables to be calibrated.
2. Capture or output a test image.
3. Evaluate the results.
4. Adjust the device accordingly.

Figure 7-12.
Device calibration.

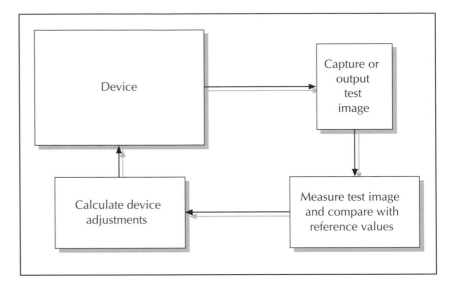

To evaluate the output produced, some form of measurement is usually necessary. For accurate color measurements, the use of a colorimeter or spectrophotometer may be necessary, although many devices can be calibrated with densitometers, or even by visual appearance. Calibration utilities eliminate some of the trial and error of adjusting devices to produce the correct output. They are supplied with some output devices, or they may be purchased from the device manufacturer or third-party vendors.

The calibration of different devices is discussed in the following sections.

Scanners

Both drum and flatbed scanners are very stable over time, the main source of drift in response being the fading of color filters.

Monitors

Calibrating a monitor involves setting up the white point, the brightness and contrast, and possibly the gamma function. Equally important, however, is calibration of the viewing environment.

Monitor calibration routines are incorporated into many applications, usually requiring a standard white point and gamma setting and sometimes additionally requiring the user to visually match the display of test elements. More accurate methods require measurement of the phosphor chromaticities.

Monitor calibration is particularly problematic if there is no control of ambient lighting, as this may change during the day

and lead to variations in the apparent display contrast. Furthermore, application-specific calibration routines can cause the appearance of a color image to vary in different applications. Users should also be aware that beam intensity varies in different areas of the screen, and that there is some drift in intensity as the device warms up after being switched on.

In working environments where accurate color judgments are made, it is best to exclude natural daylight. If this cannot be done, its effect should be minimized by using blinds and by arranging the room layout so that color monitors are situated away from windows. Subdued or dim lighting conditions are better than brightly lit environments.

It may also be necessary to restrict the number of different applications in which color judgments are made to avoid potential conflicts in color appearance between them.

One widely used practical method of calibrating a color monitor is as follows:

1. Convert an IT8.7/1 reference image to CMYK and print it.
2. Set the monitor white point to 5,000 K.
3. Ensure that the ambient illumination conforms to the standard viewing conditions.
4. Compare the display image with the printed reproduction.
5. Adjust the monitor gamma to achieve the closest possible match between the printed test image and the display, paying attention to:
 - Lightness of highlights, midtones, and shadows;
 - Color balance in neutrals; and
 - The intensity of the most saturated colors.

The displayed image should be in the color mode in which you edit color (RGB, CMYK, or LAB), and the method used to convert the test image to CMYK should be same as the method used for color images.

Imagesetters

The imagesetter's beam intensity needs to be calibrated along with the film processing variables, such as development temperature and time. First, a test element containing small type elements and lines is output, and the exposure intensity is adjusted until an emulsion density of around 4.0 (depending on the type of film) is achieved in solid areas with the type and lines remaining clean and sharp. Next, a grayscale with a range of tonal values between 0 and 100% is output,

and the dot values on the resulting film are measured with a transmission densitometer. The imagesetter is adjusted until it is successfully **linearized** (i.e., until the dot sizes recorded on film are the same as the dot values specified). Variation should be no more than 1–2% from the specified values.

Frequency-modulated screening requires an additional adjustment in the way in which the laser dots overlap in building up the image spot. The screening algorithm should compensate for this.

Printers

The colorants used by any printing device (including digital printers and conventional printing presses) are defined in the device profile, so the main variables that must be calibrated are the colorant density and the amount of dot gain. The accepted tolerances for most conventional printing processes are ±0.1 density units and ±2% dot gain.

Printing ink colors are defined in ISO 2846, although there is also some slight variation between the pigments produced by different ink manufacturers. Any changes to ink colors will require a new profile to be created.

Proofing Devices

Calibrating a proofing device involves printing a reference image, measuring the resulting output, and then either:

- Adjusting the device to make it conform to its characterization profile.
- Comparing the test image with one printed on the target printing press, then adjusting the proofing device so that it behaves like the printing press to be used for the production run.

Proofing variables are colorant, hue, and density and the amount of dot gain produced. Proofing devices should be set up more precisely than production presses, the tolerance levels ideally being half that allowed on printing presses.

Printing Presses

Printing press setup is controlled by the press operator. The mechanical conditions of the press and the characteristics of the ink used will induce fluctuations in the printing characteristics. Many printers work with, or close to, one of the industry-wide standards, such as SWOP, which specify aim values for the density and dot gain of the primary colorants. These standards are likely to be replaced by ISO 12647, which also specifies color measurement aim values of solid patches printed by the primary colorants and their overprints.

These standards classify papers as coated, uncoated, and newsprint. Most papers fall under these classifications, but certain types, such as recycled papers, may need further adjustments.

The press operator adjusts the ink flow on every job to regulate the ink densities that are transferred to the paper. Dot gain is controlled mainly by adjusting the ink viscosity, although other factors, such as printing pressures, can also be altered if necessary.

Mapping Color Gamuts

Different colorant systems have limitations on the range of colors they can reproduce. The gamut of colors that can be displayed on a color monitor differs from the printable gamut and also from the gamut that can be recorded on a transparency. Although all hues can be matched between any two systems, there will be differences in the range of chroma values, depending on the primary colorants used, and in the range of lightness values, depending on the media white point and the range of colorant densities that can be imaged. Thus the problem colors for reproduction are typically high-chroma colors, highlights, pale pastels, and the very deep or dark colors.

As Figure 7-13 shows, the maximum chroma of a reproduction media is determined by the primary colorants. The maximum chroma point of two media can differ both in lightness and chroma, as shown in Figure 7-14.

The problem of mapping from one gamut to another is often referred to as **gamut compression,** although the reproduction gamut can often be larger, in some hues at least, than the original medium. It is also important to distinguish between the gamut of this original medium and the gamut volume occupied by a given image. Automatic compression of an original gamut so that it falls within a reproduction gamut can easily lead to unnecessary loss of contrast or chroma, if applied to images whose lightness or chroma does not extend to the limit of the original medium.

The gamut mapping problem can be solved in several different ways. In general, people prefer reproductions in which:
- The lightness of neutral colors of the original have been mapped more or less linearly to the reproduction (uniform compression).
- The hues are largely unchanged.
- Chroma is compressed non-uniformly, with the highest compression close to the gamut boundary.

Figure 7-13.
Typical gamuts for
display and print
systems.

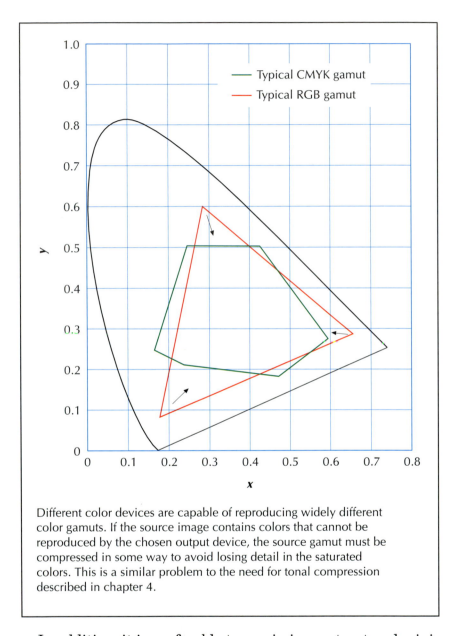

Different color devices are capable of reproducing widely different color gamuts. If the source image contains colors that cannot be reproduced by the chosen output device, the source gamut must be compressed in some way to avoid losing detail in the saturated colors. This is a similar problem to the need for tonal compression described in chapter 4.

In addition, it is preferable to maximize contrast and minimize changes in neutrals.

Color Appearance

It has been shown that colorimetry alone is not sufficient to define the appearance of a color since it depends on the viewing environment and reproduction media. By using a model that makes appropriate adjustments for these factors, it is possible to define the appearance of a color in terms of perceptual attributes (such as hue, chroma, and lightness).

Figure 7-14.
At a given hue (violet in this example), the gamut of source and destination color spaces may have different shapes. As a result, the "plan view" of the *xy* chromaticity diagram and the CIELAB a* vs. b* diagram can be misleading. This difference needs to be considered when mapping the gamut of one media to that of another.

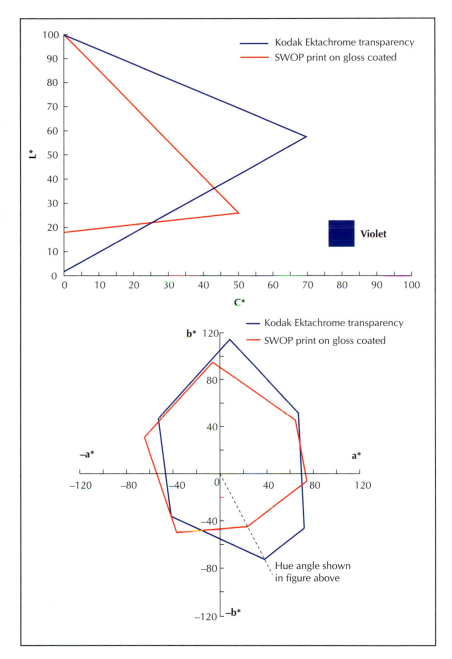

Several color appearance models have been proposed, most of which are based on a chromatic adaptation transform that adjusts the tristimulus values according to the viewing environment, then transforms the data into correlates of the **perceptual attributes**.

In 1997 a technical committee of the CIE provisionally agreed upon a standard model of color appearance, known as

the **CIE 1997 Interim Color Appearance Model** (or **CIECAM97s**).

In this model, a preliminary transform is used to normalize the *XYZ* tristimulus values of the sample:

$$\begin{bmatrix} R \\ G \\ B \end{bmatrix} = M_B \begin{bmatrix} X/Y \\ Y/Y \\ Z/Y \end{bmatrix}$$

where M_B is a 3×3 matrix.

The same transform is applied to the media white point (or other reference white) and the white point of the illuminant.

These normalized tristimulus values are further transformed by applying factors that model the degree of adaptation and the effect of the surround, and converted to R'_a, G'_a, and B'_a values that represent the retinal cone response after adaptation to the illuminant.

Appearance correlates are then calculated for hue, chroma, and lightness. Other perceptual correlates—including redness-greenness, yellowness-blueness, brightness, colorfulness, and saturation—can also be calculated if required.

The significance of this model is that it provides a common method of defining appearance attributes, which can be used in developing color transforms with greater interoperability than ones which use different appearance models or none at all. It is intended that CIECAM97s will be adopted as part of the ICC profile format.

Color Conversion, Gamut Mapping, and Color Appearance in the Workflow

The general aim of color reproduction is to reproduce the desired color appearance from a color original to a specific media, and color management enables a wide range of source devices and reproduction media to be used interchangeably.

An ICC profile defines the transform between a device space and a device-independent CIE-based space. Gamut mapping takes place when a color is transformed from XYZ or L*a*b* (which does not have a gamut limit) to a specific device. Since the gamut of a source device will always be smaller than a color space derived from mixing spectral colors (such as the CIE spaces), a gamut mapping is only required for output devices. To accommodate the color appearance of the original and the reproduction, the CIE coordinates of the PCS space are modified at both source-to-PCS and PCS-to-destination stages. The overall process is shown in Figure 7-15.

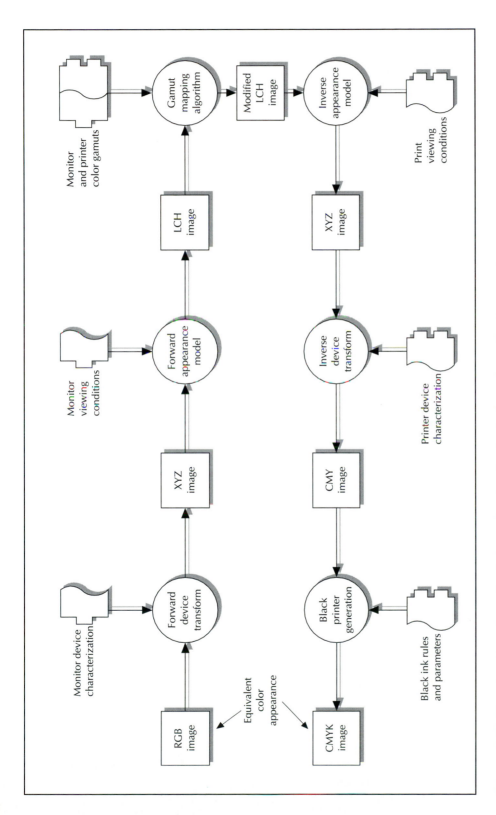

Figure 7-15. Five-stage transformation between input and output color values, allowing gamut mapping to take place within a color appearance space. In the present ICC profile format, the data for the forward device transform and forward appearance model are combined in the input profile, while the inverse appearance model, inverse device transform, and black printer generation are combined in the output device profile. Gamut mapping can at present take place within both input and output profiles. *Reproduced by permission of Prof. Lindsay McDonald.*

An appearance model such as CIECAM97s (described above) is used to convert between device XYZ and L*a*b* and appearance coordinates.

Bibliography

Berns, R. S. (1996). "Methods for characterizing CRT displays." *Displays* 16, 173–182.

Dispoto, G., and M. Stokes (1995). "Limitations in communicating colour appearance with the ICC profile format." *Proceedings of IS&T/SID Colour Imaging Conference* 3, 155–159.

Fairchild, M. D. (1998). *Colour appearance models*. Reading, MA: Addison Wesley.

Fairchild, M. D. (1995). "Considering the surround in device-independent color imaging." *Color Research and Application* 20, 352–363.

Fairchild, M. D. (1994). "Some hidden requirements for device-independent colour matching." *SID International Symposium* 865–868.

Fairchild, M. D., and K. B. Munsell (1994). "Testing colour appearance models in cross-media image reproduction." *Journal of Photographic Science* 42, 87–88.

Giorgianni, E. J., and T. E. Madden (1997). *Digital colour management*. Reading, MA: Addison Wesley.

Gregory, S.; R. Poe; and D. Walker (1994). "Communicating colour appearance with the ICC profile format." *Proceedings of IS&T/SID Colour Imaging Conference* 2, 170–174.

Hoshino, T., and R. Berns (1993). "Colour gamut mapping techniques for colour hard copy images." *Proceedings of SPIE Conference* 1909, 152–164.

Hunt, R. W. G. (1994). "An improved predictor of colourfulness in a model of colour vision." *Color Research and Application* 19, 23–26.

Hunt, R. W. G. (1991). "Revised colour appearance model for related and unrelated colours." *Color Research and Application* 14, 146–165.

ICC (1996). *International colour profile format version 3.4.*

Johnson, A. (1996). *Pira review of colour management.* Leatherhead: Pira International.

Johnson, A. J. (1992). "Device-independent colour: is it real?" *TAGA Proceedings.*

Lo, M-C.; R. Luo; and P. Rhodes (1996). "Evaluating colour model's performance between monitor and print images." *Color Research and Application* 21, 277–292.

MacDonald, L. W. (1996). "Developments in colour management systems." *Displays* 16 4, 203–211.

MacDonald, L. W. (1993). "Gamut mapping in perceptual color space." *Proceedings of IS&T/SID Colour Imaging Conference* 1, 193–197.

MacDonald, L. W.; M. R. Luo; and S. A. R. Scrivener (1990). "Factors affecting the appearance of coloured images on a video display monitor." *Journal of Photographic Science* 38, 177–186.

MacDonald, L. W., and J. Morovic (1995). "Assessing the effects of gamut compression in the reproduction of fine art paintings." *Proceedings of IS&T/SID Colour Imaging Conference* 3, 194–200.

Morovic, J. (1998). "A universal gamut mapping algorithm." *Proceedings of Color Imaging in Multimedia Conference* 169–177.

Pawle, G. (1995). "Inside the ICC color device profile." *Proceedings of IS&T/SID Colour Imaging Conference* 3, 160–163.

Pointer, M. R. (1980). "The gamut of real surface colours." *Color Research and Application* 5, 145–155.

Stone, M. C.; W. B. Cowan; and J. C. Beatty (1988). "Color gamut mapping and the printing of digital images." *ACM Trans Graphics* 7, 249–292.

8 PostScript and PDF

In the graphic arts the PostScript page description language
is the normal means of transferring graphics and documents
between different applications and platforms, and to output
them on hard copy devices. The two main exceptions are
high-end systems that use raster-based description methods
(either proprietary or using the TIFF/IT format), and low-
end printers for which the use of PostScript would impose
speed and cost penalties.

The PDF format provides an alternative output to Post-
Script language descriptions, but since it shares the same
imaging model, it will be useful to describe this first and
then show the differences between the two.

PostScript is essentially a graphical programming
language used to create precise descriptions of graphical
objects that can be accurately rendered on an output device.
A fundamental strength of the language, and the main reason
that it has eclipsed alternative page description languages, is
its concept of **device independence.** Graphical objects are
defined within a limitless coordinate system, and it is not
until the page is output that it takes on the finite resolution
of the specific output device. Device independence allows
pages to be printed at the highest resolution available on the
printer or imagesetter that is used to output them.

PostScript language code will also execute on a wide range
of computer platforms, and its graphical descriptions are inde-
pendent of the hardware or operating system on which it runs.

PostScript code is written not by a human programmer,
but by a PostScript printer driver. When an application's
print function is invoked, PostScript code is generated by the
driver and sent to the chosen output device. Here the device's
interpreter translates the code into low-level instructions
which it executes, eventually producing a raster image of the

page. Compared with more general-purpose programming languages such as C++, PostScript is a relatively simple language, yet its design makes it flexible and powerful.

Defining a page description dynamically through the use of programming constructs in this way has proved to be very successful. More recently, however, there has been a move to reduce the dynamic aspect of PostScript in order to make its page descriptions more compact and robust, through the increased use of the **Portable Document Format (PDF).**

PostScript was first developed in 1985 by Adobe Systems, as one of several languages then available for controlling printing devices. Other printer control languages, such as Hewlett Packard's Printer Control Language (PCL), also exist. They are of less interest to the graphic arts, though, as they are not designed to support high-resolution output devices or to render the full range of complex graphics that can be created in a graphics program.

PostScript was widely adopted by the nascent desktop publishing market. But as DTP matured, the weaknesses of the original PostScript language, for example in controlling color and halftone screening, became a barrier to further adoption, until language extensions were developed for these purposes. In 1990, Adobe published PostScript Level 2, which incorporated these extensions and added a number of sophisticated functions. The language has since been further extended in Level 3, which was published in 1996.

Some of the features of the language include:
- A set of graphical operators that can encode any graphical object.
- A color processing mechanism that will handle almost all input color spaces.
- Dynamic memory management.
- Dictionaries to store data that may extend the functionality of the language or that may change during execution.
- Ability to handle file decompression during output.
- Interactive control of the output device setup.

Memory management reduces the chance of a memory limit being encountered during file output, which was a frequent problem with Level 1 interpreters.

PostScript color processing uses color lookup tables to convert between device colors using a CIE-based color space, as described in Chapter 6.

A **forms cache** stores repeated page elements (such as borders, logos, tints, or other graphics that are common to a number of pages) in memory, so that they do not need to be reprocessed for each page.

The language is designed to be very flexible and extensible. It can define procedures and data dynamically during execution, using constructs such as dictionaries. A **dictionary** is a lookup table, which stores a set of parameters needed for a particular stage in the interpretation process. An example is a halftone dictionary that holds screening parameters (screen frequency and angle and dot shape).

PostScript Fundamentals

PostScript achieves device independence for page descriptions (and all the separate elements that comprise them, such as graphics, fonts, colors, and so on) by maintaining a clear distinction between **user space,** where documents are created, and **device space,** where they are output. Page descriptions remain in user space until they are actually output.

Creating and printing a document using PostScript can be divided into four separate phases, as illustrated in Figure 8-1. First, the user creates a document (usually in a page-layout application) and saves it in the native format of the application or the host computer. Next, the document is "printed" from the application (either directly to an output device or to a file on disk), and at this point the PostScript driver translates the document into PostScript code.

Figure 8-1.
Conceptual PostScript model.

An application's PostScript driver (or generic PostScript driver) translates from the host computer's native graphics format (such as QuickDraw or Windows GDI) into the PostScript laguage code. The resulting code is sent to an interpreter that examines the code, generates a raster image for each page, and passes it to the printer or exposing mechanism.

The resulting code is then sent to the output device, where the interpreter executes the code and translates the page into a raster image in the coordinate system of the output device. Finally, the raster image is sent to the **marking engine,** which transfers it to film or paper.

Creating the page and translating it to PostScript code both take place in user space, while code interpretation and printing take place in device space. This conceptual distinction between user space and device space is fundamental to PostScript's device independence. Although interpretation takes place in device space, the interpreter will not necessarily be running on the device itself. Some devices use a separate hardware **raster image processor (RIP)** that is housed independently of the output device, while low-cost devices often make use of the host computer from which the page is printed.

An important consequence of the concept of user space and device space is that an interpreter and output device do not need to have any interaction with the application used to create the document. Device-specific information that is needed at execution is made available to the interpreter through a **PostScript Printer Description (PPD)** file, or by directly interrogating the device itself.

Although a PostScript interpreter will process all of the valid instructions it receives, a page description is more device-independent if it conforms to the Document Structuring Conventions published by Adobe.

These conventions specify an overall structure for a PostScript page description and define structure comments (prefaced by "%%") that are incorporated into the page description. These comments are not actually processed by the interpreter, but they allow other programs to read and display the file and to carry out operations, such as imposing the individual pages in a publication, managing the resources it needs, and handling any errors.

Program Structure

A PostScript program that conforms to the document structuring conventions has two parts: a **prolog** and a **script.** The main purpose of the prolog is to identify application-specific procedures that will be used when the program is executed. It will also include a header that contains comments naming the document's creator and any resources, such as fonts, that are used.

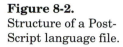

Figure 8-2.
Structure of a Post-
Script language file.

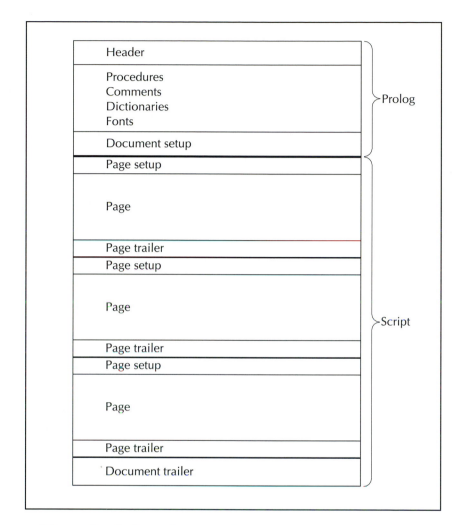

The script defines the page elements in a document. It consists of a document setup section, followed by the individual page descriptions. Each page in the publication is defined in turn through a series of instructions to the interpreter to perform graphics operations. At the end of each page in the script, the instruction *showpage* tells the output device to output the page. Each page may also have its own setup section.

A trailer announces the end of the document. It may also define some of the resources deferred from the prolog.

The prolog/script distinction is not a required feature; it's a convention used by well-structured PostScript files.

PostScript Operators

PostScript graphical commands are known as **operators,** and they are used in conjunction with the procedures defined in the prolog and with specific data or **operands.** For example,

in Figure 8-3 the *lineto* operator has been given the operands 340, 300, and a line is drawn from the last position to this new coordinate. There are over 200 operators, each with a specific function and usage. Operators carry out tasks like:

- Constructing paths.
- Controlling the specification of type.
- Controlling the specification of images.
- Drawing lines and objects.
- Controlling the way that colors are output.
- Controlling the way that the page is output.
- Defining the graphics state (such as the current color or line width).
- Defining transformations in user coordinates (allowing scaling and rotation to take place).

Some of the operators effectively combine a number of lower-level operators. For example, the *rectstroke* operator is equivalent to the sequence *moveto, lineto, lineto, closepath,* and *stroke*.

Definitions of a graphical object used in a publication can be held in a separate resource file instead of being embedded into the page description. The resource is then simply named in the page description. Named resources must, of course, be available to the interpreter. If they are not (as often happens in the case of fonts) an error will occur.

Resources defined in the PostScript language include:

- Screening parameters (halftone dictionaries).
- Character-drawing procedures (font dictionaries).
- Color lookup tables (color-rendering dictionaries).
- Input device profiles (color-space arrays).
- Output device features (page-device dictionaries).

A resource can be kept in memory by the interpreter and used whenever it is called for by the page description, or it can be stored on disk and fetched as needed. Multiple instances of a resource can be used in a page description, allowing, for example, halftones on the same page to have different screen rulings or frequencies.

The Imaging Model

The PostScript imaging model is analogous to opaque paint being applied to paper. Paint can be applied in one of three ways: as a line, as a fill, or as a bitmap image. Because paint is always opaque, every instruction to paint an object will paint over whatever was last painted at the same coordinates

Figure 8-3.
The PostScript code
(top) that produced the
60-pt. Helvetica Bold
letters "GATF" the 5-
pt. straight line, and
the 5-pt. curved line
(bottom).

```
%!PS-Adobe-3.0
%%Title: A PostScript fragment
%%Creator: Phil Green
%%Pages: (atend)
%%DocumentNeededResources: (atend)
%%DocumentSuppliedResources: (atend)
%%EndComments
%%BeginProlog
%%EndProlog
%%BeginSetup
%%EndSetup
%%Page: 1 1
%%BeginPageSetup
    % set the current font
/Helvetica findfont 60 scalefont setfont
    % add some text
180 240 moveto
(GATF) show
    % draw a line
5 setlinewidth
180 300 moveto
340 300 lineto
stroke
    % draw a Bezier curve
180 220 moveto
255 170 250 260 340 210 curveto
stroke
%%EndPageSetup
    % output the result with the showpage operator
showpage
%%PageTrailer
%%Trailer
%%Pages: 1
%%DocumentSuppliedResources:
%%DocumentNeededResources:
%%EOF
```

Figure 8-4.
When one color is painted on top of another, it is opaque. The underlying color is knocked out and does not print.

and obscure it completely. This makes it important to paint foreground and background objects in the correct sequence.

Before any object can be painted, however, its location must be defined by a path operator. Thus, for example, *lineto* defines the location of a line to be painted, while *stroke* applies paint to it according to the current graphics state. The **graphics state** defines the attributes, like color and line width, that are to be used when the next object is painted.

PostScript's opaque painting model does not allow painting one color over another transparently or additively. The only exceptions are:

• When an object is set to overprint the underlying object.
• When a *mask* operator is used.

When colors are set to overprint, both the underlying object and the overprinting object will be printed. Only colors in the Separation color space can overprint.

A **mask operator** is used to make an object transparent. A PostScript mask works like a stencil, allowing a second object to be painted over the first in the open areas of the stencil.

Figure 8-5.
The exceptions to
PostScript's opaque
imaging model.

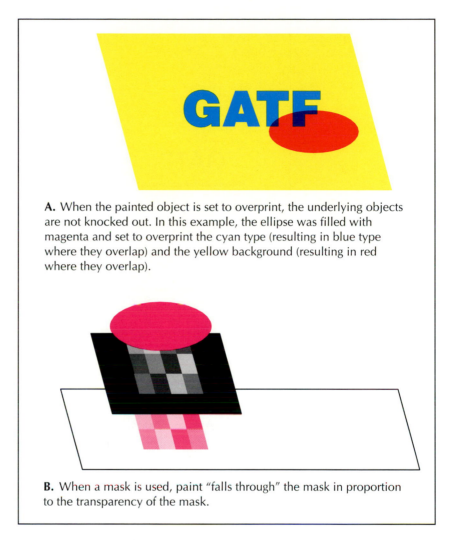

A. When the painted object is set to overprint, the underlying objects are not knocked out. In this example, the ellipse was filled with magenta and set to overprint the cyan type (resulting in blue type where they overlap) and the yellow background (resulting in red where they overlap).

B. When a mask is used, paint "falls through" the mask in proportion to the transparency of the mask.

User Space

Pages are created in user space, which is a device-independent coordinate system with its origin at the lower left, as shown in Figure 8-6. User space is a limitless space with coordinates based on units of ¹⁄₇₂ in., which corresponds closely to the point system used in the graphic arts. Coordinates are translated into device space by the interpreter, and a transformation matrix determines how the user space coordinates will be mapped to the output device, allowing scaling or rotation as the page is output.

Applications can specify measurements in whole units or any fraction of a unit, so there is no limit on the precision available. Applications display measurements that are based on the PostScript unit, converted to points, inches, or metric units.

Figure 8-6.
Translating user space
coordinates to device
space.

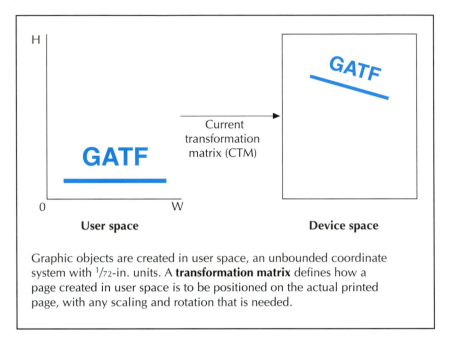

Graphic objects are created in user space, an unbounded coordinate
system with $^1/_{72}$-in. units. A **transformation matrix** defines how a
page created in user space is to be positioned on the actual printed
page, with any scaling and rotation that is needed.

Type is rendered in PostScript as a graphic object, refer-
ring to the font file to obtain the precise vector description of
each character as it is needed.

Graphical Primitives and Paths

Vector drawing in PostScript is based on three fundamental
procedures or graphical primitives: **straight lines, arcs,**
and **curves.** These are the basic building blocks of every
type of graphic object, regardless of how complex it is. The
use of such simple and well-defined building blocks makes
their behavior highly consistent and predictable, regardless
of the different applications and device spaces that may be
used to create and output them. Lines have just two coordi-
nates defining the position of each end of the line; arcs are
based on a portion of a circle; and curves are described in
PostScript as **Bezier** cubic curves.

To draw an object using these graphical primitives, Post-
Script first defines a path that describes the object's outline.
A **path** in PostScript is essentially a series of points that are
linked together. Paths can be open or (as long as there are at
least three coordinates) closed. Closed paths can be given a
fill color which covers the area bounded by the path. As well
as defining lines and shapes, paths are also used to create
clipping templates for other graphics. A path can also be
thought of as a virtual line, since nothing is actually drawn
until color is applied to the path by either stroking or filling

Figure 8-7.
A path in PostScript is a virtual line that can be open *(A)* or closed *(B)*. It can also be filled with a color *(C)* and stroked with a line of any thickness *(D)*.

it. The path coordinates and the stroke width can be specified with great precision, giving the user complete control over the creation and output of graphic objects.

To draw a character, a series of straight and curved paths are constructed according to the vector font description to form the character outline, which is then filled with the current color in the graphics state.

Once a path procedure has been interpreted by the output device, it can be stored in memory and reused when required, saving on the processing needed for repeated elements within pages. Paths can be made up of multiple segments and can incorporate subpaths. The only limit on the number of paths that can be used is the amount of memory required to store them during output. This limit is infrequently encountered in Level 2 or 3 devices, except with very complex graphics.

Encapsulated PostScript

An **EPS file** is a special kind of PostScript object that can be embedded into a page. In addition to PostScript code, it can contain text, graphics, images, and even other EPS files. It is not sent directly to an output device, as it has no device setup operators and no *showpage* command. An EPS file will include:

- A header identifying it as an EPS file,
- Bounding box coordinates defining the area of user space that it will occupy, and
- An optional bitmap preview of the object.

Unlike a PostScript file, an EPS file cannot describe a document with multiple pages. Previews can be either PICT (for the Mac) or TIFF (for the PC), or they can be in the device-independent **EPSI format.** EPS files are often application-specific, and if so they may not be editable in other programs unless a filter for the original application is present.

Images

PostScript describes the position and color of scanned images using the *image* operator. **Image** defines the following image properties:
- The image format (its height and width, its spatial resolution, and the number of colors),
- The coordinates of the user space where the image will be placed,
- The source data for the image (the color values for each pixel), and
- A definition of how the source color values are to be translated into the current color space.

Scanned images are given a vector outline called a **bounding box** that defines their position in user space. Just as the user can scale and rotate an object as it is mapped from user space into device space, PostScript allows the user to define how the original image source coordinates are to be mapped into user space with an image matrix. In most cases, the color values for the individual pixels will be contained not in the page layout file but in a separate TIFF or EPS file. When the printer driver turns the page into PostScript code, it inserts the color values.

Color Processing

Non-PostScript printer drivers are limited in the input color space that they can accept. QuickDraw and GDI printers accept only RGB (requiring the graphics application to convert into RGB if necessary). Alternate printer control languages use relatively inflexible conversions. PostScript enables conversion from the input color space to take place during interpretation. The *setcolorspace* operator triggers the conversion process, and this allows data to be input in any of the following types of color space:

Figure 8-8.
Image matrix.

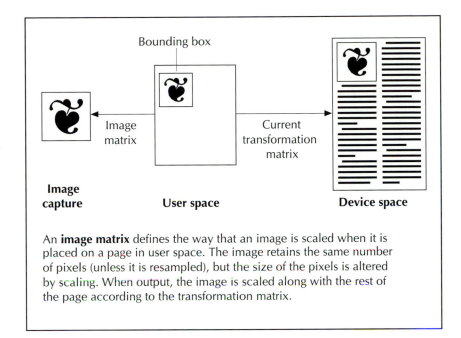

Bounding box

Image matrix

Current transformation matrix

Image capture **User space** **Device space**

An **image matrix** defines the way that an image is scaled when it is placed on a page in user space. The image retains the same number of pixels (unless it is resampled), but the size of the pixels is altered by scaling. When output, the image is scaled along with the rest of the page according to the transformation matrix.

- Device-dependent color spaces (RGB, CMYK, monochrome, and HSB),
- CIE-based device-independent color spaces, and
- Special color spaces (including separations and patterns).

PostScript color processing is very similar to that defined in the ICC architecture (see Chapter 7). An input profile is referred to in PostScript as a Color Space Array (CSA), while an output profile is known as a Color Rendering Dictionary (CRD). In-RIP color conversions can be performed with PostScript data streams or PDF files, if a color space array and color rendering dictionary are available.

The **separation color space** is available to define colors that will not be output as composite CMYK. It has two main uses:

- To send color images to output devices that produce a single film or plate for each color and do not support composite output, and
- To output special colors that are being used in addition to the CMYK set, such as bump colors and HiFi colors.

There is no limit on the number of colors defined as separations that the PostScript language will permit, although different applications impose their own limits on the maxi-

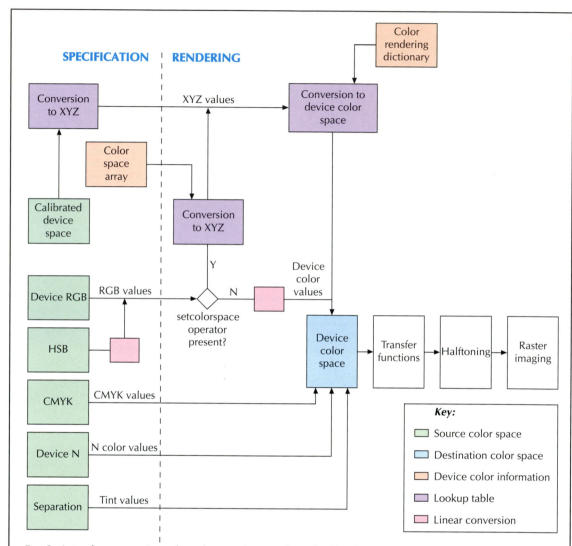

PostScript color processing takes place at the RIP if invoked by the application from which a file is printed, for example checking "Manage composite on printer" in PageMaker's CMS Preferences dialog.

Color values of an image are specified within user space, and its color space defined with the **setcolorspace** operator. Color values can be converted to output device color values either by the linear Level 1 conversions or by the more sophisticated Level 2/3 conversions. After conversion, transfer functions and halftoning can be applied.

To use Level 2/3 processing, the interpreter must have:
• The color space of the source color values defined with the **setcolorspace** operator
• A color space array that defines how the source color values are to be converted to XYZ values
• A color rendering dictionary that acts as a lookup table to convert from XYZ values to device color values

Figure 8-9. PostScript color processing.

mum number of special colors that can be incorporated into a publication.

PostScript supports the use of up to twelve bits per color for each color channel.

The Printer Driver

The role of a PostScript printer driver is to generate PostScript code when a document is printed. The driver creates code by translating from the host computer's native graphics format, such as QuickDraw routines on the Mac or Windows GDI functions on the PC. The driver is also responsible for integrating any resources that are needed and incorporating any external files specified in the document (such as EPS files) into the output.

Unlike other kinds of printer drivers, a PostScript driver is not specific to the output device, but to the host platform or application. PostScript printer drivers are written by third-party vendors and the developers of graphics applications, as well as by Adobe. Generic PostScript printer drivers are incorporated into the MacOS (selected as LaserWriter in the Chooser) and Windows (selected as PostScript Printer in the Printers control panel). Different printer drivers will generate different PostScript code for the same page description, even though the printed output may be identical.

Although PostScript code is created in user space and is therefore independent of the characteristics of the output device, it must be appropriate for the target output device. The driver does this by using printer description files that supply information specific to the output device, including the paper size, the maximum image size, and the available resolutions.

Code can be generated either as **ASCII characters,** which can be viewed and edited in a word processor, or as **binary code,** which will be processed faster by the interpreter. The code is usually sent directly to the output device, but if necessary can be output to a file using the "Print to File" (or "Print to Disk") option. To send this PS file to an output device, a downloading utility can be used, or the file can be distilled to PDF.

PostScript Errors

PostScript code can occasionally result in a page that appears to be different from what was intended, or which fails to output altogether. Most often these problems are caused by the way that the page was constructed or printed, but unpredictable execution errors do arise occasionally.

Interpreters on high-resolution output devices normally log such errors and the offending operators, but it can still be difficult to see exactly what has caused the error.

One type of PostScript error, *limitcheck,* arises from interpreter memory limits being exceeded. PostScript itself does not impose any limits on the number or size of objects that consume memory during output, such as the number of paths that are used in a document. The output-device interpreter, however, has just a fixed amount of RAM available, and this must hold all the fonts, procedures, paths, and so on used in the document, as well as graphic objects, halftone and color-rendering dictionaries, and programming constructs like stacks. High-resolution devices additionally use hard disk space to store the current page during output; often they split a page up into a series of bands.

Page assembly applications have limited abilities to predict such errors. Running a file-checking utility (see Chapter 11) will trap most potential errors, but unless it is able to simulate the memory management of the interpreter, it cannot absolutely guarantee that a document will output successfully. The chance of a limitcheck error occurring can be minimized by:

- Splitting very long paths into multiple paths.
- Cropping images in image-editing programs, instead of using a clipping path in an illustration or page-layout application, especially where complex paths are used to define the crop area.

Code that has been generated by the printer driver in a way that conforms to Adobe's Document Structuring Convention produces more predictable output and can be more readily used by different applications. Code should also make optimum use of memory resources during processing, by bringing into memory only those items that are required by the document and removing them when they are no longer needed.

Output problems can of course be caused by user errors, such as supplying incorrect fonts or specifying composite output for a publication containing special colors. In such cases the file may be printed without PostScript errors, but this does not produce the output wanted. These issues are discussed in Chapter 11.

PostScript is an extremely powerful graphical imaging method, and its dominance is unlikely to be challenged by

any other page description language in the near future. The main threat to the PostScript language is arguably from the emergence of HTML and its variants as native file formats.

PostScript Limitations

The PostScript language as defined by the Level 2 specification had a number of limitations, the principal ones being:

- The inflexible nature of the opaque painting model, which makes relatively simple operations, such as trapping and adding transparent color, either very complicated or completely impossible.
- The lack of true vignettes, which makes it necessary to construct tint gradations and blends from a large number of separate objects.
- The lack of page independence within the structure of the PostScript file, which makes it difficult to split a document up for page imposition, or to use multiple processors.
- The difficulty of editing a document once it has been translated into PostScript code.
- The lack of support for high-end, device-dependent operations, such as trapping and imposition, leading to the need for third-party software to handle these functions.
- The inability of printer drivers (including those developed by Adobe) to generate compact, error-free PostScript code.
- The frequency of execution errors when PostScript code is output.

These problems have been addressed by three recent developments: the **PostScript 3** specification, the **Portable Document Format (PDF),** and the introduction of a scalable architecture called **PostScript Extreme.**

PostScript 3

In the PostScript 3 specification some important additions were made to the language. The most important to digital color reproduction are:

- **Raster masks.** Clipping paths can be converted to raster masks, which eliminates the limitcheck problems that can arise with over-complex clipping paths.
- **In-RIP trapping.** Users can set trapping parameters in a graphics program (provided it supports this feature), and trapping can then be executed as part of interpretation.
- **Smooth shading.** Gradient fills can be specified as high-resolution color transitions, and several different methods can be used to specify them: they can be defined simply as an axial or radial gradation, or as a more complex user-

defined mathematical function. There is also support for 3D fills, which can be on a 3D wireframe mesh or lattice, or a curved 3D surface defined by multiple Bezier curves.

- **Greater integration with ICC profiles.** As the color processing information in an ICC profile is very similar to that in a PostScript color rendering dictionary, it is possible adapt an ICC profile to the format of a CRD. Level 3 interpreters are able to manage this process and ensure correct synchronization between profiles, CRDs, and rendering intents.

- **Calibrated RGB and CMYK color spaces.** These are in effect colorimetrically defined device spaces, similar in principle to the sRGB standard. Applications can specify colors in these spaces, or the interpreter can transform uncalibrated device colors into them using a color space array.

- **HiFi color.** Previously PostScript allowed colors other than CMYK to be defined as "separations," but did not include them in its device color spaces or in its color processing models. A new **Device N** color space supports up to 256 colors.

- **Halftones.** Several new types of halftone are defined. These include vendor-specific halftone screens, which are not defined by the PostScript language but are determined during execution by interrogating the output device; halftone screens specified by threshold arrays with adjustable screen angles; threshold arrays at device resolution; and threshold arrays at device resolution that support 16-bit gray levels.

PDF

The PDF (Portable Document Format) overcomes several of the limitations of the PostScript language. A PDF document has page-independence, editability, and a more robust and less error-prone structure. A PDF file is designed to be viewed on screen as well as print, and this makes it possible to check the page content before imaging onto hard copy.

PDF is based on the same imaging model as PostScript, and it incorporates the majority of PostScript operators. A PDF file is created by partially interpreting a PostScript file, but not rasterizing the output. The structure of a PDF file is thus more like a database of the objects in the document, with direct access to each object, instead of a program that has to be executed in order to render a page description. A PDF file consists of a **header,** a **body,** a **cross-reference**

table, and a **trailer.** The body takes the place of the script in a PostScript file, and it contains a sequence of numbered objects that represent all the text, graphics, and images in the document. The cross-reference table indexes each object in the file.

A PostScript file is converted to PDF with **Acrobat Distiller.** It can then be viewed with **Acrobat Reader. Acrobat Exchange** is additionally used to edit some of the document properties (for example by incorporating hyperlinks or interactive forms). PDF files are also intended for use as a means of distributing documents in electronic form, and they have a range of multimedia capabilities such as sound and video.

Several raster and vector graphics applications, such as Adobe Photoshop and Illustrator, can open a PDF file and edit the page content, although the edited document may need to be resaved as an EPS or PostScript file. Image editing applications, such as Photoshop, rasterize the page as they do with EPS files.

Earlier versions of PDF were unable to support the high-end features of PostScript, but the format now incorporates support for trapping, OPI (Open Prepress Interface, defined in Chapter 10), and high-resolution output. It can also preserve information in a PostScript file, such as halftone screen parameters. Color images are unchanged by being encoded within a PDF file, unless the JPEG compression option is set to anything other than high quality.

PDF files are created from PostScript files by the Acrobat Distiller program (or a third-party alternative such as 5D's Niknak). Thus it is necessary to first create a PostScript file by printing the document to disk using a PostScript printer driver. This does require an additional stage, although the process can be automated by using hot folders. Job options are set in Distiller to control compression, font embedding, and high-end options such as OPI, overprint settings, and color processing.

Distiller offers a range of compression options according to the type of object and the quality requirements. These are highly efficient, and the process of conversion from PostScript to PDF usually reduces the file size dramatically.

Fonts can be embedded into the PDF file (if the font is supplied by a participating vendor), which avoids the frequent problem of documents failing to render accurately due to the lack of the correct fonts. However, it should be noted that the

font still needs to be available when the PostScript file is distilled, or the same problems will occur.

PDF files can be sent directly to a PostScript 3 device that supports direct PDF printing. If direct PDF is unavailable, the document can be printed from Acrobat Reader or Acrobat Exchange, which will reconvert it to PostScript.

A PDF driver called **PDFWriter** ships with Adobe Acrobat, but it creates the PDF file from the QuickDraw or GDI screen display, and is unable to handle complex documents or high-resolution files. Several applications have a "save as PDF" option, which usually invokes a printer driver based on PDFWriter.

PDF is an extensible format, and there are numerous plug-ins available from Adobe and third-party developers. Examples include plug-ins that:

- Embed Portable Job Ticket Format data within a PDF document,
- Add JavaScript code to a PDF form to enable dynamic interaction with the user,
- Impose the pages in a PDF file,
- Convert between PDF and different levels of PostScript, and
- Enable editing of the objects within a PDF file.

The simplicity and robustness of the PDF format make it likely that most production workflows will be based on the PDF format. However, the range of options for features such as resolution, compression, and color make it possible for documents to be incorrectly created, just as with PostScript. The PDF format also has weaknesses in:

- Handling of special colors and composite color,
- Inability to include some types of trap information,
- Embedding of TrueType fonts, and
- Lack of a color-managed screen display.

PDF is also a static format, which is difficult to adapt for complex variable data, although it can be given limited dynamic capabilities by using its forms and JavaScript capabilities.

A version of the PDF format is emerging as a standard for high-end printing (CGATS.12/1), known as **PDF/X.** A PDF/X-1 file must include all components used in the document, including OPI-linked image files, fonts, and color profile data. Image files must be in one of the following

formats: TIFF, TIFF/IT, EPS, or DCS. Only lossless compression methods are supported, and the color space must be either device-independent or CMYK. If the color space is to be converted, the file must be prepared for a single source-to-destination transform (i.e., all elements must use the same profile).

For situations where it is not essential to embed all components, the alternate format PDF/X-2 can be used.

PostScript Extreme

PostScript Extreme is a scalable production architecture that makes use of the page independence of PDF to enable multiple RIPs to work on different pages of a document. RIP speed rarely matches marking engine speed, and so in a high-volume environment, multiple RIPs are sometimes used to accelerate RIP processing. Concurrent processing of different pages within a document by multiple processors is only possible through the Extreme architecture. The architecture also makes it possible to use **Portable Job Ticket Format (PJTF)** data embedded into the PDF file to manage the workflow, and to view, edit, or replace pages and alter print settings.

Job files sent to a PostScript Extreme system are received by the **Coordinator.** The Coordinator directs files in PDF format directly to a page store; PostScript files are directed to a **Normalizer** that converts them to PDF format. Pages are sent to the installed RIPs as required by the production workflow, and from there to the **Renderer** or **Assembler,** which imposes the pages and manages the data stream to the marking engine. Color processing and trapping also take place during RIPing.

There is also support for the caching of RIPed page elements (rather than whole pages), in order to support variable image printing.

Bibliography

Adobe Systems (1990). *Document structuring conventions specification v. 3.0.*

Adobe Systems (1990). *Encapsulated PostScript file format v. 3.0.*

Adobe Systems (1999). *Portable Document Format reference manual v. 1.3.*

Adobe Systems (1998). *PostScript language reference manual.* 3rd ed. Reading, MA: Addison Wesley.

Ames, P. (1993). *Beyond paper.* Mountain View, CA: Adobe Press.

Andersson, M.; W. Eisley; A. Howard; F. Romano; and M. Witkowski (1997). *PDF printing: the next revolution after Gutenberg.* Torrance, CA: Micro Publishing Press.

Kent, G. (1996). *Internet publishing with Acrobat.* San Jose, CA: Adobe Press.

Kent, G. (1996). *Internet publishing with Acrobat: A comprehensive reference for creating and integrating PDF files with HTML on the Internet or intranets.* Hayden Books.

Merz, T. (1998). *Web publishing with Acrobat / PDF.* Springer Verlag.

Romano, F. (1999). *PDF printing and workflow.* Prentice Hall.

Witkowski, M. (1998). *The PDF bible: The complete guide to Adobe Acrobat 3.0.* GATFPress.

Note: Many of the Adobe publications can be freely downloaded from *www.adobe.com.*

9 Output Systems

With the exception of scanned images, graphical information produced on a computer system is normally in vector form. Output devices, on the other hand, are almost invariably raster devices, and it is necessary to map the vector shapes onto the individual pixels of the output device in order to drive the marking engine.

The precise way in which this is done depends to a large extent on the type of output device. Color hard-copy output devices may produce composite output (i.e., a print in color) or separations (i.e., separate hard copies for each color channel). Separations are normally required when the hard copy is an intermediate, such as film or plate for use in commercial printing.

Hard-copy output devices also vary in terms of their ability to image a gray scale. Many devices are effectively **bilevel** (or **binary) systems** whose pixels can be either black or white (no intermediate levels of colorant are possible). Other devices are able to modulate the density of individual pixels; the number of levels that can be achieved will rarely be greater than 256, and may be as a low as 4, depending on the marking engine technology and the way in which it is driven. Where the number of achievable levels is low, some form of **dithering** or **halftoning** will be needed in order to render a color image.

Displays are also raster devices, and vector information must similarly be converted into intensity signals for individual display pixels. Vector information is converted from the operating system's native format into pixel intensities by the computer's graphics subsystem. Dithering is only required if the operating system is not configured to map the full range of intensities to the display.

Figure 9-1.
Different output systems realize the full range of tonal values through a combination of device pixel size and device gray levels. Shown here are four halftone cells, imaged on different devices. Because the number of tonal values that can be imaged is the product of the number of device pixels in the cell and the number of gray levels, the cells imaged by each device are visually equivalent (as long as the cells are sufficiently small that they are not individually resolved by the eye).

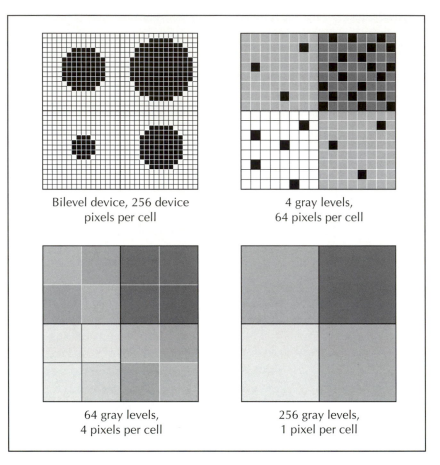

Bilevel device, 256 device pixels per cell

4 gray levels, 64 pixels per cell

64 gray levels, 4 pixels per cell

256 gray levels, 1 pixel per cell

Color hard-copy devices such as laser and inkjet printers typically have 300–1,200 addressable pixels per linear inch. Bilevel photographic systems, such as imagesetters and platesetters, usually have much higher addressable resolutions, in the range of 1,000–3,000 pixels per inch. Color displays are normally in the 60–100 pixels-per-inch range.

Raster Image Processing for Hard-Copy Devices

Hard-copy marking engines transfer colorant directly to paper (in the case of digital printers and proofers) or expose a light-sensitive medium (in the case of film recorders, imagesetters, and platesetters). Mapping a page description to a device is known as **raster image processing,** while the process of converting the interpreted page description into individual device pixels is known as **scan conversion.**

The scan conversion process results in drive values for each addressable pixel. The vector shapes in the page description will have been mapped into the coordinate system of the output device, curves rendered as line segments, and the pixels

Figure 9-2.
Typical stages in Post-
Script interpretation
and raster image
processing.

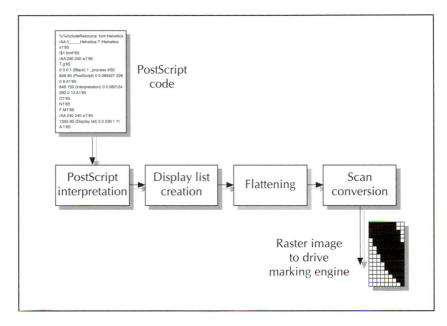

that are to be inside filled shapes computed. Where a line
does not fall exactly onto pixel boundaries, **stroke adjust-
ment** may be applied to maintain consistency of line width.
In the case of fonts, this process is supported by hints con-
tained in the font file. Stroke adjustment is particularly
important on low-resolution devices where line widths can
only be approximated and variations can be highly visible.

Figure 9-3.
Rasterization without
stroke adjustment
(left) and with stroke
adjustment *(right)*.

From PostScript
Language Reference
Manual v. 3.

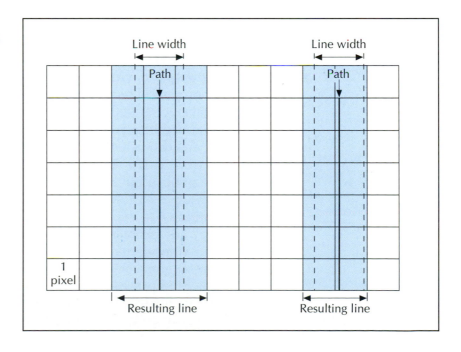

Raster images are also mapped into the device pixels, with image pixels being resampled if they do not coincide with the pixels of the output device. Halftoning will also be carried out if necessary.

In the case of a PostScript device, the page description is interpreted by executing the PostScript code. The interpreter may map the resulting shapes directly into device pixels, or to an intermediate representation such as a **display list.** A display list is a vector description in an internal device-specific format.

The page description may also be translated into an alternative, proprietary format for subsequent editing and output on a high-end **electronic page composition (EPC)** system. Once the data has been converted to such a format it is possible to apply high-end features, such as trapping and screening techniques.

Some post-interpretation representations are device-independent and can be output to different devices or media if required. This approach is sometimes referred to as **RIP once, output many (ROOM).**

Although conceptually the interpreter is part of a PostScript output device, it does not have to physically reside within the device itself. It can be an independent system, capable of serving one or more marking engines, or it can be located within a standard platform host computer. An interpreter can also be either hardware-based (for fast execution) or software-based (for ease of upgrading).

Many systems use Adobe's **Configurable PostScript Interpreter (CPSI),** a software interpreter that can be configured by the output device vendor to exploit device-specific features. Advantages of using a CPSI are:

• The system can enable the operator to edit the PostScript data if necessary, altering features such as the page size, resolution, and the use of fonts.
• Screen previews can be incorporated in the system, displaying the publication on a monitor so that the user can see exactly how it will be output before downloading to the marking engine.
• The memory and processor resources of a workstation or powerful desktop system can be used.
• The interpreter can work in conjunction with Adobe's Pixel-Burst display-list processor ASIC to accelerate output.
• Proprietary, device-specific features, such as screening technologies, can be integrated into the system.

The amount of data created when a file is rasterized for high-resolution output is approximately 100 times greater than on a laser printer. Because of the much higher memory requirements, high-resolution devices may not output an entire page at once, but divide the output area into horizontal bands. The rasterized page is stored temporarily on a hard disk while each band is sent in turn to the marking engine.

Many output functions are logically executed in device space, since this enables page descriptions to remain device-independent. This approach enables device-specific parameters to be used for such functions and allows editing to take place right up until final output. It may also be possible to exploit the availability of powerful processing resources in the output environment. Device-dependent output functions include:

- Conversion to the device colorant space
- Halftoning
- Compensating for tone value transfer characteristics (dot gain)
- Trapping
- Imposition
- Inserting high-resolution images into the workflow in place of low-resolution placeholders

Many of these functions depend on information about the final output media, as well as specific device characteristics, in order to generate optimum output.

Some information may need to be supplied by the user, but in many cases it will be recorded in the PostScript Printer Description (PPD) file. If the device supports bidirectional communication it will be possible for the interpreter to interrogate the device about its features and current state.

RIP technology is an area of rapid advance, with foreseeable developments including multiple processors, powerful hardware components like the PixelBurst coprocessor, and more intelligent software architectures.

Exposure Systems

Some output devices are designed to expose photographic emulsions on media such as film, paper, and plate. Such systems use a high-intensity light source (usually a laser diode or LED) to expose the light-sensitive material in a manner similar to the way an electron gun builds up the display image on a computer monitor. The **address grid** is based on the stepping increment in the vertical direction, and the frequency

Figure 9-4.
Address grid of an
output device.

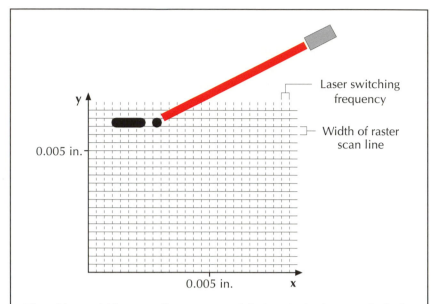

The address grid is a coordinate system of device pixels, the size of which controls the placement and resolution of halftone images. Pixel size is determined mainly by the stepping increment of the raster scan in the vertical dimension and the laser switching frequency in the horizontal dimension. Many devices support a range of different output resolutions, each one having its own logical address grid. Note that the address grid is considered to be a rectangular matrix of pixels, although the actual laser spot is round or elliptical. The practical minimum spot size is around 8–10 microns, as it becomes difficult to image consistently to film below this level.

with which the laser can be switched in the horizontal dimension. Both horizontal and vertical addressability is constrained by the size of the smallest laser spot that can be imaged.

Laser sources use different wavelengths, the shorter wavelengths being associated with greater power and resolution. Those used in imagesetters are usually in the red and infrared regions, which are cheaper to manufacture than blue lasers, but generate output of lower intensity. They require film of relatively high sensitivity, in which there is more costly silver metal. Some systems use an array of lasers or a beam-splitter to expose multiple raster scan lines simultaneously.

Laser exposure technologies are evolving rapidly, and some systems incorporate removable laser-array assemblies that can be upgraded without having to replace the rest of the device.

Systems vary in the way in which they move the exposure beam. In a typical flatbed system the beam is reflected from a rotating polygonal mirror; it is moved along the scan line by being reflected from one face of the mirror during its rotation. When the next face of the mirror is presented to the beam, it flies back to the start of the scan line, and the medium is advanced the width of one scan line while the beam returns. In drum exposure systems, beams may also be deflected laterally by an electromagnetic field.

The addressable resolution of the system may be improved by modulating the point at which the laser is switched on and off (allowing a variable imaging length along the raster scan line), and by modulating the beam intensity or the spot size. In some cases a third-party controller can be used to achieve a higher degree of modulation than the device's own controller.

In flatbed exposure systems, the media is advanced after each scan line by a roller or **capstan;** while in a drum system the media is moved into position and held securely as the laser moves to image the whole surface. Drum systems are sometimes said to hold register more consistently; they can be fitted with register pins to hold the material in position while it is exposed.

Lack of imaging precision can be a problem with film and plate output for color reproduction. Positional accuracy of a few microns across the film or plate is necessary to hold all the separate colors in register, but some devices do not achieve anything like this level of accuracy. Output devices that are not able to hold and repeat a high degree of accuracy every time the films are output cannot be considered color-capable.

Emulsion density on film should be no less than 4.0, in order to prevent any light from passing through the film when it is exposed to the plate. The density is controlled by the amount of exposure and by processing factors such as development time, temperature, and rate of replenishment of fresh developer. Film and plate emulsions need to be highly sensitive in order to minimize the imaging time. A degree of latitude is built into the emulsion to allow for small fluctuations in exposure and processing, but the more sensitive the emulsion, the less latitude there is.

The film or plate material is handled in light-proof cartridges, and after exposure it is transferred to a processor that develops, fixes, washes, and dries it. Some imagesetters and platesetters incorporate in-line processing.

Computer-to-Plate

Many printers are investing in computer-to-plate (CTP) systems that bypass film entirely. With electronic imposition of complete flats, it makes sense to go a stage further and expose plates instead of film, eliminating several prepress production stages.

Imaging directly to plate also does away with some of the distortions introduced in film-based platemaking, including the relative dimensional instability of film (and the consequent risk of expansion and misregister) and exposure undercutting at emulsion edges. The beam profile and the effect of light scattering produces a soft dot in some CTP systems, which tends to sharpen during the pressrun.

Polyester litho plates are flexible enough to be loaded in an imagesetter in roll form and exposed. Metal plates are exposed in dedicated plate exposure units (sometimes known as **platesetters),** which can incorporate automatic plate feed and register punching.

CTP is a major investment, and the cost involved can only be justified by a minority of printers, especially when compared with the low capital costs of conventional platemaking equipment.

Figure 9-5.
Computer-to-plate technology (B) eliminates the film output and stripping stages (A) in the production workflow.

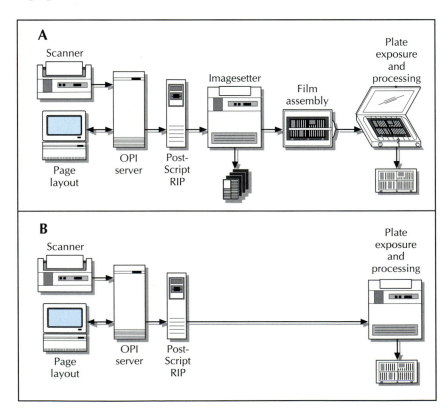

Figure 9-6.
CTP output device for film and polyester plates.
Courtesy Purup-Eskofot.

In many instances, it is not possible for every element in a job to be supplied in digital form, and then it is necessary to combine film produced conventionally with the digital data. In hybrid workflow environments, automatic step-and-repeat machines may be used to add the film-based material. The platesetter receives the imposition instructions and exposes the digital information, masking the areas that are missing. The device then uses the register marks as a guide to position the films and expose them conventionally.

Alternatively, film or artwork can be scanned and converted into digital form. Very high resolution scanners (known as "copydot" scanners) are used to avoid image quality loss on line artwork, such as type with fine strokes, and to avoid the need to descreen halftones, which risks changing color values. One type of scanner designed for this purpose converts the scanned data directly into PostScript code, which can then be inserted into a PostScript CTP workflow.

When alterations are required, the new matter is either stripped in manually or the films are re-output. Editing rasterized CTP data poses problems, and it is more common for changes to be made to the customer files and new plates produced for alterations.

Platesetters have to be large enough to accept the full plate size for a given job (unlike films which can be assembled from strips). Some models incorporate automatic plate-handling mechanisms and can accept plates up to 48×66 in. (1,200×1,650 mm). They may incorporate work-

Figure 9-7.
The Platesetter Merlin, a fully automatic CTP device that offers automatic plate loading, exposure, and processing.
Courtesy Purup-Eskofot.

flow management (including queuing and preparing files while the previous job is being exposed), automatic compensation for shingling, and placement of color bars, register marks, and fold and trim marks.

CTP plates have been developed with sensitivities to laser energy in the green, blue, and infrared regions. The latter, usually known as thermal plates, have relatively low sensitivities. As a result, they are slower to expose but can be handled in daylight. They tend to produce a high-quality image but require baking.

Other plates are more sensitive and must be handled in the dark or in lightproof cartridges. With a high-sensitivity plate and multiple blue laser exposure heads, total exposure duration at 4,000 dpi is similar to that for conventional diazo and photopolymer plates.

Some CTP systems found in on-press plate imaging use a **laser ablation** process to remove the upper layer of the plate to reveal an ink-receptive surface.

Halftoning

Since the first printing presses were built, printers have been concerned with techniques for reproducing a range of tones in processes that are essentially binary. All kinds of methods have been used in the past to create this illusion of tone, including woodcuts, etchings, and engravings on copper and steel. The basic principle used in all these techniques is to print areas of color that mingle with the white of the paper surface to create an illusion of tone. A general term for this

Figure 9-8.
Detail of a nineteenth-century woodcut. Before the halftone process came into use, tone was often reproduced by cutting lines into wood or metal.

illusion is **dithering.** If the dither pattern is made up of areas that are too small to be individually resolved by the eye, the illusion of tone is complete. In most cases the process used has insufficient resolution to make this possible, and a compromise is necessary.

In the 19th century the periodic (regularly-spaced) halftone screen was developed, and it became popular through its suitability for photographic methods of image reproduction. It remains the dominant process for commercial printing, although digital imaging now makes possible a much wider range of screening methods.

Digital color output systems tend to have relatively lower resolution than that which can be achieved in commercial printing. They are not, in many cases, bilevel devices; they can vary colorant density or droplet size over a limited range. To meet the needs of such devices, alternatives to periodic halftoning have been developed, including nonperiodic screens such as frequency modulation.

The conventional, periodic halftone screen should thus be seen as a special case of the halftone process, which also encompasses the full range of dither patterns used in both hard-copy output devices and displays. The objective of any halftoning method are:

- To render the full range of tonal values without discontinuities (**contouring).**
- To minimize the visibility of the screen pattern.
- To avoid the occurrence of interference patterns (**moiré)** between screens that overprint each other.

- To render accurately spatial information from the image such as sharp detail.
- To render flat tonal areas (**tints**) smoothly without noise.

The Conventional Halftone

When an image is screened by the conventional halftone process, its tonal values are reproduced by a pattern of regularly spaced dots, all of which have the same density but vary in size. The tonal value of a pixel defines the proportion of the substrate that is to be covered by the halftone dots. The larger the tonal value, the larger the area covered, and the darker the tone appears to the eye. In a midtone, for example, the dots might cover around 50% of the total area of the paper; the **dot area** would then be said to be 50%.

In the traditional photomechanical halftone process using a contact screen, the dot area can vary continuously from zero to 100%. The size of the dot is controlled by the amount of light that passes through the contact screen during exposure and falls on the light-sensitive film. This variable-size dot is in effect what a digital halftoning system attempts to emulate.

The photomechanical transfer of tone from original to final reproduction is prone to variation at several stages:
- Exposure intensity may not be fully controlled, leading to variation in the dot size on film or plate.
- Contact exposures (as when making a plate or proof from a film) cause dot sizes to change slightly.
- Mechanical and optical effects make the apparent size of printed dots larger.

The three parameters of a conventional halftone are the **screen frequency** (or **screen ruling), screen angle,** and **dot shape.**

Screen frequency. The greater the screen frequency, the better the illusion of continuous tone and the more sharpness and detail of the original that can be conveyed. At frequencies from 150 lpi upward, the halftone dot becomes less and less visible until, at between 200 and 300 lpi, it is no longer apparent at normal viewing distances.

Screen frequencies over 200 lpi are typically used:
- To give extra sharpness and crispness to an image.
- To retain the grain in an original, such as when the photographer has deliberately used a fast film.
- To retain the sharpness of scanned images that include fine detail such as type.

Figure 9-9.
Halftone gray scales. The greater the halftone screen frequency, the less apparent the halftone screen becomes.

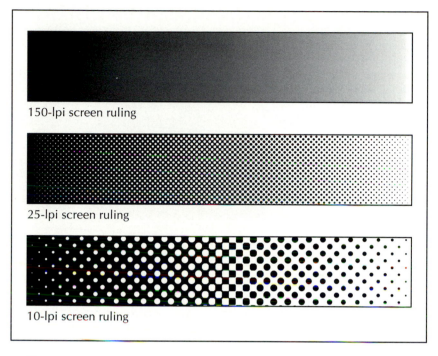

150-lpi screen ruling

25-lpi screen ruling

10-lpi screen ruling

Screen frequencies of 600 lines per inch or more have been achieved, and at these resolutions it is impossible to detect the screen pattern. However, most people agree that increasing the screen frequency beyond 250–300 lpi has little or no effect visually.

The screen frequency that should be used is dependent on the requirements of the product and the printing process. It may be as little as 80–100 lpi in newspapers, or it may be 200 lpi or more for a prestige brochure printed by sheetfed litho on a smooth coated paper. High screen frequencies can make the printing of a job more challenging, since halftones will be more prone to dot gain and filling-in. When specifying a higher screen frequency than normal, it is important to ask the printer if the process and the paper can support it.

Table 9-1.
Highest commercially available screen rulings.

Process	Screen ruling
Lithography	200 lpi
Screen printing	133 lpi
Flexography	150 lpi

Note: Higher screen rulings are available, especially for sheetfed offset lithographic printing on good-quality coated stock, but there is usually a premium to pay.

Figure 9-10.
The image on the left has a screen ruling of 100 lpi, while the same image on the right has been reproduced at 200 lpi.

Screen angles. A periodic halftone screen consists of dots arranged in a regular pattern of rows and columns. If more than one color is being printed, the screens must be rotated to prevent objectionable moiré patterns. The ideal angle between two colors is 30°, which reduces moiré patterns to a minimum. In four-color printing, it is not possible to angle all four colors at 30°, as the fourth color would end up at the same angle as the first color. Many high-end systems use the angles originally developed for traditional halftoning:

Cyan	15°
Magenta	75°
Yellow	0°
Black	45°

Figure 9-11.
The most commonly used screen angles for four-color process work, keeping a 30° separation between colors likely to cause moiré.

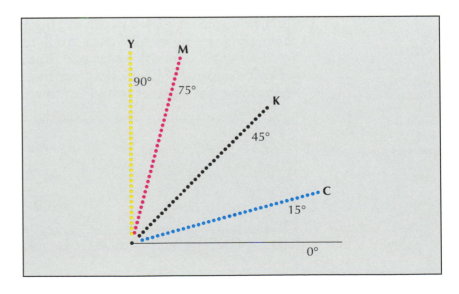

Other sets of screen angles are possible, as long as the black screen (which tends to be most visible to the eye) is set at 45°, the angle that is least noticeable; and the cyan and magenta pair (which are most likely to cause a visible moiré pattern), are angled at 30° to each other and to the black.

Mono halftones almost always use the 45° angle. In conventional color separations, the black plate is quite light and it is possible to modify the angles listed above, as long as the relative angles between colors remains the same. In color separations using gray component replacement (GCR), the black is much heavier, and it is definitely preferable to keep it at 45°.

At the correct screen angles, the moiré pattern appears as a tiny rosette where the dots of the four colors cluster together in a ring. If screen angles are not set with great accuracy more objectionable moiré patterns will be seen, especially in large areas of even color or flat tints. Moiré in multicolor tints cannot be entirely eliminated, but it can be reduced by increasing the screen frequency of the tint, or by making the screen frequencies of each color slightly different.

Dot shapes. The actual shape of the dot has little effect on the visual appearance of a halftone, other than affecting its tonal gradation in midtones. The coarser the screen ruling, the more visible the shape of the halftone dot will be.

A conventional photographic halftone based on a crossline screen produces a dot shape that is square at the 50% tonal value and becomes circular as the dot becomes larger or smaller. As the dot size approaches 50%, the corners join up with the adjacent dots, creating a jump in tonal value. In the midtones of halftones and graduated fills, these **artifacts** can be quite noticeable.

These problems can be dealt with by using an elliptically shaped dot. Here the dots join up first at the long edge, and then later on the short edge, thus distributing the jump in tonal value over a larger range of dot sizes and providing a

Figure 9-12.
Halftone dot shapes can be user-defined if the application program supports custom spot functions.

Figure 9-13.
A. Square dots are said to enhance sharpness.
B. Elliptical dots create smoother tone transitions in midtone areas, such as flesh tones.

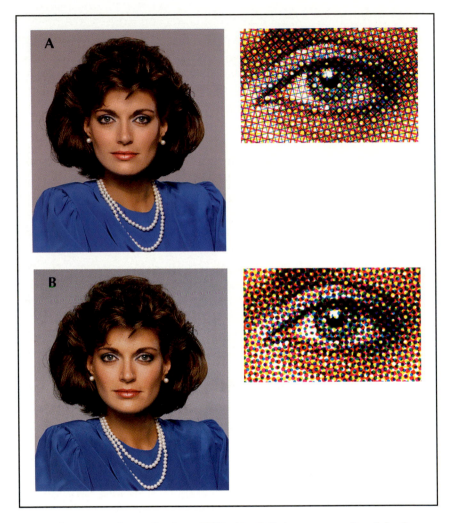

smoother tonal gradation. Elliptical dots are preferable for pictures where there is a lot of important midtone detail, such as flesh tones.

Halftone parameters can be included in EPS files, but these parameters can be overridden in favor of the output device's native screening methods.

An output device may not recognize halftone parameters that are specified. If, for example, unsupported screen angles are requested from a PostScript Level 1 interpreter, the interpreter will use the nearest available angles. PostScript Levels 2 and above allow the application to define different screen frequencies for different colors.

Tints. Tints are areas of tone produced by printing halftone dots instead of a solid ink film. Tints are frequently used to

incorporate additional areas of color on a page, often as a background to type. They can be printed in CMYK to reproduce any of the colors in the CMYK gamut, and they can be printed in special colors to extend the range of colors on the page. Tints can be used as areas of flat color, in which the same dot size is printed in the whole of the area defined, or as graduated tints over any specified tonal range.

Graduated tints will have a contoured appearance if there are not enough gray levels available for a smooth transition. They can also consume a disproportionate amount of memory and time on the raster image processor (RIP).

PostScript devices with pre-Level 3 interpreters do not reproduce a graduated tint as a continuously varying halftone, but as a series of separate lines. The number of lines is equal to the number of gray levels used in the tint. This can be specified by the user in some graphics applications.

Imaging the Halftone Screen

A digital halftone screen is based on the grid of pixels that the controller of an output device can address. In conventional halftoning, the address grid is subdivided into an array of cells each containing a number of individual device pixels. A halftone dot is then imaged within each cell.

Given that the size of an addressable pixel is fixed, the size chosen for the halftone cell determines both the screen frequency (the number of cells per linear inch) and the number of gray levels (the number of addressable pixels within the cell).

Thus if the halftone frequency changes, so will the number of gray levels. The relationship between halftone frequency and gray levels is defined by:

$$\text{Device resolution} = \text{Screen frequency} \times \sqrt{\text{Gray levels}}$$

To achieve 256 gray levels, the halftone cell would need to be based on a 16×16 grid of device pixels. It follows that the maximum screen frequency at this number of gray levels is the device resolution divided by 16. A 3,200-dpi imagesetter will thus enable a 200-lpi screen to be output; while a 300-dpi laser printer would only be able to produce an 18-lpi halftone.

Although CMYK values are sometimes specified in integer (whole number) steps between 0 and 100, it is common to use a precision of 0.5%. Halftone cells with 8×8 and 12×12 pixels can also be used, although there can be a slight risk of con-

touring as the 256 levels of the image are mapped onto a smaller number of gray levels. A dithering technique can be used to overcome this.

Threshold arrays. The tonal value of any halftone cell is determined by the total number of device pixels within the cell that are switched on (imaged by the marking engine). The locations of the imaged pixels within the cell do not affect the tonal value, and so the sequence in which the pixels are switched on (and the resulting halftone pattern or dot shape) is completely flexible. (In fact the halftone pattern does affect the tonal value somewhat, since the amount of dot gain is linked to the periphery of the halftone spots, but the tone reproduction curve for a given halftone pattern is reasonably consistent and can be compensated for through a transfer function.)

The sequence in which device pixels within a halftone cell change from white to black as the tonal value specified for the cell increases is known as a **threshold array.** The threshold array specifies a threshold value for each device pixel within the halftone cell. When an image is sent to the interpreter, it compares the threshold value of each pixel in the cell with the tonal value of the corresponding region of the image. All the device pixels with threshold values below

Figure 9-14.
Threshold array.

A threshold array defines the order in which device pixels are imaged as the gray scale value increases. In this example, a halftone cell consists of an 8×8 array of device pixels that are switched on from the center outward (A). A 12% dot, corresponding to a gray scale value of 8 in this threshold array is shown in B. Once a threshold array has been constructed, it can be tiled across the whole output device address grid. Small differences between cells permit more flexibility in the screening systems used.

Figure 9-15.
Halftoning with single cells (A) and super-cells (B).

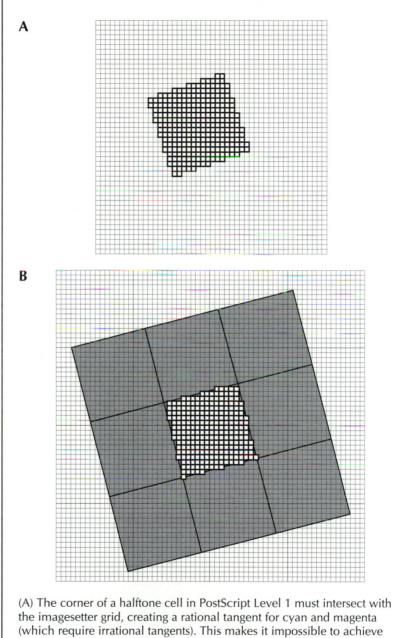

(A) The corner of a halftone cell in PostScript Level 1 must intersect with the imagesetter grid, creating a rational tangent for cyan and magenta (which require irrational tangents). This makes it impossible to achieve accurate screen angles; instead, the nearest possible angle (rational tangent) is substituted.

(B) PostScript Level 2 supports supercells that contain several halftone cells. The corners of the supercell intersect with the imagesetter grid, even though the individual cells do not. Cells may not be exactly the same size, but give more flexibility in building the dot and make it possible to achieve almost perfect screen angles for cyan and magenta.

the image tonal value are switched on, while the remainder remain off. Because a threshold array is specified in terms of individual device pixels, it is device-dependent and cannot be constructed unless the output device is known.

Spot functions. The sequence in which the device pixels are switched on can also be described by a mathematical function known as a **spot function.** A spot function is resolution-independent, and thus the resolution of the target output device does not need to be known at the time that the spot function is specified. The interpreter uses the spot function to calculate the threshold values of the threshold array. If the spot function specifies that the sequence is to be directly related to the distance from the dot center, then as the gray level changes from white to black the dot will gradually be built up in a spiral. If the spot function relates the sequence to a center line instead of a center point, then a line screen will be built up.

Figure 9-16.
An individual halftone dot is built from the array of device pixels defined by the output device address grid.

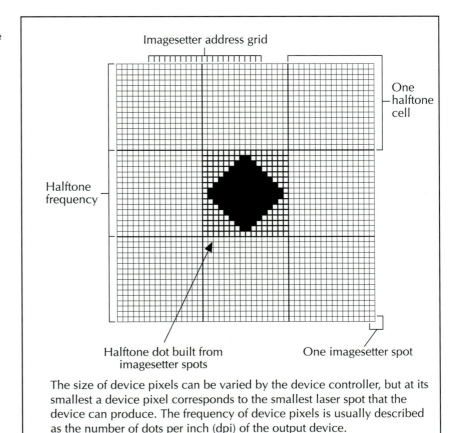

Imagesetter address grid

One halftone cell

Halftone frequency

Halftone dot built from imagesetter spots

One imagesetter spot

The size of device pixels can be varied by the device controller, but at its smallest a device pixel corresponds to the smallest laser spot that the device can produce. The frequency of device pixels is usually described as the number of dots per inch (dpi) of the output device.

A spot function is generated by the user application according to the dot shape chosen by the user. In applications that allow custom dot shapes it is possible to define the spot function by entering PostScript code.

The spot function default in most PostScript interpreters is the **Euclidean dot,** which is a composite shape built up from different spot functions. It simulates the traditional "square" dot obtained from a photographic halftone screen, with a distinctive checkerboard pattern in midtones and round dots elsewhere in the tone scale. This type of dot pattern shows a jump in tonal value in midtones as the corners of the squares join up. This tone shift can be a problem in images that are dominated by midtones, and smoother transitions can be achieved by choosing an elliptical or rhomboid dot shape.

A threshold array is defined for a single halftone cell in PostScript Level 1, but in Level 2 implementations can be based on multiple cells (or **supercells)** to give a better chance of precisely matching the requested halftone parameters. Calculating a threshold array can be a computationally intensive process, but once the calculation has been performed, the threshold array can be rapidly tiled across the entire address grid. After computation, a threshold array can also be held in a screen cache in the output device to avoid the need for recalculation each time a halftone screen is required within a document.

A spot function can, if required, define a multicenter halftone cell. In this case the halftone cell is divided into four subcells, and a cluster of device pixels is switched on within each subcell. The overall number of device pixels that define a given tonal value remains the same as with a single-cell halftone dot, but the effect is of a higher screen frequency.

If the device does not have a bilevel marking engine but can vary the intensity of the device pixels, the number of pixels needed in each halftone cell can be reduced. This relationship can be expressed as:

Number of pixels in cell =

$$\frac{\text{Gray levels in image}}{\text{Available intensity levels in device}}$$

From this relationship it can be seen that if the device can achieve 256 intensity levels, just a single device pixel is required to define a halftone cell for an image with 8 bits per color.

Frequency Modulation

In the previous section we looked at threshold arrays that form a clustered dot by switching on device pixels in a sequence in which each pixel is adjacent to an existing pixel. Threshold arrays can also be built in which the sequence of pixels is not clustered together but dispersed throughout the halftone cell. It is also possible to dispense with the threshold array and calculate screen values directly by "error diffusion." Dispersed dot halftones encompass a range of screening techniques, including frequency-modulated and stochastic screens.

Frequency-modulated (FM) screening uses small clusters of device pixels (typically between one and sixteen pixels) which are dispersed throughout the halftone cell. The clusters or "spots" are of a constant size, but the number of spots within a halftone cell varies according to the tonal value being imaged. Spots become widely spaced in highlights and clustered closely together in shadows. A frequency-modulated screen thus has an appearance of a variable dot spacing, in contrast to conventional halftone screens that have a constant spacing and variable size.

Some FM screening methods also use information about neighboring pixels to decide whether a pixel should be switched on. This technique, often referred to as **error dispersion,** tends to give a less clumpy appearance than FM. Error dispersion is computed on the fly during output, making it a processor-intensive operation.

It is possible to combine clustered-dot and dispersed-dot methods to give a halftone dot that varies in size and also in spacing. One example of this approach is known as **second-order frequency modulation.** The range of dot sizes and the degree of modulation that can be achieved are dependent on the resolution of the address grid.

Although frequency-modulated (stochastic) screens do not have the periodic dot pattern of a conventional halftone screen, they often exhibit other visible patterns. These patterns can be regular or noise-like, and they can be particularly objectionable in flat tints and gradations. The challenge in nonperiodic screening is to minimize these effects, and a great deal of work is being done on techniques to do so.

Frequency modulation can make a reproduction appear more like a photographic original. (In a photograph, tonal information is carried by grains of metallic silver, the overall tonal value in any area corresponding to the amount of light it has received during exposure. The exact size and position

Figure 9-17.
A. Conventional halftone screen (cyan printer has been enlarged to show detail).

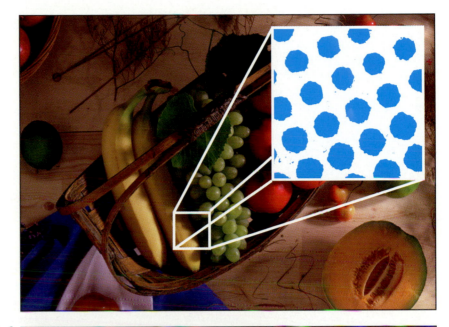

B. Frequency-modulated halftone screen (cyan printer has been enlarged to show detail).

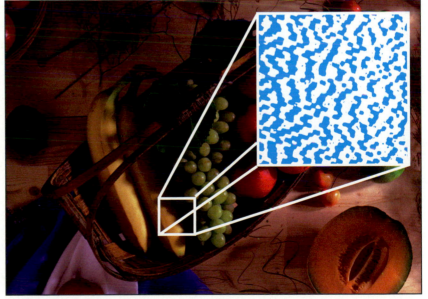

of every grain is subject to a number of factors, including the presence of nearby grains.)

The benefits claimed for FM screening are:

- Any number of colors can be printed without interference patterns, such as moiré.
- Greater tone value stability, with less fluctuation with inking variation.

- Appearance can be equivalent to using a high screen frequency.
- Sampling frequencies can be reduced without loss of quality.
- Greater ink densities are possible, resulting in a larger color gamut.
- Screen angle problems that arise in periodic screening are avoided.
- There is less risk of object moiré (screen interference with patterned image detail).
- Better rendition of image detail.
- More homogenous rendition of special colors.

These benefits have been confirmed in studies by Pira International. However, the appearance of an FM-screened image is indistinguishable from one screened by conventional screens, when viewed at normal viewing distance. The benefits of FM are perhaps more readily apparent when applied to lower-resolution printing processes, such as flexo and office inkjet printers. They can also improve the appearance of certain types of image, for example by eliminating object moiré.

Spot sizes in FM screens are usually specified in terms of their size in microns; they range from 14 to 80 microns. Smaller spots are especially prone to variation during plate exposure and processing, and to wear during printing. Because of the small spot size in comparison with a conventional halftone dot, special care must be taken to calibrate plate exposures and avoid dusty working environments. Plates with high resolving power are required for FM screens. Larger spot sizes are more robust but give more visible noise.

Table 9-2.
Spot sizes for different processes.

Spot size (microns)	Process	Equivalent dot area for for 150-lpi AM screen	Number of device pixels on a 2400-dpi output device
14	High-quality sheetfed litho	0.5	2
20	Heatset and sheetfed litho	1	4
30	Coldset litho	2	9
40	Flexo	4	16

Dot Gain

Halftone dots undergo a series of transformations before their eventual appearance on the printed sheet, and at each transformation a distortion occurs that affects the tonal value of the final printed image.

Initially, there will be a small change in dot size when the page is output onto film or plate, unless the output device has been perfectly calibrated. When film is exposed onto the printing plate or onto an intermediate contact film, there will be another change in dot size. This change will be of the order of 3% for a conventional screen, but significantly more for FM screens owing to the smaller areas being imaged. A further distortion occurs when the ink film is squashed during printing, causing it to spread out sideways. Finally, light scatter in the paper has the effect of reducing the reflection from the paper, as if the dot size had been further enlarged.

Halftone dots thus end up larger on the printed reproduction than on the printing plate. This phenomenon is known as **dot gain,** and it makes halftones look darker as a larger proportion of the paper surface is covered by ink. Midtones are especially affected, and shadow tones tend to fill in and obscure shadow detail.

Dot gain is an inevitable aspect of the printing process. The amount of gain can be minimized in a well-controlled process, but it cannot be eliminated. It is essential to standardize the degree of dot gain inherent at each stage and make allowances for it when the films are output.

The term dot gain was previously defined as the difference between the actual dot size on the film and the dot size on the print. Since film is no longer an essential intermediate, it is now more usual to define dot gain as the difference between the dot areas specified in the digital file and reproduced on

Figure 9-18.
Dot gain.

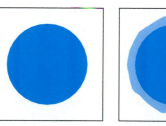

The square around each dot shows the area occupied by a "100%" dot.

A 40% dot on film

The same 40% dot becomes a 57% dot when printed

Dot gain is the change in size between the dot recorded on film and the dot finally printed on paper. The gain includes both the mechanical increase and the optical effect that arises from light scatter. In this example, a 40% dot on film has an apparent size of 57% when printed, and hence a gain of 17%.

Figure 9-19.
The image on the left incorporates an allowance for dot gain on press, while the image on the right does not as indicated by the shift in its tonal gradation.

the print. Dot gain is also known as **tonal value transfer** or **tone value increase.**

The difference between the dot size in the file and that actually output on film (or on the plate in a CTP system) is known as **recorder gain.** Appropriate adjustments must be made to compensate for recorder gain to ensure that correct tonal values are imaged on the film or plate.

Dot gain is influenced by a large number of factors, including the design of the printing press, pressures of rollers and cylinders, and the properties of the ink and paper used. Of these, paper has by far the largest effect, and the more absorbent and porous it is, the greater the dot gain will be. The second most important variable is the ink: higher ink weights and lower viscosities lead to more dot gain.

All of these variables can be standardized, and, in fact, there are widely accepted standards that define an acceptable range of dot gain for each paper type. Paper is grouped into four basic types (art, matte, uncoated, and newsprint), and a standard dot gain value can be specified for each one.

The tone value increase between plate and print has two components: the mechanical enlargement of the dot through pressure and absorption, and the optical effect of light scattering. This effect, in which the dot seems to cast a shadow into the paper, is often known as **optical dot gain,** and it makes a printed tonal area seem darker than the physical dot size alone would suggest. In laminate proofing systems (such as Cromalin) only optical dot gain occurs, and the layers of laminate manage to simulate by optical means alone the combination of mechanical and optical dot gain that occurs during printing.

Tonal value transfer throughout the tonal range can be shown in a **tone reproduction curve (TRC).** The dot gain is the vertical difference between the original tonal value and the tonal value on the print.

Figure 9-20.
A tone reproduction curve shows the amount of dot gain that occurs at each tonal value.

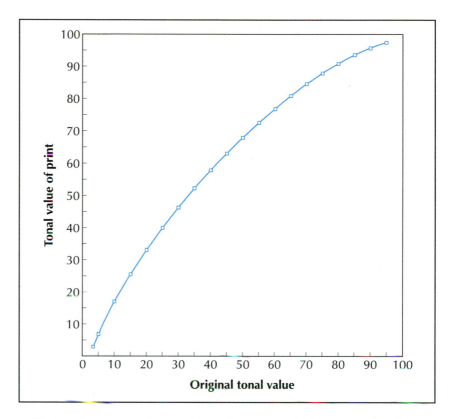

Dot gain cannot be evaluated accurately by eye, so a densitometer is used. It measures the density of a halftone area and calculates the area that is effectively covered by ink. Measurements are usually accurate to within 1%.

The amount of dot gain that occurs is influenced by the size of the dot periphery, and, for this reason, it is greater in midtones and with finer screen rulings.

The tone reproduction curve for offset litho usually follows the same basic shape (unless there is some distortion caused by abnormal conditions), so that the whole curve can be extrapolated from one or two readings. Tone reproduction curves in gravure, flexo, and screen printing also follow consistent patterns, although they are somewhat different from those of offset litho.

Dot gain is normally compensated for during conversion to CMYK dot values, and it should not be necessary to compensate additionally, for example, with transfer functions.

Printers are continually improving their ability to print sharper halftones with less dot gain. Gain on web presses, usually much higher than on sheetfed presses, is gradually coming down closer to sheetfed levels, but, at the same time,

good sheetfed printers are themselves achieving even lower levels. This is an advantage, since it allows higher ink weights and finer screens to be printed without causing excessive dot gain and filling-in of shadows.

Displays

Monitors used in the graphic arts are mainly **cathode-ray tube (CRT)** displays. Three electron guns (one for each color) repeatedly scan across the display screen and selectively fire electrons at the screen, causing colored phosphors to emit light. Persistence of vision results in these successively illuminated pixels being seen as a continuous two-dimensional image.

Display characteristics are determined by two main factors: the **light-emitting phosphors** and the **display gamma.**

The phosphors used in displays are reasonably standardized; a little variation between models can be seen during warming-up and in the deterioration of the phosphors over time. The intensity of the emission at each location is controlled by the exact voltage potential between the electron gun and the screen. A **digital-to-analog converter (DAC)** in the host computer converts the digital values used to describe the pixel into the analog voltages needed to create the display.

The term gamma describes the way in which the RGB digital values are mapped to the intensities of the electron gun. The gamma is the exponent, so, for example, a gamma of 1.5 would imply intensities of $R_{1.5}$, $G_{1.5}$, and $B_{1.5}$. This relationship is modified by the brightness and contrast (also known as **gain** and **offset)** settings that are under user control, and they are typically adjusted by the user to compensate for changes in ambient illumination.

The display **gamma** is actually the product of two separate components: the gammas of the display hardware (or CRT), and the frame buffer lookup tables of the host computer. CRT gamma is quite consistent between different devices. (The great majority of CRTs are manufactured with a gamma of 2.2 with relatively little variation between them.) The frame buffer LUT is the main source of variation in display gamma and tends to vary between different platforms: the Macintosh has a LUT gamma of 1.4; the PC usually 1.0; and a typical workstation 1.7.

The following display properties are determined by the graphics board and the video driver:

Addressable resolution. The number of pixels that can be displayed on screen depends on the frequency (or pitch) of the phosphors and the spacing of the shadow mask, and also on the amount of video memory available. The effective display resolution is also influenced by the spot size of the electron beam, the width of the scan line, and any light scattering or interference that occurs.

Color depth. Graphic arts systems are normally set up for twenty-four-bit color, for which the DAC must support eight bits per color channel and the video board in the host computer must have three bytes of RAM memory available for each screen pixel in the display. Outside of the graphic arts, users may have eight-bit (256 colors) or sixteen-bit (65,536 colors) displays, with dithering of intermediate colors. (In practice, a sixteen-bit display is almost indistinguishable from a twenty-four-bit display.)

If the image is created for display only (for example in a page designed to be downloaded over the Web), it is often necessary to convert the image to eight-bit index color. If the conversion to eight bits is performed adaptively, an acceptable screen display can be generated for most images. To reduce the risk of unpleasant dither patterns, the 216 colors common to both Mac and Windows operating systems can be used as a color palette for indexing.

Refresh rate. If the rate at which the electron beam repeats the raster scan of the whole display (i.e., the refresh rate) is too low, the screen will appear to flicker. A refresh rate of seventy cycles per second (70 Hz) is the minimum for flicker-free screens, although even at 80–90 Hz, a degree of flicker can be apparent. Flicker becomes more noticeable at higher brightness settings and can also be a result of a strobing effect from fluorescent room lighting.

Graphics boards. Since a color monitor is an analog device, the colors it can display vary continuously between the minimum and maximum luminance levels for each color. The constraints on addressability and color depth are the limitations of the graphics board and the driver software responsible for converting the digital image to analog voltages, rather than the monitor itself. A good graphics board will utilize the monitor to the best effect, speeding up screen redraws and enabling more accurate color judgments to be made.

The three types of graphics boards are:
- **Standard boards** in which all processing is carried out on the host computer, the board simply transforming the pixel values to analog signals and passing them to the monitor.
- **Accelerator boards** that have built-in basic graphics operations and drawing primitives.
- **Graphics coprocessors** that store graphic objects and instructions and calculate the way in which graphics commands from the host computer are to be executed.

Accelerator boards enhance the display speed considerably, but graphics coprocessors are a better solution, as they reduce the demands made on the host computer's resources.

Color depth and resolution can be adjusted (within the range supported by the amount of video memory available) by the operating system's "displays" control panel or, in many cases, by a control panel supplied by the device manufacturer. Expanding color depth and resolution increases the amount of computation needed, causing a drop in performance, unless the extra processing is carried out by a fast graphics board.

Display factors. As ambient illumination changes, the eye adapts to the overall amount of light, and the apparent brightness of the display changes. To minimize the effect of ambient illumination, room illumination should be as consistent as possible, and natural daylight must not be allowed to fall directly on the screen. Where critical color judgments are made, the monitor surroundings must be considered very carefully and standardized viewing conditions (described in Chapter 1) implemented.

Ergonomic factors should also be taken into consideration. Eye strain and headaches among monitor users are linked to the brightness of the display and to strain on shoulder and back muscles. Users should take occasional short breaks, focusing on a distant spot away from the screen. If problems are encountered, it can help to reduce the display brightness when working on jobs that do not require color judgments.

Working with a large monitor is essential for graphic arts work, in order to have a full view of the page and any other on-screen items. The common 14- and 15-in. screens (as measured diagonally across the screen) are appropriate for business applications, but when used for page-makeup or image-editing, the user is forced to continually scroll the display.

A 19-in. monitor will display a page full-screen in portrait orientation, while a 21-in. screen also makes room for other items like menus and toolbars to be displayed. Where space and resources permit, a second monitor allows the display area to be divided between the current document and other windows such as color palettes.

A CRT display is relatively large and heavy, with a front-to-back dimension in most cases greater than the screen diagonal. Flat-panel displays exploit a variety of display technologies, the most widely used being the liquid crystal display (LCD). Flat-panel displays are not widely used in the graphic arts at present, but a number of promising technologies, including gas plasma, make it possible that flat-panel displays could shortly become be an option for many applications, particularly where space is important. For end-user applications, flat-panel technologies offer many exciting possibilities, including lenticular screens that can generate three-dimensional displays.

Bibliography

Adams, R., and F. Romano (1999). *Computer-to-plate: Automating the printing industry*. 2nd edition. GATF*Press*.

Doyle, S. (1997). *Advances in printing plate technology*. Leatherhead: Pira International.

Fink, P. (1992). *PostScript screening*. Mountain View, CA: Adobe Press.

Kang, H. R. (1996). *Color technology for electronic imaging devices*. Bellingham, WA: SPIE Press.

MacDonald, L. (1997). *Display systems: design & applications*. New York: Wiley.

Travis, D. (1991). *Effective colour displays*. Academic Press.

Tritton, K. (1996). *Stochastic screening*. Leatherhead: Pira International.

Viggiano, J. A. S. (1985). "The color of halftone tints." *1985 TAGA Proceedings*.

Viggiano, J. A. S. (1990). "Modelling the color of multi-colored halftones." *1990 TAGA Proceedings*.

10 Workflow

In a production environment, color files may be handled on different machines dedicated to specific parts of the production task—from scanning, editing, and separating, through final output. Files are transferred among various machines as they move through the different phases of production. A typical production workflow is shown in Figure 10-1.

Figure 10-1.
Typical production workflow.

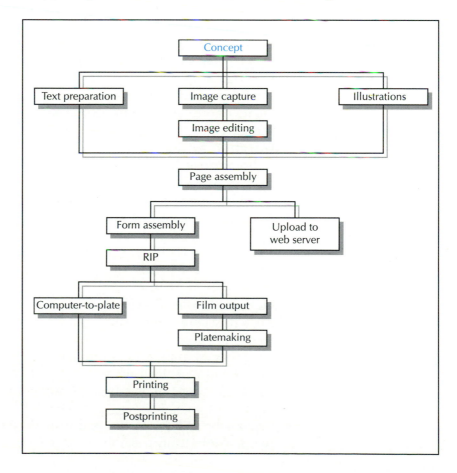

The ability to implement and maintain an efficient workflow is increasingly important to graphic arts businesses. The primary components of workflow can be considered as the individual production processes, the physical connections between them, and the automation achieved in routing jobs through to completion. It is closely linked to the process management tasks of scheduling, production control, and billing.

Some components of automated workflows include:

- **Pipelines.** A pipeline is a series of processes that can be applied to a job. Files may move automatically between different processes through watched folders. Pipelines can if necessary be combined to define a complete production workflow.
- **Queues.** An automated production queue is a sequence of jobs awaiting processing. Entry to a production queue may be controlled by production management software or by a human operator. Queue priority should ideally be editable, so that jobs can be moved up in the production sequence where necessary.
- **Batch processing.** A production task is applied to a series of files instead of a single file.
- **Preflighting.** On entry into automated workflows, jobs should be checked for conformance with production requirements and to verify that all the resources needed are present.
- **Watched folders.** When a file arrives in a watched folder or **hot folder** location, a predefined process or pipeline is applied to it. The new file will usually be saved in another location, and the original file may be deleted.
- **Automated backup and archiving.** Work in progress and finished jobs are automatically backed up to archive storage for possible reuse, for reprints or in case of system failure.

Automated workflows require a high level of interconnectivity, with robust file formats based on open systems and agreed-upon standards.

Workflow management systems need to be able to:
- Set and alter priorities.
- Enable content to be edited at any point in the production cycle.
- Track jobs and processes and provide tracking information to operators (and possibly customers).

- Provide access to resources required by production processes, such as fonts, color profiles, or high-resolution images.
- Provide a mechanism for controlling the versions of files in use, such as archiving a master file, or preventing concurrent processes on the same file.

The information accompanying a job — the content metadata — is especially important to workflow systems. It provides the information with which to automatically configure production processes, recognize content types, and decide the processes that should be applied. A workflow system should be able to extract content metadata, make it available to any process that requires it, and preserve or update it for later use. **Job tickets** define the information needed to process a job in a way that meets the need of the production workflow.

A production workflow is based on network and communication systems. It may make use of file compression, a picture replacement system such as OPI, and methods of passing prepress data and other information between the production management system and different processes. It's also important to consider production issues, such as trapping and imposition, as part of the workflow.

Network

In all but the smallest businesses, individual machines are linked together in a **local area network (LAN).** This network is the communications backbone of the business; it should be designed to meet the needs of the current production workflow, and it should be flexible for the future.

Files and applications that all machines need access to are held on a **file server,** which also controls printers and other shared devices. A network can be a mix of different platforms, the server often being a highly specified machine with multiple hard drives. High-end systems have tended to employ workstation-based servers, but increasingly standard-platform machines, such as dual-processor PCs running Windows NT, are used for such tasks.

In print production environments, data transfer has in the past involved sending files from one machine to another, rather than sharing files among many machines. Workflows are increasingly designed around central storage of job files, with access provided to each client system on the network. In a shared environment, it is important to define appropriate

Figure 10-2.
A simple, relatively low-bandwidth Ethernet network based on a file server.

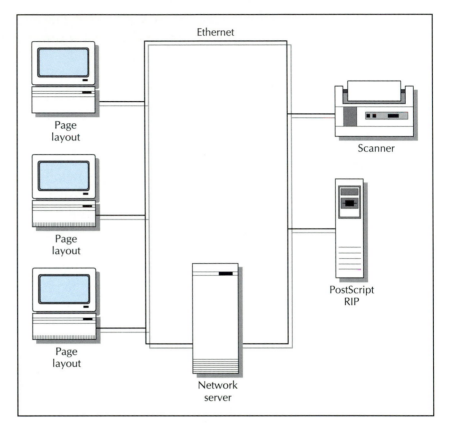

access privileges for individual users and to establish naming conventions for files, so that the file contents can be easily inferred.

Sneakernet—transferring files via removable media—should not be completely excluded, as it can often be faster than a network transfer, even when the bandwidth is high. It is also useful to have the diversity that removable media offer, in case of network problems.

Network traffic can be managed by using **routers** that examine packets of data and ensure that they are transmitted over the necessary parts of the network, using the maximum bandwidth available. Bandwidths can be increased by using higher-capacity systems such as Fast Ethernet, which can handle up to 100 Mbps. Incidentally, communications speeds are usually measured in bits (binary digits) per second, or bps; elsewhere, file transfer is measured in bytes (units of eight bits), abbreviated with a capital letter "B."

Local area networks use a range of **data buses** and **interfaces** for file transfer.

SCSI is an evolving standard, designed to be readily upgradable while retaining compatibility with older equipment. The standard is currently at Ultra2 SCSI, which provides for 80 Mbps throughput. Wide Ultra2 SCSI can support a maximum of 15 devices, although the limitations on cable length make it difficult to physically connect this many devices. The low voltage differential (LVD) technology used in Ultra2 SCSI introduces a degree of incompatibility with older equipment, and the full speeds cannot be reached unless all devices on the bus are Ultra2 SCSI.

Figure 10-3.
Adding a high-bandwidth connection between the systems that generate or require access to high-resolution image files minimizes traffic on the main network. In this example, the RIP archives high-resolution images while low-resolution preview files are circulated on the main network.

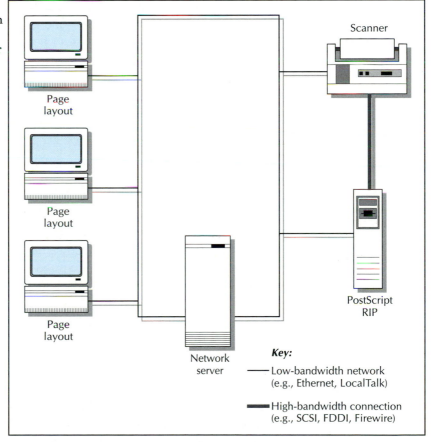

The **Universal Serial Bus (USB)** and **IEEE-1394 (FireWire)** interfaces are replacing both serial and parallel I/O interfaces in many systems. Firewire is designed to handle up to sixty-three devices and a maximum transfer rate of 400 Mbps. Other technologies, such as IBM's serial storage architecture (SSA) interface, are also being developed.

Like SCSI, **fiber optic** and **Ethernet** are both evolving systems that will be able to handle higher bandwidths in the future. The fiber optic standard FDDI (Fiber Distributed Data Interface) has been used by high-end systems for data transfer and is supported by many PostScript systems.

Communications

Communications links are widely used to transfer high-resolution data to output services and printers for film, plate, or proof. They can be also used to transfer data, such as scanned images, back to the designer or publisher for approval or inclusion in page layouts.

Complete pages can even be sent over communications links directly to a digital proofing device or printing press. In fact, communications links can act as an alternative to printing as a means of disseminating documents. Remote imaging will become more widely used as communications links become faster, more cost-effective, and more reliable.

Communications links can have analog elements (such as ordinary telephone lines) or be completely digital (such as ISDN). **Dial-up links** enable the user to connect as needed, with the service being billed by connection time. **Fixed links** provide a permanently open connection to another site and are normally leased at a monthly rate.

Analog connections using the **public service telephone network (PSTN)** require digital files to be modulated into an analog signal. The faster modems now available are approaching the transmission speed of a single ISDN line, but unavoidable line noise makes it difficult to advance beyond this without introducing digital connection protocols such as ISDN and ADSL. PSTN connections tend to be too slow when large volumes of data are sent. Speeds can be increased by using an **asynchronous connection,** in which the available bandwidth is shared unequally between upload and download.

Broadband communications networks are usually based on **ATM (asynchronous transfer mode)** and fixed links. A number of service providers now offer "store and forward" facilities, enabling users to send files over a fixed link to a central server, from where the recipient can download them, thus providing the functionality of a point-to-point connection.

E1 connections provide a 1.92-Mbps connection, while **T1** connections are 1.54 Mbps or higher.

PSTN-based dial-up digital services replace the analog links to exchanges with direct-digital connections. An ISDN

connection provides two 64-Kbps lines, and lines can be further multiplexed to create bandwidths of 2 Mbps and above.

An ISDN installation is usually connected by an interface card or an external adapter to a host computer, but it can also be connected directly to a compatible device, such as a color printer, for remote proofing.

Figure 10-4.
An example of the use of communications links between client and producer.

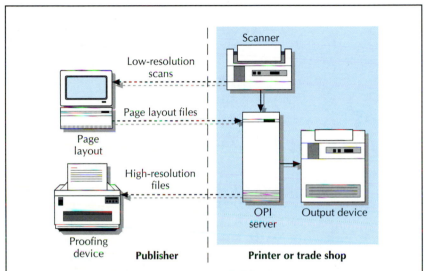

This is a link between a designer and a trade shop. Transparencies are scanned at the trade shop, and low-resolution versions are sent by modem to the designer. The pictures are placed by the designer, and the resulting page layout files with OPI comments embedded are sent back to the trade shop for the high-resolution files to be inserted. An ISDN link transmits the complete pages with the high-resolution files back to the designer's high-resolution color printer, which is being used as a remote proofing system. When the designer has approved the hard copy proofs, the pages are sent to the imagesetter for the films to be output.

Specialized communications software is necessary to manage ISDN communications. Additional options available include software to handle unattended file transfer and to manage communications from within applications such as QuarkXPress.

Network Services

Vio and **Wam!Net** both provide a managed network service with a range of bandwidth options for graphics arts users. These networks support **store and retrieve** and **store and forward** file transfer, where users send files to the network hub, from where they are downloaded by (or forwarded on to) the recipient. Messages are sent by email to alert the recipient

of the existence of files for download and to confirm their arrival to the sender.

A range of additional services are provided by both Vio and Wam!Net, including **file storage, remote proofing,** and **directory services.** File storage facilities enable files to be accessible to all users need them, as well as a secure backup system. File storage can be extended to more comprehensive media asset management services. The Vio network also provides an interface to content providers, such as image libraries and font vendors, and a secure transaction between parties using online payment technology.

The Vio network supports remote proofing via both displays and hard copies. It uses Scitex's RenderView to enable remote users to access variable-resolution images, and it publishes information for connected proofing engines, such as PPD files, color profiles, and calibration data.

The Vio network is accessed through a Web browser, and there is the possibility of users and third parties developing their own custom services using JavaScript and Java applets.

Internet Printing and Media Convergence

With the increasing use of the Internet as a communications medium, it is becoming common for documents to be prepared for both print and the World Wide Web. The tag structure of HTML makes it difficult to translate between it and graphics formats such as PostScript, but PDF files are suitable for both printing and viewing on-screen. When PDF files are used for both media, it is likely that image resolutions will need to be different. PDF files can be distilled from the same PostScript data with different resolution options, or a single low-resolution PDF can be created with the high-resolution file linked by OPI (described later in this chapter).

With the more recent versions of the HTML specification, Web pages are increasingly able to include complex graphical information. Increasing bandwidth availability and compression methods also make it possible to use higher-resolution images and greater color depth. These developments make publishing over the Internet for users to download and print locally a genuine possibility, and it should be recognized that an increasing number of documents will be published in this form.

Compression

Data compression reduces files sizes and minimizes storage and transfer requirements. Although the cost of storage media do not themselves make compression essential, there

is a need to keep transmission times to a minimum (especially when using external networks such as the Internet).

Capturing and storing an image as an array of separate pixels is something of a brute-force approach when compared to the elegance of the human visual mechanism. A high-resolution image file inevitably contains a quantity of redundant data that can be removed so that transfer and storage can be made faster and more cost-effective. Image compression algorithms use one of two approaches to remove redundant data:

- **Lossless algorithms** search for similarities within the captured data that they can code more efficiently.
- **Lossy algorithms** discard data that is least perceptible to the eye.

When lossless algorithms are used to compress an image, no information is discarded, and, after decompression, the image is identical to the original. Lossy algorithms provide higher compression ratios at the cost of some loss of information contained in the original image.

Lossless compression algorithms make use of the fact that most images do not contain all 16.7 million possible colors in a random arrangement. Rather they include objects with areas of identical or similar colors that are formed into regular shapes that do not vary suddenly except at boundaries. The likely value of a pixel can thus be inferred from the values of the surrounding pixels.

Run-length encoding (RLE) and **PackBits** algorithms simply encode a continuous run of identical pixels with the value of the first pixel and the number of identical pixels that follow. Very high compression ratios are achieved on images with large areas of flat color, but the technique is much less effective on the varying tones and detail found in a typical sampled image.

Huffman compression is a two-stage process that first divides the image into the different sequences of pixels that occur, then generates a lookup table that assigns a code to each sequence of pixels (the shortest codes being assigned the most frequent sequences). The **LZW algorithm** (named after its creators Lempel, Ziv, and Welch) creates a similar lookup table (known as a string table) to allot a code to each sequence of values that it encounters. The string table is built on the fly, and it is cleared after reaching a predetermined maximum number of entries. The LZW algorithm is

protected by a patent, and as a result many developers have adopted alternative compression methods.

Huffman and LZW handle repetitive patterns as well as solid areas of color, but like RLE, they achieve higher compression ratios on smooth images as opposed to ones with a large amount of noise or detail.

Lossy compression algorithms are based on the assumption that some high-frequency data captured by the scanner (corresponding to rapidly varying image detail) will not be perceived by the eye and can be discarded without the loss of data being perceptible.

Of the different lossy compression algorithms that exist, the **discrete cosine transform (DCT)** has become the most widely used and is the basis of the JPEG scheme. DCT is a type of **Fourier transform** (a class of frequency-domain image-processing algorithms), in which a linear transformation is applied to blocks of pixels in an image to produce a set of transform coefficients that are then quantized and encoded. Very small coefficients, corresponding to high-frequency information, can be discarded or coarsely quantized.

The amount of information discarded during JPEG compression, and the resultant compression ratio and reproduction quality, can be controlled by the user at the point when the file is compressed.

Even at very high quality (low-compression ratio) settings, some information is inevitably discarded in lossy compression. The degradation of an image may be almost insignificant, but nonetheless there will be some loss of detail, and JPEG compression should be used with care, especially where quality requirements are high. The observable image quality degradation effects of the DCT algorithm typically include:

• Visibility of "blocky" artifacts
• Smoothing of detail
• Fringing at edges
• Contouring in smooth areas of tone

The DCT algorithm can be modified to reduce these effects and to make the quantization process work adaptively according to the requirements of different regions of an image.

The **JPEG scheme** is a standard for image compression developed by the Joint Photographic Experts Group in collaboration with the International Standards Organization (ISO) and the Consultative Committee of the International Telephone and Telegraph (CCITT). JPEG is based on the

DCT algorithm but can also include other compression algorithms, which can be selected according to the needs of the application. The Huffman algorithm is also included in the standard and is used in combination with the DCT algorithm to get good compression ratios, or alone for cases where lossless compression is required.

A set of default DCT quantization tables are specified in a "baseline" JPEG standard, but application vendors can substitute their own values or make the process work adaptively according to the needs of the image. In practice, most images can be compressed with baseline JPEG at a ratio of up to 10:1 without a perceptible quality loss. Images with smooth gradations are most prone to degradation and should be compressed with lower compression ratios.

All four compression algorithms described above are supported in the TIFF file format. In the case of JPEG, a TIFF extension allows image compression parameters to be defined in tags (although such parameters are not essential for baseline encoded images, as they are included in the image data). This allows images to be compressed and decompressed successfully by different applications.

The PostScript language incorporates filters that can compress and decompress JPEG (baseline) and LZW images. The JPEG filter allows quantization tables and quality factors to be specified through the application. It also provides a means of converting images into a YUV or YUVK color space in order to separate luminance and chrominance components so that chrominance can be more highly compressed.

Since the JPEG standard is loosely defined and different implementations are possible, images compressed by one application may not be recognized by other applications, particularly if a specialized plug-in has been used. In this situation, the same application or plug-in may need to be employed at both compression and decompression stages.

Other methods include **fractal** and **wavelet compression.** Fractal compression looks for self-similarities within the structure of an image that can be encoded more efficiently. These are in effect complex similarities of pattern rather than relatively simple similarities of individual pixels and groups of pixels. Wavelet compression is a frequency-domain compression with parallels to the DCT method; it describes the relationship between pixels as a parent wave function and a series of daughter wavelets of decreasing magnitude that describe the high-frequency components of the image.

Figure 10-5.
Examples of different
levels of JPEG com-
pression. The image
is a detail from an
ISO 12640 CMYK
SCID file.
A. Uncompressed

B. 5:1 compression

C. 13:1 compression

Ideally, image compression should take place in the background, transparent to the user except when it is necessary to specify preferences, such as the level of quality. Systems that automatically compress files on the fly, such as communications devices, should also detect files that have already been compressed and not attempt to compress them further, as in doing so the file is likely to become larger (if the compression is lossless) or degrade quality further.

The compression methods discussed so far are usually applied to images with either RGB or CMYK components and are applied equally to each component. However, if the color components are organized so that luminance information is separate from chrominance (color), it is possible to improve the performance of the compression algorithm, for example by discarding some of the chrominance data while preserving luminance.

This principle is used in the encoding of Photo CD images. Subsampling is carried out on the YCC data so that only one bit of color information (CC components) is kept for every four bits of luminance information (Y component). Huffman encoding is then used to compress both lightness and color.

When the image is decompressed, interpolation is used to restore as much of the lost color information as possible.

Using different amounts of data for different color components makes it possible to achieve maximum compression while preserving the appearance of the image, but it does add a further stage to the decoding process.

It should be noted that when high-resolution images are handled on an internal network, the time required to run the compression and decompression algorithms imposes a performance penalty that may make it preferable to work with uncompressed files.

OPI

Open prepress interface (OPI) enhances a production workflow by holding high-resolution files on a server and sending low-resolution versions for placement within page-layout applications. The original high-resolution versions are then inserted when the job is output.

Low-resolution versions of scanned images are placed in a page, and OPI comments define which high-resolution files to substitute when a page is output.

OPI allows the scaling and cropping defined in a page-layout program to be applied without the user needing access to the high-resolution files. This speeds up page assembly and minimizes traffic on the main network, keeping high-resolution file transfer to a minimum (typically between scanner, image editing platform, OPI server, and output device).

There are two possible ways of working with OPI. The usual method is for the creator application (the OPI **producer)** to insert OPI **comments** into the PostScript code as it is generated, in place of the image data. This PostScript stream is sent to the OPI application (the **OPI consumer),** which processes the OPI comments and substitutes the corresponding high-resolution files as needed. In this method, the low-resolution image used in the document does not need to have been created from the original high-resolution file. This makes possible a flexible workflow, in which, for example, the placement files are scanned on a local low-resolution scanner, while the high-resolution file is scanned and archived on a remote server, without having to use the same original.

Alternatively, the low-resolution files can be first created from the high-resolution files, then transmitted to the page assembly environment, where they will be assembled with other page elements and later sent to the OPI consumer for insertion of the high-resolution files. In this case, OPI com-

ments can be included when the low-resolution files are created (if the EPS file format is used). Or an OPI tag can be included to define the file name and path of the high-resolution file (if the TIFF format is used). Image previews can be a problem with this method, especially when the page assembly platform is different from that of the OPI server.

The image is positioned on the page in the page-makeup application, and scaling, rotation, and clipping paths are all defined by the application in the PostScript stream prior to the OPI comments. Thus the task of the OPI consumer is simply to perform file substitution.

When an OPI comment is encountered by an OPI consumer, it will check whether there is a higher-resolution version on the OPI server and, if so, insert it. OPI comments are simply ignored by other applications, and an OPI consumer also ignores unsupported comments (such as pre-OPI 2.0 comments, which can also include image placement and limited image-editing information). The OPI consumer will normally be running on the OPI server, but it is also possible for it to run on a different machine, including one which is remotely connected to the OPI server.

An OPI workflow can, if required, apply OPI substitution more than once. The OPI consumer preserves OPI comments in case there is another consumer downstream in the workflow.

OPI comments define the following details:

- Information on whether the image file has been distilled to PDF.
- Name of the target low-resolution file that is to be replaced (and optionally the full pathname of the high-resolution version).
- Width and height of the final image.
- Crop area.
- Information about whether a color is set to overprint.
- Information about the inks to be used.
- Image dimensions of the target file (for comparison with any high-resolution versions on the OPI server).
- A quality setting that tells the OPI consumer whether OPI replacement is required, optional, or unnecessary.

OPI comments can define a crop area for an image, although these define just four coordinates and are thus limited to rectangles (and parallelograms).

Composite rather than separated images are recommended for use with OPI.

A page-makeup application will create its own linked, low-resolution version when a high-resolution image is placed in a document. This is simpler than using OPI, allowing the user to check the links to any high-resolution files before printing. If the page-makeup application has access to the high-resolution files, it may be preferable to use file linking, rather than OPI.

OPI is designed to work in both PostScript and non-PostScript environments. When used in a fully PostScript environment, the workflow is as shown in Figure 10-6. A TIFF image, usually a low-resolution version, is placed on the page in a page-layout application. The resulting file is then separated into the individual color components (CMYK), and, if necessary, the high-resolution version of the file is inserted before the image is rasterized and sent to the output device.

In a non-PostScript environment, the high-resolution files and the page-layout files are output independently of each other (as shown in Figure 10-7) and combined at the film stage prior to making plates.

The insertion of high-resolution files into the workflow is a processor- and memory-intensive operation and a potential

Figure 10-6.
In an all-PostScript production environment, the high-resolution files are held on the OPI server and inserted into the pages when they are output.

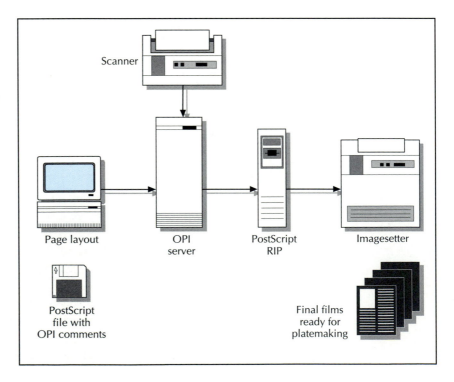

Scanner

Page layout

OPI
server

PostScript
RIP

Imagesetter

PostScript
file with
OPI comments

Final films
ready for
platemaking

Figure 10-7.
Workflow in a mixed environment including "legacy" high-end systems. The move to open systems and all-digital workflows has made the latter increasingly rare.

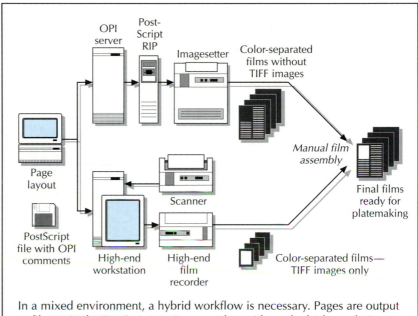

OPI server

Post-Script RIP

Imagesetter

Color-separated films without TIFF images

Page layout

PostScript file with OPI comments

Scanner

Manual film assembly

Final films ready for platemaking

High-end workstation

High-end film recorder

Color-separated films— TIFF images only

In a mixed environment, a hybrid workflow is necessary. Pages are output to film as in the PostScript environment but without the high-resolution images, which are scanned and output directly to film on a high-end system. The two sets of films are stripped together manually or by an automated step-and-repeat machine before platemaking.

bottleneck in production. Workstation-based OPI servers are essential to maintain a flow of high-resolution data to the output device.

Trapping

When a design calls for areas of color to abut, there is a risk that slight misregister during printing will cause a white line to appear between the two colors. Misregister of as little as 0.001 in. (0.025 mm) can be visible to the eye if the colors are highly contrasting, and while register between printed colors is usually held to an accuracy between 0.001 and 0.004 in. (0.025–0.1 mm), other factors, such as paper stretch and variation in the dimensions of film output, also contribute to the perception of misregister.

Spreading the two colors into each other slightly prevents the white line from appearing. This process is known as **trapping.** Although trapping is now completed by electronic methods, it was formerly done manually on film, and was also referred to as creating **spreads** and **chokes.**

Creating the spreads (where an object is enlarged outward) and chokes (where the background of an object is enlarged inward) was a skilled and time-consuming process when

traditional film-based methods were used. Many complex graphics were either difficult or impossible to trap manually, and there was inevitably a degree of variation depending on the individual stripper's interpretation of the job. Electronic trapping offers much greater control and precision, and it

Figure 10-8.
Misregistration is when colors do not print in the correct position, owing to dimensional changes in film, plate, or paper, or positioning inaccuracies in the output device or the printing press.

Figure 10-9.
Trapping with conventional photographic methods is simply a case of spreading colors into each other slightly. This cannot be done in PostScript, so an extra trap object is created.

To provide trapping of the images in the illustration at the left, a 0.75-pt. cyan box was placed around the picture and set to overprint. Also, a 0.75-pt. cyan outline of the letters "GATF" was placed around the magenta letters and also set to overprint. (The background of the illustration at the right has been removed to make it easier to see the trap objects.)

offers the possibility of creating traps that could not be generated manually, such as color blends.

The amount of misregister to allow for depends mainly on the size and dimensional stability of the paper. A multicolor press holds perfect register between colors once the plates have been positioned, and any misregister is caused by other factors, such as slight errors in fit between the films, lack of the necessary tolerance in positioning the plates on the press, and paper stretch during printing. Printing on web presses and on sheetfed presses that do not have enough units to print all the colors in one pass leads to greater variations in register.

Many printers are achieving very high standards of plate registration, aided by punch-register systems and computer-controlled cylinder movements. The inevitable spread that occurs on press when wet ink is transferred to the sheet is often enough to trap any remaining misregister, and, as a result, many printers do not require trapping at all. Nevertheless, because of film and paper fit issues, trapping remains an important consideration and should not be overlooked.

Trapping can take place as part of graphic design and page assembly, or at the output stage.

Illustration programs, such as Adobe Illustrator and Macromedia FreeHand, enable traps to be inserted into EPS graphics. It is also possible to specify output preferences in a desktop page-layout application. Trapping in QuarkXPress or PageMaker is more efficient than creating individual trap objects, as trap settings can be applied to a whole document as well as to individual graphics.

At the output stage, dedicated trapping utilities running on workstations, the trapping facilities in a high-end CEPS system, or RIP-based trapping programs are used. High-end CEPS systems and dedicated trapping programs analyze the page to locate regions of color that touch, and then trapping is handled automatically. Trapping utilities such as Imation TrapWise, Farrukh Trapper, and DK&A Trapper apply traps to EPS files, running largely unattended after the initial setup. The three fundamental methods of trapping are:

Vector trapping. The graphic objects in the file are analyzed, and where they touch new vectors are added to the boundary. The new vectors are stroked and set to overprint the two adjacent objects. Since the stroke straddles the boundary, its width should be twice the trap width required.

Figure 10-10.
Trap specifications in
DK&A Trapper.

Raster trapping. The file is rasterized and the individual pixels compared, with new pixels added on the boundary between regions of pixels.

Hybrid trapping. The file is rasterized and examined pixel by pixel, with new vector trap objects added to the file.

Vector trapping in the RIP is applied to interpreted Post-Script data. If the intermediate format used by the RIP prior to conversion to device pixels is a flattened, non-overlapping object format, trapping will be simpler and more compact.

Many trapping systems apply traps to separated files such as DCS format, rather than composite files. Ideally, trap information should be kept separate from the page content. This enables the page description to remain device-independent and reusable.

Imposition

When a job is printed, the number of pages on the printing plate will depend on the size of the finished job and the press format. There can be up to sixteen pages (or even more on large press sheets, or small-format jobs like pharmaceutical inserts) on each plate, and it is essential that all the pages are positioned accurately, so that when the job is folded the pages appear in the correct sequence. A single transposition can result in a large quantity of printing being scrapped, and even seemingly minor errors can create extra work in binding or unpleasant effects in the finished job.

Pages imposed together to image one side of a press sheet are known as a **flat.** The two sides are referred to as a sheet or **section.**

Figure 10-11.
Imposition scheme for a stitched publication. S is the section number, with sections numbered from zero outward.

The imposition process is accomplished by:

- Stripping page film together either manually or with automatic step-and-repeat equipment.
- Imposing pages electronically before output.

Electronic imposition is increasingly preferred for film output, as it makes it possible to generate a one-piece plate-ready film. For CTP and direct-to-press systems, it is obviously a requirement. If the width of film that can be output by the imagesetter is less than the width of the press sheet, it is possible to output strips of film that can be joined together after output. Registration tables to facilitate this process are available.

Imposition takes place downstream of page makeup, and it is performed on final page data with all fonts, images, and so on in place. Imposition software usually has as input the PostScript stream for a document; it interprets the PostScript code to extract individual pages. It is also possible to use PDF and TIFF/IT files as input.

Manually imposing page film is a relatively quick and straightforward operation, still performed where there are difficulties in achieving full electronic imposition.

Some of the issues to consider in electronic imposition are:

- The workflow will ideally be fully digital, and if color separated films are received from other sources, such as advertisers, they must either be rescanned and combined with the digital data or stripped in manually after output.

- The maximum output width of the imagesetter determines the size of the film that can be output. Large-format imagesetters are becoming increasingly common to meet the need for imposed, press-ready films.
- After imposition, individual page elements can be difficult to edit.
- Any alterations and corrections after output will require reimaging of the entire flat (except in the case of corrections to films, which can be stripped in manually).
- Inconsistencies in film or plate transport in the exposure device will lead to misregister, and this will be greater on larger flats.
- Large amounts of storage are needed for rasterized image data, even if they are stored only temporarily until a job is completed.

Imposition programs, such as Imation PressWise, Farrukh Systems Imposition Publisher, and DK&A INposition (a QuarkXPress extension), can be used to carry out imposition, although it is important that the printer is in agreement about the actual folding method. Some imposition programs produce a low-resolution preview of the imposed flat that can be checked before the job is output.

Factors that are taken into account when planning an imposition scheme include:

- The size of the finished job.
- The size of the sheet or reel that is printed.
- Allowance for control elements, such as register marks, cut marks, and color control strips.

Figure 10-12.
DK&A INposition, an imposition program.

- The folding and binding equipment that will be used.
- The total number of pages.
- The number of pages in a section or signature.
- The paper grain direction.
- Any allowance for laps.
- Any allowance for shingling.

Whenever possible folds are planned to run in the grain direction of the paper. This is especially important where the fold is a book or cover spine.

Laps are added to folded sections to allow the suckers on saddle-stitching machines to open the section up so that it can be dropped onto the saddle. The lap allowance is usually between 0.25 and 0.4 in. (6–10 mm).

Figure 10-13.
A lap is created so that the binding equipment can open the folded section in preparation for inserting and stitching.

Binding lap, or lip

Shingling of pages is necessary in saddle-stitched publications that are more than 0.1 in. (2.5 mm) thick (48 pages of 70-lb. [100-gsm] coated, book paper). The inner sections are pushed outwards as they are inserted into the other sections, and fore-edge margins will be truncated unless the pages are offset slightly to compensate.

Page-makeup systems are concerned mainly with the page as the unit of production, and extending this to page imposition may seem the next logical step. It increases the publisher's control over production; complete, plate-ready output is delivered to the printer. However, it also means taking responsibility for a complex area of production that is usually the printer's domain.

Figure 10-14.
Shingling.

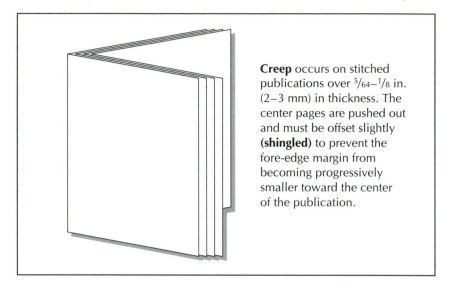

Creep occurs on stitched publications over $5/64 - 1/8$ in. (2–3 mm) in thickness. The center pages are pushed out and must be offset slightly (**shingled**) to prevent the fore-edge margin from becoming progressively smaller toward the center of the publication.

Metadata

Job Tickets

Adobe's Portable Job Ticket Format (JTF) defines setup information that may be required to image a document on an output device. The format is extensible, supporting the inclusion of information that is not directly related to the imaging of the pages on an output device, such as delivery details and tracking information.

A JTF file is divided into two separate structures. The first identifies the files containing: the documents to be output, the page sequence and page dimensions, and attributes such as color space. The second structure defines the imposition of sheets that are to be imaged.

Job ticket information can be a stand-alone file, in which case it is saved as a .JTF file. Or it can be embedded into a PDF file, in which case the job ticket resides in the JobTicket object of the file's catalog.

CIP3

Automation of production processes requires that production data is available to each process. The CIP3 format provides a means of including this information with a job, which can be made available to printing and postprinting processes.

In a production environment, the different elements of process information are defined at different stages in the workflow. By encoding this information in a standard way, it is not necessary to reenter the information at each stage in production. The CIP3 data can be added to and amended as a job progresses through the workflow. This enables better integration of the separate processes involved in prepress, printing, and finishing.

Figure 10-15.
CIP3 workflow.

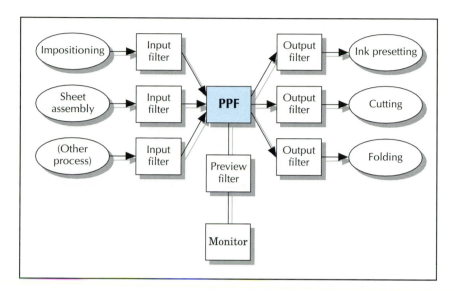

CIP3 data can be used in a number of ways:
- To interface with production management systems to aid the activation of scheduling processes and the collection of production data.
- To automate ink presetting on a printing press.
- To provide job information, such as run length and paper type, that is used in setting up the press.
- To generate cutting and folding programs for finishing equipment.
- To provide an image of each plate for checking purposes.

CIP3 is based on the production of printed sheets, which will often have multiple pages. The CIP3 data for a sheet (or a partial or complete product containing multiple sheets) is encoded as a PPF file. The notation follows that of the PostScript language and shares the same data types. It can be embedded into the PostScript stream for the job (in the prolog after the PostScript comments section), or encoded as an independent file that is referenced in the PostScript stream. The PostScript stream in which the CIP3 data is embedded may have already been imposed or may require further processing to impose pages ready for output.

It can also be embedded into a TIFF/IT job file, in a PDF file, or as part of a Portable Job Ticket Format in a PDF file.

A CIP3 PPF file contains the following information:
- Administrative data, such as the job name, copyright, and application name.

- Preview images and transfer functions for each color separation to enable ink key presetting for the press.
- Color and density measuring information that define the aim values and tolerances for the primary colors, either as densitometric or colorimetric values.
- Register marks.
- Cutting and folding information.
- Detailed information on the final makeup of the job, including collating and binding requirements.
- Additional fields that can be used to store application or vendor-specific data.

Since the image data for a sheet will ultimately determine the inking requirements, it can be used to calculate settings for the inking controls of the press. Different press types have methods of setting up remote-controlled inking, including different widths of inking zones, so it is not possible to define actual levels for each zone. Instead, the CIP3 format specifies a preview image which, together with a transfer function, can be used by an application to calculate press-specific inking presets.

To ensure that there is enough information for accurate calculation of ink presetting, it is recommended that preview images have a minimum of 300 dpi for line work, 50 dpi for continuous tone, and 64 gray levels.

A series of transformation matrices define the way in which the coordinates are mapped from the PostScript file, through the imaging area of film, plate, and press, to the final job.

IFRAtrack

The newspaper industry is more time-critical than most other forms of printing, and the scale and complexity of newspaper production make workflow issues particularly important. A production tracking system has been developed for the industry by a working group of the international newspaper industry body, IFRA, with the aim of integrating existing tracking systems of the separate production processes and exchanging information between them. This system is of interest to the wider graphic arts community as one that could be extended to production control and scheduling.

IFRAtrack is based on a messaging system using a standard message format. The format defines three types of entity—**production objects,** their **states,** and **workflow events.** Objects include items such as issues, editions, ver-

sions, products, sections, pages, elements, forms, films, plates, pressruns, reels, delivery routes, drops, van loads, and bundles. Each can have a process state (not started, in progress, completed, on hold, or aborted) and a schedule state (in time or late). An event recorded by a process tracking system, such as the completion of a press run, generates a message that causes the process state of the object to be updated. This information is sent to a list of recipients on networked drives and is then available to other processes and to production management systems.

The message format defines the following fields for any production object: object name, status change, workflow, attributes, links to other objects, deadlines, previews, message time, and text comments. The format is extensible and permits additional object classes and attributes to be added. The file format is designed to be readily parsed and converted to other formats if necessary (for example, by integrating the data into a local database).

Variable Workflows

As digital production systems and electronic communications become more ubiquitous, there is a widening range of options for the production and distribution of documents. Many production workflows have been designed to accommodate multiple media, delivery methods, and destinations for their end product. For example, a brochure may be produced for commercial single-site printing in a run of several thousand copies; it may also be placed on a Web site for customers to view online or download and print locally. It may also be interrogated by search engines and its contents extracted to form part of other information resources, such as online databases.

The traditional production model aims to achieve economy of scale by printing as long a run as is justified by the forecast demand for a product, then distributing or warehousing the finished products. This philosophy is challenged by changing patterns of demand and the capabilities of digital production technologies.

Distributed production. The reduced economic and environmental costs associated with distributing data instead of printed products can now be balanced against the possible increase in production costs. With falling costs of short production runs there is, in many cases, a strong case for distributing production to sites closer to the end user. Many

graphic arts businesses have developed business networks that enable them to cooperate in providing a distributed production facility to their customers.

On-demand production. In many areas of manufacturing, purchasers have reduced their inventory costs by buying goods as they are needed instead of ordering them for stock. Most printed items have an unpredictable demand, and purchasers are tempted to try to reduce per-copy costs by ordering large quantities. The risk of the items no longer being required or becoming out of date is balanced against the setup costs for reprints and the problems associated with running out of a product because of the long lead times printers require. By making short runs possible on demand, without a cost penalty, digital color printing allows the purchaser to buy smaller lots more frequently. Short lead times and more frequent output also make it possible to ensure that the latest information is always included.

The logic of distributed and on-demand production, together with the falling costs of page printers, suggests that in many cases customers can more economically distribute and print themselves.

Other types of product and workflow affected by digital production are considered below.

Short-run printing. The setup costs of conventional printing processes make short production runs uneconomical. The lack of film, plates, or conventional press makeready makes setup costs much lower for digital printing. Suddenly, a wide range of products are possible.

Individualized output. A key difference between a conventional press design and a digital printer is that the latter is not restricted to printing the same image on copy after copy. The data is reimaged for each sheet that is printed, and it is possible to vary it each time, depending on the ability of the RIP to process the new data at the same speed as the marking engine transfers it to paper. The printing image can be said to be invariable on a conventional press and variable on a digital press.

This possibility is of great interest to publishers and advertisers wishing to tailor a communication to what is known about the intended reader. Typical items produced in this fashion include documents with a proportion of boiler-

plate text but with some information relevant only to the client, direct mail targeted to the preferences of the individual consumer, and individualized instruction packages designed to accommodate a particular student's abilities. Other uses of variable-image printing include overprinting customer information on newspapers and periodicals and product coding on cans and packaging.

In-house production. Purchasers can achieve cost and time savings upstream of the production process by eliminating elements associated with external purchasing, such as supplier liaisons, transportation of files and artwork, and arranging payment. This is already widely exploited in simple document production through in-house reprographics and facilities management units, but for quality color work most organizations use external printers.

Visualization and prototyping. Digital color printing makes it feasible to produce single copies or very short runs to test and approve visual concepts for new products, including both traditional items like cartons and new products like multimedia screen designs. Distributing a small quantity to potential users also makes it possible to test-market the product and draw users into an approval cycle traditionally limited to the designer and client.

Compilations and offprints. Some customers require specific journal articles or book chapters. If the original publications have been produced conventionally, the publisher will either have to send the client the entire book or periodical, or prepare an "offprint" by photocopying or by cutting up the printed copies. If the items are held in a database, producing digital output of individual articles and book chapters is no problem. They can even be bound together as a unique, customized publication.

Bibliography

Adobe Systems (1993). *Open prepress interface specification v. 2.0.*

Ajayi, A., and P. Groff (1997). *Understanding electronic communications.* GATF*Press*.

Cichocki, A.; A. Helal; and M. Ruzinkiewicz (1997). *Workflow and process automation: Concepts and technology.* Kluwer Academic Press.

Hinderliter, H. (1998). *Understanding Digital Imposition.* GATF*Press.*

Lawler, B. (1995). *The complete guide to trapping.* Indianapolis: Hayden Books.

Ricker, J. (1999). *Managing metadata with XML and RDF: Improving workflow for web applications.* New York: Wiley.

11 File Preparation

According to a GATF survey, 57% of all jobs sent to service providers fail to output correctly. The reasons for failure identified by the respondents include (in order of frequency):
- Missing fonts
- Missing or incorrect trapping
- Wrong color space
- Images in wrong file format
- Incorrect page settings
- Graphics not linked
- Incorrect bleeds
- No laser proof
- Missing graphics
- Incorrect resolution
- Other

Figure 11-1 shows the issues involved at different stages in preparing files for reproduction. It is of course necessary to consider whether a document is destined for viewing on screen, or being printed, whether on a digital or conventional printing process.

Image Creation

Color Space

The key issues in preparing color images for reproduction are as follows:

Although RGB workflows are increasingly common, many printers continue to prefer to receive images in CMYK.

Workflows for conversion between source and destination device spaces were described in chapters 6, 7, and 10. Repeated conversion between color spaces is undesirable, as it is likely to degrade image quality.

Where possible, graphic elements should be created in the destination color space (CMYK for commercial printing, RGB for most other devices), instead of creating them in one color

Figure 11-1.
The issues involved at
the different stages of
preparing files for
reproduction.

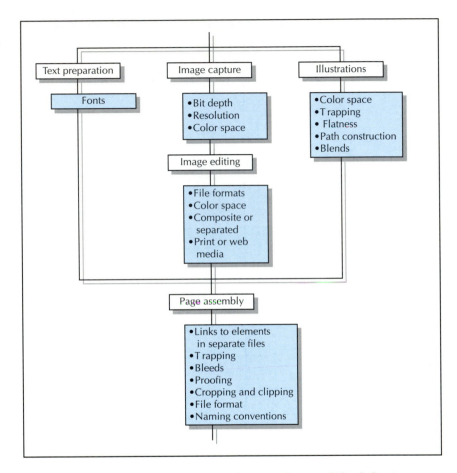

space and allowing the color values to be modified during
conversion to another.

If color space conversions are required, they should be car-
ried out by applying ICC profiles, instead of using the color
separation routines of the page-makeup application.

**Composite and
Separated Color**

Color images can be output either as **separations** or as
composite color.

Conventional printing processes need a separate plate for
each color that is printed. If the output device is unable to
extract the separate colors from a composite file, the image
must be preseparated. This can be done by saving separate
files in EPS-DCS format.

Imagesetters and platesetters always generate a separate
film or plate for each color. They may require files to be sepa-
rated or composite, depending on how they process the color
information. The bureau or trade shop will advise on whether
separated or composite files are preferred.

Figure 11-2. Workflow for Composite and Separated Output

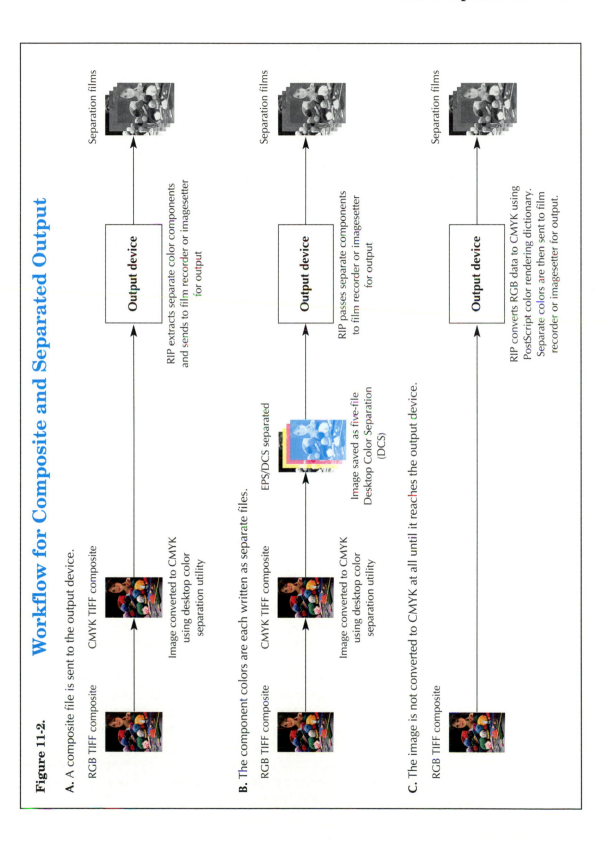

A. A composite file is sent to the output device.

RGB TIFF composite CMYK TIFF composite Output device Separation films

Image converted to CMYK using desktop color separation utility

RIP extracts separate color components and sends to film recorder or imagesetter for output

B. The component colors are each written as separate files.

RGB TIFF composite CMYK TIFF composite EPS/DCS separated Output device Separation films

Image converted to CMYK using desktop color separation utility

Image saved as five-file Desktop Color Separation (DCS)

RIP passes separate components to film recorder or imagesetter for output

C. The image is not converted to CMYK at all until it reaches the output device.

RGB TIFF composite Output device Separation films

RIP converts RGB data to CMYK using PostScript color rendering dictionary. Separate colors are then sent to film recorder or imagesetter for output.

Digital color printing devices do not require separate plates for each color, as they extract the values for each color from the files during output. Files sent to digital printers and proofing devices should always be sent as composites.

Composite color objects (images, graphics, or documents) can be saved as either TIFF or EPS files, but the TIFF file format does not currently support separated colors. Separated files can be saved as EPS (using the DCS format) or as TIFF-IT.

Note that creating separated files does not mean converting them to CMYK, but simply extracting the separate color components so they can be processed individually. Conversion to CMYK must have already been carried out elsewhere before a DCS file can be created.

Resolution. Guidelines for calculating image resolution were described in Chapter 5.

File format. Image file formats will depend on the output environment. Table 4-1 shows the main file format options for color images.

Profiles. ICC profiles for color images must be available at the point when color space conversion takes place. Profiles can be embedded into image files using the Photoshop Color-Sync Export plug-in.

Preparing Images for the Web

Quality requirements for the web are naturally much lower than for print, and the overriding need is to generate small files. To minimize image file size, resolution should be reduced to 72 dpi and either bit depth reduction with lossless compression, or JPEG compression applied. Depending on the image, it may be possible to generate an acceptable image with between four and eight bits per pixel. Adaptive bit depth reduction produces good results, but if a proportion of users can be expected to have 8-bit displays it may be better to use the 221-color web palette common to Windows and Mac OS. Preparing images for web pages is more efficient in special applications such as Debabelizer and Adobe ImageReady.

When a series of images is to be downloaded, the process can be made to work in the background by using JavaScript to define an image array. JavaScript and Java applets enable dynamic effects to be applied to images, for example to create powerful animations (using timer and loop controls), define a

link area, display a sequence of images, or execute a script on a user action such as clicking on the image.

Document Creation

Documents for print are largely created in the professional page-layout applications, Adobe PageMaker, Adobe InDesign, and QuarkXPress, although several other applications exist for special purposes (such as long documents).

File Formats

Files can be prepared for output in a number of different formats, depending on the workflow, the type of work, and the equipment and practices in use. The usual choices will be between native application formats, PostScript, and PDF.

Native application formats. A native application format is the default format of the creator application, which will usually be a page-layout program, but may also be a vector drawing program such as Adobe Illustrator, or any other user application from simple word-processing to advanced CAD (computer-aided design) or 3D programs. Native application files can readily be edited if the output service has the relevant application installed, but there are often platform and version problems.

PostScript. PostScript files are often specified as a file format for transferring files to an output device. They are more platform-independent than native application formats, and items such as images and fonts can be included in the Post-Script file to prevent many of the output problems that were described earlier. PostScript files cannot readily be previewed or edited, and if the designer has made an error in creating them from the native application files it will be necessary to re-output them from the application files. For this reason it is a good idea to supply the application files along with the PostScript files in case of problems.

For customers to supply PostScript files, they need to have the ability to output PostScript correctly from the creator application. If the PPD file for the destination output device is available, the code is more likely to be successful when it is output.

PDF. PDF is a more robust format for supplying documents for reproduction than either PostScript or native application files. PDF files can be previewed both by the designer and by

the output service, and their compactness makes them suitable for transmission over communications links.

They can be edited in some vector programs such as Adobe Illustrator, although for significant changes it is preferable to return to the native application files. After editing, they need to be redistilled to PDF.

Customers supplying PDF files need to be able to output PostScript correctly, and to distill the resulting PostScript files correctly with the appropriate job options.

Color

Graphics and page-layout information can be output in separated or composite format, depending on the requirements of the output device.

Graphic elements, like images, can be created in any color space as long as an ICC profile defining the color space is available.

A special color, which requires a separate printing plate, has to be output to film or plate independently of the process colors. To prevent the special color from being converted into a process color, the convert-to-process option in the page-layout application must not be checked.

Scaling

Original images and illustrations are usually enlarged or reduced when they are reproduced. Depending on the application, different ways of scaling an image may be provided: specifying a scaling ratio, specifying a percentage enlargement or reduction, or specifying the new dimensions.

To determine the scaling ratio, simply take one dimension of the final size of the image and divide it by the corresponding dimension on the original. The percentage enlargement or reduction is found by multiplying the scaling ratio by 100. For example, a 4×5-in. (102×127-mm) transparency is to be enlarged to fit a 6-in. (152-mm) column. Dividing the final size by the original size (6/4) gives a scaling ratio of 1.5, or an enlargement of 150%.

In many instances, it is only necessary to specify the new height or width, with the proportions locked to ensure that both dimensions are scaled together. Choose the most important dimension to specify, which is usually determined by the column width or design grid of the publication. Scaling vector objects, such as type and graphics, has no effect on image quality, as the output device will automatically use the best resolution possible.

Figure 11-3.
Scaling.

A graphic or picture is usually scaled by simply entering the new size. The scaling factor can be found by dividing the reproduction size by the original size, and, if necessary, this can be converted to a percentage by multiplying by 100.

If the file size is preserved when an image is scaled, the image will be resampled. This will alter the amount of data available for each scanned pixel, and the relationship between the size of the pixels on the original image and the screen frequency of the reproduction will be changed.

If a sampled image is enlarged significantly, the individual image pixels may become noticeable unless interpolation is applied by resampling the image. Scaling an image down will improve resolution, but unless it is resampled at the same time, the resulting file will be larger than memory. Guidelines for choosing the correct scanning resolution for the output were described in Chapter 5.

The bounding box coordinates of the EPS file define the size at which the object will be output, regardless of whether it is a graphic or bitmap. A low-resolution preview of a sampled image will often look "jagged" on screen, but the resolution of the final reproduction will be defined by the high-resolution to which the preview is linked.

Scaling takes place prior to halftoning when the page is sent to the output device and rasterized. Scaling thus has no effect on the screen ruling of the printed image.

Avoid problems with scaling raster images by:
• Scaling and resampling them in an image-editing program to maintain the correct relationship between resolution and screen frequency.

- Scaling and resampling the original scanned image, as repeated transformations can cause some information to be lost from the image.

Curves

Curves are constructed as Bezier splines by defining control points, as described in Chapter 4. Because of the amount of processing required to interpret and render a curve, they can cause output problems when exceptionally complex paths are defined, or there are a very large number of curves in a graphic or document. Particular problems can be encountered in clipping paths and blends.

Chapter 9 describes how a curve is rendered on an output device as a series of straight lines, the end points of which are defined by coordinates in the vector graphic program. A smooth curve has many lines and a low flatness value, but each line is treated as a separate object to be rendered when the file is output. On a low-resolution device, such as a laser printer, this will not cause a problem, since the interpreter will rationalize the number of points to the resolution of the device. A high-resolution output device will be capable of

Figure 11-4.

A. The more points used to define a curve, the smoother it is, but the longer it will take to process and output. You can alter the number of points through the flatness property.

B. Set curve flatness to 6–10 pixels when sending pages to a high-resolution device to minimize the time the interpreter spends processing paths.

inserting many more lines, and, unless the curve flatness is set high enough, the output time may be extended.

In practice, curve flatness does not become visible until the setting reaches a value that is determined by the output-device resolution. It is usually possible to set a flatness value of six to ten pixels for output on a high-resolution device. Long and complex curves can cause PostScript limit errors, and sometimes it is necessary to split curves into two or more separate objects to avoid this problem. Many vector programs have a Split Long Paths command for this purpose.

Cropping and Clipping

If part of an image is to be discarded, a crop area or clipping path is defined. If an image is cropped within a page-makeup program, only the bounding box coordinates are altered and the actual sampled image itself remains unchanged. The file size will remain the same and the entire image will still be processed and rasterized. This can take a large amount of extra time during output, as the RIP first processes the whole image and then executes the cropping instructions.

If a cutout around an image is required, rather than a rectangular crop, it is often defined with a **clipping path.** Everything beyond the clipping path will then be discarded when the image is output (although like a rectangular crop, clipping does not remove the unwanted data until the final stage in the output). A clipping path defined as a series of Bezier curves (using the pen tool) is a good way of creating a cutout, although a complex path can make *limitcheck* errors more likely. Setting the flatness of the clipping path to a high value reduces this possibility. If a large amount of the image is to be discarded, it can also be worthwhile to make a rectangular crop in an image-editing program before creating the clipping path.

Avoid problems with cropping and clipping sampled images by:
- Cropping in an image-editing program, unless the amount that is to be discarded is small.
- Avoiding complex clipping paths where possible.
- Increasing the flatness value of clipping paths.

Blends

Tint gradations and blends in graphics can give rise to two problems: processor overload and contouring (banding or shade-stepping).

On a pre-Level 3 device, gradations are imaged as a series of lines of successively changing tonal values. Each line is

Figure 11-5.
A cutout *(bottom)* is a crop with a nonrectangular cropping path. Making a rectangular crop first in an image-editing application *(top)* helps to minimize file sizes, especially on large images where the cutout is only a small part of the original image. Next, a nonrectangular clipping path is drawn around the object *(middle)* and the image and clipping path are saved as an EPS file.

effectively a separate object, and the PostScript interpreter has to render each one in turn. The more gradations there are in a graphic, the longer it will take to process. A complex graphic can take an unacceptably long time to output, or even cause the job to crash through a PostScript limitcheck error. On some high-end recorders, there is a limit in the number of gradation steps that can be output, and again, processing will fail if this is exceeded.

Banding or **shade-stepping** occurs when the transition between one tonal value and the next is visible. It can be seen when there are too few gray levels for a smooth, con-

tinuous gradation, and its effects are exaggerated by the sensitivity of the visual system to edge definition.

If the use of a pre-Level 3 PostScript device is unavoidable, problems with blends can be minimized by:
- Using the maximum number of steps possible in the gradation.
- Adding a small amount of noise to a gradation in an image-editing application if contouring is thought likely.
- Avoiding special color blends where possible.
- Converting complex graphics with multiple gradations and blends into sampled images.

To convert an EPS graphic to a sampled image:
- Open the EPS file in an image-editing program.
- Set the resolution to twice the screen ruling at which the job will be printed.
- Save as a TIFF or EPS file.

The sampled version of the graphic will be exactly the same on the final printed job as it was in the original object version. And, although the file size will be larger and will take longer to read into memory, it will be processed much faster. Note that if it subsequently becomes necessary to scale up the image by more than a small amount, the vector-to-raster conversion of the original graphic should be repeated so that the image has the correct resolution.

Trapping

Document-level trapping is best applied in the RIP, using trap settings specified for the document. However, some trapping applications do not trap imported EPS graphics, and traps may need to be applied in the vector drawing application in which the graphic was created.

Basic rules for trapping include:
- Spread lighter colors into darker colors.
- Keep the trap width to a minimum to avoid an unwanted border or the appearance of a third color.
- If the two colors trapped are equally dark, spread the background color into a foreground object.
- Spread backgrounds into photographic images.
- Do not trap white knockouts.
- Do not trap within images.
- Do not trap type in small point sizes or with fine strokes or serifs.
- Use color combinations that allow you to overprint the type onto the background.

- Use common colors for an object and its background.
- Avoid traps greater than 0.004 in. (0.1 mm) for sheetfed work, since press misregister rarely exceeds this amount.

Most trapping programs are only able to handle trapping information on separated files, not composites.

Trapping is difficult to apply manually in cases where one of the objects is a blend, or where more than two colors touch.

File Preparation Guidelines

Many printers and trade shops have prepared information sheets and checklists for their customers to help reduce the possibility of files that will not run. A clear understanding of what is expected avoids disputes over payment for work on client-supplied files.

A number of industry bodies have also produced comprehensive guidelines on how to prepare and present files in digital form, and many ad agencies, publishers, printers, and output services use these guidelines as a basis for agreement.

Guidelines have been published by the Scitex Graphic Arts Users Group (SGAUA), the Digital Distribution of Advertising for Publication Association (DDAP) in the United States, and the Digital Artwork Transfer Industry Committee (DATIC) in the United Kingdom. In summary, DATIC specifies:

- CMYK color space.
- Linework to be vectorized where possible.
- Resolution requirements according to the producer's specification.
- For mono ads, the EPS format is recommended.
- For color ads, either EPS or TIFF/IT is recommended.
- Files should not be supplied in native application formats.
- Control strips should be present, either generated by the output device, included in the file header, or embedded in a profile.

DDAP recommendations are similar to DATIC, the main exception being the file format recommendations PDF/X-1 and TIFF/IT P-1. DCS2 files are also recommended as a robust format, and they can additionally be placed and previewed within page-layout applications.

The **Artwork Delivery System (ADS)** also defines a number of file attributes for sending ads to newspapers and other periodicals.

Document Creation for the Web

A document can be created for publishing over the Internet in a traditional page-layout application, or in a special web page application. Web and print formats have very different structures, and documents cannot easily be converted between them. Page-layout applications do have HTML export options, but the conversion from the native application format is not very reliable at present. HTML can be used as a print format, but the low resolution of images used in web pages make it unsuitable where quality requirements are high. Web page design programs such as Dreamweaver avoid the need for manual creation of HTML tags.

File Checking

Having a job fail during output on an imagesetter can be a disruptive and costly occurrence. Potential output problems can be anticipated by running a preflight check that tests how the PostScript code will perform when it is run on a high-resolution device.

You can identify some potential problems prior to dispatching your job by making a low-resolution print on an ink jet or laser printer. A composite color print will show the appearance of the document, while a print of each separation is useful for checking against films and plates in separated workflows.

A successful print is not a complete guarantee that a document will output successfully, as there are some possible problems (such as PostScript code errors) that will not necessarily be flagged. Naturally, if all the fonts needed to run a job are available to the laser printer because they are on the user's hard disk, but subsequently are not included when the job is sent for output on a high-resolution device, the job will not output successfully.

A job can be preflighted from within a page-makeup program such as PageMaker or QuarkXPress, using a plug-in or extension. If the pages have been output as PostScript code, it is also possible to use file-checking and preflighting utilities such as Elseware's CheckList, Island Checker, and LaserCheck. Some of these utilities make a laser printer emulate an imagesetter, and thus pick up problems that might not be caught on an ordinary laser print. Others allow the user to view a PostScript file on screen and see information about the file, such as the presence of embedded files, most recent modification dates, and so on.

Another method of file checking is to create PDF files for viewing or printing. Turning the PDF files back into PostScript also results in more reliable execution when output.

If you are sending a job to a printer or an output service, you will have a much better chance of avoiding output problems if you send the following along with your files:

- A list of all the files used in the job, and details of file formats used.
- A list of the applications (and version numbers) used to prepare the files.
- A list of all the fonts used, with the exact font name, style, and the name of the manufacturer of each font.
- A specification for the job that identifies details such as the title, number of pages, output size, and any screening parameters.
- A color laser or ink jet print of the job.
- A set of black-and-white prints for the color separations, if the job is being supplied as CMYK.

Specification information can be entered into electronic job tickets by file transfer systems, using a custom form or a recognized format such as Adobe's Portable Job Ticket Format.

Alterations and edits to a document are often simply appended to the file. By performing a "Save as" with a new filename, instead of a "Save," the application rewrites the file and produces a more economical description. It is a good practice to do a "Save as" immediately prior to output.

Sending to a Service Provider

A number of items should be checked to make sure that a job will output correctly and will not tie up the output device for an excessive amount of time. The most important questions to ask, and the most common causes of output failures, are:

- Are all the links in place?
- Are all the fonts and other resources used in the file available to the output device?
- Are all the job parameters—page size, screen rulings, etc.—correct?
- Have all the colors been specified correctly?
- Are separated or composite images required?
- Have all items been correctly scaled and cropped?
- Will there be excessive demands on the output device from the way that blends and paths have been used?

File Links

A page-layout program establishes links to graphics and images when these items are placed on the page. When the page is output, the application makes sure that all the linked files are output as they are needed. However, if any of the

Figure 11-6.
The Picture Usage
dialog box in
QuarkXPress 4.0.

files has been renamed or moved after placement, the links will be broken. The application may then fail to find the right files and be unable to output the page.

Page-layout programs such as QuarkXPress and Adobe PageMaker allow you to review the status of all current links and modify them if necessary. They also provide an option (Collect for Output and Save for Service Provider) to locate all the files needed, regardless of where they are on the network, and save a copy of them to a new location.

Graphics that incorporate other linked elements create extended link paths. When the page is output, the RIP has to find and process each linked element before it can output the page.

Figure 11-7.
Many levels of files-within-files make the interpreter work hard. Here an EPS graphic contains another EPS as a logo, which, in turn, contains a font. To output the image, the interpreter must search for each one in turn.

Avoid problems with file links by:

- Reviewing links before a publication is sent for output.
- Avoiding extended links where possible by nesting no more than two levels of graphical elements (including fonts) on a page.
- Avoiding renaming files after they have been placed.
- Ensuring that all linked files are included with the job when it is sent for output.
- Listing all the files used in the publication in a specification that accompanies the job.
- Copying the page-layout file to the same folder or directory as the linked files when transferring to removable media.
- If the publication is too complex to copy the page-layout file to the same folder or directory as the linked files on removable media, make sure that the arrangement of files is clear.

Fonts

To ensure that the correct font is used on the output, the output device must have the exact same font available to it as the one used in the creation of the publication.

Even fonts that have the same name but originate from different vendors can vary considerably in the cut of the letterforms, relative weight on the page, and the width of their characters. In most cases, the traditional font foundries, such as Monotype, supply the most authentic versions of classical typefaces, with complete character sets, a full range of styles and weights, and proper hinting. Obscure fonts from little-known vendors are the most likely to be unavailable at the output service or to cause output problems.

Avoid problems with fonts by:

- Checking that all fonts will be available to the output device.
- Listing all the fonts used in the publication with the exact font name, style, version, and vendor.
- Sending copies of any fonts that you have modified.

Job Parameters

Printing plants have different requirements for page orientation and **film polarity** (negative or positive), according to the printing process and whether positive- or negative-working plates are used. The usual requirements are shown in Table 11-1.

When an output service receives a job, it will normally check the list of files, fonts, graphics, and so on, and any

Table 11-1.
Film requirements for reproduction.

Process	Film emulsion[1]	Film polarity
Offset lithography	Down	Negative or positive
Gravure[2]	Down	Negative or positive
Flexography	Up	Negative
Screen printing	Up	Positive

Notes:

1. The emulsion direction refers to the film as viewed from the right-reading side.

2. Gravure cylinders are usually engraved from digital data. Where film is used, it is commonly prepared for offset lithography.

proofs supplied with the job. Next, it will load the files and check that all graphic and image files are in place and correctly named and linked, and in the correct color space and file format. The output service may also check that any user-defined trapping has been done correctly; that colors have been defined as separate or composite as appropriate; that fonts and any other necessary resources are available; and that any other job parameters are correct. After making any necessary adjustments, the job will be processed and finally checked against your low-resolution proof and any specifications you have supplied.

Creating PostScript Output

PostScript code is generated when the print command is invoked by the creator application and a PostScript printer driver is selected as the current printer. If the job has been sent to an output service in a native application format, the output service will carry out this stage. Alternatively, a designer or publisher may create a PostScript file on disk (for sending to the output service, or creating a PDF file), or send a PostScript stream directly to a digital printer.

The most recent PostScript printer driver can be freely downloaded from the Adobe Web site.

The PDF file. The PostScript Printer Description (PPD) file for the target output device should be available when the document is printed. The PPD provides information about the target device, including its screening methods, imageable area, resolution, and supported color spaces. If the target device is not known, or a PPD file is not available, a default PPD such as Color General can be used, although a PPD for a device similar to the target device may give better results.

When creating PostScript output for subsequent distilling to PDF, the Distiller PPD should be used. To avoid resetting the Distiller default resolution and color space job options each time, the Distiller PPD can be edited to specify the values normally used.

Transfer functions. Transfer functions should only be applied to linearize the output from an uncalibrated output device.

Halftone parameters. Set the appropriate screen ruling, screen angle, and dot shape. The output device will substitute alternatives if the ones you specify cannot be achieved, or if more precise screening algorithms are available. If no halftone parameters are specified, the output device will use default settings. When sending files to a high-resolution PostScript device, Accurate Screens should always be specified. If better screening technologies are available, they will be used and any PostScript parameters will be ignored.

Page size. The page size will be taken from the size specified in the creator application's Document Setup dialog. It may be necessary to specify a slightly larger size in the Print dialog if the application's page size does not include bleeds and cut marks.

Fonts. The "include fonts" option should be chosen.

Spot colors. Spot colors defined in a document created in Adobe PageMaker and QuarkXPress will be included in the PostScript stream, unless the "convert to process" option is selected.

Trapping. Trapping information defined in the page-layout application should be included in the PostScript data. Note that some applications only define trapping information for composite files.

Distilling to PDF Default values in the Distiller application are appropriate for PDF files destined for screen display, but not for high-resolution printing. Distiller job options need to be set as follows:

Figure 11-8.
Advanced job options
in Adobe Distiller.

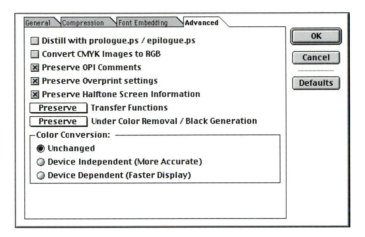

Default resolution. This is used for rasterizing vector graphics and fonts and should be set to the resolution of the output device.

Compression. Choose the preferred compression options in the Compression tab.

For color images, ZIP and JPEG Low are recommended, as higher JPEG compression ratios may cause degradation. The automatic option will apply JPEG to images containing high-frequency detail, and ZIP to images with smooth gradations.

Downsampling. The downsampling option should only be checked if images are not in a suitable resolution for the output medium. Downsampling is only activated if the image resolution is at least double the amount entered in this dialog.

Font embedding. In the Fonts tab, the Embed All and Subset Below options should be checked, with a value of 99% in the Subset Below option.

Spot colors. If spot colors are present in the document and separations are being produced, check the "Distill with prologue.ps/epilogue.ps" option.

Color conversions. Uncheck the Convert CMYK to RGB option and check the Color Conversion unchanged option.

Check the Preserve option for OPI comments, overprint settings, halftone screens, transfer functions, and undercolor removal, unless you have settings in the document that you want to be overwritten. The Preserve Transfer Functions

option must be checked if color duotones in TIFF format are included in the document.

PDF for the Web

The PDF format was originally designed for screen display, and so the default options work well. The compression options in Distiller should be selected to give the highest compression ratios, with JPEG High for color images.

Using Service Providers

In terms of output services, you have these choices: sending your job directly to the printer for output; using the services of a trade shop or output bureau; or developing your own in-house output facility.

Going direct to the printer eliminates one link in the supplier chain and avoids a possible area of conflict. On the other hand, specialized output services can add value to your job and ensure that any problems are resolved before the job is received by the printer.

A good service bureau will pay great attention to quality control, and ensure that devices are calibrated and that correct profiles are available. For imagesetters and platesetters, they will output and measure a test element once or twice a day to make sure that exposure and processing conditions are not causing a drift in the dot values that are being output.

In-house film output is appropriate for publishers with the resources to acquire and operate an imagesetter or film recorder and the associated processing. Imagesetters are usually the most expensive prepress equipment investment. Low-cost models are available but tend to be less consistent and less productive than high-end models, and the possible additional stripping cost when the pages are imposed should also be considered.

When using outside services, some important questions to ask are:

- What are the estimated output costs per page?
- What rate is charged for alterations?
- What type of equipment is used and what is its technical capability (e.g., bit depth, addressable resolution)?
- What resident fonts are available?
- What processing is available on the RIP for trapping, imposition, and color conversion?
- What are the maximum output dimensions?
- What kind of proofing is available?
- What communication links are available for file transfer?

- How far downstream can they take the job? For example, can they produce one-piece imposed and punched film ready for platemaking?
- How long will files be stored after output and in what form?

Bibliography

Agfa Compugraphic (1994). *Working with pre-press and printing suppliers.* Mt. Prospect, IL: Agfa Prepress Education Resources.

Stone, V. (1996). *Electronic prepress essentials.* Pittsburgh, PA: GATF*Press.*

12 Proofing

Proofing is a key element of the production process. Without it, errors would not be corrected and costly reworking or a loss of value in the finished product would result. Good management of proofing tools enables the final job to be matched closely to the client's expectations at the lowest possible cost.

It is important to consider both the role of the proof in the approval cycle and the proofing technology used. This chapter will help you to understand the different proofing systems on the market and the context in which they are used.

The main reasons for making a proof are:

- To approve or, if necessary, correct a job before it is printed.
- To show how design decisions will be realized when the job is printed.
- To form a basis for agreement on what will be produced by the printer and paid for by the customer.

To fulfill these functions, the proof should be a good simulation of how the job will look when it is printed. It should be fast and economical to produce so that it does not consume too much of the time or resources available. The accuracy of the simulation of the final print is of critical importance, and the proof should ideally match the characteristics of the printing process, rather than the other way around.

Proofing Stages

Proofs can be made at any stage in the production process, from initial concept to printing and binding. There is a point, however, where the role of the proof changes from a client-designer communication to a client-printer communication. Up to this time most proofs will be generated as part of the design process and will include thumbnails and roughs to

show the initial design concept, followed by visuals and laser proofs of the layout and typography.

From the point when the job is sent to a commercial output service or printer, the purpose of the proof is no longer to support the exploration of different design possibilities, but to demonstrate that the production process has correctly implemented the specification and design. In both cases, the emphasis is on approval. In a well-managed job, approval of each stage in production is reached as quickly and efficiently as possible.

Typical proofing stages are:

1. A **visual** or **rough.** This allows approval of the designer's concept of the job before complete page layouts are produced.
2. A **design proof.** The layout proof or **comprehensive** shows the finished design, with all the text and image elements in place. (At this stage, it may not be possible to show exactly how illustrations will appear on the final job, in which case they are approximated.) It can also be used as a reading proof for the text if the copy has not already been finalized.
3. A **final color proof** or **contract proof.** This closely simulates the finished job and may be produced on separate sheets or made up as a **book proof** to look like the finished job. The printer will use the final color proof as a guide for the production run and will match it as closely as possible.

The comprehensive proof allows the customer to approve the design of the job, while the contract proof is approved as a more or less accurate simulation of the final printed job.

Proofs are often made at other stages, depending on the workflow and the requirements of the printer and the client. These proofs may be for internal purposes rather than client approval.

An intermediate proof may be made to check specific elements, such as the scanning, color separations, and screening of images. This is often in the form of a **scatter proof,** showing just the high-resolution scanned images.

A **form proof** is made from imposed pages to check imposition details and as a final check before committing to film, plate, or print.

Proofs are sometimes made after correction of color proofs to show the effect of text changes. Because the color elements are unchanged, this proof can be made on a less costly medium, such as a laser print or an Ozalid dyeline proof.

Figure 12-1.
Possible approval points in the production cycle.

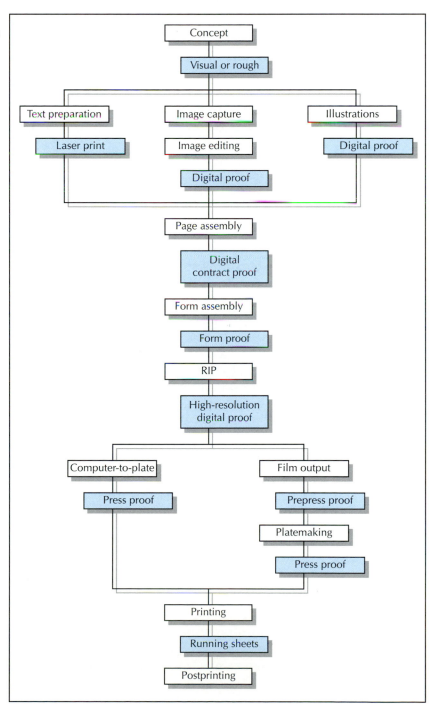

Requirements of a Proofing System

A proof is intended to show the appearance of the final reproduction. The required characteristics include:

- **Resolution.** The resolution should ideally be similar to the final printing process. Low-resolution proofs make it difficult to judge the appearance of type, other linework, and halftone screens (particularly if the device is a bilevel one).
- **Color gamut.** The color gamut should be as large as all the processes that the proofing system is required to emulate, in order to have a chance of matching colors of the reproduction.
- **Control of colorant amounts.** The system should be able to render the colors specified without contouring. This will require control of gray levels and screening methods, unless the device produces contone (continuous-tone) output.
- **Consistency.** The colors produced on the device must be highly repeatable.
- **Choice of substrates.** In some cases it is important for the proof to be imaged on the same paper as that of the final print. Similarly, accurate simulation of gloss levels and special finishes such as varnishes may be important.
- **Economy.** Proofing does not itself add value to a job, and the unit cost of color proofs should be kept as low as possible. The cost of proofs is made up of both capital and consumables.
- **Speed.** The time taken to produce and transmit proofs is particularly important in some environments.
- **Accurate PostScript interpretation.** Pages produced by a proofing system should be interpreted in the same way as the final job, including elements such as text line breaks, colors, overprint settings, trapping, etc.
- **Acceptability.** A color proof must ultimately be accepted as a good simulation of the final result by both client and printer, both of whom are committed to the appearance it shows.

Some specific requirements of different proofing stages include the following:

Visuals. Accessibility, economy, and speed are the most important requirements for the designer, who may wish to produce a series of options for a client and make modifica-

tions quickly and with a minimum of cost and effort. The ability to produce color visuals from digital data is useful, but at an early stage in the design process, rough sketches and thumbnails may also be generated manually using colored markers or other media.

Design proofs. The ability to show an accurate representation of all the textual and graphical elements in the finished design is vital. This means that the page must be interpreted in the same way by the RIP in the proofing system as it is in the imagesetter. A common problem is that the fonts used in the design are not available to the proofing device and, as a result, the output looks different.

Design proofs are usually made on laser printers with much lower output resolutions than imagesetters. Design proofs generated in this way will not show the precise weight or sharpness of the text, and tints are printed at a screen ruling much coarser than the final print. Tints may look lighter or darker than on the final print, unless the printer has been calibrated to the printing process.

Color is usually an important element in the design proof, although it may not be possible to match the exact color appearance of the final output or show the effect of color editing.

Final color proofs. The printer uses the final color proof as a guide for the production run, matching it as closely as possible.

Final color proofs have traditionally been produced by the trade shop or printer making the color separations, and they are responsible for ensuring that the proof matches the characteristics of the printing process. The use of digital prepress systems gives designers and publishers the possibility of creating proofs before files are sent for output to film or plate.

If electronic proofs created in this way are to be used as final color proofs, it is essential that care is taken to calibrate the proofing device to closely match the printing characteristics.

Consistency between proofs made from the same color separations is also important, since otherwise it would not be possible to use a proof as a guide to the corrections needed.

If a particular proofing system produces a slight deviation in its output, it can still be interpreted successfully as long as the variation is consistent. Color proofs should ideally be cheap and quick to make, and multiple copies should be available at a low unit cost.

Color Matching

Color proofing systems, until recently, were designed to be able to match the color reproduction characteristics of a specific printing process (with some possible adjustment for different media). Increasingly the need is to be able to simulate a variety of printing processes, including digital printers with colorants quite different from those defined in standards for printing inks.

This requirement can only be met by digital proofing methods, using color management to apply profiles for the target devices. Where the proofing system has an extended color gamut (such as the Iris and Digital Cromalin systems), a wide range of final printing processes can be simulated, and many special colors can be matched.

Figure 12-2. Digital Cromalin AX2 digital color proofing system.

It is possible to make an output device emulate another system for which a profile is available by using color management tools. A display can show the appearance of a job as it will be reproduced on another system by applying a Color-Sync Color Match filter. A hard-copy printer can emulate another system through a device link profile. To convert an image from an output color space (such as SWOP CMYK) to the color space of a proofing device using ICC profiles, the "relative colorimetric" intent should be selected.

No matter what the target printing system is, calibration of the proofing device is essential for accurate color matching.

Proofing Technologies

Proofing technologies can be divided into **digital proofs, photomechanical prepress proofs,** and **press proofs.** Digital proofs are output from page-makeup data, while photomechanical prepress proofs are made directly from the final films, and press proofs are printed with the printing plates.

Figure 12-3.
Proofing systems.

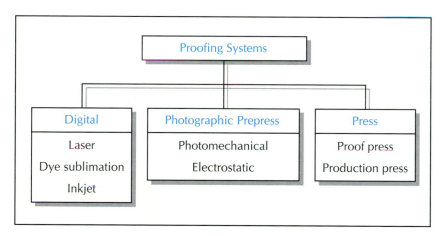

Digital Proofs

Digital proofs initially met with some resistance from clients and printers, but they are now largely accepted. Although they image the sheet by completely different methods from conventional printing, they have a good fit with all-digital workflows. They are the only realistic solution in a number of situations, such as where the final job is printed on a digital press. They are also frequently preferred in CTP workflows and for remote proofing.

Digital proofs have the critical advantages of lower cost and faster production than analog proofing methods. And because they are made at a much earlier stage in the workflow, they enable editing and correction to take place before a job is committed to production.

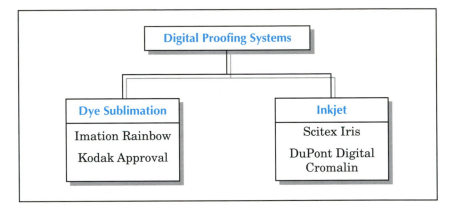

Laser and inkjet proofs are also the only methods of pro-
ducing multiple copies of proofs economically prior to
platemaking.

Digital proofs are made directly from digital page and
image data. They enable the page makeup, color separations,
and editing to be approved before the files are sent to the
printer or to a bureau for output to film. The resolution and
screening methods may not match those of the final printing
process.

Digital proofing systems give the user a great deal of con-
trol over printing characteristics, with complete freedom to
adjust tonal reproduction curves as necessary. However,
because the colorants are very different from printing inks,
simulating the effect of the final printing process is not a
simple matter of using the same data as for the films or
plates, and calibration and color management are essential.

Special colors are not available in most digital proofing
systems and must be simulated with the closest CMYK com-
bination. The ability to match special colors accurately is
dependent on the gamut of the proofing system colorants
and the color management profiles available. In the case of
PANTONE colors, CIE-based specifications for the colors are
licensed to the proofing system vendor, and good matches can
be obtained if the device profile accurately defines the trans-
formation between the CIE-based color space and device
colors.

The resolution and color gamut capabilities of some low-
cost inkjet printers (notably the Epson 1440-dpi piezo inkjets)
makes them acceptable for a large proportion of color proof-
ing. Some vendors market these with color management
front ends that allow them to compete with some high-end
proofing systems.

The three main types of digital proofing technologies used are electrostatic, inkjet, and thermal systems.

Electrostatic systems. Laser printers (mono and color) are regularly used for design proofs to check elements of page design and typography.

Dye sublimation (a thermal system). Dye sublimation devices, such as the Imation Rainbow, produce continuous-tone output and have achieved a degree of acceptance as final color proofs. Resolution is relatively low and so they render linework poorly. Media and colorant costs are higher than for other systems, and substrates are restricted to special receiver papers.

Figure 12-5.
Kodak Approval
Digital Color Imager.
*Courtesy Eastman
Kodak Co.*

Inkjet. High-end inkjet proofing devices generate variable-size ink droplets, giving an approximate simulation of conventional halftoning with a clustered-dot screen.

Figure 12-6.
Kodak Approval Proof.
(Detail enlarged 10×.)

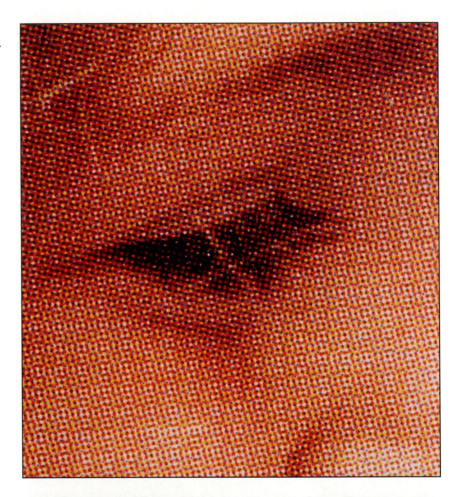

Figure 12-7.
Imation Rainbow dye
sublimation proofing
device.
Courtesy Imation.

A wide range of different types of media can be used, and many inkjets are able to print on plain paper. Glossy coated papers are also widely available.

The resolution and color capability of some low-cost inkjet printers are sufficient for color proofing if accurate color profiles are available. As their capital costs and running costs are very low in comparison with other proofing systems, this makes them an ideal choice for a large proportion of color proofing work.

Although several proofing systems are able to simulate the color appearance of a conventional printing process adequately, very few have sufficient resolution to be able to accurately simulate the halftone screen pattern. One approach is to image the proof in a high-resolution laser output device based on an imagesetter or platesetter. This additionally has the advantage of using the same RIP as will be used to image the films or plates.

High-resolution laser ablation systems used in the Kodak Approval and Polaroid PolaProof also have the capability of showing actual halftone dots.

Other proofing technologies are available or in development. Two special-purpose systems that should be mentioned here are:

- **Transfer printers** (such as the Imation inkjet Transfer System) that print onto donor materials that can transfer the image to any surface, making it possible to proof packs and product decorations.
- High-resolution **pictrographic printers** (such as the FujiFilm Pictrography).

Soft Proofing

If an image or a page is being approved in digital form and a hard-copy record is not required, proofing may be done on a color monitor. This gives an opportunity for repeated editing and correction to be carried out interactively during the design phase, without the need to transfer files to another output device. A digital file for soft proofing can also be sent on disk or transmitted electronically via modem or ISDN link, eliminating the need to transport physical media.

The use of soft proofs for color approval has two main problems. First, the screen image is not perceived as giving a good match to the printed image due to differences in color gamuts and in the ways that the visual system adapts to reflection prints and displays. And second, there is no physical record that can be submitted to the printer or kept by the client.

Nevertheless, soft proofing can be viable if the following conditions are met:
- Standard viewing conditions are used.
- Monitors are profiled and periodically recalibrated.
- Color interpretation is carried out with the aid of a **software densitometer** (the Info dialog that shows the color value of the pixel currently under the cursor), color sample books, and tint charts.
- Color management systems and ICC profiles are used to ensure accurate matching of color between the display and the printing process.

Monitor proofing of high-resolution image files can be a problem due to the need to access very large files. It is also only possible if both the creator and the approver are using the same application and computer platform, and if all the fonts used are available on both platforms.

Such problems can be overcome by using PDF files, which can be created at a resolution for screen viewing to minimize file size. The approver only requires a copy of the Acrobat Reader in order to view or print a PDF file (regardless of the fonts, applications, or computer platform used in its creation). With Acrobat Exchange it is also possible to attach alterations and comments to the document before returning it to its creator for amendment.

Soft proofing enables publishers to save on the time and costs involved with the traditional hard-copy-based approval cycle. They also make possible different methods of reaching final approval, including interactive alteration (with immediate display of the effect of changes) and prepublication review by a larger number of people.

Remote Proofing It is increasingly common for prepress work to be carried out at a different geographical location from the client's. Shipping proofs to the client is slow and costly, and remote proofing can be a better solution. A remote proof can be either a hard-copy proof made by an output service local to the client, from data sent by the prepress service provider; or it can be a soft proof viewed on screen by the client. In both cases color management profiles are essential.

Prepress Proofing Photomechanical systems remain an important means of proofing where film is made as part of the workflow. Proofs are made by exposing the films in contact with a light-sensitive

Figure 12-8.
Eurosprint: a compact
DuPont Cromalin
prepress proofing
system.
*Courtesy E. I. duPont
de Nemours & Co., Inc.*

substrate and applying a colorant or developing a latent
image. The exposure and coloring processes are repeated for
each printing color.

Multilayer laminates used in prepress proofs can give a
deceptively high level of gloss, which leads to disappointment
with the finished job unless the client makes an allowance
for the additional gloss. Matte finishes are available for most
systems and should be used unless the finished job itself is
going to be laminated or UV-varnished.

Press Proofing

In the past, when a proof was needed, the printer had to
print copies from the type, blocks, or plates that would later
be used to print the job. Prepress proofing systems have to a
large extent replaced the press proof, although there are still
circumstances when press proofs are the best method of
proofing. They are made, as their name suggests, on a print-
ing press using the printing plate that will be used in the
production run. They are usually produced on specially
designed presses that are very fast to prepare for printing,
but print much more slowly than a production press, making
them economical for the very small quantities needed for
proofing.

Another form of press proof is the **pass-on-press.** The
client goes to the printer and sees printed sheets (or sections
on a web press) at the beginning of the run, while the opera-
tor is adjusting the position of the image and the ink weights.
This is an effective way of controlling a job right up to the
point when it is on the press, but it should not be used as a

Table 12-1.
Advantages and uses
of different proofing
methods.

Soft Proofs

Advantage of soft proofs:
- Eliminates time and cost of hard-copy proofs.

Use soft proofs when:
- Interactive correction is desirable.
- Hard-copy proof is not required.
- Accuracy of simulation of final result is not critical.

Digital Proofs

Advantages of digital proofs:
- Approval can be reached at an earlier stage.
- Eliminates expense of correcting final films.
- Can be produced by designer or publisher.

Use digital proofs when:
- Substantial alterations are likely.
- Film is not being used (in direct-to-plate systems or in digital color printing).

Photomechanical Proofs

Advantages of photomechanical proofs:
- Cheaper than press proofs.
- Allow approval at an earlier stage than press proofs.
- Eliminates the cost of correcting plates.
- Accurately shows detail, such as halftone dot structure.

Use photomechanical proofs when:
- A single copy of the proof is adequate.
- Simulation of ghosting, printing inks, and so on is not critical.

Press Proofs

Advantages of press proofs:
- Multiple copies can be produced economically.
- Inking variables, such as ghosting, that will occur on the final job are simulated.
- Press proofs can be printed on the job paper.
- They use printing inks with the same hues and overprinting characteristics as those used on the production press.
- They can be printed on both sides and made up as book proofs, if necessary.

Use press proofs when:
- Clients have difficulty in interpreting other types of proofs.
- A very accurate simulation of the final job is required.
- Multiple copies of the proof are needed.

substitute for approval at an earlier stage, since only the overall ink weights can be adjusted at this stage.

Press proofs are usually made on the same paper as that specified for the finished job and can be printed on both sides if necessary and made up into a book proof. They can also be given the same finish as the final job by varnishing, laminating, foil stamping, or whatever else is called for by the design.

A well-implemented approval cycle allows the client to get the finished job that they want without incurring additional expenses and delays, and the proofing system that is used should assist in achieving that goal. It should aid the designer in communicating and controlling the important aspects of each job and monitoring their reproduction throughout the process. With this in mind, the main factors that will affect the choice of proofing system are:

- The cost of producing the number of proofs required.
- The importance of color accuracy.
- The ease of making changes.
- The degree of interpretation necessary.

Questions to ask about a proofing system include:

- What types of colorants are used, and how well do they simulate the inks used in printing?
- What are the resolution and gray-scale capabilities of the device?
- What size of paper is accepted by the device, and what is the maximum image size that can be printed with bleeds, trim marks, and register marks?
- Can proofs be made on the job paper, or are special papers required?
- What screening methods can be used?
- What kind of calibration and color management support are available with the system?
- What is the speed of output and the size of the memory and page buffer?
- Is a special working environment required?

Many publications use more than one proofing system. One common practice is to make final color proofs only for advertising, where accuracy and approval are more critical, and to use a cheaper system for the proofing of editorial illustrations.

Choosing a Proofing System

The following factors should be considered when selecting a proofing system:

Output size. Press proofs can be as large as the final printed sheet, while prepress proofs can be made in sizes up to approximately 36×25 in. (914×635 mm) with room for bleeds, trim marks, and so on. Many digital proofing systems have more restricted formats. To image bleeds, trim marks, register marks, and control strips, the proof's image area must exceed the size of the image by at least 0.5 in. (12.7 mm) on all edges. In other words, an image area of 9½×12 in. (241×305 mm) is the minimum for proofing a single page with room for bleeds, etc. It is often necessary to proof two pages to show the effect of a double-page spread, for which minimum output sizes of 18×12 in. (457×305 mm) are required.

Substrates. Some systems require special papers to be used, or restrict the range of weights or finishes. This makes it impossible to create a realistic proof of the job as it will appear when it is ultimately printed.

Halftoning capability. Screening methods are usually different from the screen pattern of the final print.

Evaluating Proofs

Two key objectives in color reproduction are realized by an effective approval cycle. The first is to achieve the best reproduction possible, consistent with the inevitable constraints of time and budget, and the second is to make the production process as smooth, efficient, and painless as possible. Proofing plays an important role in this.

Getting the best reproduction possible naturally means that errors should be identified for correction, and any serious flaws in the design should be rectified. Most problems arise from either failing to correct a significant error at the right time, leading to extra costs or the loss of product value; or from effecting minor changes that make little or no difference in the finished job, but add to its production time and costs. Occasionally, these are two sides of the same problem, one that has been referred to elsewhere as losing the "significant few" among the "trivial many."

The way to avoid these problems is to set up an approval cycle for each job, identifying the elements that must be approved and specifying the point at which approval should

Figure 12-9.
Image correction
marks in ISO 5776.

No.	Symbols	Instructions/Meaning
1	$+$	Increase (tone value, in percent, complete or limited area)
2	./.	Decrease (tone value, in percent, complete or limited area)
3	~	Equalize (e.g., color and lightness)
4	⌇	Sharpen up contour and/or borderline
5	⊕	Register
6	⅋	Delete a part
7	⇆ ↓↑	Move a part in specified direction
8	↻↺	Rotate
9	◐	Reverse image polarity (negative to positive or vice versa
10	⊒	Reverse (from right-reading to wrong-reading and vice versa)
11	\|← →\|	Indicate, change size to (insert dimension in mm)
12	⇳	Trapping (insert changes value in mm)
13	Σ	Overall change (use symbol in conjunction with another symbol

take place and by whom. One simple way of ensuring that everything is checked at some stage or other is by using a checklist.

Checking color on proofs is aided by a proof viewing cabinet and illuminated transparency viewer with 5,000 K light source, a densitometer for checking ink weights and dot sizes, and a spectrophotometer for measurement and comparison of color values.

Version Control Make sure that proofs are clearly marked "first proof," "second proof," and so on to avoid possible confusion. Copies of proofs should be kept, as well as a record of any corrections specified (perhaps by photocopying the marked-up proof).

If possible, file all proofs or copies of them centrally, so that a record is available of alterations and corrections, and

an "audit" of the approval cycle can be undertaken to improve working methods. It should be possible to trace through a set of proofs for a job to discover where an error appeared and what changes, if any, were specified.

If there is a chance that proofs will get mixed up, add the title of the job and the number of the section or signature in a waste area on each proof. Many applications are able to add the current date to a file when it is output, and this **electronic date stamping** can be used to monitor which version is the latest. When circulating proofs, make sure that people know when they are to be returned and which version they are viewing.

The intentions of publishers and designers sometimes remain unclear to the trade shop or printer, owing to differences of terminology or interpretation. The objective should be to write clear, precise, and unambiguous instructions.

Corrections and alterations should always be in writing. Where they are communicated verbally, written confirmation should also be sent by fax or by mail to avoid any possible ambiguity.

Quality Control

Whatever type of proofing system is used, some form of control elements should be incorporated so that ink weight and dot gain can be checked. If proofs are produced by a trade shop or printer, they should be asked to include a control strip on the proof. For digital proofs, small test elements should be included in the output file. Ideally, these should include solid patches in the colorants of the proofing system (for checking the densities being imaged) and in the colorants of the printing system being emulated.

Process control standards have been defined for color proofing in ISO 12647 (see chapter 14). They include a colorimetric specification of the colorants used, the tonal value transfer characteristics, and production tolerances.

Proofing in the Workflow

Proofing has always been an integral part of print production, but its essential function — allowing inspection and approval of work done — has been called into question by contemporary quality management thinking. From a quality assurance perspective, proofing is a tool for getting a job right eventually, when what we should be looking for is a way of getting it right the first time — every time.

Increasing standardization of the printing process, combined with the trend towards carrying out prepress work at

the design stage, point to the possibility of eliminating the distinction between the design proof and the final color proof. It is becoming technically and economically possible to produce a finished prototype of a job for customer approval, and for this prototype to act as both an iterative design proof and, following approval by the client, as a final color proof.

This approach requires:

- Rigorous standardization and calibration of every element of the production process.
- More accurate digital proofing tools, including good color management.
- An ability by the designer, the client, and the printer to interpret the digital proof.

Digital proofing tools have the potential to be used to produce a full prototype or visualization of a job at the design stage and support interactive alterations until it can be finally approved. If the job could then be passed into a well-controlled production process working to known standards, no further proofing would be necessary.

Bibliography

Green, P. J. (1997). *Professional print buying*. Leatherhead: Pira International.

ISO 5776:199x *Graphic technology—Symbols for text and image correction* (in preparation).

13 Digital Printing

While conventional printing processes are mature technologies, in which developments in press design, inking systems, and materials are largely evolutionary and incremental, digital color printing is the focus of intensive research and innovation. Unlike the conventional processes, digital printing systems are falling in price and are also improving in quality of output, speed of production, and workflow management.

Digital printing systems can be distinguished by their imaging speed, the resolution and screening methods, the range of media that can be printed on, the marking technologies, and the colorants. Also important are the workflow integration and the products they are designed to produce.

Resolution

Addressable resolutions of digital printing systems vary all the way from a few dozen dpi in high-speed inkjet overprinting heads to 4000 dpi in Pictrographic systems imaging on photographic media. When considering device resolution, however, it is especially important to distinguish between addressable resolution and spot size, since on many devices the spot that is imaged onto the substrate is substantially different in size from the device pixel that is addressed. For example, the addressable resolution of an inkjet printer is fixed by the spacing of the nozzles, but the size of the droplet that appears on paper is influenced by the volume of ink ejected and the absorbency of the media.

Halftoning Method

A distinction can be made between contone printers, which image a fully variable colorant density, and all other printers, which require some form of halftoning in order to reproduce the full range of gray levels. Dye sublimation printers are the main type of contone devices, but other systems are increasingly able to vary spot density or size to a degree, and

this increases the apparent resolution of the device. Screening methods are often developed specifically for the device in order to achieve the most visually pleasing results from the resolution and gray levels available.

Imaging Limitations

Although highly flexible, many digital printing systems have limitations in the range of printing that they can do. Many systems have a restricted tonal range, with difficulty in imaging highlights. Others have difficulty in printing large solids or require special treatment where an image crosses a fold.

Speed

High-speed digital printers have existed for many years, but the challenge is to image higher resolutions and wider widths at these speeds. One requirement of higher speeds is to design the imaging head as an array instead of a single nozzle or beam, preferably in the full width of the sheet or web. This reduces the need to repeatedly track across the width of the media. Other developments in imaging speed are continuing, but in some cases the barrier to further increments are in the ability of the front-end to deliver rasterized data to the marking engine (especially with variable image printing) and the ability to transport the sheet or web through the system under register control and into the postprinting subsystem.

The usual measure of printing speed for digital printers is the number of pages per minute that can be imaged. Wide formats, multiple print heads, and simultaneous duplex printing may increase the overall speed of the system. Low-speed office-type systems are often referred to as **page printers.**

The Technologies

There are numerous methods of actually transferring a rasterized image to paper. For convenience, we have divided the digital systems into **inkjet** (where a liquid ink is propelled onto the paper); **electrostatic** (where a toner is transferred by an electrical charge, usually following laser exposure); and **thermal** (where a wax or dye colorant is transferred to the paper by heat). This classification is something of a simplification, and many devices do not fit neatly into one or other of the categories proposed. There are also conventional presses that have been modified to accept direct digital imaging of the printing surface.

Colorants and image transfer methods in digital printing are unlike those used by conventional printing processes, and

so color gamut, resolution, and tonal characteristics tend to be different. Screen rulings tend to be lower. Dye-sublimation printers tend to produce the best quality results—with 300-lpi continuous-tone images that have the same amount of information as a high-resolution litho print. Electrostatic systems are capable of addressable resolutions up to 2,400 dpi, which enables a 150-lpi gray scale image to be printed. In all systems, there is a trade-off between imaging speed and resolution, so that, for example, inkjet heads mounted on web offset presses print very coarse images at full web speeds, while, at the other end of the scale, higher resolutions can be achieved on proofing systems that operate at slow speeds.

All digital systems have three basic components: a **raster image processor** to convert the image into a bitmap suitable for the printer; a **buffer** that holds the rasterized image in memory ready for printing; and a **marking engine** that transfers colorant to the substrate. The RIP may be located within the printing device itself, externally in a separate hardware or software RIP, or in the host computer. In some cases, the printing speed of the marking engine can be as high as that of a small conventional printing press, but in practice the speed may be limited by the capabilities of the RIP and the page buffer.

Inkjet

Inkjet printers generate ink droplets, either by forcing a continuous stream of ink through a nozzle (with the unwanted droplets deflected electrostatically to a waste gutter) or by propelling droplets on demand according to the image requirements. **Drop-on-demand** inkjet printers propel ink by thermal or piezoelectric methods. **Thermal inkjets** (or **bubble jets)** heat a tiny amount of ink until it vaporizes, its expansion forcing liquid ink through an aperture at a high speed, while **piezoelectric** (or **phase-change)** systems rely on the properties of quartz and ceramic materials to change shape when a charge is applied, mechanically forcing ink out through an opening. **Continuous inkjets** are used on web offset presses or in binding lines to add customer- or batch-specific information. Most systems are effectively binary— droplets cannot vary in size—but some continuous inkjet printers have the ability to send several droplets to the same location on the paper, resulting in the droplets merging and spreading as they arrive at the paper surface. The number of droplets that can be sent to the same spot determines the number of gray levels that the process can achieve.

Figure 13-1.
Inkjet printing.

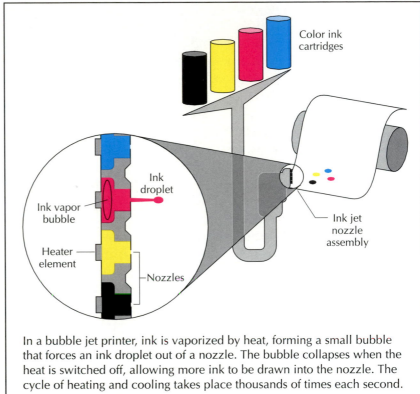

Color ink
cartridges

Ink
droplet

Ink vapor
bubble

Heater
element

Nozzles

Ink jet
nozzle
assembly

In a bubble jet printer, ink is vaporized by heat, forming a small bubble
that forces an ink droplet out of a nozzle. The bubble collapses when the
heat is switched off, allowing more ink to be drawn into the nozzle. The
cycle of heating and cooling takes place thousands of times each second.

Most inkjet page printers can produce resolutions compa-
rable to low-end laser printers, at around 300–720 dpi. At
this resolution, working at up to 20,000 cycles per second, a
twelve-jet array takes a minute or so to print a single page.
The lower resolutions and faster droplet generation of press-
mounted continuous inkjets allow them to print at the full
production speed of the press, which may be as much as
70,000 copies per hour.

Inkjet devices can print on most papers, although drying
is slow on stocks with low absorbency, and wicking (ink
spreading into the paper fibers) can occur on more absorbent
materials.

In **solid ink** or **phase-change** inkjets, the ink used is
solid at room temperature and briefly liquefies as it is heated
prior to printing. It then resolidifies immediately upon
reaching the paper, giving a better color strength as little ink
is absorbed into the medium. Although imaging speeds are
faster than conventional inkjet, resolutions are lower.

Because actual spot size is partly dependent on the
absorbency of the media, it is important to consider inkjet

Figure 13-2.
Sample of high-resolution inkjet output. (Detail enlarged 10×.)

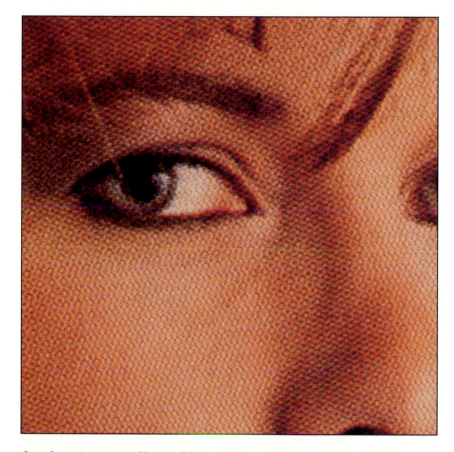

droplet size as well as addressable resolution. Piezo inkjets are capable of smaller droplets than thermal systems, currently at around 8–10 picoliters. In some printers the effective resolution is doubled by making two passes over the media, giving up to 1,440 dpi. Piezo imaging heads currently on the market have droplet sizes as low as 3 picoliters, giving a spot size of around 30 microns and a single-pass addressable resolution of 1200 dpi. In addition, piezo systems are capable of a small degree of droplet size variation, with typically three sizes of droplet.

Pigment inks have been used in some systems in place of the more usual dye-based inks. Pigments have larger molecules and tend to be less transparent, but enable higher colorant densities to be achieved.

An inkjet publication web in development by Scitex and partners is a 20-in. (508-mm) web press, imaging 200 ft./min. (61 m/min) and producing up to 12,000 fully variable duplex pages per hour. This is the fastest inkjet system currently in development.

Electrostatic Printing

Electrostatic printing covers photocopiers, laser printers, and other printing devices that employ the xerographic principle of using an electrical charge to attract toner to image areas.

A pattern of charged areas corresponding to the image that is to be printed is created on a dielectric drum. Toner with an opposite charge is brushed over the drum, where it adheres only to the image areas and is then transferred to the paper.

The image is formed on the drum by first applying a charge to the whole drum. A high-intensity light source scans across the surface, switching on and off according to the image requirements, and the charge is dissipated wherever light falls on it. In a photocopier, the light is reflected from an original on a platen through a lens on to the drum, while, in a laser printer, the light sources are laser or LED devices driven by digital image data.

Current electrostatic printing technologies include **dry electrophotography** (with pigmented toner powder as the printing medium); **liquid electrophotography** (with pigment particles suspended in a liquid); and **phase-change electrophotography** (with pigment suspended in a waxy solid that is briefly liquefied during image transfer). Toner particle size in liquid electrophotography (around 2 microns) is smaller than solid toners, and higher-quality prints can be produced.

Solid toner tends to have a matte appearance, although semi-glossy finishes are available in some systems. Liquid

Figure 13-3.
Schematic of color laser printer.

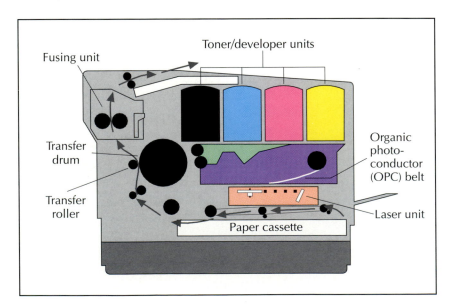

Figure 13-4.
Color laser prints.
(A) The laser scan
lines are visible in a
conventional print.
(Detail enlarged 10×.)

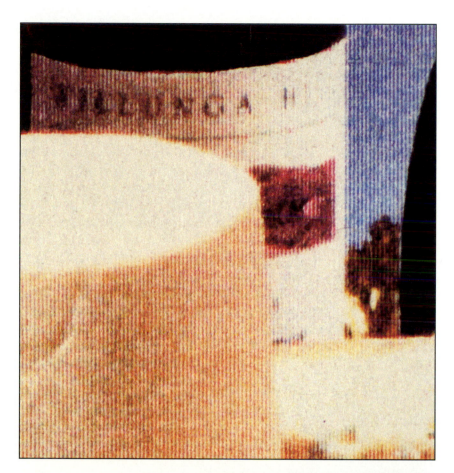

(B) Here frequency-
modulated screening is
used, although at a
much lower resolution
than would be found in
litho printing. (Detail
enlarged 10×.)

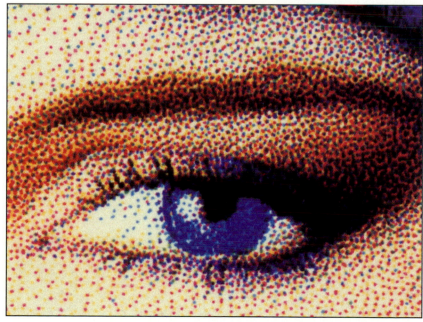

electrophotography has a gloss appearance much closer to that of offset litho printing.

A similar type of printer, called **electron beam** or **ion deposition,** generates a stream of negative ions to form a charged image directly on the drum. These devices do not currently have the resolution capability of laser printers, but are much faster and are widely used for document printing.

Laser printers usually have resolutions of 300–600 dpi, although 2,400 dpi is technically feasible and a number of 1200-dpi systems are marketed. Toner particle size (around 10 microns) and the resolving power of the transfer drum set the ultimate upper limits on the possible resolution.

Thermal Printers

Although the term "thermal printer" covers a very wide variety of different techniques, two are of particular importance: **thermal transfer** and **dye sublimation.** Both types use semiconductor resistors to heat the colorant so that it can be transferred to the paper. In thermal transfer, the colorant is effectively melted onto the paper, like a miniature version of wax sealing. In dye-sublimation printing, the colorant is vaporized before transfer to the paper.

Thermal systems that produce binary images do not have adequate resolution to form conventional periodic halftone

Figure 13-5.
Thermal printing.

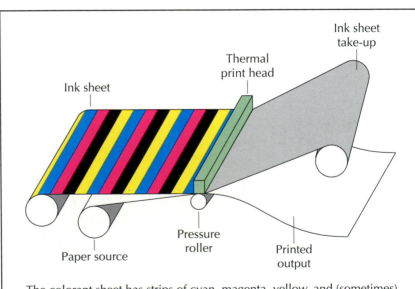

The colorant sheet has strips of cyan, magenta, yellow, and (sometimes) black, which pass under the thermal print head. The print head heats the colorant and vaporizes or melts it on to the paper.

Figure 13-6.
Thermal dye sublimation print. (Detail enlarged 10×.)

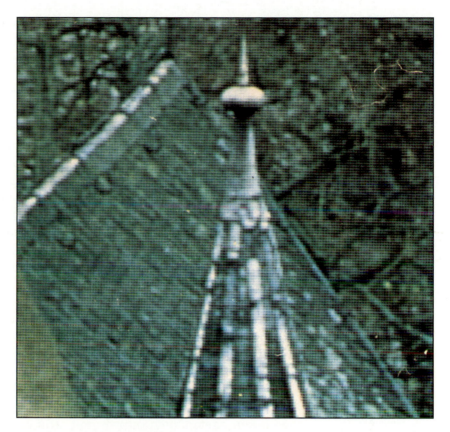

screens and instead use coarse patterns to reproduce continuous-tone images.

In a dye diffusion thermal transfer (or dye sublimation) device, tiny resistors are heated and vaporize a colored wax onto the proofing substrate. By applying a variable voltage to the resistors, different densities of colorant can be transferred to give a grayscale instead of a binary image. The dyes of the three primary colors (black is often unnecessary due to the high density of the CMY solid overprint) combine, resulting in a continuous-tone image very similar to a photographic print. Dye-sublimation systems of this sort do not simulate a halftone dot when used for proofing, and because a continuous-tone image is produced a resolution of around 300 dpi is adequate for the reproduction of images.

Dye-sublimation printers produce brilliant, saturated colors. The slow speed of output makes them suitable mainly for one-off prints such as color proofs, prints from digital cameras, and presentation materials. Special papers are required for most systems.

High-Volume Printing

For longer runs, electrostatic systems are currently the most successful technologies, with speeds that approach those of conventional lithographic printing. In the future, it is possible that inkjet may emerge as the most viable digital printing technology, but at present the difficulty in achieving acceptable resolution at high production speeds excludes inkjet from color printing at speed.

In order to compete with conventional printing presses, digital color printers combine some features of conventional press configuration with innovative imaging methods in a hybrid design that resembles neither the small-scale office printer nor the conventional production press.

Since high production volumes are essential to recover the relatively high capital costs of digital presses, it is important for users to consider workflow management, including the preparation and rasterization of pages, as well as the physical speed of the marking engine. Most systems have some form of buffer to hold RIPed pages prior to actual transfer to the imaging device and employ workflow management routines, including imposition, job queuing, color management, and OPI file replacement to ensure the smooth handling of color pages and images. In some cases, the press may be unable to handle the amount of data needed to change the whole image on each impression, and only a part of the page can be variable on each copy.

Digital color presses are faster to set up than conventional presses since there is no need to adjust position or inking levels. Proofing is done by printing a single copy of the job for approval on the digital press itself, prior to output of the remainder of the print run. The proof, an exact facsimile of the production run, is in effect a production press proof.

The drum technology used in electrostatic digital printers is essentially the same as that used in laser printers and photocopiers, and it must be replaced regularly. On a high-volume multicolor printing system, annual maintenance costs can be very high.

Xeikon

The Xeikon marking engine, developed by Xeikon of Belgium, uses dry electrophotography and employs a multiprocessor approach to enable fully variable data to be processed. It is reel-fed, printing up to 2,100 pages per hour. The maximum width is 500 mm, making it possible to image a B2 size (19.68×27.83-in.) sheet.

LED arrays are used in eight separate printing units to print cyan, magenta, yellow, and black on each side of the paper. The imaging heads operate at a resolution of 600 dpi, but are able to vary the amount of charge imparted to the drum by the LED spot. Up to sixteen density levels can be

Figure 13-7.
The general system schematic is similar for all engines based on the Xeikon, including the Agfa Chromapress.

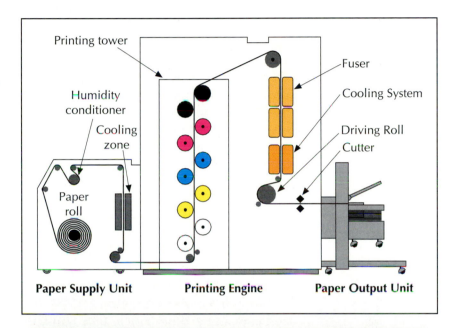

Figure 13-8.
Color laser print produced by an Agfa Chromapress. (Detail enlarged 10×.)

imaged, giving a printed result that is claimed to be equivalent to offset litho at 175 lpi.

Agfa, Barco, IBM, and Xerox have developed front ends for the Xeikon engine, incorporating sophisticated workflow planning functions, together with automatic imposition, OPI file swapping, and color management.

Indigo

The Indigo E-Print has only one printing unit, but by feeding the sheet back through after each consecutive pass, it can print up to six colors on each side. Liquid electrophotography allows the E-Print to use pigment particles of 1–2 microns in size, giving improved resolution with smoother solids and better highlight detail in comparison with dry electrophotography. The liquid ink polymerizes instantly on contact with the paper, printing a very sharp image with no physical dot gain (although optical dot gain is still present).

Printing speed is 8,000 pages per hour for one color, but every subsequent color halves the output speed. A four-color duplex job is output at a speed of 500 copies per hour. Print resolution is 800 dpi, and the resolution enhancement technology used makes the print appearance similar to conventional offset litho at a 150-lpi screen ruling.

A 640-MB buffer stores up to 100 compressed and rasterized pages at a time. For longer runs, the press can only rasterize and transfer part of the page fast enough to vary it for each copy. However, it can rasterize the variable data and combine it with the constant page elements at the full pro-

Figure 13-9.
Schematic of Indigo E-Print 1000 printing device.

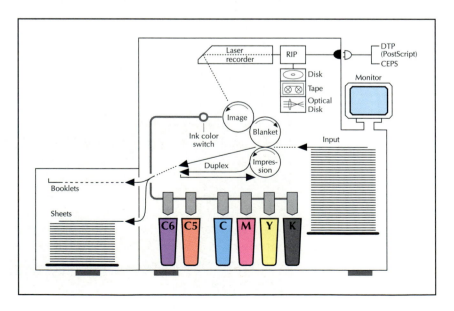

Figure 13-10.
Sample output from
the Indigo E-Print
1000. (Detail enlarged
10×.)

duction speed. The single-unit design calls for the ink to be
removed from the printing blanket after each revolution. To
achieve this, the ink has to be formulated with relatively low
adhesion, which also means that, as a result, it can be
rubbed off some printing papers.

**Direct-Imaged
Conventional
Presses**

Adapting conventional printing presses to direct on-press
digital imaging is another route to achieving digital color
printing, and one that manufacturers of conventional presses
such as Heidelberg are following. The Heidelberg DI range,
for example, includes plate exposure systems with laser
diode arrays as part of the press design. Each laser diode is
connected to an optical fiber, which transfers the laser light
to lenses distributed across the plate cylinder. A range of
CTP plate imaging methods are used, including laser abla-
tion and thermal exposure, and both waterless and "wet"
plate systems have been developed.

Imaging resolution is variable up to 2,540 dpi, comparable
to many imagesetters and allowing normal screen rulings to

Figure 13-11.
Heidelberg Quick-
master DI press.

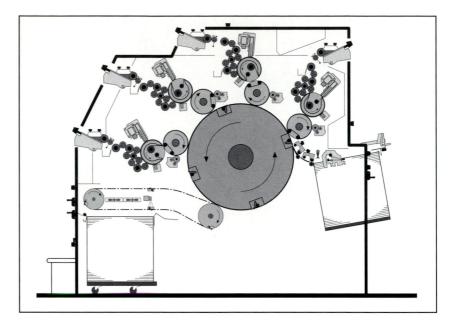

be used. The process is commercially viable on runs of 500 to
5,000, which is considerably higher than the economic run
lengths of digital color presses.

Preview systems allow the printer to check rasterized
pages prior to production, including data for elements such
as trapping, halftone appearance, and font substitutions.

Other DI presses in production or commercially available
include the Scitex/KBA Karat and systems from Screen,
Kodak, Roland, and Adast. Some follow conventional press

Figure 13-12.
The Scitex/KBA
74 Karat press.
*Courtesy Karat Digital
Press GmbH*

configurations, but others have taken the opportunity to thoroughly reengineer the press design and introduce innovations such as keyless inking.

An advantage that direct imaging has over conventional platemaking is that there is no degradation of the image on transfer from film to plate. This factor is particularly useful in images using stochastic screening, where small variations in the transfer of the small pixels that make up the image can cause large shifts in tone or color.

Modified conventional press designs must be able to image the printing cylinders very quickly, as the printing press has the highest capital cost of all the production equipment and unproductive time is extremely expensive. Imaging times are typically in the 5–15 minutes range (with all cylinders being imaged simultaneously), but some form of plate preparation is often required, such as wiping the plate surface to remove ablation dust or moving a fresh plate surface into position on the plate cylinder.

When compared with conventional printing, direct-to-press imaging has the advantage of automatic registration of colors without adjustment during makeready. It also enables the printer to accept jobs in electronic form for direct transfer to the press, eliminating the need for prepress operations.

Workflow Integration

The productivity of digital printing systems is enhanced if they are integrated into the production workflow. It is especially important to consider the preprinting or **front-end** aspects, such as the network, RIP, and data management.

Many page printers are designed to be **network-ready** with network interface cards and support for network protocols. An increasing number of systems are including a Web server in the printer firmware, to enable printer control through a browser interface and support for distributed printing.

A high-volume system will have a dedicated RIP, and may compress post-interpreted data for intermediate storage in page buffers prior to screening and imaging. Transfer functions to maintain calibration may also be applied to the data at this stage.

Electronic collation is performed by many systems, especially those producing book blocks. The pages are rasterized and sorted so that the print order corresponds to the page order, thus removing the need for postprint collation of the hard copies.

Postprint options are important in determining the products that a digital printing system can produce. As well as basic folding and collation, specialized systems are available for products such as business forms, flexible packaging, and books.

High-volume digital presses are relatively costly, and a more scalable method is to cluster a number of smaller page printers together, with a single RIP that receives and rasterizes the incoming data and shares the print volume between the printers in the cluster.

Color Matching

The ability to match a color original is ultimately determined by the gamut and tonal range of the process, and the color management profiles used. Colorants tend to have different spectral absorption properties than inks used in conventional printing processes, and the resulting color gamuts are different and in some cases larger. Many systems are configured to match existing standards for commercial printing (such as SWOP), but if the gamut is larger then a wider range of colors, including special colors such as Pantones, can potentially be matched. An ICC profile converts color data from a gamut-unlimited CIE-based color space, and if the characterization data from which the profile was created includes the full colorant densities the entire gamut of the device will be utilized.

Color-matching abilities are limited by restricted tonal ranges, and in particular the difficulty in imaging very small spots. Some laser and inkjet printers are unable to reproduce dot areas below around 10%, making it difficult to print highlight detail. A solution adopted in some systems is to incorporate additional low-strength cyan and magenta colorants. This assists in matching highlight and pastel colors, and also provides extra density for high-chroma colors when overprinted with the normal-strength colorants.

Reliability and repeatability have proved to be an issue with many digital printers. Although ambient operating conditions (temperature and humidity) have little influence on print densities, internal drift in the system and batch variations in colorants make wide color variation possible. One study of color laser printers showed mean variations of up to 7.3 ΔE over a four-month period, with yellow prone to the largest variation.

Day-to-day variation between colorant batch changes tends to be much less, especially if systems are allowed a warm-up period of around 30 minutes.

Developments in Digital Printing

Digital color printing technologies will continue to develop. Some will represent radical departures; some will be evolutionary changes to current systems; and others will be novel hybrids of existing and new technologies.

Many other imaging technologies exist, and others are in development. Some notable examples include:

Elcography. A liquid ink is electrostatically coagulated in image areas and transferred to a moving web. This is a relatively low-resolution system with possible applications in newspaper printing.

Pictrography. This is a hybrid photographic/digital system, in which laser diodes expose a light-sensitive donor material at 4,000 dpi to create a dye image that is then developed and transferred to a receiver paper.

Thermo-autochrome. This is a similar process to Pictrography, in which there is no intermediate and the media contains the color dye layers.

Will Digital Printing Take Over?

Digital printing is not, as some people have speculated, about to overtake the conventional printing processes. Conventional printing processes are faster and cheaper for medium to long runs and produce better quality. Digital systems cannot achieve quality comparable to conventional printing without a heavy penalty on output times. A 64-page magazine, for example, would be printed at a speed of 125 copies per hour on the fastest color digital system currently available, compared with a production speed of around 40,000 copies per hour on a heatset web. Production costs are also considerably higher.

A more likely outcome is that the spectrum of price/performance, with gravure at the long-run end and screen printing at the opposite end, will be transformed to make room for a range of new systems producing an increasing amount of relatively short-run work. Shorter runs will continue to comprise an increasing share of the total printing market, making digital color systems probably the fastest growing sector of printing.

The newer printing technologies are also ideal partners and enabling technologies for electronic publishing, producing all kinds of printed output that would otherwise be technically or economically impossible. Digital printers designed for

higher production volumes are being developed, and inevitably the length of run at which it becomes cheaper to move from conventional to digital printing will continue to fall.

Bibliography Bruno, M. (1995). *Printing in a digital world*. Pittsburgh, PA: GATF*Press*.

Fenton, H. and F. Romano (1997). *On-demand printing: the revolution in digital and customized printing*. Pittsburgh, PA: GATF*Press*.

Fenton, H. (1998). *On-demand printing primer.* Pittsburgh, PA: GATF*Press*.

Martin, G. (1993). *Non-impact printing*. Leatherhead: Pira International.

14 Conventional Printing

The changing market for printed products, with a greater demand for color and a greater emphasis on quality assurance, has brought about radical changes in the technology and management of the printing industry. A combination of digital prepress and press automation has significantly reduced setup costs, shortened lead times, and made possible new products that could not have existed before. They have also brought significant savings in preparation costs, and publishers can now expect better quality, faster turnaround times, lower prices, and a much more flexible approach toward meeting their specific needs.

The conventional printing processes are mature technologies, based on simple physical or chemical principles that have developed and evolved over many years. Electronic methods of generating color reproduction have had less of an impact on the technology of putting ink on paper than in the prepress arena, although major changes are taking place in direct imaging to plates and presses. The recent changes in press development have been of three main kinds: reducing the time taken to prepare and run each job; automating press functions; and adding interfaces to sophisticated quality and production management systems.

Radical changes in the ways in which printing plates are created have taken place in recent years, with intermediate image transfer steps being eliminated through the adoption of computer-to-plate systems. Most major press manufacturers have also invested heavily in developing direct-to-press imaging systems, and some of these (such as the Heidelberg DI range of presses) are now commercially established while many others are in development.

The key strengths of conventional printing, in comparison with current digital printing systems, are:

- Low unit costs of copies.
- High production speeds.
- Wide range of processes and formats, including large sheets and rolls.
- Complete flexibility in choice of substrates, in terms of thickness, substance, surface finish, and type of material.
- High-resolution capability.
- Integration with other manufacturing stages, especially postprinting processes such as binding and finishing.

Although some digital printing systems are beginning to offer comparable features, there remains a considerable performance gap.

The cost, in real terms, of color printing has fallen throughout the last two decades, making color a real option for every printed product. The production costs per copy of a typical mass-market color magazine, from origination through to delivery of finished copies, are now on a par with the toner costs for a single-color laser print. Continuing advances in plate imaging methods and pressroom automation will deliver further reductions in real costs to publishers, although these reductions are likely to be of an incremental nature.

The only way of bringing production costs down by a further order of magnitude would be to pass them on to the user, by distributing the information content of the publication in electronic form for viewing on screen, or for output by the user on-demand using a local printing device. While this approach is commercially viable for specialized products, for the mass market the conventional printing processes remain the most cost-effective means of publishing text and images.

The major conventional printing processes are **offset lithography, flexography, gravure,** and **screen printing.** These are all established technologies capable of producing commercially acceptable color on a range of materials. Lithography has by far the largest market share, but technological advances in other processes, especially in flexography, render its continued dominance uncertain. Letterpress is still used in certain niches, such as label printing, but it cannot compete with the other processes for cost-effective color printing.

Modern printing presses are designed to achieve economies of scale. A single printing plate may carry up to 32 pages, and there will be as many printing units on the press as is necessary for economic production. Many presses are fitted with ancillary equipment that will dry or cure the ink and

Figure 14-1.
Schematic of a heatset web offset lithographic press.

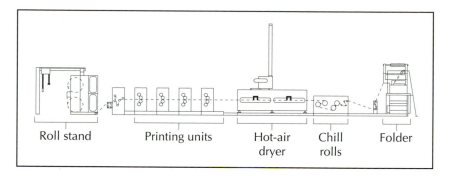

Roll stand Printing units Hot-air dryer Chill rolls Folder

then cut and fold the paper into a finished periodical or book. Numbering, perforating, and gluing may also be performed in-line on the printing press.

The largest sector of the market is occupied by general commercial printers, producing anything from small leaflets and CD inserts to reports, brochures, and short-run magazines. Other major sectors of the printing industry specialize in books, periodicals, newspapers, direct mail, point-of-sale, security printing, and the various forms of packaging and product decoration.

Price is nearly always the most important consideration when print buyers place a contract, and the printer with the equipment best adapted to produce the job efficiently, at an acceptable level of quality, will be most likely to win the contract. Printers face continuing pressure to invest in equipment and technology that improves their ability to meet market demands. A prime example of this is the long-term trend toward installing multicolor presses capable of printing four or more colors in one pass, in response to the growing demand for color. Another is the investment in press technology that speeds up makeready (through devices such as automated plate-changing equipment, paper stack handling, and remote-controlled ink adjustments), as a response to the publishing trend to shorter run lengths and greater diversity of titles.

Print faces increasing competition from electronic media. Where a publication consists mainly of large volumes of text, CD-ROM can be a far cheaper method of distribution. When users want sound, moving images, or interaction, multimedia may be the most appropriate format. However, the cost of distributing large files in many applications and the convenience of accessing a hard copy, weighed against the limitations of viewing information on a screen, often makes print the most suitable and cost-effective media. On-demand printing of publisher-supplied electronic information on small

color printers remains a possible threat to traditional print in the long term. The most likely projection is that the overall consumption of information will continue to rise, and print will continue to coexist with other media.

The major printing processes have their own characteristic features. The most important of these are:

- The way in which the image is formed on the image carrier.
- The method of inking the image carrier and transferring the ink from it to the substrate.
- The ways in which the ink is dried.
- Whether the material is printed in reel (roll) or sheet form.
- The particular constraints of each process.

Note that all the characteristics listed above are strongly influenced by the type of paper used. Smoother, coated papers allow high ink densities, minimum dot gain, long tonal ranges, and fine screen rulings, while more absorbent papers with rougher surfaces affect these variables adversely.

Other factors that determine the suitability of a process for a particular product include:

Paper infeed. Paper (and other substrates such as board, plastics, and metals) can be fed into the press in a continuous reel or web, or else in single sheets. Web presses run faster than sheetfed machines and can print on cheaper and lighter materials that are not rigid enough for sheet feeding, including lightweight coated stocks, plastics for packaging, and metallic foils. Web presses are equipped with folding units that deliver a complete magazine or book section, instead of just a printed sheet.

Ancillary equipment. To enhance the continuous production flow, many presses are equipped with numbering, scoring, gluing, perforating, or coating devices positioned in-line after the last printing unit. Where a job requires these operations, presses fitted with the appropriate ancillary equipment will be much more economical than completing this work off-press.

Number of in-line printing units. Printing presses commonly have one, two, four, or more printing units, each one printing a single color. Printers in certain specialty markets like greetings cards often have presses with six or more

units. Unless the print run is very short, it is most efficient to print on a press that has the same number of units as there are colors in the job. Four-color work, for example, should normally be printed on a four-unit press.

Versatility. Many presses can be reconfigured to produce different products. Multicolor sheetfed presses may be able to turn the sheet during printing, so that both sides can be printed in a single pass. Web presses can produce different products by reconfiguring the path of the web through the press and the folder unit.

Size. Printing presses are built in all sizes, taking sheets or rolls from 8 to 78 in. (210 to 2,000 mm) wide. Even larger sizes can be printed by the screen printing process.

Image carrier. Different processes require different printing surfaces or image carriers (printing plates, cylinders, screens, and so on), and they are a significant element in the cost of a job. Most output bureaus assume that a job is to be printed by sheetfed lithography unless otherwise instructed; for other processes, or for printing by web offset, the films may have to be made differently. Lithographic plates require positive or negative film that has the emulsion on the wrong-reading side, for example; while for flexography, right-reading negatives are required.

Range of substrates. The nature of the printing surface, the inks used, and the transport mechanism of the press all limit the range of substrates that can be printed. Only the screen printing process and inkjet (and one or two minor specialty processes, such as tampo printing) can print on items that cannot be fed through a press, such as fully formed cartons, other assembled products, and so on.

Ease of image change. Press manufacturers have invested a great deal in reducing the preparation time (known as **makeready**) associated with mounting and positioning each new printing plate, preparing the paper feed, and adjusting the ink flow. Fragmentation of publishing markets and the growing number of small, specialty titles has led to greater demands for shorter run lengths. Makeready reduction is a major goal in maintaining competitiveness. Automatic plate-changing equipment is becoming popular on multicolor

presses, but printing a completely variable image and changing to another image while the press is operating at full production speed is only possible in digital processes.

Drying systems. Several methods of converting liquid ink films to dry films are used on printing presses. Some rely on the evaporation of ink solvents and others on a chemical change assisted by some form of energy. The latter allow higher ink weights to be printed without setoff or marking.

The characteristics to consider at the prepress stage are:
- **Inking.** The typical ink weights printed and the nature of the colorants used.
- **Dot gain.** The change in dot values from film to print, which will require compensation on the films produced.
- **Tonal range.** The highest and lowest percent dot values that can be printed.
- **Resolution.** The highest screen ruling that can be printed.

Specific parameters to adjust or compensate for during color separation or film output include:
- The maximum overprint possible.
- The spectral characteristics of the inks used.
- The smallest and the largest printable dot.
- The amount of dot gain.
- The type of halftone screens to be used.

If you are responsible for sending files for output straight to film, you may have to ensure that the relevant adjustments have been made.

By far the great majority of printing surfaces (or **image carriers**) are produced photographically. This is done by exposing a film positive or negative onto a light-sensitive coating and then processing the printing surface to create the image and nonimage areas. Methods of creating the image by exposing direct from digital data are now available for most processes, but they have not yet been widely adopted by printers.

Lithography

Offset lithography is the dominant printing process, owing to its high print quality and the relatively low costs of plate preparation and press makeready. A lithographic plate has a water-receptive surface (or, in the case of waterless lithography, an ink-repellent surface) of aluminum or plastic in the

Figure 14-2.
The lithographic
process.

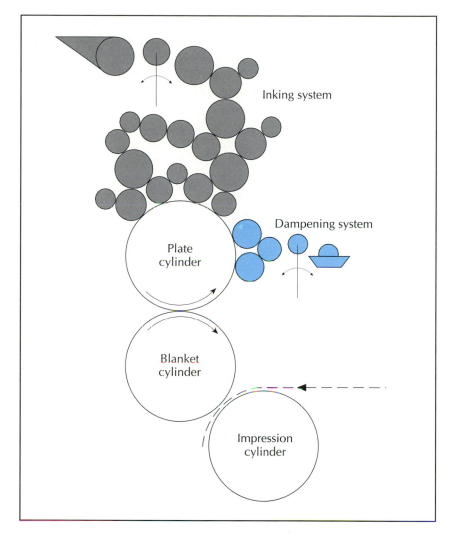

nonimage areas, and an ink-receptive, light-sensitive coating
in the image areas.

During printing, inking and dampening rollers are in con-
tact with the plate. The nonimage areas are wetted with
dampening solution and repel ink, so that it only adheres to
the image areas. This condition continues as long as the
ink/water balance is correctly maintained.

Ink transfers from the plate to a rubber blanket, which
then transfers the image to the substrate. The blanket's
resilience allows it to mold to the paper surface, producing a
clean, even impression even on textured papers.

As with other processes, the maximum ink weight that can
be printed is determined by the need to avoid **setoff** (the
transfer of wet ink from the face of one sheet on to the reverse

of another in the delivery pile) and **marking** (the smearing of wet ink on parts of the press), as well as the filling-in of halftones and tints.

Lithographic plates are relatively cheap to make, demanding little skill to achieve consistent results. They are very thin (0.006–0.020 in. or 0.15–0.5 mm) and can be stored for several years if preserved with a coating of gum. An aluminum lithographic plate has a high resolving power, and as a result will hold image detail down to around 5 microns. Combined with the photographic plate imaging systems, this enables it to print with the finest resolution and detail of all the processes.

Screen rulings can, as a result, be extremely high. Rulings of 600 lpi and above have been achieved using waterless plates, although 150–200 lpi is more usual in commercial printing on coated papers and 100–133 lpi on uncoated stock and newsprint.

Presses are built in configurations from single-color sheetfed machines up to very large web units that are coupled together to print publications with multiple pages. The paste inks used in lithography contain catalytic drying agents that cause the ink to dry slowly in normal room conditions. **UV-curing systems** are widely used to give instant drying and high gloss levels. **Infrared systems** are the main alternative method of accelerating the drying process. On web offset presses, coated papers are printed with inks that set hard after being heated and then chilled. Web presses fitted with this equipment are referred to as **heatset,** and other web presses are called **coldset.** Heatset presses are necessary for web printing on coated papers.

Lithographic presses will print on papers and boards up to 0.04 in. (1 mm) thick (depending on press design), and both smooth and textured surfaces can be printed. Metals and plastics are more difficult to print by lithography, due to their inability to absorb the printing ink. Only specialty printers handle these materials.

The main limitations of lithography are inherent in the use of water as part of the process. The balance between the water and the ink is very sensitive and easily upset. Ink may appear in nonimage areas if there is too little water, or alternatively, the ink will fade and water marks will appear in image areas if there is too much water present. Other effects can include inking inconsistencies, such as roller marks in solids and tints. The inking system also requires careful setting and monitor-

ing, and most waste occurs at the beginning of a run as the printer adjusts the color registration and ink levels.

Attempts have been made to eliminate these problems. One approach, known as **waterless lithography,** uses plates with a silicone layer to form the ink-repellent nonimage area. It has not yet been widely adopted, partly because of a reluctance to innovate and partly because a new set of problems is caused by the absence of water. Waterless lithography has been used successfully in Japan for some time, and it is likely that it will become more widespread in the future. One advantage of waterless lithography is that it makes very fine screen rulings possible.

Anilox-type inking, derived from flexographic inking systems, is being used successfully in some markets, such as newspaper printing. A simple inking system with a large transfer roller engraved with tiny cells ensures that the same ink film thickness is transferred to every part of the image.

Modern multicolor presses invariably have computer controls that accelerate functions like ink setting and register control. Some press manufacturers have developed systems that offer fully automated control of quality by on-line measurement of the sheet or web as it is printed and automatic follow-up adjustment. The high capital cost of these systems and the difficulty in controlling all the relevant variables have limited the number of printers who have installed them.

For very long runs of color printing, lithography competes with the gravure process, especially in the production of color periodicals and catalogs. Perhaps more important from the printer's point of view has been the replacement of a significant amount of small offset capacity by copiers and laser printers, although the high per-copy costs for color copying mean that small offset presses remain competitive on longer runs, while delivering higher quality.

Lithographic Plate Preparation

Lithographic plates are coated with a light-sensitive material. A film positive or negative is secured against the plate and exposed to a high-intensity light source that leaves the nonimage areas soluble in a developer. Since lithographic plates are very thin, it is also possible to expose them in an imagesetter if the plate material is sufficiently flexible. Plastic plate material in roll form, which is cut to the correct length for the press after imaging, is used in platesetters or imagesetters. Preparing plates in this way is known as **direct-to-plate** or **computer-to-plate.**

Flexography

Flexographic presses print from a flexible relief plate using liquid inks. A simple inking system makes the flexographic press relatively easy to set up and run. An anilox transfer roller ensures even plate inking without the need for careful adjustment. Inks can be either solvent-based (mainly for printing on nonabsorbent materials such as plastics and glass) or water-based (especially for absorbent materials like paper and board). The main solvent used is alcohol, although a small proportion of more hazardous hydrocarbons is also used. Most flexographic printing is now done with water-based inks.

Figure 14-3.
The flexographic process.

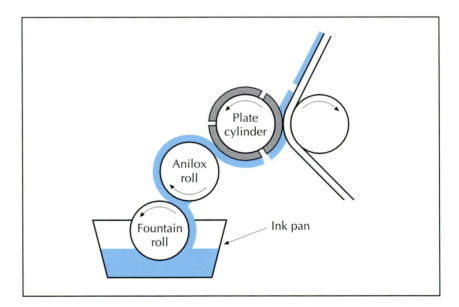

The main drawback of flexography is the distortion of the image as it undergoes pressure during image transfer. Solid areas are not seriously affected, although when printing on nonabsorbent materials there is usually an unprinted line (or **halo**) around the edge of the solid. Small type tends to be squashed, however, and halftone dots are badly deformed. The result is that the tonal range that can be printed may be as little as 25–50% on an absorbent substrate like newsprint. It is also difficult to print finer screen rulings, with 150 lpi being the usual upper limit that is only achieved on very smooth materials like plastics.

Flexography as a process has come from being something of a poor relation of other processes, fit only for the lowest-grade work and for substrates that could not easily be printed by lithography, to a position where it has been talked about

as a challenger to lithography as the dominant printing process. It is unlikely that flexography will ever match the resolution and tonal range of high-quality lithographic color, but improvements in quality through developments in inks, press design, and platemaking continue to be made. For example, plates have been developed that are thinner and harder than previously. By using these plates with lighter printing pressures and appropriate inks, sharper images can be printed with less distortion and dot gain. Printers have also employed laser-engraved ceramic anilox rollers to control the precise volume of ink that is transferred and replaced conventional heat drying ovens with UV-curing units to achieve lower dot gain.

Flexographic Plate Preparation

Plates for flexography were originally made by molding rubber to a relief (letterpress) image. This method has been superseded in many plants by photographic methods and electronic engraving. Photopolymer flexo plates are made by exposing a thin (0.04–0.10 in. or 1.0–2.5 mm) plastic material that has a light-sensitive coating to a photographic negative of the image that is to be printed. Exposure hardens the image area, and the nonimage area is then "washed out" by solvent to leave the image in relief.

The thickness and resilience of the plate material results in image distortion when the plate is mounted on the press and subjected to the pressure of printing. The image lengthens slightly in one direction, which can cause problems in some products like packaging, where a precise image length is required. A slight anamorphic distortion, known as **disproportioning,** is applied during preparation, or alternatively, the plate can be exposed in position on a cylinder. The complications of flexographic platemaking require specialized prepress systems, and it is not feasible to use film that has been prepared for lithographic printing.

Direct-digital methods of plate preparation are rapidly increasing in importance in flexography, since they eliminate intermediate production steps, shorten lead times, and integrate with electronic copy preparation methods. They also offer the only route to achieving quality levels comparable with the other printing processes, through improved color registration and better control of final dot sizes.

Laser-engraved rubber plates are made by mounting the rubber plate material on a cylinder and vaporizing the non-

Figure 14-4.
DuPont photopolymer
flexographic plate.
*Courtesy E. I. du Pont
de Nemours & Co., Inc.*

image areas with a CO_2 laser. The image data can be fed
either from an analyze cylinder on which the artwork is
mounted, or from digital data prepared in a DAR (Digital
Artwork and Reproduction) electronic prepress system. Flex-
ographic print quality is markedly improved by the use of
frequency-modulated screening and high levels of gray com-
ponent replacement.

Gravure

The strength of gravure has always been in long-run quality
color in the periodical, mail-order catalog, and packaging
fields, together with advertising color preprints for news-
papers. But current changes in publishing practices and
markets (including growing regionalization in periodicals,
the shift to flexography for carton printing, and the elimina-
tion of preprints in newspaper production in favor of
run-of-press color) have lead the move away from gravure.

The potential for gravure printing in other markets such
as color books remains unrealized, because run lengths are
falling as publishers adopt strategies that call for smaller
inventories, shorter run lengths, and more frequent updating
of titles.

Figure 14-5.
The gravure process.

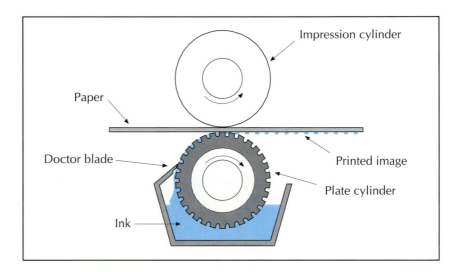

In gravure printing, the image area on the printing cylinder is recessed so that it is slightly lower than the nonimage areas. The whole printing cylinder rotates in an ink trough, and a steel blade scrapes the ink off of the cylinder's surface so that it remains only in the recessed image areas. Ink transfer from cylinder recess to paper is often electrostatically assisted, with the ink and the impression cylinder given opposite charges. Because the depth of the image recess is variable, it is possible for a gravure press to print ink films of variable thickness, unlike other processes. This produces a continuous-tone image with no halftone screen, and, as a result, gravure printing can exhibit excellent tonal qualities.

If the steel doctor blade is not supported in solid areas of the image, it will abrade small image features and remove ink from the recesses. For this reason the image is created from small individual cells, each cell having a depth that corresponds to the tonal value required. The cell structure is not noticeable in images, but can be quite objectionable in text, which has a ragged appearance not unlike 200-dpi laser printing.

Cylinder preparation is time-consuming and costly, making gravure competitive only on longer runs. The image on a gravure cylinder lasts for many millions of impressions without wear. Color variation is virtually eliminated by the design of the inking system, making the process highly suitable for the printing of packaging where consistent color is very important.

There are two main types of gravure presses: large publication presses, producing multipage jobs like catalogs and

periodicals; and smaller presses printing flexible packaging, wallpaper, gift wrapping, and so on. Gravure presses are normally reel-fed, with the exception of a small number of sheetfed presses designed for proofing and the printing of cartons and short-run, high-value products.

The hazardous nature of solvent-based gravure inks have caused some problems for gravure printers. Aromatic hydrocarbons, employed for their ability to promote the efficient transfer of ink from cell to paper and to evaporate quickly from the paper after printing, give rise to high rates of **VOC (volatile organic compound)** emissions, which are known to cause environmental and health problems. Ink manufacturers have developed water-based alternatives, but there are problems in formulating them so that ink transfers consistently to the paper without leaving residues on the cylinder. Further work needs to be done in developing alternative inks and papers.

Apart from the ability to produce long print runs economically, the main strengths of gravure are consistency of color and its ability to print good quality color on very cheap uncoated papers. Once the cylinder has been imaged, the ink weight that is printed cannot be altered, which is a great advantage in applications, such as packaging and consumer catalogs, where color consistency can be of critical importance. As long as the paper surface is smooth (and preferably supercalendered), even the lowest-grade mechanical papers give good results. Very cheap papers with supercalendered surfaces can be printed, and this is often a factor in choosing gravure over lithography for the production of periodicals and catalogs. The heavy ink films possible with gravure enhance the brilliance of special colors and metallic inks. Plastics and other nonabsorbent materials can also be printed without difficulty.

Gravure Cylinder Preparation

The gravure cylinder is normally solid steel, plated with a skin of copper, and the image is formed by etching or engraving a pattern of cells with a variable depth. After proofing, the copper may be plated with chromium to harden the surface and extend its life.

Cylinders can be imaged either photographically or electronically. Photographic imaging involves exposing a film positive to a tissue with acid-resistant properties. The tissue is attached to the surface of the cylinder and chemically etched, the **resist** controlling the depth of etching.

Figure 14-6.
Gravure cylinder
engraving on a Helio-
Klischograph.
*Courtesy Linotype-
Hell Co.*

Photographic cylinder etching is still in widespread use in plants specializing in packaging but has been superseded in most publication gravure plants by electronic engraving. This process is similar to analog scanning: a positive is prepared and mounted on an analyze scanner, which sends image data to an engraving device on which the cylinder is mounted. A stylus scans the cylinder, pecking cells to the required depth. There can be up to twelve scanning heads on the analyze drum and a corresponding number of engraving heads on the cylinder.

Gravure positives have in the past been continuous-tone film or bromides prepared photographically from mechanical artwork and transparencies. Where scanning of originals is still used, publishers now prefer to supply halftone film positives prepared in the same way as positives for offset lithography, and an **offset gravure conversion (OG)** method is used to convert the halftone positive to a continuous-tone image.

Electromechanical engraving lends itself naturally to digital prepress, by simply replacing the analyze scanning of the positive with image data from a page-makeup system. This considerably shortens cylinder production times, since there is no need to convert the original artwork to continuous-tone positives and mount them on the analyze cylinder. Quality is also improved by direct cylinder engraving. Interfaces between the engraving system and PostScript front-ends have been developed and have had a considerable impact on both periodical and packaging markets, enabling gravure to compete with flexography and lithography in shorter run lengths.

Attempts to replace electromechanical-stylus engraving with laser or electron-beam engraving have not been successful thus far. It has proven difficult to develop materials that can be easily vaporized by a laser while also remaining sufficiently durable to resist abrasion by the doctor blade and the printing substrate. Electron-beam engraving systems also remain too costly for widespread commercial use, and development work in this area has ceased. Photopolymer plates (produced in the same way as flexographic plates) have so far met with limited success.

Screen Printing

Screen printing is a stencil printing technique, in which ink is forced through the open areas of the stencil, through a mesh screen, and onto the substrate.

Like the other conventional processes, the fundamental principle is extremely simple, and equipment for screen printing can consist of no more than a frame, a bed, and a squeegee. More complex equipment may be used for high-speed multicolor printing, or for dedicated machines printing directly onto products or packs. The ability of the screen printing process to print on any substrate makes it very versatile. It is the only process capable of printing items on mirrors, ceramics, bottles, plastic pots, and road signs.

In screen printing, as in flexography, small highlight dots cannot be held easily on the stencil. The halftone screen ruling and the tonal range are limited by the size of the openings in the screen mesh and the ability of the ink to flow through without clogging. Inks and meshes are selected with the

Figure 14-7.
The screen printing process.

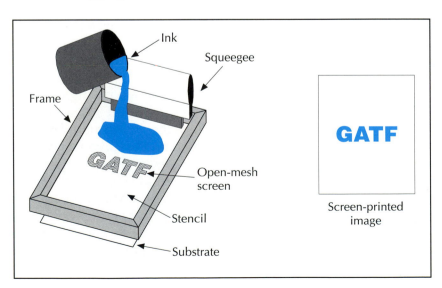

application in mind; nylon and polyester meshes with a mesh count of 50–500 openings per inch are available, together with very fine stainless-steel and phosphor-bronze meshes for high-resolution work such as printed circuit boards.

Hazardous solvent-based screen inks are being phased out in favor of water-based inks for most applications. High-speed and multicolor presses are normally fitted with UV curing to prevent the wet ink from marking.

Screen printing is an extremely versatile process with continuing improvements in quality. Because very heavy ink weights are possible, it is the first choice for display items, such as point-of-sale materials, signs, and other items where strong, eye-catching colors are required. One interesting application is in printing solid areas on prestige brochures and book jackets that have color and text printed by lithography, taking advantage of the much heavier and more consistent ink weights possible in screen printing. However, some of the traditional screen printing market for very short-run posters is being lost to inkjet printing.

Screen Printing Stencil Preparation

Stencils for commercial screen printing are made by exposing a light-sensitive stencil material through a film positive. Nonimage areas are hardened during the exposure, and the image areas can then be washed away with water. The stencil is attached to the mesh screen before wash-out. Direct-exposure systems for the production of screen stencils from digital data are used only in specialized product areas.

Hybrid Presses

Printing presses that print by more than one process are becoming increasingly common. Printers can use the relative advantages of each process to optimize the quality and production efficiency of the end product. A flexography/gravure hybrid, for example, offers the tonal quality and long-run efficiency of gravure, combined with the ease of preparation associated with flexography, to create effective promotional literature or other targeted information. Similarly, a web offset press fitted with inkjet heads can overprint variable customer information during the run of the press.

Press Automation

The continuing trend to shorter runs is one of the factors that has spurred press manufacturers to develop higher levels of press automation. In some regions, shortage of suitably skilled labor has also been a driving force.

Press automation systems have been developed for most aspects of press performance. Some are simply remote controls, in which the task of the operator is eased by grouping individual press controls in a central console. Others are linked to sensors detecting some aspect of press performance and make adjustments to compensate for any deviations that are detected. Systems of this kind include automatic registration controls using optical detectors that scan a web as it is printed and drive compensating rollers to maintain registration. Other examples include on-line densitometers and spectrophotometers that monitor printed control patches and adjust inking levels to maintain color within the tolerances that have been defined.

A great deal of press automation is designed to reduce makeready times to a minimum. Systems exist to automate every task that is performed during makeready, from locating the plates in the clamps to adjusting the paper transport mechanism for paper size and thickness.

An ultimate goal of some manufacturers is to automate the process completely and remove the human operator. This goal is still some way from realization.

Standardization and Quality Control

Since considerable variation is possible in inking and tonal value transfer, there is a need for standardization in order to ensure predictable and repeatable results. This need can be addressed at three levels: the individual machine, the plant, and the industry.

All standardization efforts involve measurement of solid and halftone patches on printed control strips, as well as adjustments to press parameters such as inking levels and ink viscosity, in order to establish and maintain consistent results.

Because solid density and tonal value transfer are interdependent (since dot gain increases with ink film thickness), it is important to establish a target density for each color and a tonal value transfer that can be maintained at that density. Since paper surface affects the densities that can be achieved, and the corresponding tonal value transfer, the exercise has to be repeated for each paper type.

At the level of the individual press, a printer may **fingerprint** the press to determine the optimum printing densities and the tonal value transfer characteristics at those densities. Optimum densities can be determined in a number of ways, the most common being:

1. By finding the density at which a parameter known as **print contrast** is maximized. Print contrast is defined as:

$$\frac{D_s - D_t}{D_s}$$

where D_s is the solid density and D_t is the density of an 80% tone patch.

2. By finding the density at which the color gamut of the process is largest.

Many plants produce specifications that apply to all the presses in the plant, which may also include details of how files and films should be presented.

Much of the drive for standardization has come from print purchasers and advertisers, who have a great interest in the predictability of color reproduction. In collaboration with printing industry representatives, a number of industry-wide specifications have been developed such as **SWOP (Specifications for Web Offset Printing)** and **UKONS (UK Offset Newspaper Specifications)**.

Table 14-1.
Industry specifications for color printing. The publication of ISO 12647 removes the need for such industry-based specifications as it defines process control parameters for all printing processes.

Standard	Published by
Specifications for Web Offset Printing (SWOP)	SWOP, Inc.
Eurostandard Offset	System Brunner
Specifications for European Offset Printing of Periodicals (FIPP)	International Federation of the Periodical Press
Specifications for Non-heatset Advertising Printing (SNAP)	Printing Industries of America
UK Offset Newspaper Specifications (UKONS)	Newspaper Society (UK) and Pira International

More recently, industry representatives from different countries have integrated specifications from a wide range of industry sectors into an international standard, ISO 12647: *Graphic Technology — Process control for the manufacture of halftone color separations, proof and production prints.*

The standard defines specifications for offset litho, coldset litho, and letterpress on newsprint, gravure, and screen printing. It also includes specifications for proofing and film output, together with production tolerances.

The existence of an internationally recognized set of specifications for color printing is of great importance to the increasing globalization of the industry, and enables purchasers to have confidence that color reproductions will be produced consistently on different media, by different processes, and at different plants.

Before films or plates can be made, it is essential that the exact characteristics of the printed output are known, in order to set gray balance and tone compression correctly and compensate for any distortions, such as dot gain. For the majority of jobs, it is not realistic to adjust the color separations for each printing press, since, in many cases, this information is not known at the time the films are output.

Rather than expect the film supplier to attempt to calibrate the films to the individual press, many lithographic printers work to established industry-wide standards. These standards specify printing characteristics that most printers are capable of matching. The publisher needs only to know which standard applies, in order to automatically generate correctly adjusted films. ICC color profiles incorporating these standards are available from a variety of sources, including the German printing industry research organization FOGRA *(www.fogra.org)*.

The alternative to generating films to known standards is to calibrate the films to the individual press, once its specific characteristics have been established. Where standards do not exist, publishers must obtain a specification for press characteristics from the printer. Otherwise, they must supply originals and allow the printer to generate the films.

Research is continuing into ways of establishing some elements of standardization in flexography, gravure, and screen printing. ISO 12647 encompasses these processes as well as offset lithography.

On-press process control is normally through densitometry. Solid inks and tint areas are measured and compared with the aim values defined by the proof or the relevant standard.

Some traditional densitometric control parameters, such as grayness and hue error, are superceded by the increasing use of colorimetry in place of densitometry.

Table 14-2.
Summary of ISO
12647-2 specifications
for print color and
dot gain.

A. CIELAB L*/a*/b* coordinates of printing inks and secondary overprints for the color sequence CMY.

	Gloss coated wood-free	Matte coated wood-free	Gloss coated web offset	Uncoated white offset	Newsprint	Variation tolerance for process printing (ΔE)*
Black	18/0/–1	18/1/1	20/0/0	35/2/1	40/1/4	2
Cyan	54/–37/–50	54/–33/–49	54/–37/–42	62/–23/–39	57/–23/–27	2.5
Magenta	47/75/–6	47/72/–3	45/71/–2	53/56/–2	53/48/0	4
Yellow	88/–6/95	88/–5/90	82/–6/86	86/–4/68	79/–5/60	3
Red (M+Y)	48/65/45	47/63/42	46/61/42	51/53/22	52/41/25	
Green (C+Y)	49/–65/30	47/–60/26	50/–62/29	52/–38/17	53/–34/18	
Blue (C+M)	26/22/–45	26/24/–43	26/20/–41	38/12/–28	41/7/–22	

*Tolerances are higher for newsprint and lower for special colors.

B. Tonal value increase (dot gain) at 50%, with 150-lpi screen frequency and positive-working plates.

	Coated wood-free	Gloss coated web offset	Uncoated white offset	Newsprint (100 lpi)
Heatset web		19		
Coldset web				27
Sheetfed litho	17	19	23	

C. Tonal value increase (dot gain) at 50%, with 150-lpi screen frequency and negative-working plates.

	Coated wood-free	Gloss coated web offset	Uncoated white offset	Newsprint
Heatset web		27		
Coldset web				33
Sheetfed litho	25	27	31	

Production print variation for tonal value increase is 4% at 50%.

Printing Problems

High levels of quality and consistency are regularly achieved in commercial printing. The most frequent quality problems that occur with the printing processes can be briefly summarized as follows:

- Substrate deformities, including excessive moisture absorption that leads to misregister or curl and the rupture of the paper's surface, bringing about blistering, picking, and other defects.

- Breakdown of the image/nonimage separation. Image areas can wear or break up (flexography and lithography) or get dirty and fill in (gravure and screen printing), causing a loss of detail, especially in highlights. Similarly, nonimage areas can become worn (gravure and screen), fill in (flexography), or fail to repel ink (lithography). As a result, ink—usually in the form of streaks, spots, or a light overall tint—appears in the nonimage areas. Damage to the printing surface shows up as scratches or dents, and dirt can appear as printed or unprinted spots.
- Inconsistencies in inking. Lithography is especially prone to inking irregularities. These may be caused by a failure to set and maintain the ink and dampening levels accurately across the sheet, or by a weaknesses in press design and maintenance. On the printed sheet, uneven inking appears in the form of bands in larger tint areas or ghosts (repeat images) in areas of solid color.
- Incompatibility of one or more materials with each other or with the printing process. Unexpected and sometimes unpredictable effects can occasionally occur and it may be difficult to pinpoint the exact cause of the problem. Most problems can be avoided by employing a combination of good design and specifications, by proofing at the appropriate stages in production, and by using reliable printing facilities.

Bibliography

ISO 12647-1 *Graphic technology—Process control for the manufacture of halftone colour separations, proof and production prints Part 1: Parameters and measurement methods.*

ISO 12647-2 *Graphic technology—Process control for the manufacture of halftone colour separations, proof and production prints Part 2: Coldset offset lithography.*

ISO 12647-3 *Graphic technology—Process control for the manufacture of halftone colour separations, proof and production prints Part 3: Coldset offset lithography and letterpress on newsprint.*

MacPhee, J. (1998). *Fundamentals of lithographic printing: Volume 1, Mechanics of printing.* GATF*Press.*

O'Rourke, J. (1997). *The complete guide to waterless printing: A reference and user's manual.* Quantum Resources, Inc.

Thompson, R. (1997). *Fundamentals of printing materials and technology.* Pira International.

Tritton, R. (1993). *Colour control in lithography.* Pira International.

Appendix: *Understanding Digital Color* Website

Resources for digital color imaging have been made available to readers of this book through a dedicated website hosted at the London College of Printing.

The resources are organized by chapter and include sample images showing some of the techniques and effects described in the book, data and methods of calculation for color transformations, test images for device calibration and control, and a process color tint chart that you can print on your own printer.

There are also links to other websites that provide relevant and useful information. The site is updated regularly. The URL is *http://twinpentium.lcp.linst.ac.uk/digitalcolor*

If you have any comments on the site or suggestions for resources that would be useful to readers, please contact the author: *green@colourspace.demon.co.uk*

Index

Accent color 48
Additive primary 7, 11
Additivity 11
Address grid 219, 220
Adobe 168, 194, 196, 218
 Acrobat Distiller 211, 294–296
 Acrobat Exchange 211, 310
 Acrobat Reader 211, 212
 Illustrator 51, 211, 264, 281
 Imageready 280
 PageMaker 51, 57, 59, 179, 264,
 289, 291, 294
 Photoshop 51, 52, 53, 56, 57, 75–
 76, 95, 106, 155–156, 179, 211
 Portable Job Ticket Format
 212, 213, 270
Agfa 168, 174, 330
Aliasing 91
American National Standards
 Institute (ANSI) 31
Analog 65, 66, 68, 118
ANSI PH-2.30 31, 170
Archiving 248
Artifacts 127, 229
Artists' illustration 2, 86–87
Artwork 86–87, 288
ASCII characters 207
Asynchronous connection 252
Autotrace 101

Banding 71, 285, 286–287
Bezier 90, 92, 202, 210, 284
Bilevel system 215
Binary 55, 65, 66, 89, 207, 215
Binuscan ColorPro 156
Bit depth 71–76, 94, 123
Bitmap 89, 91, 198
Bits per second 250
Black 12, 48, 228, 229

Black generation 150–155, 181
Black point adjustment 133
Blend 284, 285–287
Blooming 121
Blue 6, 7, 11, 12, 25
Boolean logic 67
Bounding box 204, 283
Brightness 22, 23, 26, 29, 78
Brightness adaptation 19, 21, 22
Broadband 252
Bump plate 159
Bytes 250

Calibration 167, 181–185
Capstan 221
Catchlight 82
Cathode-ray tube (CRT) 242, 245
CCITT 94, 256
Characterization 144, 147, 148,
 167
Charge-coupled device (CCD) 17,
 114–118, 119, 124, 181
Choke 263
Chroma 23, 25, 27, 31, 74, 139,
 149, 150, 185, 186
Chromatic adaptation 21, 22
Chromaticity 39, 45
Chrominance 259
CIECAM97s 188, 190
CIE chromaticity diagram 39, 40
CIE color space 30, 37–41, 45, 50,
 124, 139, 143, 161, 165, 166, 175,
 180, 187, 188, 194, 306, 334
CIELAB color space 30, 41, 42, 45,
 79, 95, 98, 170, 173, 174, 187, 357
CIELUV 41
CIEXYZ 173, 174
CIP3 270–272
Clipping path 94, 284, 285

Closed-loop color 165
CMC*(l:c)* 42
CMY 28, 142, 144, 145, 146, 152,
 157, 159, 161, 172, 357
CMYK 12, 28, 29, 48, 52, 53, 54,
 55, 56, 57, 60, 62, 76, 77, 81, 88,
 93, 94, 95, 96, 98, 107, 113, 115,
 123, 124, 125, 131, 132, 133, 134,
 139, 141, 143, 144, 146, 149, 150,
 152, 155, 156, 157, 158, 159, 162,
 165, 165, 171, 172, 175, 178, 180,
 183, 205, 206, 210, 213, 231, 241,
 259, 262, 277, 279, 280, 288, 295,
 305, 306
CMYK, specifying 50–53
Color 5–36, 48, 50–52, 61–62,
 65–83, 103, 104, 173, 186–190,
 278–280, 282, 303
Color, special 48, 53–55, 294, 295
Color atlas 51
Color balance 103–104, 107, 139
Color conversion 139–163, 164,
 165, 167, 188–190, 295–296
Color depth 243, 244
Color difference 42
Color discrimination 18–19
Color management 99, 165–191
Color matching 60–61, 304–305,
 334
Color measurement 37–48
Color order system 26, 27–28
Color original 2, 85–109
Color perception 13–17, 18–19
Color processing 173, 180–181,
 204–207
Color profile 170–179, 254
Color rendering dictionary 177,
 180, 181, 205, 210
Color rendering intent 176
Color reproduction 3, 5, 78–79
Color separation 135, 139–163
Color space 23, 26, 28–29, 30–31,
 94, 139, 140, 204–205, 206, 219,
 277–278
Color space array (CSA) 180,
 181, 198, 205
Color specification 48–64
Color spectrum 6
Color temperature 9–10, 121
Color wheel 8–9, 25
Colorfulness 22, 23, 25, 26, 27
Colorimetry 37, 45, 182
ColorSavvy ProfileSuite 176

ColorSync 169, 170, 176, 305
Commission Internationale de
 l'Eclairage (CIE) 10, 37
Compression 94, 99, 149, 150,
 249, 254–260, 295
Computer-to-plate (CTP) 3,
 222–224, 267, 305, 331, 345
Cones 14–15
Continuous-tone image 68, 71
Contouring 71, 76, 225, 231, 285
Contrast 78, 79, 80–81, 102,
 104–106, 108
Copyright 99, 101
Cropping 87, 128, 208, 261, 285
Curve 202, 216, 284–285
Custom palette 159–160
Cyan 7, 11, 12, 48, 228, 229

Densitometer 42–45, 182
Densitometer, software 107, 310
Density 42–43, 104, 142
Desktop Color Separation (DCS)
 format 93, 94, 95, 161, 212,
 265, 278, 279, 280
Despeckle filter 106
Device N color space 210
D50 illuminant 10, 33, 34, 35
DIC Color Guide 59
Diffuse highlight 82
Diffuse reflection 10, 13
Digital Artwork and Reproduction
 (DAR) system 348
Digital Artwork Transfer Industry
 Committee (DATIC) 288
Digital color system 67
Digital image 67, 76, 88–92,
 106–109
Digital negative 128
Digital photography 1, 2, 98,
 99–100, 119–121, 165, 166
Digital printing 3, 275, 319–336
Discrete cosine transform (DCT)
 256, 257
Distributed production 273–274
Dithering 78, 215, 225
DK&A INposition 268
DK&A Trapper 264, 265
Document creation 281–288
Document structuring conventions
 196, 208
Dot area 226
Dot gain 184, 227, 238–242, 342,
 357

Dot shape 226, 229–230
Downsampling 295
Draw program 101
Drying systems 342, 344
D65 illuminant 34
DuPont Cromalin 162, 304, 311
Dye sublimation 319, 326, 327
Dynamic range 104, 117

Eder MCS 160
Elcography 335
Electromagnetic spectrum 5
Electron beam printer 326
Electrostatic printing 324–326
Elseware CheckList 289
Encapsulated PostScript (EPS)
 92, 93, 94, 95, 178, 203–204, 211,
 212, 230, 261, 264, 278, 280, 283,
 287, 288, 291
Encoding 68, 76, 77
Enlargement 102, 106, 123
Error dispersion 236
Ethernet 250, 252
Euclidean dot 235
Euroscale offset litho 166
Eurostandard 51, 355
Exposure systems 219–224
Extra-trinary color 54, 159, 161

Farrukh Imposition Publisher 268
Farrukh Trapper 264
Fiber optic 252
File checking 289–290
File format 92–98, 280, 281–282
File links 290–292
File preparation 277–297
Fill-in 227
Fingerprinting press 354
Flare 11
Flashpix 94, 98
Flat 266
Flatness value 284
Flexography 166, 338, 346–348,
 358
Fluorescence 12, 35, 87
FM screening 127, 128, 236–238
Focoltone color system 48, 52, 57,
 59
FOGRA 168, 356
Font 91, 198, 202, 211, 212, 217,
 277, 290, 292, 294, 295
Fourier transform 256
FujiFilm Pictrography 309

Gain 242
Gamma 77, 242
Gamut 12, 87, 149, 185–186,
 188–190, 302, 304, 306
GATF/RHEM Light Indicator 34
Gloss 13
Gradation 134–135, 236, 285, 287
Gradient 209, 231
Grain 106
Graphical primitive 202–203
Gravure 338, 348–352, 358
Gray, neutral 107
Gray component replacement
 (GCR) 50, 150, 152, 153, 154,
 155, 156, 159, 181, 229
Gray levels 71, 74, 76, 134, 231,
 235
Grayscale 72, 74, 76, 94, 215
Green 6, 7, 11, 25, 26

Halftone 210, 220, 226–231, 234
Halftone dictionary 198
Halftone parameters 294
Halftone screen 76, 127, 225,
 231–235
Halftone screen frequency 68, 125
Halftoning 215, 218, 219,
 224–238, 314, 319–320
Heidelberg Quickmaster DI press
 331, 332, 337
HiFi color 54, 95, 205, 210
Highlight color 48
Hue 9, 22, 23, 25, 26, 27, 29, 74,
 184, 185, 186
Hue angle 26
Hue, saturation, and brightness
 (HSB) 26, 27, 29, 205
Hue, saturation, and lightness
 (HSL) 24, 26, 26, 56, 61, 108
Hue, saturation, and value (HSV)
 26
Huffman compression 94, 255,
 256, 257, 259
Human eye 14–17
HyperText Markup Language
 (HTML) 209, 254, 289

ICC-based color management
 155, 157, 168–170
ICC color profile 155, 156, 170,
 171, 173, 174, 176, 178–179, 180,
 188, 209, 278, 280, 282, 334, 356
IFRAtrack 272–273

Image 85–109, 111, 277–281, 283
Image carrier 342
Image correction marks 315
Image-editing application 106, 107, 109, 128, 131, 135
Imagesetter, calibration 183–184
Imation 309
 PressWise 268
 Rainbow 307, 308
 TrapWise 264
Imposition 219, 266–270
Incident light 13
Indexed color 94
Indigo E-Print 162, 330–331
Infrared radiation 5
Ink 11, 60–61
Inkjet 162, 307, 320, 321–323
International Color Consortium (ICC) 168
Internet 2, 98, 254
Ion deposition 326
ISCC-NBS Color Name Chart 61, 62
Island Checker 289
ISO 31–34, 35, 44, 45, 46, 47, 96, 147, 148, 160, 170, 178, 184, 256, 258, 315, 355, 356, 357
ISO viewing conditions 30–34
IT8 test target 174–175, 183

JavaScript 212, 280
Job parameters 290, 292–293
Job ticket 249
Joint Photographic Experts Group (JPEG) 256
JPEG compression 94, 95, 96, 211, 256, 257, 258–259, 280, 295, 296

Kelvin scale 9
Knockout 287
Kodak 168, 174, 332
 Approval 307, 308
 ColorFlow 179
 Q60 target 174

LAB 76, 94, 171, 172, 180, 183
Lap 269
Laser ablation 224
Light 5–13
Lightness 22, 23, 26, 27, 74, 80, 149, 150, 185, 186
Lightness, chroma, and hue (LCH) 26

Linear array 118
Linearization 184
Lithography 242, 338, 342–345, 358
Lookup table (LUT) 143, 146–149, 168, 170, 172, 173, 175, 180, 195
Lossless compression 255
Lossy compression 255, 256
Luminance 27, 31, 259
LZW (Lempel, Ziv, Welch) algorithm 94, 255–256, 257

Magenta 7, 11, 12, 48, 228, 229
Marking engine 196, 215, 216
Masking equation 145
Mechanisms of adaptation 19–26
Metadata 249, 270–273
Metamerism 37
Microsoft 168
 Windows 168, 207, 280
 Windows GDI 91, 195, 204, 207
 Windows Metafile 91
Misregister 263, 264, 265
Moiré 88, 161, 225, 228, 229, 237
Monitor 7, 11, 13, 28, 182–183, 242–245
Munsell 27–28, 30, 59

Natural Color System 27, 28
N-color separations 159–162
Network 249–254, 333
Neugebauer equation 145, 146
Neutrality 79
Newton's rings 106, 136

Object-based graphics 91
Opacity 43
Open prepress interface (OPI) 211, 212, 249, 254, 260–263
Originals 87–88, 102–106, 136
Output systems 215–245

PANTONE 11, 43, 48, 49, 51, 55–56, 57, 58, 60, 155, 160, 162, 306
PANTONE Hexachrome 12, 160, 171
Path 202–203, 208, 284, 285
PDF 94, 193, 194, 205, 207, 209, 210–213, 254, 261, 267, 271, 281–282, 288, 289, 293–296, 310
Perceptual attributes 21–26, 186, 187
Perceptual rendering intent 150

Persistence of vision 17

Phase-change system 321, 322, 324

Phosphors 28, 242

Photo CD (PCD) 31, 94, 96–98, 156, 165, 259

PhotoImpress 156

Photomultiplier tube (PMT) 114, 115, 117, 118, 124

Photoreceptors 14, 15, 17,

PICT 91, 204

Pictrography 309, 335

Picture library 98, 100

Piezoelectric 321

Pixel 67, 68, 70, 88, 89, 92, 101, 106, 215, 216, 231

Pixelation 91, 122

PixelBurst coprocessor 219

Plate 3, 222, 224

Platesetter 222, 223

Portable Document Format *See* PDF

PostScript 75, 91, 93, 155, 180–181, 193–210, 211, 212, 218, 223, 230, 235, 254, 262, 267, 271, 281, 282, 285, 286, 287, 289, 293–296, 302

PostScript Extreme 209, 213

PostScript Printer Description (PPD) 196, 219, 254, 281, 293, 294

Preflighting 248

Press 184–185, 331–333, 353–354

Print contrast 355

Printer, calibration 184

Printer driver 207

Printing, conventional 337–359

Printing, digital 3, 275, 319–336

Printing, high-volume 328–333

Printing, problems 357–358

Process color 48

Production object 272

Profile connection space (PCS) 169, 170

Proof 3, 184, 254, 299–317

 categories 300, 303, 305

 digital 3, 162, 305–309, 312, 317

 evaluation of 314–316

 selection of 314

 technologies 305–313

 version control 315–316

Proofing stages 297–301

Quality control 316, 354–357

QuarkXPress 51, 57, 253, 264, 268, 289, 291, 294

Radius 130

Raster 67, 89, 91, 92, 94, 101, 215

Raster image processing 196, 216–219

Raster mask 209

Rasterization 217

Reconstruction 68, 77

Red 6, 7, 8, 11, 25

Reflectance 42, 45

Refresh rate 243

Rendering intents 149–150

Resampling 70, 284

Resolution 21, 68–71, 76, 79, 99, 121–122, 123, 125, 127, 231, 243, 244, 295, 319, 280, 287, 302, 319, 342

Resolution target 71

Retina 14, 15, 17

Retouching 109

RGB 28, 29, 31, 57, 76, 77, 81, 92, 94, 95, 98, 107, 123, 124, 125, 132, 134, 139, 141, 142, 143, 144, 145, 146, 150, 155, 156, 157–158, 159, 161, 165, 171, 172, 173, 175, 177, 178, 180, 181, 183, 204, 205, 206, 210, 259, 277, 279, 295

Rhodopsin 14

Rods 14, 15

Run-length encoding (RLE) 255, 256

Sampling 68–71, 76, 89, 125

Sampling frequency 125

Saturation 23, 25, 29, 78

Scaling 87, 282–284

Scanner 17, 45, 113–119, 121, 122–136, 181, 182, 223

Scanning 111–119, 121–136

Scitex 95, 96, 156, 254, 323

Scitex/KBA Karat 74 press 332

Screen angle 226, 228–229, 238

Screen frequency 198, 226–228, 238

Screen printing 338, 352–353, 358

Screen ruling 198, 226–228, 287, 290

Service provider 290, 296–297

Shade-stepping 285, 286–287

Sharpness 78, 102–103, 107,
 128–130, 131
Shingling 269–270
Simultaneous contrast 22
Specification for Web Offset Print-
 ing (SWOP) 51, 166, 184, 305,
 334, 355
Spectral absorbency 11
Spectral power distribution 7–9,
 10, 25, 37
Spectral reflectance curve 8
Spectrocolorimeter 47
Spectrophotometer 45–47, 182
Spot function 234–235
Spread 263
sRGB 144, 157–158, 177, 210
Standard observer 38
Standardization 354–357
Status T filter 43, 44
Stochastic *See* FM screening
Stripping 222, 267
Stroke adjustment 217
Subtractive color 11, 12
Supercell 233, 235
Synaesthesia 18

Tagged Image File Format *See*
 TIFF and TIFF/IT
Thermal printer 320, 326–327
Thermal transfer 326, 327
Threshold array 232–234
TIFF 92, 94, 95–96, 98, 171, 178,
 204, 213, 257, 261, 262, 279, 280,
 287
TIFF/IT 96, 193, 213, 267, 271,
 280, 288
Tint 50, 51, 88, 226, 229, 230–231,
 285
Tonal gradation 79, 81–82,
 108–109, 134–135
Tonal range 342
Tonal rendering 79, 140
Tone, illusion of 224, 225
Tone adjustment 130–132
Tone reproduction 79–80, 240
Tone value increase *See* Dot gain
Touch plate 159
Toyo 56, 59
TransCal HiFi ColorSeps 159
Transfer function 75, 76, 294
Transmittance 37, 45
Transparency 2, 11, 85, 86, 88,
 102, 111, 114, 136

Trapping 209, 212, 219, 263–266,
 277, 287–288, 294
Trilinear array 118
Tristimulus values 38, 39, 40, 41,
 45, 47, 144, 145, 146, 172
TRUMATCH 52, 53, 57

UK Offset Newspaper Specifica-
 tions (UKONS) 355
Ultraviolet radiation 5
Undercolor addition 153, 156
Undercolor removal 151, 152,
 153, 155, 181
Unsharp masking 102–103, 114,
 128–130, 131

Value See Lightness
Vector 67, 92, 94, 99, 215
Vector graphic 67, 89, 90–91, 92,
 284
Viewing conditions 31–35, 102,
 106
Vio 253, 254
Visible spectrum 5, 6–7
Visual 300, 302–303
Visual cortex 17

Wam!Net 253, 254
Waterless lithography 345
Wavelength 5, 220
Wavelet compression 257
Web offset lithography 344
White 7
White point 79, 132–133
Workflow 1, 2, 4, 123, 136,
 157–159, 178–179, 188–190, 223,
 247–276, 277, 279, 305, 316–317,
 333–334
World Wide Web 2, 254, 280–281,
 289, 296

Xeikon 328–330
XYZ tristimulus values 38, 41,
 45, 144, 145, 146, 171, 172, 180,
 188, 190

YCC 30, 31, 94–96, 98, 165, 259
Yellow 6, 7, 11, 12, 48, 228
YUV color space 257

ZIP compression 295

About the Author

Phil Green teaches at the London College of Printing, School of Printing and Publishing, in the United Kingdom, where he is currently course director of the MA Digital Imaging.

Beginning as a trainee printer in 1972, Green has had a diverse career in the graphic arts, including positions in color press operation, prepress, and production management. In 1979, he founded the worker-owned Blackrose Press, a small lithographic printer in London.

He has taught at LCP since 1986, conducting classes at all levels from apprentice to postgraduate. He has current research interests in gamut mapping and colorimetry.

Green, who has an MSc from the University of Surrey, is the author of a number of other publications, including *Professional Printing Buying* and *Digital Photography*. He is a member of the editorial board of the *Journal of Prepress and Printing Technology,* and he also conducts seminars on graphic arts topics and provides consultancy services in color imaging.

———

The author welcomes feedback and discussion on the topics that are covered in this book. He can be reached at *green@colourspace.demon.co.uk*.

About GATF

The Graphic Arts Technical Foundation is a nonprofit, scientific, technical, and educational organization dedicated to the advancement of the graphic communications industries worldwide. Its mission is to serve the field as the leading resource for technical information and services through research and education.

For 75 years the Foundation has developed leading edge technologies and practices for printing. GATF's staff of researchers, educators, and technical specialists partner with nearly 14,000 corporate members in over 80 countries to help them maintain their competitive edge by increasing productivity, print quality, process control, and environmental compliance, and by implementing new techniques and technologies. Through conferences, satellite symposia, workshops, consulting, technical support, laboratory services, and publications, GATF strives to advance a global graphic communications community.

The GATF*Press* publishes books on nearly every aspect of the field; learning modules (step-by-step instruction booklets); audiovisuals (CD-ROMs and videocassettes); and research and technology reports. It also publishes *GATFWorld,* a bimonthly magazine of technical articles, industry news, and reviews of specific products.

For more detailed information on GATF products and services, please visit our website *http://www.gatf.org* or write to us at 200 Deer Run Road, Sewickley, PA 15143-2600 (phone: 412/741-6860).

Orders to:
GATF Orders
P.O. Box 1020
Sewickley, PA 15143-1020
Phone (U.S. and Canada only): 800/662-3916
Phone (all other countries): 412/741-5733
Fax: 412/741-0609
Email: gatforders@abdintl.com

GATF*Press:* Selected Titles

Binding, Finishing, and Mailing: The Final Word. Tedesco, T. J.

Careers in Graphic Communications: A Resource Book. Flecker, Sally Ann & Pamela J. Groff.

Color and Its Reproduction. Field, Gary G.

Computer-to-Plate: Automating the Printing Industry. Adams, Richard M. II & Frank J. Romano.

Computer-to-Plate Primer. Adams, Richard M. II & Frank J. Romano.

Flexography Primer. Crouch, J. Page.

The GATF Encyclopedia of Graphic Communications. Romano, Frank J. & Richard M. Romano.

The GATF Guide to Digital Color Reproduction in Newspapers. Adams, Richard M. II & Ray Reinertson.

The GATF Practical Guide to Color Management. Adams, Richard M. II & Joshua B. Weisberg.

Glossary of Graphic Communications. Groff, Pamela J.

Gravure Primer. Kasunich, Cheryl L.

Guide to Desktop Publishing. Hinderliter, Hal.

Handbook of Graphic Arts Equations. Breede, Manfred H.

Introduction to Densitometry: A User's Guide to Print Production. Brehm, Peter.

Lithography Primer. Wilson, Daniel G.

On-Demand and Digital Printing Primer. Fenton, Howard M.

On-Demand Printing: The Revolution in Digital and Customized Printing. Fenton, Howard M. & Frank J. Romano.

Printing Plant Layout and Facility Design. Geis, A. John.

Professional Print Buying. Green, Phil.

Screen Printing Primer. Ingram, Samuel T.

Sheetfed Offset Press Operating. DeJidas, Lloyd P. & Thomas M. Destree.

Solving Sheetfed Offset Press Problems. GATF Staff.

Solving Web Offset Press Problems. GATF Staff.

Total Production Maintenance: A Guide for the Printing Industry. Rizzo, Kenneth E.

Understanding Digital Imposition. Hinderliter, Hal.

Web Offset Press Operating. GATF Staff.

What the Printer Should Know about Ink. Eldred, Nelson R. & Terry Scarlett.

What the Printer Should Know about Paper. Wilson, Lawrence A.

Colophon

The author, based in London, wrote the manuscript using Microsoft Word on a PC and then transmitted the text, in RTF format, to GATF in Pittsburgh as email attachments. Similarly, the author transmitted most of the new illustrations using EPS, PDF, or JPEG formats. Two CD-ROMs containing large multi-megabyte images were sent by overnight courier.

At GATF the book followed a Macintosh workflow. The manuscript was edited in Microsoft Word and then imported into QuarkXPress for page layout. The PDF illustration files were opened in Adobe Illustrator 8.0 and saved in Illustrator EPS format. The JPEG files were opened in Adobe Photoshop 5.0 and saved in TIFF format. Many of the line images from the 1994 edition of the book, in FreeHand 3.1 EPS format, were opened in Illustrator, modified following the author's instructions, and saved in Illustrator EPS format.

Once the editorial/page layout process was completed, the images were transmitted to GATF's Center for Imaging Excellence, where all images were adjusted for the printing parameters of GATF's in-house printing department and proofed.

Next, the entire book was preflighted, digitally imposed using DK&A INposition, and then output to a Barco Crescent 42 platesetter. The cover was then printed two-up on a 19×25-in., six-color Komori Lithrone 28 sheetfed press with aqueous coater. The interior was printed on a 23×38-in., four-color Heidelberg Speedmaster Model 102-4P sheetfed press. Finally, the book was sent to a trade bindery for case binding.